TRADITIONAL THEMES IN
JAPANESE
ART

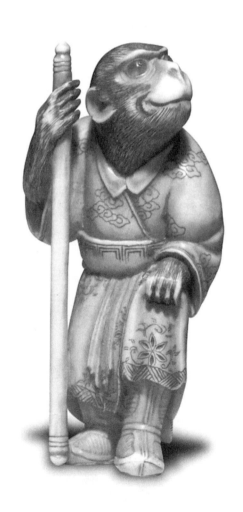

TRADITIONAL THEMES IN

JAPANESE ART

CHARLES R. TEMPLE

A Wordcraft Associates Publication

REGENT PRESS
BERKELEY, CA

ISBN-13: 978-1-58790-149-2
ISBN-10: 1-58790-149-8
Library of Congress Control Number: 2008923030

First Edition

Cover design by Emily Burch
Interior design by Kiyoshi Design
The cover illustration is a netsuke of Songoku,
"The Monkey King," boon companion
to Sanzo-hoshi on his travels in India.
The figure was carved by the 19th c. Japanese artist,
Mitsuhiro, in ivory (5.2 cm in height).
Photo courtesy of Frances Bushell

Manufactured in the United State of America
Regent Press
2747 Regent Street
Berkeley, CA 94705
www.regentpress.net

DEDICATIONS

FOR BERNARD HURTIG,
FATHER OF THE PROJECT,
AND IN MEMORY OF O.A. BUSHNELL
AND TAKESHI KITAZUME

CONTENTS

Foreword

IX

Themes A to Z

1

Selected Sources

333

Where to Find It

335

FOREWORD

This book is intended as a compact reference work. It contains a selection of time-honored themes used even today in the works of Japanese artists who, as did their predecessors, find creative inspiration in their country's myths, legends, historical events (factual and embroidered), literary and dramatic works, folklore, ghost stories, and fairy tales. A section entitled *Where to Find It* is a listing of recurring themes in Japanese art and entries in the book that deal with them.

For those interested, the classical collections of traditional themes in Japanese art, on which I have relied in assembling the entries in this book, are works by Will H. Edmunds, *Pointers and Clues to the Subjects of Chinese and Japanese Art*; Henri Joly, *Legend in Japanese Art*; Edmund Papinot, *Historical and Geographical Dictionary of Japan*; T. Volker, *The Animal in Far Eastern Art*; and V.F. Weber, *Ko-ji Ho-ten* (in French). Collectively, these compilations form a comprehensive database-in-print that should be accessed by anyone wishing to travel more widely in the world of Japanese art.

I am indebted to many persons who contributed to the publication of this book. Among them are Bernard Hurtig, art collector, who sponsored the original research and writing that led to the making of this book; the late O.A. Bushnell, scientist, novelist, and aficionado of things Japanese, for having been my industrious and erudite companion in the preparation of a larger work on traditional themes in Japanese art; and the late Takeshi Kitazume, painter and musician, for enlightened commentary on Japanese artists and their use of myths and legends. Interior book design is by Kiyoshi Design; cover design by Emily Burch. Joe Wollenweber and Emily Burch are also to be thanked for their hands-on editing and creative counsel. Needless to say, responsibility for the book's errors and deficiencies is all mine.

Charles R. Temple
San Francisco, 2008

TRADITIONAL THEMES IN

JAPANESE
ART

Abe no Nakamaro *poet*

Imprisoned in a high tower for the crime of purloining the details of the Chinese calendrical system, he cut open a finger, and with the fresh blood, wrote a poem about the moon on the sleeve of his robe before he starved to death.

Abe no Seimei *astrologer-magician*

He cured the Emperor Toba of an illness caused by Tamamo no Mae, one of the ruler's concubines, who was in reality a malevolent, nine-tailed fox. He also freed Regent Fujiwara no Michinaga of a spell by transforming the magical paper on which the spell had been written into a crane.

Abe no Sadato *warrior*

Noted for his bravery, he was killed at the battle of Kuriya River, during an engagement between the Abe and Fujiwara families.

Abe no Muneto *warrior*

Brother of Abe no Sadato, he was captured by the Fujiwara and imprisoned in Kyoto for nine years. At the end of that time, he was either executed or allowed to become a monk.

Abe no Yasuna *poet*

Descendant of Abe no Nakamaro, he fathered Abe no Seimei through a union with a fox-woman named Kuzonoha, whom he had saved from hunters.

Agata

Agata *deity*

She is believed to cure venereal diseases.

Aizen Myo-o *Buddhist minor deity*

Revered as a king of light (i.e., knowledge) and of love. An image of him in Kongo Temple on Mount Koya shows his brilliantly red body posed against a flaming crimson mandorla.

Akechi no Mitsuhide *warrior and poet*

He caused the death of Oda Nobunaga through treachery. He met his own death at the hands of the inhabitants of a village where he had taken refuge from Toyotomi Hideyoshi, an ally of Nobunaga's.

Akoya *courtesan*

She was brought before a magistrate on charges of concealing the whereabouts of her lover, Fujiwara no Kagekiyo, after the battle of Dannoura (1185). She played so expertly on a *samisen* (a three-stringed, banjolike instrument) that she was declared innocent of any deceit. The magistrate believed that such skill was the sign of a person pure in heart.

Aku Hachiro *warrior*

During a siege against Takasagu Castle, Aku Hachiro threw stones, each so heavy that 50 men could scarcely lift one, at the besiegers. He also smashed into their ranks using the trunk of a huge tree as a club.

Akusen *sennin*

Usually seen as a long-haired, bearded old man dressed in mugwort (*Artemisia vulgaris*) leaves, he was able to run as fast as a horse. He lived on plants and pine cones, the latter said to confer immortality on anyone who ate them.

Amaterasu *sun goddess*

She was born from her father Izanami's left eye; her brother, Susano-o, emerged from Izanami's nostrils. In a fit of wildness, the adult Susano-o defiled his sister's rice fields and her weaving room. Offended, she withdrew into a cave and closed its entrance with a huge rock, plunging the world into darkness. In order to entice her from her place of refuge, the other gods assembled before the closed cave to watch the goddess Ame no Uzume perform a shamanistic dance while nearly naked. The gods laughed, and Amaterasu, puzzled by this, pushed ajar the rock door of her cave. The god Ame no Tajikara had been waiting for that moment; he seized the rock and pulled it away from the entrance. The sun goddess, attracted by her image reflected in a mirror previously hung in a *sakaki* (*Cleyera Japonica*) tree standing in front of the cave, emerged. Once she was in the open, a *shimenawa* (a rope of plaited

rice straw), was quickly strung across the cave's mouth, making a barrier beyond which Amaterasu could not pass. With the sun goddess's reappearance, the world was flooded with light.

Ame no Uzume (also known, in various representations, as Uzume, Oichi-hime, Otafuku, Ofuku, Okame, and many others) *Shinto deity*

Ame no Uzume is the goddess of sex and, by extension, fertility. Before a cave in which her sister, Amaterasu, was sulking, she danced on a wooden tub, stamping until she made it resound, and acting as if possessed by a dark spirit, she pulled at the nipples of her breasts and pushed her skirt-string down below her private parts. Thanks to Uzume's performance, light returned to the universe. In another scene of a divine striptease, she seduced Saruta-hiko, the Monkey Prince and guardian of earth's roads, so that he allowed her free passage. She later married him. Japan's artists have depicted Uzume in worshipful renderings of her ecstatic dance before the assembled gods (in what Shinto calls "the Celestial Festival"), but they have also taken great license in other portrayals. She may be seen as a topless woman with the drum-like tub, brandishing a phallic spear, and wearing a headdress made of leaves and mosses, or she may be shown as a plump, jolly village wanton.

Amida Buddha *deity*

"Buddha of Boundless Light," he stands for unbounded intelligence, and rules over the Western Paradise. Usually depicted enthroned on a lotus, with a protuberance from his head, a small bump in the center of his forehead, and tightly curled hair.

Ando Zaemon Shoshu *faithful retainer*

Receiving a letter promising him amnesty after defeat at the battle of Kamakura (1333), he wrapped the missive around the hilt of his sword and with that weapon committed suicide.

Anju-hime *maiden*

Sold into slavery, she and her brother are seen in a harbor town, she carrying water in yoked pails, he lashing reeds together into bundles.

Ankisei *sennin*

He explained Daoist doctrines to the Chinese emperor Shih-Huangdi. He disappeared from the court one day, leaving behind some books and a pair of bejeweled red shoes. (Nangyo Koshu, a female *sennin*, also left behind a pair of red shoes when she rose into the heavens. Her shoes, however, were jewel-less.)

Antoku *emperor* (r. 1180-85)

After the sea-battle of Dannoura (1185), in which the Taira were overwhelmingly

defeated by the Minamoto, Antoku's grandmother committed suicide and murder by leaping into the sea with the boy-emperor in her arms.

Aoto no Saemon Fujitsuna *administrator*

When he dropped a purse containing ten copper coins into a river by accident, he spent 50 more of those coins to hire five men to recover them. He explained to friends that he was putting that money into circulation instead of hoarding it. On another occasion, he was in charge of an escort taking rice to a monastery at a time of famine throughout Japan. Crossing a bridge, one of the oxen drawing the rice wagon urinated into the river below. Fujitsuna compared the animal's action—supplying water where none was needed rather than urinating in a dried-out ricefield nearby—to that of the government giving rice to monks who were rich enough to buy the grain, instead of giving it to the starving masses.

Araki no Murashige *warrior*

Wishing to dispose of Murashige, Oda Nobunaga (1534-82), the great pacifier of Japan in the sixteenth century, posted a man behind each of the two heavy wooden sliding doors that separated his quarters from the audience area of his mansion. The plan was that when Araki made his obeisance—his head would then be just above the track in which the doors ran—the two men were to push the panels together with all their strength so as to crush Araki's head. But the suspicious warrior escaped death by laying his ceremonial iron fan into the doors' groove, thereby making it impossible to close the panels completely.

Ariwara no Narihira *court noble and poet*

He is shown as a handsome man, dressed in court costume, sometimes accompanied by a page carrying his sword. He may be depicted walking through a field of irises in bloom, riding past Mount Fuji on his way to exile, or standing beside the Tatsuta River, marveling that it has not taken on the hue of silk dyed with Korean purple.

Asahina Saburo (also known as Asahina Yoshihide) *warrior*

A man of enormous strength, in battle he used a large tree trunk as a club. He also hurled a massive rock a great distance, subdued a huge carp, wrestled with Matano no Goro, swam with a crocodile (sometimes shark) under each arm, and bent iron bars. His most celebrated exploit was his descent into Hell, bypassing the sorceress who stood at Hell's entrance, where he was entertained by Emma-o, the King of Hell. (Aku Hachiro is also credited with rock-throwing and tree-wielding.)

Ashinaga and Tenaga *fantastic creatures*

Said to illustrate the benefits of cooperation, the *tenaga* (long arms) and the *ashinaga* (long legs) are usually shown joined together. The unnaturally long-armed figure,

with legs supposedly of a normal length, sits astride the shoulders of a grotesque long-legged companion with arms of a normal size. In such a position, they become a single figure with each partner benefiting from the other's peculiarity.

Ashikaga no Takauji *shogun*

Takauji (1305-58) revolted against the emperor Go-Daigo (r. 1318–39) and occupied Kyoto where he named a rival emperor. In 1336, he captured Go-Daigo on Mount Hiei, but the legitimate emperor escaped and, with his followers, set up a court in Yoshino, south of Kyoto. Not until 1392 was a single imperial court reestablished.

Atago (in the *Nihongi* known as Kagutsuchi) *deity*

The god of fire, he was one of the children of the sacred first couple Izanagi and Izanami. In giving birth to him, his mother, Izanagi, was so badly burned that she died. In Shinto beliefs, he is the god who protects dwellings against fire.

Ayashi no Omoro *bandit*

A man of great courage, he employed magic in the practice of his trade. The legendary emperor Yuraku sent soldiers to capture or slay Omoro. They set fire to his house, and, when the flames were at their highest, a gigantic white dog leaped from a window. The commander of the soldiers stabbed the animal to death with his sword. The body of the dead dog then reverted to that of the bandit-sorcerer.

Azazuma-hime *concubine*

The shogun Ietsuna (1641-80) was so fond of Azazuma that he neglected his duties and spent many days with her on boating excursions. She is depicted in art as a young woman sitting or standing in a boat, and sometimes standing under a willow tree.

Azuma no Kimi *fictional woman*

One of the characters in the eleventh-century Japanese novel *Genji monogatari* (*The Tale of Genji*), she eloped with her lover in a boat that took them down the Uji River. She should not be confused with Azazuma, mistress of the shogun Ietsuna, who was joined by her lover on many boating parties.

Badger *in folklore*

In folktales, the badger is mostly portrayed as an evil creature. It has the power to assume any shape it desires. In one form, it is a bearlike creature with a distended abdomen and a long tail; in another, it is a foxlike animal with a swollen scrotum. The badger can lure wayfarers to their deaths in treacherous swamps by beating on its belly-drum. It can smother its natural enemy, the hunter, with its huge scrotum, or lead men onto dangerous paths by taking the form of an errant moon or will-o'-the-wisp. It can enter a living person's body and, eventually, kill its host. Less lethal pastimes include: seducing village maidens in its male form and persuading fishermen to empty their nets of fine catches while disguised as a priest. A badger is often shown in art in the company of two other pot-bellied figures: a blowfish and Hotei, a god of good fortune.

The Badger's Hanging *folktale*

A badger assumed the appearance of a young man who had made a double-suicide pact with his mistress. He met her in the woods and showed her a rope, on either end of which he had fashioned a noose. He proposed that they climb to a tree branch and fasten a loop of the rope around each of their necks. They would then jump into space in opposite directions. In falling, their weights would counterbalance each other, their feet would not touch the ground, and they would perish side-by-side. The

badger had secretly calculated that his human weight would be greater than that of the girl's, and he would safely reach the ground while she would be left hanging to die alone. However, even though he had taken on human form, he still only weighed as much as a badger. The heavier body of the girl came to rest on the ground; the lighter one of the badger rose upward—and he was hanged to death.

The Badger's Revenge *folktale*

A samurai mortally wounded a badger who, in the form of an old woman, had been cracking the skulls of wayfarers by flinging a baby that became a lethal rock at their heads. The hag crawled away to die in a hole underneath a bamboo hedge. Some time later, when the samurai was fleeing from enemies, he tried to jump over that same hedge, but his trousers became snagged on the bamboo, and he fell. Before he could get to his feet, his enemies killed him. The spirit of the dead badger claimed its revenge.

Baifuku *sennin*

He resigned his government post in disgust at the corruption he saw around him. He became a mountain hermit and, through studying Daoist principles, discovered the elixir of life. A phoenix and several genii carried him off into the heavens. Baifuku is usually presented in art sitting astride a phoenix, or seated on the ground with the bird resting beside him.

Baku *mythical animal*

A two-horned creature with a snout like an elephant's trunk, tusks, a lion's mane, a tiger's feet, and a long-haired tail, he devours men's bad dreams.

Bamboo *art motif*

Throughout the Far East, the uniqueness and versatility of bamboo have been recognized for centuries. Symbolically, bamboo connotes long life, faithfulness, and worldly wisdom because, rather than remaining upright, it bends in a strong wind, but does not break. It is widely represented in Asian art, often in association with a pine and a plum tree (a trio known as The Three Friends), and it shelters animals, such as the tiger, and human beings, such as The Seven Sages of the Bamboo Grove.

The Bamboo Cutter *folktale*

An old man, a bamboo cutter, one day finds in a stalk of bamboo a tiny child whose body gives off a bright light. Eventually, she is revealed to be a daughter of the moon, exiled to earth for a period of 20 years for failing to obey her mother. She is finally recalled, but before leaving, gives the bamboo cutter a vial containing the elixir of life. He and his wife, having no wish to live now that their daughter has gone, present the vial to their emperor, who has it cast into a deep crater of Mount Fuji.

Banki

Banki *imperial concubine*

A Chinese emperor wrote a poem about a beautiful dancer named Pan Fei (J. Banki). In it he claimed that lilies grew from her footsteps. Her tiny feet and the poem are said to have been the source of the custom of footbinding. Pan Fei created a number of dances that were performed long after her time. She was the only one, however, who performed the Sword Dance in an unforgettable manner. While she danced before the assembled court, she stabbed herself with the sword. She died with such grace, not showing the slightest sign of pain, that everyone watching thought she was presenting a new and moving variation on the established theme.

Bat *in folklore*

The bat is a symbol of good luck and prosperity in both Japan and China.

Bear *totemic animal*

The bear is the totemic animal of the Ainu, a Caucasoid people who have long lived on Japan's northern island of Hokkaido. The animal is not widely represented in Japanese art.

Bee *in folklore*

Bees swarming into a house are considered to be a sign of future prosperity. The *sennin* Sosenko could turn rice grains into bees.

Beggars *historical figures*

In olden times, the most obvious beggars were Buddhist priests and monks, wandering about with their beggars' bowls and empty wallets, soliciting money or food. They often clapped blocks of hard wood together, much as fire wardens did at night, or tapped a small hand drum while chanting prayers or requests. In addition to his empty bowl, a Buddhist beggar might carry a *shakujo,* an alarm staff topped with jangling iron rings, or small bells. An especially devout mendicant would carry on his back a small wooden shrine, holding an image of the Buddha.

The Bell of Miidera *legend*

Not far from Otsu, a village near the southern end of Lake Biwa, stood Onjo Temple, the seat of the Tendai sect's Jimon branch. By the tenth century it was known as Miidera or Three Wells Temple. The priests of Miidera and those of Enryaku Temple had become bitter rivals in a struggle for wealth, power, and prestige. Benkei Musashibo, a partisan of Enryaku, carried off Miidera's huge bell. Having installed it on Mount Hiei, Benkei struck the bell to call his comrades to prayer. It emitted only a moaning sound. Irritated, Benkei heaved the bell to his shoulder, carried it to the brink of Hiei, dropped it at the cliff's edge, and kicked it so that it went rolling back to Miidera's gates, about ten kilometers away.

Benkei Musashibo *warrior-priest and hero*

Benkei was the son of a priest in Kumano. As an adult, he was a veritable giant for his time; 2.4 meters tall, who had the strength of a hundred men. Artists have shown him wrestling with an enormous carp, bigger than himself, or bashing about with a huge iron staff. Their portraits of the full-grown priest, with his impressive bulk, make him a walking armory, bearing seven different kinds of weapons: the samurai's two swords, a long bow, a bunch of arrows in a quiver, an ax, an iron cudgel, a spear (or halberd), and a sickle fastened to a chain wound about his waist. His capacity for sake and sex were also remarkable.

He and Minamoto no Yoshitsune met on Gojobashi, the Fifth Avenue Bridge across the Kamo River in eastern Kyoto. Benkei had stationed himself there, vowing to take a thousand swords on behalf of his favorite charity—himself. He had killed 999 warriors and taken their swords when the thousandth one approached, a youth playing a tune on his flute. To the bully's surprise, the youth defeated him in a swift exercise of swordplay. Benkei recognized not only his vanquisher's skill as a swordsman, but also his superior virtues of the spirit—a force to be reckoned with. Benkei knelt in the dust at Yoshitsune's feet, offering him eternal allegiance.

In the years that followed, Yoshitsune and Benkei fought side-by-side in several battles, notably in the naval engagement of Dannoura (1185) in which Yoshitsune's forces annihilated Taira enemies. Unfortuntely, Yoshitsune had a falling-out with his half-brother Yoritomo, now head of the Minamoto clan. With Benkei, he fled from his brother.

Many tales are told of their adventures. While crossing the Inland Sea near Dannoura, they were assailed by the ghosts of all the drowned Taira that rose from the waters. At a barrier gate, the fugitives, disguised as priest and porters, are detained by the guards, who think they recognize Yoshitsune as one of the baggage bearers. Benkei, the priest, beats his lord Yoshitsune as if he is indeed only a mere porter. By so doing, Benkei convinces the guards, but not their captain, that the porter cannot possibly be Yoshitsune. The captain, touched in his samurai spirit by Benkei's proof of loyalty, allows the troop to pass to freedom, even though he now knows that he must sacrifice his own life for betraying Yoritomo's trust in him. Benkei's dance of exultation, when he realizes that his subterfuge has been successful, is one of the great moments in the world of theater. In 1189, Yoritomo's allies attack the little band. Guarding his lord to the end, Benkei died on his feet (according to one account), pierced by numerous arrows while he fought to hold the bridge leading to their household on the far side of the Koromo River. But other legend makers would

not let the heroic pair die. They averred that Benkei did not stand on that bridge; rather, it was an effigy girded in his armor. He and Yoshitsune escaped to live on, in Hokkaido, in China, in Manchuria, or in some other distant land.

Ben no Naishi *court lady*

A beautiful and spirited woman who served in the court of the emperor Go-Daigo (r. 1318–39), she was abducted by the followers of a noble who wanted her as his mistress. She was rescued, however, and brought back to the court at Yoshino. She refused to be married to her rescuer on the grounds that since she knew her life was to be a short one, entering into marriage would be a foolish act. She became a nun at the age of 22.

Benten *deity*

One of The Seven Gods of Good Fortune, Benten is also the goddess of love, speech and learning, and prosperity. She appeared to Hojo no Tokimasa as a woman, whose lower body had the form of a dragon. Benten is represented in art holding a flute, or a sword and jewel, or—when she is depicted with eight hands—an ax, bow and arrow, lasso, scepter, trident, thunderbolt, and wheel. She is often paired with a white serpent that has an old man's head, and is sometimes shown with her fifteen sons.

Bimbo *deity*

He is called in Japanese *bimbogami,* "poor god," and he is the god of poverty.

Binzuru *helper of the sick*

Binzuru was one of the Buddha's original sixteen disciples, but he was expelled from the group after he broke his vow of chastity. He noticed and commented on the beauty of a woman who passed him by. Nevertheless, the merciful Buddha bestowed on him the power to heal sicknesses. A person who is ill should rub the part of the deity's statue that corresponds to the part of his own body that is ailing.

Bishamon *deity*

One of The Four Heavenly Kings who are the guardians of our world, Bishamon figures also as one of The Twelve Deva Kings who manage the affairs of this world. He is also one of The Seven Gods of Good Fortune, and in this grouping is depicted as a surprisingly martial figure.

Blind Men *historical figures*

Blind men are often depicted as masseurs, bathhouse attendants, and musicians in Japanese art. A Japanese fable relates that a number of blind men, when confronted with an elephant, touched the animal in various places and gave different opinions about the nature of the beast based on the areas each had touched.

Boar *in folklore*

A fierce and aggressive animal, willing to take on any opponent, the boar ought to be a symbol of courage in Japan, but that honor is reserved for the praying mantis. Still, the boar figures in many Japanese legends and folktales (e.g., as a mountain god met by Yamato Takeru, or slain by Yoritomo during a hunting party). The boar is a sign in the Japanese zodiac.

Bodhisattva *Buddha-to-be*

A person who by virtue of having accumulated sufficient moral and spiritual wisdom is ready to become a Buddha and enter into the state of nirvana. Unfortunately, most bodhisattva as represented by Japanese artists have no unique attributes by which they can be distinguished from *rakan*, lesser Buddhist saints. Both have been portrayed with shaven heads, elongated ear lobes, and with halos.

Boei *sennin*

During the Han dynasty, he ascended to the heavens on a cloud. Hearing of this, his two brothers went to the mountain retreat where he had lived. He reappeared and, while seated on a cloud, instructed them in Daoist matters.

Bokushi *sennin*

A philosopher, he dreamed one night he was on top of a mountain, and a man was heaping clothes on him while reciting texts from various books. On awakening, the dream-figure was at his bedside. Bokushi asked him for the secret of immortality, but the man only gave him a book dealing with arcane matters. The *sennin* is usually seen in the act of rising from his bed to greet the visitor.

Bonito *in folklore*

A meal featuring the first bonito caught in season is thought to be an auspicious occasion. Shavings of dried bonito, often attached to gifts, are tokens of this fish's power to bring good luck and health.

Bonze *Buddhist priest*

Bonzes are often portrayed in Japanese art as men with shaven heads, wearing long flowing robes, with their palms pressed together at chest level. Their images are quite human in feeling and appearance so that they are not easily mistaken for bodhisattva or *rakan*.

Boy's Day *(tango no sekku) traditional festival*

This festival is celebrated on the fifth day of the fifth month. Many Japanese hang paper or cloth renderings of carp on poles outside their houses. Originally, these displays indicated that a male child had been born to a family in the preceding year.

Brahman Triad

Brahman Triad *deities*

Brahma, Siva, and Vishnu, the trio known in Sanskrit as the *trimurti,* represent respectively the creative, destructive, and conserving principles in the universe.

Bream (J. *tai*) *in folklore*

At least two species of the fish known as *tai* are caught in Japan's coastal waters. The black kind, being more common, is less valued than the red and white kind. The Japanese praise the *tai* as "the king of fishes." Since it is esteemed for the texture and flavor of its flesh, it makes a fine dish to serve to guests at times of extravagant display, such as wedding banquets and congratulatory dinners. Inasmuch as the *tai* is large in head and shoulders, and small at the tail, it looks hunchbacked and therefore venerably old. For this reason it is considered to be another emblem of longevity and happiness.

The red *tai* is an attribute of Ebisu, one of The Seven Gods of Good Fortune, and a patron of fishermen, and by extension, a god of the sea. Because Ebisu always returns safely from his fishing trips at sea, the wife of a samurai always served a *tai* to her husband as part of his last meal before he set out on a long journey. The cooked bream was placed on an oak leaf. During the master's absence, the leaf on which the *tai* had been served hung above the main door of his house, to signal a safe return.

Bridge of Japan (*Nihonbashi*) *historical landmark*

This graceful arching bridge, with its busy traffic and the views that it afforded of Edo and the country beyond, became a favorite motif for artists. Located at the eastern edge of the city, near the shore of the bay, it crossed one of the many streams flowing through the swampy city. The first bridge in that location was constructed in 1603. Made of wood, it was about 55 meters long. Officials of the Tokugawa shogunate chose it as the point from which all distances throughout the nation were measured. At its eastern end began all major highways, most notably the Tokaido.

Brothel *institution*

The *joroya*—literally, whorehouse—with its architecture, arrangements, furnishings, decorations, inmates, and clients offered artists an inexhaustible treasury of themes. In general, teahouses did not serve as brothels. Rather, they were meeting places, where a pimp or a procuress brought a prostitute in order to introduce her to a potential client, or where freelance whores came in order to advertise themselves.

Buddhism *philosophy, religion*

One of the world's three great universal religions, Buddhism was founded by the Buddha, or "the enlightened one,"sometime in the sixth century BCE. He taught that people could eliminate desire and ignorance, the causes of pain in the world; and

enter nirvana, that state in which the self is freed from the wheel of transmigration and is absorbed into the supreme spirit of the universe. To do this, they had to adhere to the rules of conduct set forth in what the Buddha called the Eightfold Way. The Way included prohibitions against lying, taking the life of a living thing, murder, theft, sexual activity (for monks), and socially harmful intercourse (for laymen). It prescribed that a man earn his living in a seemly way, that he make use of his money wisely, and that he practice mental discipline through various kinds of meditation. The Buddha also advocated patience, for each person would have to undergo a number of transmigrations before being able to achieve the state of nirvana.

As practiced in Japan, Buddhism (in the Mahayana form) incorporates a somewhat eclectic set of religious principles and a huge pantheon, including such deities as Amida, the ruler of the Western Paradise, and Kannon, a bodhisattva of compassion. Buddhism has been, therefore, a rich source of subjects for Japanese artists.

Buddhist Triad *deities*

Imitating the older Brahman Triad, Buddhists of the Mahayana school created one of their own, composed of Buddha, Dharma, and Sangha. Buddha (once the mortal Shaka) represents the perfect truth, or Intelligence; Dharma (the spiritual son of Shaka) represents the truth of the doctrine, or the Law; and Sangha is a symbol of the many faithful who are being guided by their priests, or the Church.

Bugaku *classical dances*

These dances were introduced from China, apparently early in the Nara Period (710-84). Aristocrats at court learned the stately measures and the complex music for flutes, several kinds of drums, and especially for the *sho* (a sort of mouth-organ made of a fascicle of reeds). In addition to their usual gorgeous costumes, some performers wore large masks for certain dances. For others they dressed their hair in a coiffure so characteristic that it was called "the Bugaku helmet." Raised platforms to accommodate both musicians and dancers were erected in the forecourt of the imperial palace or a great lord's mansion. Spectators would sit on the wide verandahs of adjacent buildings, or on mats spread on the ground.

Bunsho *sennin*

Husband of Shinretsu (a daughter of one of The Twenty-four Paragons of Filial Piety), he and his wife, each mounted on the back of a tiger, ascended together into the heavens.

Buntei *Ch. emperor and paragon of filial piety*

Buntei is honored for devotion to his mother. Even after becoming emperor, he

attended his mother constantly for three years "while she lay ill," rarely changing his clothes or leaving her side; always tasting food and medicines before allowing her to take them.

Butei *Ch. emperor*

He was the sixth emperor of the Han dynasty. Chinese call him Wudi (r. from 141-87 BCE). A learned man, who was also superstitious and sensual, he studied the teachings of Confucius, Shaka, and Laozi, practiced the rituals of Daoist magic, and sought out honored sages in their mountain retreats. He visited Seiobo, Queen of the West, in her palace. Later, she returned his visit, bringing a retinue of fairies and ten peaches of immortality, plucked from the tree that grew in her garden. Butei died after having fasted for seven days while studying magic and astrology.

Butterfly *in folklore*

This delicate and beautiful insect is, for the Japanese, a symbol of a life free of cares. The butterfly may symbolize also, or actually contain, the soul of a human being. The appearance of a cloud of butterflies on the eve of one of Taira no Masakado's many battles with rivals of his own clan, the Fujiwara, was read as an omen that many men were to be slain. The legendary Chinese philosopher Soshu dreamed one night that he was a butterfly. Next day he asked the question: Was he truly a man dreaming he was a butterfly, or a butterfly dreaming he was a man?

Cang Jie *Ch. inventor of writing*

In the remotest past (some commentators have said in the twenty-eighth century BCE), Cang Jie invented the method of writing with signs, or ideographs, that was a precursor of the system used in China and Japan today. The idea came to him as he walked along a river one day and saw the regular pattern the gods of creation had put on the shell of a turtle.

Myth-makers, however, made Cang Jie a dragon with four eyes. It served as a minister to Huangdi (ca. twenty-eighth century BCE), the legendary "Yellow Emperor." This clever dragon was inspired to invent writing when he saw the tracks made by the feet of different kinds of birds as they walked across wet sand.

Cardinal Points and Directions

Japanese, like the early Chinese, recognized five cardinal points: north, south, east, west, and the center. The Chinese preferred to replace the single central point with two others, one at the zenith and one at the nadir.

Each quarter of the world (and therefore, of the heavens beyond) was guarded by its special deity, who protected it from attack by demons and evil influences. These protecting divinities are known to Japanese as The Four Heavenly Kings. In addition, each quarter of the world was represented by its distinguishing symbol, color, element, and animal. The kings and symbols are:

Carp

Jikoku (east)—blue dragon, seagreen or seablue, fire, pheasant;

Bishamon (north)—dark warrior, white, earth, ox;

Komoku (west)—white tiger, red, water, boar;

Zocho (south)—red phoenix, purple, air, horse.

By contrast, the center was allowed only the attribute of color: yellow or gold.

The Dark Warrior, symbol of the north, was often replaced by a crow, or by a serpent coiled about a tortoise (which is an avatar of Vishnu). Similar combinations of distinguishing characteristics were devised for deities guarding intermediate points of the compass, such as northeast and southwest.

Carp *in folklore*

In Japan the carp is a symbol of many life-enhancing things: bravery, happiness, good fortune, love, manliness, perseverance, and virility. As an example of perseverance the carp is shown in art struggling to surmount waterfalls. Sometimes the fish is given a dragon's head, an allusion to a Chinese legend adopted by the Japanese, stating that any fish that can fight its way up the Yellow River and breach the so-called Dragon's Gate (a stretch of dangerous rapids) would be transformed into a dragon. On Boy's Day (the fifth day of the fifth month), many Japanese hang paper or cloth renderings of carp on poles outside their houses. Originally, these displays indicated that a male child had been born to a family in the preceding year.

Cat *in folklore*

When the Buddha died all the animals of the world wept, except the cat, exposing thereby its malignant nature. Like the badger and the fox, the cat can assume any desired shape, usually to bring ill fortune to some human being. The wife of a *daimyo* of Nabeshima was killed by a cat-demon that took her shape and lived with her husband in her place. The demon sapped the man's life force, gaining entrance to his room each night by causing his guards to fall asleep. One night a young guard drove a knife into his thigh to keep himself awake. He saw the false wife arrive. The demon's disguise was divulged and she was condemned to die, but escaped in the form of a gigantic cat over the roofs of the *daimyo*'s mansion.

Cherry Tree *art motif*

The cherry blossom, in representational or stylized form, is one of the most ubiquitous motifs in Japanese art. It often symbolizes the fleeting nature of life.

Cherry Princess *drama*

Princess Sakura, daughter of a noble family, undergoes harrowing trials and tribulations before becoming a prostitute. Through it all, she retains her beauty, which proves to be a fatal attraction to Seigen, a Buddhist priest. She will have nothing to

do with him, and he becomes her stalker, until one day in Edo her current pimp and lover knifes him to death. Seigen's ghost haunts Sakura, and she dies of fear and perhaps, remorse.

Chestnut *art motif*

The chestnut is associated with the idea of worldly success.

Chinnan *sennin*

Chinnan, "The Dragon *Sennin*," ended a drought by causing a rainmaking dragon to come forth from a dried-up pool. Chinnan could walk hundreds of meters a day, used his hat or his umbrella as a raft to cross streams, dressed like a beggar, and ate dog's flesh.

Chodensu *painter and Buddhist priest*

Famous in the Muromachi period (1333-1573), he was noted for his paintings of *rakan*. While a young priest, his teacher forbade him to paint. Nevertheless, he secretly painted a representation of Fudo Myo-o, a deity of righteousness. He was found out when the flames that accompany representations of the god glowed in the darkness of his room.

Chodoryo *sennin*

By the time he was seven years of age, Chodoryo had mastered the doctrines of Laozi, the founder of Daoism. As an adult, he was over three meters tall, with a long beard, triangular-shaped green eyes, and arms so long that the tips of his fingers reached to his knees when he stood upright.

One day Chodoryo and Ocho, one of his pupils, encountered a demon, Rokudaijin. The demon changed eight of his minions into tigers and set them on the young men. Chodoryo, using his magical powers, created a fearsome lion that drove the tigers into flight. On another occasion, eight dragons attacked the two men. Once again Chodoryo saved himself and Ocho, this time by producing a bird with golden wings. The bird flew at the dragons and tore out their eyes with its beak and claws. The chief dragon begged for Chodoryo's pardon, and having received it, became one of the *sennin's* faithful followers. When Chodoryo was 123 years of age, he prepared the elixir of life, and after drinking it, ascended into the heavens.

Chogen *Buddhist priest*

He traveled throughout Japan seeking contributions to be used to rebuild Todai Temple, which had been destroyed by fire. He is shown in art riding on a mule and holding a stick to which his credentials as a fund-raiser are attached.

Choko and Chorei *brothers; examples of fraternal love*

Chorei offered himself to a band of robbers as their victim in place of his brother

Choko. The latter had been held up by the gang, but having no money, had been condemned to die. However, he had been permitted to go first to his brother's house to give their mother cabbage for her dinner. The thugs were so impressed by Chorei's act that they spared the lives of both brothers.

Chokyuka *Ch. Daoist sage-magician*

A famous sage of the Song dynasty, Chokyuka wore thin clothing even in the depths of winter. During an audience with one of the Song emperors, he demonstrated his magical powers by disrobing, cutting his clothing into pieces, turning the pieces into butterflies, and finally restoring the clothing intact by clapping his hands.

Choryo *Ch. warrior*

Choryo was one of the Three Heroes of the Early Han Dynasty; the others being the statesman Chinpei and the warrior Kanshin. The event from his life most often depicted in art is his rescue of the shoe belonging to Kosekiko, a sage-magician, from the claws of a river dragon, although occasionally he is shown without the dragon.

Chosai *Ch. traveler*

Chosai set out to discover the source of the Yellow River. During his journey, he encountered fabulous creatures, such as the *kirin* and a thousand-year-old tiger; and at the source of the river, a young woman dressed in a robe bedecked with stars and signs of the zodiac. He was later told that she must have been Shokujo (a name meaning "woman weaver"), one of the two heavenly lovers who are allowed by the gods to meet only once a year on the seventh day of the seventh month. That day is celebrated in Japan as a festival called Tanabata.

Chosanshu *sennin*

A being whose body resembled a tortoise's, he had big bones, round bulging eyes, large ears, and a beard as stiff as horsehair. He was seven feet tall, wore a fur robe and hat all year round, and carried a short dagger in one hand.

Choshinjin *Ch. magician and dragon slayer*

He was appointed governor of a province in China through which flowed a river inhabited by a malicious dragon. The beast often killed people on the riverbanks and, sometimes, stopped the flow of the river waters. Resolved to do away with the dragon, Choshinjin ordered some of his men to sound trumpets and gongs at the river's edge. He then leaped into the water and sank from sight, but shortly resurfaced with the dragon's severed head in his hand.

Christianity *a "foreign import"*

Introduced into Japan by the Jesuit missionary Francis Xavier in 1549, it attracted adherents, but was eventually banned as a destructive foreign import. In 1597, the

Shogun, Toyotomi Hideyoshi, proscribed its practice, executed 26 "martyrs", and ordered converts to recant. Most converts submitted without demur, but an unknown number continued to practice their dangerous religion in secrecy, despite unremitting efforts of shogunate officials to rout them out. A few of these "hidden Christians" preserved Bibles, other Christian books, and works of art, almost all in miniature, by secreting them in vaults, storehouses, behind walls, and even buried in the ground. In 1638, shogunate soldiers in an old castle on Shimabara Peninsula slaughtered some 20,000 Christian fighters, their women, and children.

Under those circumstances, few works of art employing Christian motifs were preserved from more lenient times, and very few could have been created. Government officials, in their determination to eradicate Christian's root and branch, commissioned a number of *fumi-e,* or "pictures to be tread on." These were crude representations of the crucifix, Christ on the cross, the Virgin Mary, or other sacred symbols, more often travesties than works of art. Suspect Japanese were required to walk on these symbols, thereby proving that they were not Christians. Suspects who refused to desecrate the symbols were tortured until they recanted. Those who refused to do so were executed. In 1860, after the opening of Japan by western powers, Catholic priests from France who settled in Nagasaki estimated that about 10,000 secret Christians still survived in Kyushu.

Christian themes in art (before the Meiji Era) are extant today. Seen are crosses, Christ with Buddha's attributes, the Virgin Mary as Kannon—sometimes with a child—and Eve with a cupid, which may have been a representation of the Christ child.

Chrysanthemum *as symbol*

The chrysanthemum, a symbol of longevity, has been used as a crest by the Japanese imperial family since the thirteenth century, although other families have also adopted it. Together with the plum blossom, bamboo, and orchid, it shares the honor of being a star among subjects in Japanese art.

Chuai *legendary emperor*

Husband of Empress Jingo, Chuai (r.192-200) attempted to make himself master of all Japan. Even though he knew that Koreans were aiding some of the forces opposing his, he refused to invade the abettors' country despite the urgings of his wife and ministers. He also ignored dreams sent to him by the gods, in which he was told to subdue the Koreans. For his intransigence the gods punished him with an early death.

Chugoro

Chugoro *unfortunate suitor*

He was a young man of Edo who fell in love with an attractive girl. She invited him to her house, which was situated at the bottom of a river. While both were still standing at the river's edge, she transformed herself into a monstrous frog, killed her suitor, and drank his blood.

Cicada *as symbol*

In China, the cicada was a symbol of longevity. When portrayed in the company of a praying mantis and a spider, the three insects stand for an appreciation of humanity, courage, and skillfulness. The cicada was thought to be fond of the gingko tree, so artists often show the insect poised on a gingko leaf.

Clam *in folklore*

In Japan the clam was regarded as both a phallic symbol and the creator of mirages. In one mirage, the palace of Ryujin, the Dragon King, is a principal feature; another shows Mount Horai. The magical clam "breathed out" these illusions.

Cock *in folklore*

Like the boar, the cock is seen as a valorous creature—and a noisy one. Its crowing added to the cacophony of noises that aided in enticing Amaterasu, the sun goddess, from her cave. A cock is often seen perched on a drum, a sign that the war drums were silent and peace reigned. In another context the cock is teamed with the drum since both rouse people to action, whether warriors or farmers. It also figures in the Japanese zodiac.

Cock Markets *institution*

During the last weeks of the year, merchants in bigger cities kept their shops and markets open until the hour of the cock (from six until eight o'clock in the evening). They did so as a courtesy to busy townsfolk who would otherwise be unable to purchase the things they needed for the New Year festival.

Comma *(tomo-e) art motif*

The comma as a motif in religious art is both ancient and universal throughout Eastern Asia. In Japan, artists show it either alone, in pairs, or trios. *Tomo-e,* whether single or multiple, also were used for both religious and secular purposes—especially in family crests, the insignia and banners of temples and shrines, and as decorative features on armor, weapons, furniture, and other objects. It symbolizes the yin and the yang, the female and male principles, lying belly to belly, a union of opposites. The triad may be an Asian analogue to the triskelion.

Conch Shell *as symbol*

In Japan, the conch shell, used as a horn by warriors from the earliest times, became

a sign of military victory. Less exaltedly, "to blow the conch" is a Japanese way of saying "to blow one's own horn."

Confucius *Ch. philosopher and teacher*

Through his teachings, Confucius (tr. 551-479 BCE) established an enduring concept of a society based on ethical values. The man, his life, and his doctrines are among the most widely chosen subjects in Chinese and Japanese art.

Artists usually show the master (sometimes with the *urna,* the bump of knowledge, on his forehead) in serious moments—instructing children or illustrating the principle of moderation by pointing out that well buckets, when carelessly filled to overflowing, were wasteful. Representations of Confucius—as well as of the Buddha and of Laozi—are seemingly endless.

A wry comment on Confucian, Buddhist, and Daoist doctrinal positions can be found in depictions of The Three Sake Tasters. Confucius, Shaka (the historical Buddha), and Laozi are the three men drinking sake. Although the rice wine in each sage's cup has been poured from the same container, its taste, judging by the entirely different expressions on the drinkers' faces, has evoked quite distinct impressions. It would appear that the same event is necessarily perceived in a different way, depending on one's religious and philosophical principles.

Cormorant Fishing *institution*

For centuries the Japanese have utilized cormorants as fishing birds. As practiced in the province of Gifu today, the technique is relatively simple: a leashed cormorant with a cord tied tautly around its throat—so that it will be unable to swallow any but the smallest fish—is lowered from a boat into the waters of a river. There it gulps fish into its hooked beak; when its handler judges that the catch is sufficient, he draws the bird back to the boat by means of the leash.

Cowrie Shell *as symbol*

The cowrie shell symbolizes erotic love (since its opening resembles the vulva) and uncomplicated childbirth (its name contains word elements meaning "child-easy-shell"). Once used widely in the Far East as a form of currency, it is included in Hotei's Bag of Precious Things (*takaramono*).

Crab *in folklore*

The spirits of dead warriors are said to live on in crabs, yet its scuttling, sidewise motion is taken as a sign of deviousness.

The crab also figures in a folktale called *The Fued between the Monkey and the Crab.* The story goes that long ago, a crab found a rice cake. Before he could take it home to share with his family, a monkey came along and talked him into trading it for a

persimmon seed. The crab planted the seed and patiently waited for the tree to bear fruit. Unfortunately, the fruits hung far above his reach. The same monkey offered to climb the tree and to pick some of those luscious persimmons for his friend. But once there, he feasted on the sweet ripe persimmons, and threw down to the crab below only hard, green, and bitter fruits.

With the help of his friends—an egg, a bee, a piece of seaweed, and a rice mortar—the crab bested the monkey. The latter, returning home, lit the cooking fire, to brew a pot of tea. The egg, hidden in the ashes, burst with the heat, spattering the monkey's face. Screeching with pain, the monkey dashed to get a towel. The bee flew out of the towel closet and prepared to sting him. The monkey fought him off with a clothes rack until, seeing the others closing in, he began to run. But the slippery seaweed tripped him, and the heavy rice mortar fell on him, putting an end to his career of trickery.

Crane *as symbol*

One of several symbols of longevity in Japanese mythology, the crane is a courier, companion, and carrier to deities and holy men and women. In Asian art a variety of birds—parrots, geese, falcons, cranes—carry a variety of things in their beaks— sashes, sprigs of leaves, sprays of flowers, bunches of fruits, vine stems, and pine twigs. Japanese artists settled almost exclusively on their favorite combination, a crane carrying a pine branch in its beak. Both are symbols of longevity. Perhaps in that spirit, Japan Air Lines adopted the crane as its emblem.

Crocodile *fantastic creature*

Never having seen a crocodile, early Japanese chroniclers and artists imagined a variety of fantastic creatures, with long limber necks and many teeth, looking more like the mythical dragon than an actual crocodile.

Crow *in folklore*

In the *Nihongi* the crow is a sacred bird. One acted as a messenger for the Emperor Jimmu (r. 660-585 BCE), a legendary figure who became Japan's first emperor—and ancestor of all succeeding sovereigns—during his conquest of Yamato. Jimmu's bird had been given to him by Amaterasu, the sun goddess, and so is probably connected with the Chinese three-footed crow that dwelled in the sun. As a natural creature, the crow was regarded as an omen of bad luck. Two crows appeared in the air above the boat of the adventurer Soso on the morning of the day he was to lose an important battle. In later times crows were thought to be messengers of the deities connected with the Hongu, Nachi, and Shingo shrines in Japan's Kumano district.

Cuckoo *in folklore*

The cry of the Japanese cuckoo, traditionally heard for the first time each year on a spring night, is both a sign that the season for planting rice has arrived and a melancholy lament for unfulfilled love. In the tenth century, a cuckoo painted on a screen came to life and sang.

Daidozan Bungoro *prodigy*

The son of a wrestler, he weighed nearly four kilograms at birth; after nine months, he was seventy centimeters tall. Bungoro was exhibited as a curiosity before audiences assembled to watch wrestling contests. Several Japanese artists have used the prodigy as an example of how appearances can be deceiving, i.e., he had bulk but not strength.

Dainichi-nyorai *Buddhist major deity*

He is the Japanese version of Vairocana, or Adi Buddha, the supreme and universal Sun Buddha who dwells in the Land of Eternally Tranquil Light. Japanese have made innumerable images and paintings of him. Some images are gigantic, in keeping with the belief that, because the worlds of the Buddhas are infinitely large, the several Buddhas who rule over them must also be large. The best-known example of such an immense image of Dainichi-nyorai is the one in Todai Temple at Nara. (The Great Buddha at Kamakura is an image of Amida-nyorai, another manifestation of the Buddha.)

Daito Kokushi *Zen priest*

Daito Kokushi (1282-1338), renowned as a charismatic teacher in the early history of Zen in Japan, established the Zen temple Daitoku in Kyoto. He disappeared one day and the emperor, hearing that he could be found under the Fifth Street Bridge in

Kyoto, ordered a search for the missing monk. At the bridge, he was offered melons (one of his favorite foods) if he would come up without using his legs. He replied that he would if the fruits were passed to him without the searchers making use of their arms.

Dakini *female deity*

Said to be a goddess of Indian origin, she is depicted in Japanese art as a young woman astride a white fox. A secret cult dedicated to her worship may once have existed in Japan.

Dance *in Japan*

In Japan, as elsewhere in the world, the original function of dance was to influence or compel the gods to perform, or refrain from performing, certain acts. Among the oldest forms of dance in Japan are *dengaku,* a farmers' fertility rite, and the Shinto *kagurai,* a rudely choreographed pantomime.

By the seventh century certain dances had been imported from China by the Japanese and were regularly performed. Among these were the court dances of *gigaku* and *gagaku,* featuring masked mimes, and the common people's *sangaku,* a vaudevillelike assemblage of dance patterns and feats of human and animal agility. An almost mandatory participant in a *sangaku* performance was a monkey (*saru*) who was made to jump through a hoop. Ultimately, the dance came to be known as *sarugaku* in honor of the acrobatic animal artist.

Daruma (also known as *Bodhidharma*) *Buddhist priest*

Daruma, a figure from Indian legend, is said to have brought Zen Buddhism to China and then to Japan. At one point in his life Daruma retired to a cave where he sat in (almost) sleepless meditation for nine years, remaining indifferent to the demons tormenting him and the rats gnawing at various parts of his body. Only once did he fall asleep. He was so ashamed when he awoke that he cut off his eyelids and threw them on the ground; they took root and grew into tea plants. At the end of his retreat, Daruma found that his legs had wasted away. Nevertheless, he is often depicted with legs, especially when the artist is portraying Daruma's purported voyage to Japan by sea, or crossing a river, standing on a reed, millet, or bamboo stalk.

Representations of Daruma are variegated, but his face is usually swarthy and bearded, being modeled on the stereotype of a Hindu ascetic. He is depicted seated, alone, meditating; seated, festooned with cobwebs; standing upright, yawning and stretching his body; and/or carrying one shoe (having left the other behind when he left his tomb in China to return to India). Female versions of Daruma also exist. A roly-poly, limbless version of Daruma is the snowman of Japanese children, and a

daruma-doll, on which a winning candidate paints the eyes, is a symbol of political victory.

Date no Masamune *daimyo*

A powerful *daimyo* of Sendai, he was a loyal supporter of Hideyoshi until that leader's death, and subsequently of Shogun Ieyasu. Masamune was a highly cultured man as well as a valiant and able military commander. Artists have shown him either alone, wearing a helmet with a single curved horn, or in the company of Toyotomi no Hideyoshi, just before the beginning of the siege of Odawara (1590).

Deer *in folklore*

In the *Nihongi* Yamato no Takeru was menaced by a malevolent mountain deity in the form of a white deer, which the hero killed, but in the *Kojiki* the same deity was not unfriendly and Takeru slew the white deer in a casual way. The deer, as a threatening beast, appears again in a tale told of the warrior Tsunemoto who, with a well-placed arrow, killed a stag that menaced the Emperor Shujaku (r. 931–946). The deer in Japanese legend, however, is preponderantly a benign creature, signifying good luck, longevity, and the coming of autumn. The animal has been shown as a companion of Jurojin, god of learning; Fukurokuju, god of longevity (who is more often depicted with a crane or tortoise); Seiobo, Queen of the West; Laozi, the founder of Daoism; Kannon, a bodhisattva of compassion; Rakora, a *rakan*; Mohakudo, an ascetic; and Gomo, one of The Twenty-four Paragons of Filial Piety. Saiun-zenji, a priest who served Kannon, was snowbound one winter and would have starved to death had the bodhisattva not turned herself into a deer to provide him with food.

Deities of the Thirty Days

These first appeared—one at a time, each as his day began—to Jikaku-daishi, a Buddhist priest of the Tendai sect, during the ninth century. Each divinity protects his special day against evil spirits. Moreover, they will ward off temptations that assail people, if only they are prayed to for help.

Demons

The demon, or *oni,* has a squarish head, a receding forehead crowned with two horns, beetling brows, and an open mouth with protruding fangs. His body, the skin of which may be red, green, or blue, is muscular; his limbs have three claws, each in place of fingers and toes, although sometimes his legs have only two.

The repentant demons often seen in art are examples of the *oni's* fundamental weakness: he has no power to resist even a novice priest's instructions—and a layman can overcome him by physical force. But a demon is still a creature to be reckoned with: he can, like the supernatural badger and fox, assume any shape he desires; this

ability has enabled demons to lead many a mortal man or woman to destruction or loss of virtue. Human beings caught in the grip of an evil passion can become demons. Some Japanese artists have portrayed Shoki, a Chinese demon-queller, as a bumbling hunter, continually being teased or outwitted by his quarry.

Dengyo-daishi *Buddhist priest*

He introduced into Japan the doctrines of the Buddhist Tendai sect and founded the famous Enryaku Temple, located on Mount Hiei, situated to the northeast of Kyoto.

Descent of Amida *belief and theme*

As early as the Heian Period (794-1185), a devout Buddhist believed that, as he lay dying, Amida Buddha himself, accompanied by hosts of bodhisattva, angels, and disciples, would descend from Paradise to welcome his spirit to the Pure Land. Artists soon expressed this comforting thought in paintings and sculptures that are called *raigo*.

Diviners' Sticks *implements*

Professional fortune tellers and oracle priests in both Shinto shrines and Buddhist temples use sets of 50 sticks to determine which of the eight primary trigrams the laws of chance (or the will of the gods) have chosen to answer questions asked by a petitioner. Each stick is about 30 centimeters long, and is inscribed with a different number or symbol.

Diviners and their paraphernalia appear often in Japanese art. The sticks themselves have been used as decorative motifs. The professional diviner, with his Chinese-style skullcap, portable stand, and flickering lantern, is a popular theme. Geisha and prostitutes in the old days, having learned the rules of the art, would relieve times of boredom by "casting the sticks" for their friends.

Dog *in folklore*

A sign of the Japanese zodiac, the dog is one of the animals that protect people from evil. After he had slain the deity of a mountain, a white dog guided Yamato Takeru down from the peak's heights. The refusal of a dog owned by Fujiwara no Michinaga (966-1027) to pass by a certain spot caused Abe no Seimei, a magician, to suspect, rightly, that someone had put a curse on Michinaga. Yorozu, the epitome of the faithful warrior, possessed a dog that would not leave his dead master's side. The animal finally carried the dead man's head to a burial mound, lay down beside it, and starved to death.

The dog is celebrated in *Hakkenden* (*The History of Eight Dogs*), one of the longest and most improbable novels ever written. The author Bakin (1769-1848) wrote the work over a period of twenty-seven years. In the story, a princess married

her father's dog Yatsubusa and the couple went to live in a mountain cave. The bride took with her a string of eight crystal beads, engraved with ideograms of the Great Virtues (filial piety, kindness, justice, propriety, fidelity, faith, courage, and wisdom). A bullet intended only for Yatsubusa killed both, and the string of beads vanished.

Each one reappeared in the clenched fists of eight newborn boys in a family that honored dogs by incorporating the word *inu* (dog) in the names of their male children. The boys all grew to be fierce warriors, pure and fearless. They are the "eight dogs" of the title. Each of them stands for one of the Great Virtues. Their stories are told at length in *Hakkenden,* where they face natural catastrophes, evil demons, vicious men, seductive phantoms, and giants and sorcerers in enchanted forests. They triumph over all because they are among Buddha's chosen.

Dolphin *in folklore*

In Japan dolphinlike creatures with dragons' heads, known as *shachihoko,* were rendered in gold and used as ornaments on castle roofs.

Dosen *Buddhist priest*

Dosen spent most of his life at Horyu Temple, caring for its priests and property. He is remembered especially for the extensive repairs he made to the temple's East Precinct and for the holy manner of his death. When his spirit departed from this world, he was kneeling in prayer before an image of the Buddha.

Dosojin *deity of the roads and highways*

Stone sculptures of this phallic deity, placed beside a thoroughfare of some kind, are to be found throughout Japan. Dosojin is usually represented as a couple, but also appears individually as Saruta-hiko, the Monkey Prince, or Ugadama, goddess of food, or as three separate divinities said to be Ugadama, Saruta-hiko, and Ame no Uzume.

Dove and Pigeon *in folklore*

The dove (or the pigeon) is the messenger and emblem of Japan's god of war, Hachiman. It is also regarded as an example of filial piety. A proverb reminds us, "among doves is found the courtesy of three branches," because younger birds always perch three branches below their elders.

Dragon

One of the four divinely constituted creatures (the others being the *kirin*, phoenix, and tortoise), the dragon is credited with marvelous attributes. It is a star in the Japanese zodiac—and with reason. It can cause rain to fall (and is thereby a symbol of fertility); it lends its power over terrestrial affairs and its sagacity to reigning emperors; it embodies within itself the male (yang) and female (yin) principles; and it

is a being of infinite wisdom. It can also be mischievous, petty, lascivious, disruptive, dangerous, and lethal, for to look on one was to be struck dead. All of this expresses its multifaceted nature.

The quintessential dragon is a composite creature with a frowning countenance, long straight horns, scales, a snake's body, a row of rigid dorsal spines, four limbs, claws (five, four, or three on each appendage), mustachelike hair growths, and flames shooting from its shoulders and hips. It may be depicted with wings, and as an *amaryo* (rain dragon) has smooth-skin. The fact is that artists have shown the creature in forms suitable to various legends and in accordance with their own imaginations. Thus, one can see the beast with no horns, or entirely in snake form, or as a winged fish. It can also be white, yellow, blue—or any color that is pleasing to the artist.

Dragonfly *as symbol*

The insect is a symbol of summer, and when it is depicted in association with a chrysanthemum, it is a sign of an imperial victory.

Dragon-horse *legendary animal*

A dragon-horse appeared in the legendary past to Fuxi, a king of China. Its skin bore several different arrangements of round marks: seven on the face, six on the back, eight on the left flank, and nine on the right. The monarch decided that the marks were signs that could be used to foretell the future. He embodied his observations in the *Yijing,* or *Book of Changes,* a guide to reading combinations of the round marks that, over time, have been lengthened to become the lines that form the eight trigrams (and the 64 hexagrams) explained in the *Yijing.*

In art the dragon-horse is an exceedingly variable creature: sometimes it is more horse than dragon, at other times just the opposite. In still other depictions, it is either horse or dragon, but not a hybrid. Its body may be covered with scales and its head may sprout a set of horns. Regardless of shape or superficial accretions, however, it always bears the divination marks that king Fuxi saw.

Dreams

In Japan, as elsewhere in the world, it is thought that dreams convey messages from gods, demons, ghosts, dead relatives, and other forces in the spirit world. For help in interpreting their dreams, people turn to diviners, priests, fortunetellers, grandmothers, books, other dreams, and things encountered by chance. A "good dream" foretells good luck, and a "bad dream," bad luck. The nice thing about this dual system lies in the fact that for any specific dream the worried dreamer can choose the more appealing interpretations. If a person's first dream in a new year

is one in which Mt. Fuji, a falcon, and an eggplant appear, it is a sign of impending good fortune.

In Japan (as in China) many a great man was conceived in a miraculous manner, the consequence of a marvelous dream that came to his mother. Among those notable Japanese personages are Shotoku Taishi, En no Shokaku, Kobo-daishi, Nichiren, and Toyotomi no Hideyoshi. Emperor Go-Daigo (r. 1319-38), desperately in need of a champion for his failing cause, dreamed of being sheltered by a camphor tree (*kusu no ki*) during a storm. When he awoke he understood at once that he must appoint as his general Kusunoki no Masashige to be his general, part of whose name meant "camphor tree."

Probably the most important of all imperial dreamers in the entire history of the Far East was the Chinese emperor Mingdi (r. 58-75) of the Eastern Han dynasty. In the year 61 he beheld in a dream a golden image giving off a glowing light. His diviners informed him that it might be an image of the Lord Buddha, whom the traveler Zhang Jien had told their predecessors about almost a hundred years before. Mingdi sent eighteen learned men to India, to ask the meaning of the dream and to learn about the Lord Buddha. The embassy returned to China in the year 67, bringing Indian priests, sacred images, paintings, and sutras. Mingdi raised a temple for the priests, their holy objects, and their deity. In this way Buddhism, so it is said, was introduced into China and eventually spread from that Middle Kingdom to Korea and Japan.

Many Japanese fairy tales, legends, novels, and plays either begin with dreams or are resolved through the intercession of some supernatural agency, good or bad, which enters the plot by way of a dream. Minamoto no Mitsunaka's son Yorimitsu, better known as Raiko, dreamed that Shoka, daughter of a famous Chinese archer, came to teach him her father's secret skills. When Raiko awakened, he found beside him a new bow and arrows. The Old Man who made withered trees bloom received supernatural aid from the spirit of his faithful dog, who appeared to him in several dreams. Emperor Minghuang (r. 712-55) of the Tang dynasty had a dream out of which grew the legendary and heroic demon-queller whom Japanese call Shoki. One of the most famous of China's parables, equally popular in Japan, is the story of Rosei's Dream, which reminds us how tenuous is life and how brief glory.

Dwarfs *as mythical creatures*

India's demons were represented as dwarfs in early Buddhist art. The motif was used in Japan for a short time, but gradually the native *oni,* or horned demon, replaced the dwarf in this context.

Earthquake Fish *mythical creature*

In myth, severe earthquakes are caused when Namazu, the earthquake fish, wriggles or thrashes about far below the surface of the ground. Namazu is a huge, ugly creature, having a long, black, and smooth body like an eel's, but the flat head and wriggly feelers at each side of his wide mouth mark him as a catfish. He lies deep underground, beneath most of the length of Japan, and when something agitates him, his movements cause the islands to shudder.

Earth Spider *mythical creature*

The legendary Emperor Jimmu (660-585 BCE) sent an army commanded by his trusted general Mononobe no Michi no Omi to destroy Tsuchigumo, a monstrous earth spider. Its ugly horned head had long red hair, eyes as bright as mirrors, and teeth like those in a saw blade. Six arms and two legs supported its gross body. It could move huge stones, shatter boulders, and uproot trees. Furthermore, it spun long white filaments as strong as ropes, which it used to bind both men and animals. Mononobe had his armorers fasten a net of iron cables across the mouth of the spider's cave. His warriors then lit a huge fire at the entrance. The smoke drifted into the lair, suffocating Tsuchigumo to death.

Eguchi no Kimi *prostitute*

One cold stormy night, the poet-priest Saigyo found shelter in the thatched hut

of Kimi, a young prostitute. While Saigyo slept, the bodhisattva Fugen appeared in a vision, telling him that Kimi was not a mere pleasure girl. She was, rather, an incarnation of Fugen himself, because in a previous existence she had acquired much merit through deep study and good deeds. Artists often represent Eguchi no Kimi either standing beside an elephant or seated on one, inasmuch as that animal is another manifestation of Fugen.

Eight Beautiful Views of Lake Biwa *special places*

Japanese artists sought out and rendered "eight beautiful views" of many places. Perhaps the most celebrated is the sequence of views at Lake Biwa, in Shiga Prefecture. They are (starting on the western side of the lake and moving counter-clockwise) the snow on Mount Hira at evening; wild geese flying at Katata; night rain at Karashi; the sound of the bell of Miidera at eventide; Awazu on a sunny, breezy day; the last light of day at Seta; the autumn moon on Mount Ishi; and the return of boats to Yabase.

Eight Bridges *art motif*

This motif employed suggestions of narrow footbridges laid through a field of irises in bloom. Often enough, these so-called footbridges became nothing more than representations of short planks of wood, or even elongated stepping stones, progressing in a zigzag pattern across the soggy ground. Such representations recall a poem written by Ariwara no Narihira (825-80) when, in Midawa Province, at a place called Yatsuhashi, or Eight Bridges, he saw just such an arrangement of planks and irises.

The Eighteen Learned Men of the Tang Dynasty *Ch. historical characters*

The Tang Emperor, Taizong (r. 627-50), chose eighteen of the most learned men in his empire to advise him on how best to govern China. The scholars are shown as a group in a formal garden.

The Eight Immortals of the Wine Cup *Ch. historical characters*

A group of hedonists organized by the Chinese poet Rihaku, these lovers of wine and good company who lived in the Tang dynasty were Chokyoku, Goshisho, Hoshin, Rihaku, Ritekishi, Saisohi, Soshin, and Shotsui. They are usually depicted as a group in a landscape setting.

The Eight Daoist Immortals *(hassen) sennin*

Considered to be the most important *sennin*, they are:

Chokaro—He refused all kinds of honors offered to him by Emperor Xuanzong (r. 1426-36) preferring to continue a wandering existence. His companion was a white mule (or horse, or colt, depending on the commentator), a beast that could carry him

hundreds of meters a day. Chokaro stored the mule in a gourd during his stopovers, restoring its shriveled form to proper size by spraying it with water from his mouth.

Kanshoshi—A musician and an accomplished flautist, his music caused flowers—the petals of which bore poems written in gold characters—to grow from empty pots, and he made wine appear in empty bowls. One day he climbed to the top of Seiobo's peach tree, but the bough to which he was clinging broke, and he fell to the earth and died. He is the patron saint of musicians.

Kasenko—A woman who was promised immortality in a dream, she ate mother-of-pearl, lived in a mountainous place gathering fruits and wild herbs for her mother, could fly as swiftly as a bird, and, finally, was married to a phoenix with blue wings who carried her off to the celestial paradise.

Ransaika—Represented in art as both a man and a woman, Ransaika is most commonly portrayed as a woman in a garment made of mugwort leaves, carrying a stick and a basket, and wearing one shoe only.

Ryotohin—He received from his teacher, Shoriken, a magic sword with which he slew dragons and evil genii. Ryotohin, Shoriken, and Katsugen, a *sennin* who escaped from a sinking ship by walking on stormy waters, are all shown in art mounted on swords that carry them over water.

Shoriken—A renowned general, he was initiated into the mysteries of the Dao after losing a major battle. He became Ryotohin's teacher, and before he entered the celestial paradise, he gave his magic sword to his pupil.

Sokokukyu—Usually represented as a military official carrying a pair of castanets or a whisk, he became an ascetic out of his disgust with the imperial court's debauched lifestyle.

Tekkai—Although said to have been a prepossessing man, he is portrayed in art as a lame beggar with a walking staff. His spirit was one day called to the celestial paradise by Laozi, and Tekkai left his body in the care of a disciple. When Tekkai's spirit came back, he found that the disciple, thinking his master dead, had destroyed the body in error. Tekkai's spirit could not reenter the body and had to take refuge in either the body of a freshly dead, lame beggar or in that of a dead toad—which then became a lame man. The frog story may have been borrowed from the legend of Gama Sennin. Nevertheless, Tekkai is often depicted being blown from a frog's mouth. He is also shown as the lame beggar blowing forth his spirit in the form of a court official in miniature, or sending it into the heavens.

Eight Trigrams *diviners' signs*

These are the symbols that fortunetellers use in constructing the 64 hexagrams on

which the predictions set forth in the *Yijing,* or *Book of Changes,* are based. Each trigram is made up of three lines. Only two kinds of lines are employed: the solid (—) and the broken (--). When these two kinds of lines are arranged in every possible sort of triplet, only eight different combinations are obtained: the eight trigrams. When two of these trigrams are conjoined, a hexagram is obtained. All the possible pairings of the eight trigrams yield only 64 different hexagrams. These 64 hexagrams, in the philosophy of the *Yijing,* sum up all the possible categories of experiences that a person may encounter in this world.

The hexagrams are like actuarial symbols for the probability that some experience will or will not occur. In short, they are computer codes describing the laws of chance, or the workings of karma as they apply to human experience.

Elephant *in folklore*

The elephant connotes intelligence and—in connection with the bodhisattva Fugen, a deity of longevity—a long life. Those who belong to certain sects of Tantric Buddhism regard the animal, with its phallic trunk, as a symbol of Fugen, "the joy-giving god."

Emma-o *king of the Buddhist underworld*

Emma-o is usually depicted as an angry-looking deity with a red-skinned face, an open mouth (sometimes with fangs), and a headdress that bears the ideograph meaning "king." He is most often in a seated position, and on either side of him are two of his several assistants, Domeijin and Dojojin, who see and hear all. Also in attendance are Kaguhana who smells all odors and Mirume, a female, whose eyes see everything. On demand, Tabari no Kagami, the soul-reflecting mirror, can present an instant replay of all the evil deeds ever committed in this world by a soul brought before the Emma-o tribunal. Also available for ready reference are whole libraries where both the good and the bad deeds of everyone who has ever lived are recorded.

The Buddhist underworld contains Eight Principal Hells (each of which is subdivided into sixteen parts). In one hell, sinners' tongues are torn out; in another, miscreants are branded with red-hot irons or forced to drink molten copper; in still others, their bodies are hacked to pieces or pierced with long spikes. In at least nine hells, their bodies are ground to powder, and in nine others those pulverized corpses, intermixed, are recast to form new bodies in preparation for rebirth. Some sinners are flayed, others are frozen, either whole or piecemeal. The Great White Lotus Hell is so named because the accumulation of sinners' bones, bleached by the cold, makes it look like a pond covered with white lotus blossoms. By contrast, another hell is filled with burning fires.

Enchin *Buddhist priest*

He is the founder of the Jimon branch of the Buddhist Tendai sect. Kannon, a bodhisattva of compassion, appeared to him in the form of an old man.

Endo, Morito *warrior*

He fell passionately in love with Kesa, the wife of the samurai Wataru Watanabe, but she, faithful to her husband, rejected Endo's advances. He threatened to kill her husband. Kesa, recognizing that Morito had been driven insane by his passion, deceived him, pretending that she would marry him once he had killed her husband. Together they chose a night for the murder and Kesa indicated on a plan of her house the room in which the victim-to-be would be sleeping. Endo made his way to the death-room and with his samurai's sword cut off the head of the person lying there asleep. He did not know that Kesa had taken her husband's place for the night and that the severed head he carried from Wataru's house was hers. Wracked by remorse, Endo became a priest. As part of his expiation for the murder, he chose to stand naked under the icy waters of the Nachi waterfall. Fudo, god of waterfalls (among other things), removed him from the waterfall just as he was on the point of freezing to death.

En no Shokaku *sennin*

He was conceived on the night that his mother dreamed that she had swallowed a *vajra*, a mace representing the divine "thunderbolt" that the gods employ to rid the world of evil. Although no deity, En no Shokaku was certainly a multitalented *sennin*. He could ride the winds, walk on water, make himself invisible, exorcise demons, wrestle with the gods and win, and produce food by summoning wild geese. These birds, after having been cooked and eaten, were ejected whole and alive from En no Shokaku's mouth. His lifelong task, in which he was aided by two demons, Goki and Zenki, was to climb to the summits of the world's great mountains in order to convert their resident spirits to Buddhism.

Enoki (*Celtis sinensis*, the Ch. nettle-tree) *magical ingredient and symbol*

The pulverized wood of this tree was used as an ingredient in potions said to cure an aching tooth or to rid oneself of an unwanted lover. The tree itself was a favorite dwelling-place of evil demons who, like supernatural badgers and foxes, were able to assume any shape they desired. On the last night of the year, fire-breathing foxes joined the demons, an event recorded by Hiroshige in his print "Fox Fires at Oji."

Exorcising Demons (*oni-yarai* or *tsuina*)

This magical ritual, carried out today during a festival known as Setsubun, was once performed on the last night of the old year. In recent times, it takes place on the eve

of the first day of spring. The exorcist, bearing a box that holds dried beans that have been roasted black, walks through the house or apartment, scattering the beans about while he intones *"oni wa soto, fuku wa uchi!"*—"demons out, good fortune in!"

Falcon *in folklore*

The falcon is a symbol of success in human endeavor, and good luck will come to a person who on New Year's Day has a dream in which figure two falcons, three fruits of the eggplant, and Mount Fuji.

The Feather Robe (*Hagoromo*) *legend and Noh play*

A heavenly maiden clad in a gorgeous feathered robe of the five sacred colors, descends to earth, doffs her robe, and wanders along a beach. A fisherman finds the robe and will only return it if the maiden dances for him. She puts on the robe and performs an inspired dance, after which she returns to heaven. In another version, the fisherman did not return the robe. He kept it, and the maiden, to drudge for him as his wife.

Festivals

Certain annual festivals were once national holidays. They are:

New Year's Day (*shogatsu*)—a celebration of the turning of the year on the first day of the first month, although several more days are given over to marking the advent of the new year;

Doll's or *Girl's Day* (*hina matsuri*)—on the third day of the third month;

Boy's Day (*tango no sekku*) now known as Children's Day, on the fifth day of the fifth month;

Festival of the Dead

Tanabata—the only day in the year on which the heavenly lovers, the herdsman and weaving maiden, can meet occurs on the seventh day of the seventh month;

Chrysanthemum Day (choyo no sekku)—honoring the chrysanthemum, on the ninth day of the ninth month.

Only New Year's Day and Boy's Day continue as prescribed national holidays, although the others are celebrated privately and commercially.

Festival of the Dead *(O-Bon) Buddhist memorial rites*

This time of remembering the dead is comparable with All-Souls' Day in Christian countries. According to Buddhist belief, the spirits of the recent dead come back to visit their families for a period of three days each summer. During their visit they hover about the household, eager to receive some assurances that they have not been forgotten. Living relatives make them welcome with offerings of food, sweetmeats, and drink placed on the *butsudan,* the family's Buddhist altar. These—offerings, together with prayers, recitations of scriptures by priests, oral reports, updates of what's happened since the person died, and other such rituals of conciliation—keep the spirits of the dead pacified. For most families O-Bon includes visits to cemeteries, in order to refurbish graves or at least decorate them with flowers during this time of the year. On the first night, living relatives "lighted the way" for returning spirits by putting up countless paper lanterns in homes, along streets, in temple yards and cemeteries, along river banks in towns, and beaches beside the sea. For this reason O-Bon is also known as "the Feast of Lanterns." Little boats, carrying offerings of food and lighted with at least one little lantern, are also set afloat to carry the spirits of the dead to the Western Paradise.

Fireflies *in folklore*

Willow trees and fireflies are associated in many legends and ghost stories having a watery setting. The cold light that the bodies of fireflies generate in the spring, during their mating season, has always enchanted the Japanese. They go to the countryside by the thousands to see the fireflies in their myriads, glowing and glimmering in the night. Children capture them with little nets, or by beating them down with fans, and keep their prizes in tiny cages, pails, glass jars, or even in baskets.

Fishing and Fishes *as symbols*

Whether living or preserved by drying, salting, or smoking, fish are symbols of plenty or wishes for good health. Most often represented in art are bonito, *fugu,* carp, bream, salmon, sardine, herring, eel, shrimp, lobster, abalone, clam, oyster, and limpet. Several *sennin* have been depicted either engaged in fishing or in association with fish. Among them are Kenshi, Kyoshiga, Jisshudo, and Taikobo. Ebisu, one of

The Seven Gods of Good Fortune, is almost invariably shown holding a fish or with one beside him.

Five Buddhas of the Diamond World *deities*

Members of the Shingon sect of Esoteric Buddhism especially venerate these deities. In any arrangement, whether in pictures or in sculptures, Dainichi-nyorai, as the first and most potent of the group, occupies the central position. At his right are the Buddhas Fukujoju and Muroju; at his left, Hosho and Ashuku.

Five Great Kings of Light *Buddhist lesser deities*

Because of doctrinal requirements, artists must make most of these deities look ferocious and terrifying, both in countenance and in gesture. In reality, their violence is directed, on Dainichi-nyorai's behalf, against evildoers and all other malign influences throughout the universe. In Japan, Fudo Myo-o is the most popular of these five gods. In the usual arrangements of statues, he is placed at the center, and is guarded by images of other kings at each corner: Gozanze in the east, Gundari in the west, Daiitoku in the south, and Kongo Yakusha (or Kongo Yasha) at the north.

Flaming Disk *symbol*

As a symbol of the sun, the flaming disk, like the solar wheel, is an emblem of omnipotence. It may be represented alone, or as being held in the talons of a dragon moving amid clouds or waves of the sea. Some Japanese artists have substituted the *tama*, or sacred jewel, for the fiery disk.

The Forty-seven Faithful Ronin of Ako *story of loyalty and honor*

On 14 March 1701, Asano no Naganori, *daimyo* of Ako, frustrated to the edge of madness by the behavior of malicious Lord Kira Yoshinaka, attacked and wounded him in the shogun's palace. For this profanation of a sacred place, the shogun himself commanded unrepentant Lord Asano to commit seppuku (ritual suicide). The shogun, however, did nothing to punish Lord Kira for having provoked the attack.

As a consequence of his rash deed and enforced death, Lord Asano's family and his retainers were dispossessed and dispersed. His loyal samurai, now *ronin,* warriors without a master, however, could not allow the extreme and undeserved disgrace that had fallen on their lord to go unavenged. Well aware that Lord Kira and his clansmen maintained a constant guard against just such a reprisal, Oishi Kuranosuke, chief retainer and chamberlain of the Asano clan, ordered his impatient clansmen to lie low and bide their time.

During many long months, Kuranosuke—a wise and compassionate man, who foresaw every difficulty and solved every problem—sustained the spirit of the *ronin* who swore to be his companions in the vendetta. At last, on the night of 14

December 1702, during a heavy snowfall, Oishi led 46 of his loyal band in a surprise attack on Lord Kira's mansion in Edo. They slew the villainous Kira and took his head to lay on Lord Asano's tomb at Sengaku Temple in the Shiba district of Edo. With that, Lord Asano was avenged, and the honor of the *ronin* of Ako had been saved.

Their duty done, all 47 of the *ronin* surrendered to the shogun's officials. While admiring the loyalty of Asano's men, they could not condone their having murdered a *daimyo,* but they allowed the *ronin* to commit seppuku. All together, on the morning of 4 February 1703, the heroes, led by Oishi Kuranosuke, committed suicide. For their deeds and, above all, for their loyalty, Japanese have honored them ever since. Most of the 47 *ronin* are buried near Lord Asano, in the tiny cemetery of Sengaku Temple. Innumerable prints, paintings, images, and miniature sculptures commemorate their fidelity. At least 50 different plays for Kabuki and the puppet theatre were written about them before 1900. Undoubtedly the most famous of those, parts of which are still presented almost yearly to admiring audiences, is *Kanadehon Chushingura,* or *A Treasury of Loyalty,* a fascinating drama in eleven acts. Dramatizations of the tale have been put to various ends—promoting blind loyalty to a leader; categorizing the *ronin* as opponents of the feudal system; or, in a modern business setting, emphasizing corporate corruption and office politics. The elegant and exquisitely photographed movie *Chushingura* (1962), called the *Gone with the Wind* of Japan, is a masterful retelling of the heroic legend—good and bad are clearly delineated; the heroes suffer privations while the villains flourish, but they remain true to their cause; and in the end they triumph, although they sacrifice themselves.

The Four Go Players *literati*

Four Chinese scholars, known in Japan as Toenko, Kakoko, Kiriki, and Kakuri, flee to a mountain hermitage to escape a purging of intellectuals instigated by the Qin emperor Huangdi (r. 221-10). In art, the four recluses are depicted during the years of their withdrawal from the world. In a cave or a mountain hut, they sit around a table, playing *go* (a board game).

The Four Sleepers *three sennin and a tiger*

This is a group composed of the three *sennin* Hokanzenshi, Jittoku, and Kanzan, and Hokanzenshi's tiger. The four are usually shown sleeping in a cave. Most probably, Hokanzenshi was an abbot, and Jittoku and Kanzan were monks. The two monks were also known as the "mad *sennin*" in another manifestation. In this aspect, they spent most of their time in their monastery's kitchen, disputing religious matters (it was thought) in a language no one else was able to comprehend, and being exceptionally rude to anyone who intruded on their colloquies. Kanzan is usually

shown reading or holding a scroll containing thoughts of Laozi, while Jittoku holds a broom or sweeps the floor, an act symbolic of the Buddhist teaching that any act, even a menial one, is a step towards enlightenment.

Fox *in folklore*

A vast lore has grown up around this animal, some of it imported from China, most of it native to Japan. Almost all tales reveal the fox as being cunning and malicious, if not determinedly evil. Sometimes, however, he is merely a trickster, and occasionally he can be kind. In general, though, foxes are creatures to be feared because they have the power to possess people, thereby driving them mad or making them ill. A fox-spirit can enter a human being by several routes, most often through the space between a fingernail and the flesh beneath. Once a fox has taken possession of a person, it lives according to its own will, forcing the host to do all sorts of strange things, which relatives and associates will recognize as aberrations of the mind or ailments of the body. "A fox is gnawing at her belly," is a common description of a mad woman.

Each full-grown fox can see across great distances, hear all sounds, and know the secrets of all men and nature—past, present, and future. The fox, being able to assume any shape it wishes, can fool anyone. A fox's favorite guise is the body of a beautiful woman, the person of a kind priest, or the aloof and lovely moon.

A fox may live for hundreds of years. At the age of 50 it easily assumes the form of a woman, and at the age of a hundred, that of a seductive girl. When it is a thousand years old, it becomes a celestial fox, distinguished by white or golden fur and nine full tails. The power of a celestial fox to bewitch a man is extraordinary, as is told in the story of Tamamo no Mae, the concubine of Emperor Toba (r. 1107-23). A nine-tailed fox even tried to interrupt Daruma's nine years of meditation, but the saint's armory of virtues protected him from that intrusion of evil.

Then there are the foxes of Inari, the so-called deity of rice. These foxes are his messengers and symbols. They seem to be a race apart from those malicious ones that possess people or cause other kinds of misfortunes.

A rat deep-fried in oil is succulent bait to a fox. Many an artist has shown a peasant carrying a trap baited with a rat. Others depict the fox-spirit so ensnared, in the guise of a mendicant priest, a seductive woman, or some such seemingly harmless person.

The Foxes' Revenge *moral tale*

In a certain large town lived a goldsmith who so hated foxes that he mistreated them at every opportunity. One day a beautiful and obviously wealthy young woman came

to his shop. She said that she had come from a nearby castle to ask the goldsmith to take a selection of his famed sword ornaments to her elder brother. Only too willing to oblige such prestigious clients, the goldsmith appeared at the castle with a case full of his finest wares. The young woman invited him to sit in comfort and sip a cup of tea while she took his beautiful ornaments to show to her brother. The gleeful goldsmith put the case into her hands—and in that instant she, the castle, his golden treasures, all totally disappeared. In their place he saw only an old dry well—and a grinning fox, carrying his ornaments, trotting off toward the hills.

Frog/Toad *in folklore*

Frogs are found all over the world, except in Antarctica. They require moisture and usually live in quiet freshwater or in the woods. Some frogs are highly aquatic, while others are better adapted to terrestrial habitats. Among the latter type, those with stout bodies and thick skins are often called toads, although that name is sometimes restricted to members of the most terrestrial family of the *Anura,* the *Bufonidae.* In Japanese art, it is unnecessary—indeed wasteful—to attempt to distinguish between the two.

China's legends about frogs found ready acceptance in Japan. The one about Joga explains how the frog in the moon got up there. Another legend tells of the three-legged frog that lived in a pond. The secretions from its body, its very breath, could make people sick, even kill them if they were exposed to enough of it. An astute man baited a hook with a golden coin, caught the poisonous frog, and killed it. The moral to this tale is clear: the lure of gold can destroy a greedy creature, be it animal or man.

Japanese, too, know about demon frogs, both good and bad. The great frog of Suwo is an example of a malevolent one. It ate snakes and other venomous creatures, and its spittle, shot through the air, killed anything it hit for a league around. On the other hand, benevolent frogs attract clouds, cause rain to fall, and fill springs and wells with good clear water.

Fu-daishi *Buddhist priest*

He is the man who invented a revolving bookcase (*rinzo*) big enough to hold the 6,771 sacred books of Buddhism that had been produced by his time. Anyone who could push the massive *rinzo* through three complete revolutions would acquire as much merit as if he had actually read every one of the holy books it contained. In addition, a layman would gain a long and prosperous life in this world. Portraits of Fu-daishi usually showed him standing between his two sons, Fuken and Fujo.

Fudo Myo-o *Buddhist deity*

Derived from the Hindu divinity Achala, Fudo is a god of wisdom and a symbol to the initiated of how right knowledge (i.e., the teachings of the Buddha) overcomes the evils of this world (which are represented by the demons destroyed by Fudo). He is usually portrayed in art as a fierce-faced god seated on a rock, a rope-snare in his left hand, a sword in his right. He has fangs, bulging eyes, and heavy eyebrows; his muscular body is framed by a flaming mandorla. Sometimes two acolytes, Seitaka and Kongara, accompany him. Baird (p. 22) notes that he and his acolytes are popular subjects for modern Japanese tattoos.

Fugen-bosatsu *Buddhist divinity*

When Shaka lived, Fugen was his favorite disciple. Since then he has been elevated to the status of a bodhisattva. He is the dispenser of knowledge, and is regarded as the spiritual son of Dainichi-nyorai. Fugen-bosatsu, then, is a symbol of the wisdom that comes from piety and prayer.

His own specific symbol is a white elephant, equipped with four to six tusks. Fugen sits either on the elephant's back or on a lotus blossom throne that is supported by a group of elephants, four or more in number, standing in a circle facing out. More elaborate versions of this defensive theme have those large elephants supported by a multitude of small elephants standing in a ring on the Wheel of the Law. Fugen himself, seated on the lotus throne, holds in one hand a scroll of sacred writings, in the other a lotus blossom. To Japanese, Fugen is another god of longevity, perhaps because of his association with the long-lived elephant. In statues or paintings representing the Shaka Trinity, Fugen-bosatsu is placed at the right side, Monju-bosatsu at the left.

Fugu *fish*

Ordinarily, during most of the year, and when it is *properly* prepared, the *fugu* is safe to eat. At other times, most often during the spawning season, certain of its visceral organs will produce a toxin that is extraordinarily poisonous and fatal to human beings. The *fugu* has a number of common names: globefish, trunkfish, blowfish, and sparrowfish are a few of the English versions. The *fugu* is noted for its ability to swell up to enormous size when it is endangered, at the same time raising a number of short spines as further defense against predators. Japanese make the dried skin of such a puffed-up *fugu* into a hideous sort of lantern, grotesque both in appearance and in implication. The snout of the fish, living or dead, resembles a sparrow's beak. Such a lantern is represented often in prints and netsuke (miniature sculptures in wood, ivory, and other materials).

Fuji

Fuji *mountain*

Mount Fuji is an almost perfect volcanic cone 3,780 meters high, rising in splendid symmetry above the plains and foothills of central Honshu. The volcano is only dormant, not extinct. Fuji itself was once worshipped as a deity. Later it was thought to be the home of many deities. After the introduction of Buddhism, the bodhisattva Kannon went to live atop Fuji. To dream of the mountain, especially during the New Year season, is an omen of good fortune, promising a long, prosperous, and happy life. A picture or a carving of a dragon or a snake climbing Fuji's peak is a symbol for good luck.

Fuji is the inspiration for innumerable prints and paintings, made by countless artists. A picture of a portly priest with a straw hat hung on his back, standing in awe as he gazes at the distant mountain, is a reference to the poet-priest Saigyo. If a Heian noble is represented, either mounted or afoot, he is certain to be Ariwara no Narihira, composing his famous poem to Fuji. The legendary Chinese explorer Jofuku is said to have found monks from Mount Horai, a Daoist paradise, atop Fuji, compounding the elixir of life that an emperor of China had commissioned him to discover. A picture of two young horsemen riding furiously toward Mount Fuji portrays the Soga brothers, going to claim their revenge.

Fujin (also known as Futen) *Buddhist god of winds*

Fujin resembles Raijin, the god of thunder, as closely as a twin brother: each has a demon's muscular body, fierce countenance, pair of horns, feet with two claws and a thumb, and hands made of three talons. As expected, Fujin carries a sack over one shoulder, in which he holds captive the ingredients for all kinds of winds, from suave zephyrs to raging typhoons. His other symbol (which is not always shown) is a long spear from which a pennant flutters in the wind he has released. Artists show him alone sometimes, fallen from the clouds into the sea, for example, and being attacked by a huge crab or a writhing octopus. At other times they put him in the company of Raijin, playing games, such as neck-wrestling and foot-wrestling, fighting angrily, or joining forces to rout the enemies of Japan—such as the Mongol fleets, which their divine winds and lightning blasts dispersed on two occasions.

Fujiwara no Fuhito *statesman*

Fuhito (659-720), the youngest son of Kamatari, founder of the Fujiwara family, served as a minister during the reigns of four successive emperors. Although his father is the first of the Fujiwara, Fuhito is the one from whom all the power and the glory of the Fujiwara clan emanate. Fuhito's four sons became the ancestors of the four branches of the House of Fujiwara. When Fuhito gave two of his daughters

as consorts to two emperors, he began the system of "marriage politics" by which the shrewd Fujiwara controlled the genes, loyalties, thoughts, and deeds of Japan's sovereigns for almost 500 years.

Fujiwara no Hidesato *warrior-hero*

Better known as Tawara Toda, "Lord Bag of Rice," this tenth-century hero was crossing the long bridge at Seta in Omi Province one day when he came upon a huge dragon lying in the way. He stepped boldly over it and continued on his journey. At the far end of the bridge an old man awaited him. He asked the hero for help in combating the Mukade, an enormous centipede that threatened his domain in the depths of Lake Biwa. Perceiving that the old man must be the human form of the dragon on the bridge, Tawara Toda agreed to assist him.

Soon they encountered the Mukade, thrashing about in the waters of Lake Biwa. A creature of enormous length, it initially proved impervious to Tawara Toda's arrows. The hero smeared his next arrow with spittle, a substance deadly to snakes and centipedes. The arrow slew the Mukade; it fell to the foot of Mount Mikami. The old man turned out to be Ryujin, the Dragon King. He took the champion to his palace, and bestowed on him honors and rewards: the splendid bell that later hung in Miidera Temple (later to be stolen by Benkei), a cauldron wherein anything could be cooked without need for fire; a roll of brocade that could never be used up; and a bag of rice forever full.

Fujiwara no Jo-e *Buddhist priest*

Jo-e (643-?714), a son of Kamatari, is credited with having brought to Japan from China, where he had gone to study, the great tooth of Buddha that is still preserved at Sennyu Temple in Kyoto. Before he returned to Japan, Jo-e purchased "a perfect pagoda" to take home. The dismantled parts, except for the roof, accompanied him on the ship. The roof was so heavy that he had to leave it in China.

Later, it miraculously flew across the sea and settled perfectly atop the pagoda Jo-e had built above his father Kamatari's burial site.

Fujiwara no Kamatari *statesman, founder of Fujiwara family*

By birth Kamatari (614-69) was a member of the preeminent Nakatomi family, which claimed descent from Ame no Koyane, a retainer of Amaterasu, the sun goddess herself, and of Prince Ninigi, her grandson.

Several events in his life are depicted in art, especially the savage moment when he and Prince Naka no Oe assassinated Soga no Iruka. He is also shown kneeling before the prince as he puts a shoe on the imperial foot. Events often illustrated are his attempt to regain a precious jewel stolen by dragons while being brought to

Japan from China by his daughter, who had married the Tang emperor Taizong. The jewel was recovered by a beautiful diving woman (*ama*), who brought the treasure to Kamatari but sacrificed her life in doing so.

Fujiwara no Tokihira *villain*

Tokihira (871-909) was the archenemy of Sugawara no Michizane, a brilliant scholar who served in the imperial court in many capacities. In the Kabuki play *Sugawara's Secrets of Calligraphy* (*Sugawara denju tenari no kagami*), written in the eighteenth century, Tokihira is shown arranging for the deaths of Michizane and Michizane's son, only to be frustrated in his intentions by the actions of men loyal to the Sugawara family.

Fukusuke *doll*

A symbol of good fortune, this doll takes the form of a dwarf with an oversized head, sometimes shown carrying a bag.

Fukyoku Sensei *legendary healer*

He earned a living by polishing metal mirrors, and is usually shown carrying the implements of his trade. He was also a physician, learned in the making of magical potions. When a pestilence spread amongst the populace, he cured as many as 10,000 sick people with a medicine he compounded and administered to them. He refused payment for his miraculous remedy.

Fumon Mukan *priest*

As an advisor to the imperial court, Fumon Mukan urged the emperor Kameyana (r. 1260-74) to erect a temple within the precincts of Higashiyama Palace in order to rid the complex of persistent ghosts. The emperor followed his counsel; the ghosts were laid. The sage is depicted as a priest deep in the study of sutras; spectral creatures hover about him.

Funakoshi Juemon *samurai*

As punishment for having killed a fellow samurai in a quarrel, Juemon was expelled from his clan, becoming a *ronin* (literally "wave man," a warrior who offered his services to anyone who would have them). Juemon underwent various tribulations, including being taken prisoner by a notorious pirate named Kuroemon. He managed to escape from his captors, and eventually settled in Osaka where he married and became a model citizen, to the point of being accepted as a member of one of the city's *otokodake* (roughly, voluntary district associations with policing powers). He might have lived happily ever after had not his wife conspired with her lover to murder him; his only recourse was to slay them both. Thereafter he became fanatical in his apprehension of lawbreakers, and was soon elected head of his *otokodake* group. The now virtuous Juemon—his vengeance on an unfaithful wife and her

lover being overlooked—was finally forgiven for his original crime and restored to membership in his clan.

Fusho Kadobe *archer*

A man of little means, Kadobe was a dedicated archer. He was so fanatical that he burned all the flammable materials his house was made of in order to provide himself with enough light to practice archery by night. His passion soon left him and his wife homeless, forcing them to take shelter in a cave. Word of Kadobe's skill as an archer was brought to the court of the then reigning emperor, who had Kadobe enrolled in the ranks of the imperial guards. His action bore good fruit when, on one of his seafaring ventures, the emperor's ship was attacked by a pirate vessel and was in danger of being overwhelmed. Kadobe, however, was able to shoot an arrow into the left eye of the pirates' captain, killing him instantly. The pirates, now leaderless, lost courage and broke off the engagement. The emperor and his vessel were saved.

Futamiga-ura *town*

This town boasts two "wedded rocks" (*myotoiwa*) that represent The Heavenly Couple, Izanagi and Iwanami, the creator-gods of Japan. A plaited straw rope (*shimenawa*), replaced once a year, has an end looped over each of the rocks, tying them together for eternity. A local legend asserts that the original rope was a gift from Susano-o, the rebellious and mischievous brother of Amaterasu, the sun goddess, in gratitude for his having been rescued from a shipwreck by one of the town's inhabitants. For Delay (p. 14), the rope linking the two rocks "is one of the most striking examples of the harmony that exists in Japan between the solid and the void."

Fuxi *Ch. legendary king*

Chinese know him as the first sovereign in "the line of the Five Rulers." Fuxi reigned, perhaps, in the third millenium BCE. He taught his subjects the sciences of hunting, fishing, farming, and pasturing; the arts of music and divination; and he established the laws governing marriage, family, and private property. He also developed the Eight Trigrams, which are the foundation of the *Yijing,* or *Book of Changes,* after seeing the marks on the back and sides of a dragon (or dragon-horse or turtle) as it emerged from the waters of the Yellow River.

Early carvings represent him as a dragon (or a serpent), with either a bull's or a man's head. Often the human head is given two horns, much like those that appear on some images of Moses. When Fuxi and his consort Nuwa are shown together, their dragon tails may be entwined. His emblem is a mason's square; hers is a pair of dividers of the kind used in inscribing circles. In later pictorial art, Fuxi is represented

Fuxi

as a wise old man, wearing robes of imperial yellow, sitting in a high-backed chair, holding in front of him with both hands a disk adorned with the yin-yang symbol.

Gama Sennin *frog/toad sennin*

Gama Sennin (whose name means "frog/toad *sennin*") appears in many guises. It is said that he lived on top of a mountain with a three-legged toad as his companion; that he often assumed the form of a toad when bathing; that he caused a man named Bagen, who had been spying on him while he bathed, to be changed into a toad; that he learned most of what he knew of the occult arts from a frog whom he had cured of an illness; and that he could send his spirit to roam free of his body. On one occasion when he had done this, the spirit returned to find the *sennin*'s body so decayed that it was uninhabitable. The spirit accordingly took refuge in the nearest available living object, a lame frog.

Ganshinkei *Ch. scholar and official*

During the time of the Tang emperor whom the Japanese call Genso (r. 712-56), Ganshinkei served as censor in a provincial district. He was a fair official. When Ganshinkei freed some men who had been imprisoned unjustly, the gods, as a sign of approval, ended a long drought with a downpour the people promptly called "the Censor's Rain." Several years after Ganshinkei died, a traveling merchant from his home city saw him playing *go* with another venerable sage. They were sitting at a table under a tree growing atop a famous mountain. He is numbered among the immortals. Ganshinkei usually is depicted walking along a mountain path, carrying a

traveler's bundle on his back and supporting himself with a twisted staff to which a book-scroll has been tied.

Garuda *Indian deity*

A man-eagle treated as a deity in India, where he is the mount of Vishnu, Garuda in Japan also transports gods. He moves at incredible speeds, spanning worlds as he goes.

Geisha *entertainer*

The word geisha means "artist," and the most skillful of these professional Japanese entertainers deserve the designation. Geisha are trained in the arts of dancing, singing, music, and conversation, skills that are cleverly deployed to bemuse and please male patrons of geisha teahouses (*ochaya*), or to provide diversion at private gatherings in other venues.

In the seventeenth and eighteenth centuries, courtesans (licensed prostitutes) and unlicensed prostitutes provided a variety of services, including music, to their patrons in the "pleasure quarters" of Tokyo and Kyoto. Around 1730 the first geisha—all-around, well-trained entertainers—appeared on the scene. Oddly enough, these geisha were male. It wasn't until 1750 that female geisha appeared, and by 1780 were so numerous that the term "geisha" came to refer only to a woman entertainer. Geisha were celebrities in their days of glory, celebrated during the Edo Period (1603-1868) in woodblock prints known as *bijinga* ("portraits of beautiful women").

In *Geisha: Beyond the Painted Smile,* a guide to an exhibition of paintings, woodblock prints, and photographs of geisha presented at the Asian Art Museum of San Francisco in 2004, it is noted that in 1920 the number of practicing geisha peaked at 80,000. Today they number a mere 6,000. The author of the guide writes, "It is anyone's guess how geisha will adapt to survive. If they have the will and instinct of geisha from the past they will endure."

Genkei *Ch. time-lost tale*

Genkei and his friend, Ryujin, were gathering flowers one day on a slope of Mount Tiantai in eastern China. They became lost. A fairy appeared and guided them to a cave where two sisters, both *sennin,* lived. The women gave them a drug derived from the hemp plant and invited them to share their beds. After what seemed like a short time to Genkei and Ryujin, they returned to their village—only to discover that seven generations had come and gone while they had been dallying in the *sennin's* cave.

Gentian *as symbol*

In heraldry and art the gentian is important inasmuch as both flowers and leaves are

incorporated in the *mon* (family crest) of many members of the powerful Minamoto clan.

Genpei War *civil war*

The Genpei war (1180-5) is perhaps the most famous civil conflict in Japanese history. The men and women who played important roles in the war have become the stuff of legend, and their lives and deeds are immortalized in Japanese art and folklore. Of particular literary note is *Heike monogatari* (*Tales of the Taira*), composed several years after the war's end.

At stake in the war was political control of a land inhabited by feuding clans and ambitious warlords. From 1160 to 1180, the Taira family ruled over Japan in a grand style, but they were forced from power in 1185, having been defeated at the battle of Dannoura, and vanished—destroyed by the armies of the ferocious Minamoto family. And when they died, an age died with them—the classical Heian Period that had begun in 794.

Yoritomo (1147-99), the leader of the triumphant Minamoto, established Japan's first shogunal government, one that brought the land a time of healing under a strong central authority.

The Chinese characters used to write Minamoto can also be read as Genji; those used for the family name Taira can be read as Heike. Either or both versions of the names are used in accounts of these families and their notable figures.

Gentoku *Ch. emperor, hero, and model of filial piety*

A descendant of an emperor, he was born to an impoverished family. He supported his widowed mother by making straw mats and sandals. As an adult, he was 2.2 meters tall with large ears and arms that hung to his knees. He became a warrior and, in one campaign, met Kanyu and Chohi, celebrated warriors. The three met one day in a peach orchard and pledged themselves to the defense of the House of Han, then assailed by enemies. They have come down in history as The Three Heroes of the Eastern (Later) Han (25-220).

They persuaded Komei, a great sage, to join them. Together, they fought valorously, first for the reigning emperor, then later, as the dynasty crumbled, for Gentoku himself. In 220, China split into three states and Gentoku was proclaimed first emperor of the Minor Han Dynasty in the State of Shu. He lived only two years in that role.

The three heroes are often shown standing in deep snow outside Komei's door. Gentoku, on the same quest for the sage's collaboration, is sometimes seen alone on horseback, riding on a desolate path, followed by a single servant. On one

occasion, enemies of Gentoku attacked a castle-fortress that he was visiting. He escaped mounted on his horse, which either leapt thirty feet over a chasm or swam across a flooded river.

Ghost Story of Yotsuya (*Yotsuya kaidan*)

Oiwa was old, ugly, and shrewish; her husband Iemon was lusty and selfish. One account says that he fell in love with a beautiful neighbor girl, who returned his passion. He gave a potion to both his wife and their small son that made them leprous before eventually killing them. Another version maintains that his life of debauchery so saddened Oiwa that she ran away from home and perished of hunger in a distant field. Still another tells how Iemon, suspecting Oiwa of taking a young lover, murdered her and threw her body into a nearby river.

In any event, Oiwa died unhappy—and therefore vengeful. Her spirit returned from the world beyond to haunt Iemon. In artists' renditions, Oiwa is made unforgettably hideous, with lank wet hair and a ghastly face, scarred and deformed, in which one huge eyeball, partly covered by a great flap of an eyelid, hangs half-way down her cheek. Sometimes she clasps her dead son to her bosom; other times she holds a small image of Jizo, the protector of children and of women in times of peril. Night after night this ghoulish specter haunts Iemon until he is driven insane. He kills all the people he meets in the vale of Yotsuya. Among them is the neighbor girl he has taken for his second wife.

Gigaku *ancient dance-drama*

According to tradition, a man named Mimashi, from the Korean kingdom of Paiche, introduced this Chinese musical ritual to Japan. Performers wore colorful Chinese robes. Each dancer covered his head with a mask symbolizing the character he portrayed, such as The Woman of Wu, The Drunken Persian King, a lion, a demon, or some other more familiar creatures. One mask, with a red face and a long pointed nose, may have suggested to the Japanese the idea of a *tengu*, the goblin who is part man and part bird, so important in the lore of later times.

Gihakuyo *Daoist alchemist*

Like most Daoist philosophers, Gihakuyo endeavored to devise an elixir of longevity. One day, in his mountain retreat, he thought he had succeeded in doing so. He tested the potion on his dog—who fell dead almost immediately. Undismayed, Gihakuyo swallowed some himself, and he dropped dead. A younger brother, still believing in this magical stuff, tried it and joined them in death. Finally, a third brother, more sensible than his predecessors, decided to bury those three dead bodies. As he went off to make preparations for the funerals, Gihakuyo rose from

the floor and concocted a different kind of medication. With this he revived both dog and brother.

Girl's Day (also known as Doll's Festival) *traditional festival*

This event is celebrated on the third day of the third month. It probably evolved from a Shinto ceremony of purification, called *Jomi no Sekku*. Begun in ancient times, the sins and faults a person had accreted in the past year were transferred, through the agency of suitable prayers, to a paper doll. The doll surrogate would be burned, or better, thrown into a river that carried it away to the cleansing sea. The person so purified would be free of evil—at least for a while. Over the years, the dolls became gifts for daughters and the day became Girl's Day, a mate to Boy's Day, celebrated in the fifth month.

Goat *J. zodiac animal*

Although the goat is not seen widely in Japanese art, it does appear as one of the signs in the Japanese zodiac.

Goshisho *legendary warrior*

He performed the feat of holding aloft in one hand a 500-kilogram weight, or brazier, while writing poetry with a brush in his other hand.

Gotoba (r. 1183-98) *emperor*

He struggled to regain the imperial powers that had first been usurped by the Minamoto, then (after 1219) by the Hojo families. In 1198 he retired in favor of his son, but continued to be the dominant figure of the imperial court. In 1221 he had the regent Hojo no Yoshitoki declared a rebel, but Yoshitoki's warriors defeated his forces. It is said that he personally supervised the manufacture of swords in his palace and may even have forged blades himself. Stories were told that he could cause natural things (frogs, pine trees) to cease making noise.

Gourd *as symbol*

A symbol of longevity (and of conviviality, since it was once used to carry sake to entertainments), the gourd is most often associated with holy persons, such as priests or *sennin*. Some gourds have magical powers, like the horse-carrying gourd of Chokaro or the gourd used to soothe the earthquake fish; others do not.

The Grateful Fox *moral tale*

One day Shigemochi rescued a fox cub being tormented by a group of boys. That same evening, while he sat in his garden viewing the moon, a white-haired old man suddenly appeared before him. He explained that he was a white fox, and the father of the cub that Shigemochi had released. He gave Shigemochi a jar of medicine that the god Inari himself had prepared, and explained that the ointment would gain for

Gushojin

Shigemochi both honor and wealth from the emperor himself. Not long afterward the emperor became ill. Physicians could not cure him, nor could priest-exorcists rout the evil spirits from his body. Shigemochi's ointment, however, succeeded where all other measures had failed. When he recovered, the grateful emperor raised Shigemochi to the rank of councilor and granted him the first of the Onodera family's domains in Awa. This white fox seems to have been a messenger from Inari.

Gushojin *Buddhist minor deities*

Gushojin is the general name for a class of lesser gods who attend to more important divinities. Thus, Jizo, like Kannon a bodhisattva of compassion, is accompanied by two *gushojin* who function as reporters. The one on Jizo's left notes good deeds, while the one on his right records people's evil deeds. Emma-o, the King of Hell, is also accompanied by a pair of recording *gushojin*.

Gyogi *Buddhist monk*

He popularized the teachings of Ryobo-Shinto, a form of Shinto heavily influenced by Buddhist teachings. Its main tenet was that Japan's native gods were nothing more than manifestations of the Buddha. Gyogi insisted that the Buddha and Amaterasu, the sun goddess, were one and the same deity. He is wrongly credited with the invention of the potter's wheel, a device that had existed in Japan and China centuries before his birth.

Gyokushi *sennin*

Mounted on a gigantic horse, Gyokushi rode hundreds of meters each day, exercising his powers to cause whirlwinds and thunderstorms so fierce they destroyed strongly constructed buildings. He and another *sennin,* Gyokushisho, who made a clay horse on which he traveled hundreds of meters a day, are probably one and the same person. Drops of water sprayed from Gyokushisho's mouth turned to jewels as they fell to earth.

Gyoshin *Buddhist monk*

A priest at Horyu Temple, Gyoshin resolved to honor Prince Shotoku, who had died a century before, by building a structure on the site where the prince's palace had stood until it was burned down by members of the Soga clan. With the moral and financial support of the imperial family, Gyoshin built what is called the East Precinct of Horyu Temple, on the very ground where the palace had once stood. In its several buildings he preserved many things that had belonged to the admired prince. An image of Gyoshin himself can be seen in the Yumedono, or Dream Hall, of the East Precinct.

Hachiman *god of war*

His oldest shrine, founded at Usa during the time of Emperor Nintoku (r. 313-99), was erected to commemorate the appearance of a great stone deity, who marched up to the summit of Mount Maki, which rises above the village of Usa. From there he emitted brilliant rays of light in the direction of the imperial palace. The emperor's messengers found three great stones at the summit, remnants of the shining god, and, perched on the brink, a falcon with gleaming golden plumage. Emperor Nintoku took the bird to be Hachiman and ordered a shrine built in its honor at the foot of Mount Maki. Much later, this shrine was officially dedicated to Hachiman.

Hakutaku *legendary creature*

Like the *kirin,* the *hakutaku* is said to make an appearance only during the reign of a virtuous ruler. It is represented as a composite of a beast and a human being. An example shown in Earle (p. 106) has a bearded human face, horns, the body of an ox, and multiple eyes. A Chinese emperor is said to have conversed with the creature, acquiring from it knowledge of the universe in its seen and unseen manifestations.

Hankai *Ch. martial hero*

Hankai was one of The Three Heroes of the Early Han Dynasty, who supported Koso in the wars that ultimately made Koso the first emperor of the Han dynasty. Hankai served Koso faithfully, but was accused of treason by his sovereign and

ordered executed. He was saved because he was related by marriage to the Empress Lu Hou. When she became sole ruler, she pardoned Hankai and restored him to his estates.

Hannya *woman and demon*

A standardized figure in the Noh repertory, Hannya is a woman so overwhelmed by her emotional nature that she appears with a demon's head as a sign of her wild and treacherous instability. She is usually depicted in art as a woman with long fangs and two horns growing out of her forehead. The dragon into which Kiyo-hime is transformed often bears the head of Hannya.

Hasebe no Nobotsura *faithful retainer*

A supporter of Prince Mochihito in the futile revolt against Taira no Kiyomori in 1180, Nobotsura helped the prince to escape from Kyoto during the fighting. Both wore women's clothing, in order to pass guards at the city's gates. After starting Mochihito on the road to Nara, Nobotsura—still in disguise—returned to Kyoto. Having removed his disguise, he joined his rebel comrades again. Taira soldiers captured him when his sword broke during an attack. His refusal under torture to tell his captors what had happened to Prince Mochihito so impressed Kiyomori that he set Nobotsura free. He outlived all those warring Taira and Minamoto.

Hashi-hime *Shinto goddess of lust*

As a mortal, Hashi was a wanton, jealous woman. She slept with many men, but not one would marry her. After she died her angry spirit returned to harass newly married couples, causing them to be miserable in mind and body. Finally a wise priest realized that the only way to quiet Hashi-hime's bitter spirit was to elevate her to the status of a goddess, so that victims of her attentions could attempt to placate her with prayers and offerings. Eagerly accepting his suggestion, the people built a shrine to her at Uji, near Kyoto. Hoping that the propinquity would please Hashi-hime, it was built right next to that of the orgiastic and phallic god, Sumiyoshi.

Hashi no Nakatomo *exiled noble*

During the time of Empress Suiko (r. 593-628), Nakatomo was banished from the court in Yamato. Accompanied by two brothers as retainers, he went eastward, to the coast of Musashi Province. The three exiles made a meager living catching fish in the waters of the Sumida River, where it meets the Bay of Edo. One day, among the fish trapped in their net, they found a tiny golden image of Kannon, a bodhisattva of compassion. Although it was only about 4.5 centimeters long, it glowed with an awesome light. Nakatomo and his brothers made an altar for it in their reed hut, which eventually grew into a regional shrine.

Hatamoto *samurai vassals*

Hatamoto means "at the foot of the standard" or "under the flag." At first it referred simply to the military camp of Tokugawa Ieyasu, but was later extended to include all samurai who swore allegiance to him directly, rather than through an overlord *daimyo*. Within the military caste, they ranked below nobles and *daimyo*. Their descendants continued to serve Ieyasu's descendants until the end of the Tokugawa shogunate in 1868.

The Haunted Temple *folktale*

A samurai, Saito Sukeyasu, took shelter for the night in a temple said to be haunted. There an abnormally tall, black-robed Buddhist monk thrust a huge arm through a sliding door and tried to seize Sukeyasu. In the ensuing struggle, the door was torn from its grooves and Saito pressed it down on his assailant. Gradually, the monk's struggles ceased. Saito removed the door and found the dead body of a badger on the floor.

Hayato *special imperial guards*

In ancient times, certain warriors serving in the palace guard played a magico-religious role when the emperor had to be protected from evil influences. Such occasions included the first day of a new year, the emperor's investiture, reception of a foreign envoy, the start of a journey, the approach to a curve in the road, and the fording of a river. The *hayato,* assuming the magical powers, as well as the guard duty of alert and faithful dogs, would bark and howl. According to one account, *hayato* wore masks fashioned like dogs' heads. Very old stone images of warriors wearing dog-head masks have been found in Yamato Province.

Hatakeyama no Shigetada *warrior*

At the second battle of Uji River (1184), Shigetada's horse was wounded as they crossed the water. A prodigiously strong man, Shigetada slipped from the saddle, put the steed's forelegs over his own shoulders, and helped it return to shore. On that same day he rescued Ogushi Jiro from drowning by towing him back to shore while he clung to the horns on Shigetada's helmet. Both Shigetada and his son died while resisting arrest on trumped-up political charges.

Heiji monogatari *historical chronicle*

The author of *Heiji Monogatari* (*Tales of the Heiji*) is unknown. The work was formerly attributed to Tokinaga Hamuro. The chronicle is concerned with heroes and events of the Heiji War (1159) when Minamoto Yoshitomo, Fujiwara Nobuyori, and their supporters rose in rebellion against the Heike clan, only to be suppressed and killed.

Heitaro Sone Masayoshi *fairy tale*

Heitaro, a warrior renowned for his skill as an archer, was hunting with his lord in the Kumano mountains when a prized falcon got caught by its leash amid the branches of a willow tree. Servants came with axes to chop it down. But Heitaro, with a well-aimed arrow, cut the leash, freed the bird, and saved the willow. Later, the warrior fell in love and married a beautiful woman he met at his mother's house. When the willow tree from which he had rescued the bird was cut down, his wife, before she died, told him she was the spirit of the tree in human form.

Henjaku *Ch. physician*

Henjaku kept an inn. One day, a sage and magician, Chosunkun, stopped at the inn. Chosunkun taught Henjaku the arts of healing. Henjaku is regarded as the first Chinese physician to dissect a human body, and, after studying veins and arteries, the first to propose the theory of pulses, which is so important in Chinese classical medicine. He founded systems of pathology and pharmacology, all the while treating patients and achieving many miraculous cures. Legend adds that the skin over his abdomen was transparent, enabling him to observe the flow of blood, the digestion of food, and the action of medicines. Some artists have depicted him, handsome and scholarly, dressed in fine robes, simultaneously reading a scroll and listening attentively to Chosunkun's teachings. Others have shown him, finely dressed, seated on the ground, pouring a liquid from a gourd into a cup-shaped cavity at one end of a long boulder, while Chosunkun, standing beside it, watches the procedure. In contrast with the young and elegant Henjaku, the teacher is old, thickset, and, in some representations, unkempt, even primitive, being dressed in skins and leaves, like many sages and *sennin*.

Heron *in folklore*

The heron shares attributes and legends with the swan, the crane, and the stork—mostly because storytellers and artists couldn't tell one big bird from another. The white heron is a symbol of longevity, as are the others, and when paired with a white lotus is also a symbol of purity. Gods, sages, and heroes of romances also rode about on the backs of herons. The *sennin* Oshikyo, for example, after studying magic in a distant place for 30 years, informed his family that he would visit them on the seventh day of the seventh month. At the appointed time he flew in on the back of a heron, enjoyed a short reunion, and then ascended to heaven on the back of his winged carrier.

Hichibo *apprentice magician*

He noticed that a neighbor who sold medicines by day, retired into a big jar hung

from his doorpost at night. Realizing that this neighbor, whose name was Koko, must be a magician, Hichibo became his pupil. At the end of his studies, Koko gave him a bamboo pole and a piece of paper inscribed with a magical spell. With that charm he could make the pole transport him over great distances in a very short time. When the pole was laid on the ground, he could transform it into a dragon with power over the spirits of darkness. Astride this pole, Hichibo went traveling for a period of what he guessed was three days, but in fact was fifteen years. Ultimately, he lost the paper charm, and with it went his command over magical forces. The demons who had been waiting for this moment killed him. Artists have depicted Hichibo riding on the back of a stork or a crane, rather than on his bamboo pole. Sometimes, having confused him with his teacher Koko, they show him peering out of a big jar.

Hihashi *folktale*

Hihashi met a beautiful girl who lived near Indigo Bridge, a fabled Chinese construction built over a bridge near the ancient Chinese capital of Ch'ang-an, and immediately fell in love with her. But her mother would not let her marry any man unless he brought her a mortar and pestle made of jade. The old woman needed those valuable utensils to grind magical herbs given to her by a fairy. Hihashi searched far and wide for many weeks before he finally found the sought objects. After the marriage, the mother rewarded the couple by giving them magical potions to drink that transformed both Hihashi and his wife into *sennin*.

Hiketa no Akaiko *model of devotion to emperor*

Akaiko, a beautiful maiden, slept one night with the Emperor Yuryaku (r. 457-79). She was sent home in the morning, but could not forget her lover. The emperor's chamberlain escorted her to the palace night after night, year after year, but she was not called again to sleep with the sovereign. The years went by; she did not marry; she lost her beauty. But she continued to appear every night at the imperial residence. When the emperor finally learned who she was, he tried to reward her for all those lost years. But she needed nothing: she was content to have served him.

Hiko-hohodemi *Shinto deity*

Hiko-hohodemi of Satsuma was a mighty hunter, while his oldest brother, Hiko-hosusori, became a mighty fisherman. Hohodemi borrowed his brother's magical fishhook one day, went out on the sea to test his luck, and promptly lost the hook. Hosusori took the hunter's bow as forfeit until the missing hook was returned. Trying to placate him, Hohodemi shattered his own precious sword blade and from the pieces fashioned 500 new fish hooks. But Hosusori would not accept them. Hohodemi sought help from Ryujin, the Dragon King, who dwells at the bottom of

the sea. Ryujin welcomed the intruder, listened to his tale, and moved at once to help him. He had his chamberlain summon to the palace all the creatures of the deep. All responded except for the red *tai*, whom Ryujin's subjects called Akame, the Red Woman. She sent word that she was too sick to leave home. Ryujin dispatched his own physician, Tako the octopus, to treat Akame. He found the missing fishhook in her mouth.

When Hohodemi finally got back to Satsuma, he found that Hosusori had seized his dominions. Using the power of tide-rising jewels, he caused the waters to rise so high that they almost drowned Hosusori. The usurper submitted to his brother's rule. Hohodemi reigned in Satsuma for 580 years. Descended from his grandson Jimmu is a race of fighting men who, in later times, served among the guards of the emperors of Japan as *hayato,* "the dog-faced" warriors.

Hime-gimi *fictitious heroine*

Hime-gimi is the beautiful daughter of a princess who has died, and the victim of a wicked stepmother. When a handsome noble falls in love with Gimi while she is playing a flute, her stepmother is furious. She plans to have the girl kidnapped and sold into whoredom. Gimi's maid learns of the plan, and the two women flee to a sacred shrine for sanctuary. The resident god takes pity on Gimi and sends a vision to her lover telling him where she is. He comes to her after many trials and dangers. They marry and live happily ever after. The stepmother dies of chagrin.

History of A Three-meter-square Hut (*Hojoki*) *essay*

Kamo no Chomei at about the age of 30 retired from the world, became a Buddhist priest, and lived a solitary life on Mount Hino, not far from Kyoto. About the year 1210 he reduced the area of his dwelling to about three meters on each side, big enough for his simple needs. A Thoreau of the East, Chomei wrote *Hojoki,* a short account of the way he lived in his retreat, as "a friend of the moon and the wind," solaced by his flute and his writing. The memoir has influenced generations of Japan's aesthetes who practiced the discipline of the tea ceremony.

Hiyoku-dori *fabulous bird*

This creature has two heads attached to one neck, the body of a bird of paradise, and a pair of long, lyre-shaped plumes in its tail. It is a symbol of faithfulness.

Ho Bai (*J. Kahaku*) *deity of the Yellow River*

For many centuries, Chinese peasants living along the banks of the great Yellow River worshipped Ho Bai, its potent and unpredictable god. They imagined him with the body of a fish and the head of a man. Each year, in order to please him, people of communities along the river's long course threw into his embrace a beautiful

maiden attired in costly vestments and adorned with jewels. During most years Ho Bai seemed to be content with their offerings. Every year the village headsmen, the mayors of towns and cities, and especially the priests and priestesses who conducted the rituals of worship addressed to the god, all grew rich. Gifts of money and foods came to them, presented by families desperate to save their daughters from being chosen for sacrifice. After many years, an enlightened governor of Ye in Henan stopped that practice with one last great offering to Ho Bai. He ordered his soldiers to throw all the cheating headmen, mayors, priests, and priestesses—who for so many years had been growing fat on the credulity of common folk—into the river.

Hoichi *ghost story*

In a temple in Shimonoseki lived Hoichi, an old blind priest who knew all the ballads about the war between the Taira and the Minamoto family clans. One night, as he sat in his usual place on the temple's verandah, the restless spirits of certain Taira warriors who died in the battle of Dannoura (1185) bewitched Hoichi. They led him to the cemetery nearby, and made him play the *biwa* (a lutelike instrument) as he sang the heroic exploits of the members of the two families. Night after night, they compelled him to go with them. At last some temple servants noticed Hoichi wandering off. They followed him, and were horrified to see ghostly warriors, clad in ancient armor, dancing to the music of Hoichi's voice and *biwa*. When his abbot learned of this, he wrote sacred texts on the blind man's arms, legs, brows, and other uncovered parts of his body, even the bottom of his feet, overlooking the priest's ears. Feeling that these charms would shield Hoichi from further evil, he allowed the blind priest to take his usual seat on the temple's porch. Early next morning the younger priests found Hoichi, still sitting there as usual—but with both his ears having been torn from his head by the furious Taira spirits. Hoichi did not seem to mind their loss because his spirit had been saved.

Hojo Masako *wife of Minamoto no Yoritomo; later known as "the Nun-Shogun"*

The oldest of Hojo Tokimasa's children, Hojo Masako (1157-1225) grew up a strong-willed woman, who managed her children as if they were puppets and governed Japan as if it were her private domain. Indeed, in all the history of Japan no woman (save perhaps the earliest "empresses," who are more legendary than real) ever approached Hojo Masako in the degree of power she exercised over family and nation. Wed to Minamoto no Yoritomo, after his death she became a shaven-headed nun, but continued to exercise power, having a role in choosing shoguns who succeeded her husband, once even acting as regent.

Hojo Tokimasa

Hojo Tokimasa *warrior*

Tokimasa (1138-1215) was a man of great influence during Minamoto no Yoritomo's time as shogun and thereafter under successive shoguns. His lies helped to increase Yoritomo's hatred for his half-brother Minamoto no Yoshitsune. On Yoritomo's death, he became the guardian of his son, Yoriie, and later conspired in the boy's assassination. When it was revealed that he was in a plot to murder Yoriie's successor, his daughter, the Nun-Shogun, exiled him to his hometown of Hojo, where she forced him to become a monk.

A legend tells that one day he went to the shrine of the goddess Benten on Enoshima, an island near Kamakura, to ask her for a favor. Benten agreed to grant his wish—provided that henceforth he would not commit any unjust deeds. If he failed to keep his promise, she warned, his family would die out after the sixth generation. He agreed. As the goddess returned to her home in the heavens, Tokimasa saw the lower part of her body, shaped like a dragon's and covered with scales. He found three of those triangular scales on the temple's floor (although another account says he picked them up on Enoshima's beach). Arranging those three scales, two at the bottom, one at the top, with their narrow ends pointing upward, he formed the insignia that he adopted for the Hojo *mon*. He soon broke his promise to Benten, and as a consequence his line died out after the sixth generation, just as she had cautioned.

Hokyosha *sennin*

He meditated while sitting on a flat stone six meters square. On Mount U, he found a stone pot and a sword. One day multicolored clouds issuing strange music surrounded him. Two celestial messengers, one seated on a dragon, the other on a stag, appeared and persuaded Hokyosha to go with them. The *sennin* mounted a crane, or a heron, and was carried off into the skies.

Honen-shonin *Buddhist priest*

In 1175 Honen established the Buddhist Jodo (or "pure land") sect, being inspired to do so by revelations made to him in a dream by Amida, the Buddha of Light. The Pure Land was the Western Paradise of Amida, and to enter it, a Jodo adherent had merely to repeat over and over again *"Namu Amida Butsu"* ("Hail Amida Buddha")—a practice known in Japanese as *nenbutsu*. He was exiled in 1207, but his influence continued.

Ho-o *phoenix*

Chinese called the phoenix one of The Four Divinely-constituted Creatures. In Chinese astrology it presides over the southern quadrant of the skies, and therefore

is a symbol of the sun. The *ho-o* is also a symbol of the empress and yin, the female principle, as the dragon is associated with the emperor and yang, the male principle. Moreover, the *ho-o* is an emblem of longevity, good luck, and (because it was so faithful to its absent mate) of conjugal felicity. The gods on high rely on it as a messenger; and as a means by which *sennin*, sages, and other worthy mortals might be conveyed to the heavens.

In body it resembles parts of a pheasant, a peacock, and a bird of paradise. The head is like a pheasant's crowned with a high cock's comb. Its tail is long, abundant, and curling, and its five-colored plumes make a wonderful sight when displayed. The colors are symbols for the five essential virtues: red for uprightness; sea blue for humaneness; yellow for goodness; white for faithfulness; and black for gentleness. Its song, made up of variations on five distinct notes, is most pleasing, like music played on a flute. Often the *ho-o* is shown in the company of other divine creatures, such as *kirin* and dragons. The *ho-o* perched in the branches of a *kiri* (*Paulownia imperialis*), that most beautiful of Japan's trees, creates a symbol of the emperor's authority. It is employed as a motif in imperial palaces, furnishings, and other possessions. And always, atop the emperor's palanquin, the auspicious *ho-o* stands.

Horse *as symbol*

Nomadic tribesmen from the Asian mainland introduced the horse to Japan. Japanese warriors made it their own animal—only other warriors and members of the upper classes could mount horses. It became a symbol of virility, valor, and hardiness. White horses were the most esteemed, often considered sacred animals. A horse figures in the wild actions of Susano-o, younger brother of the sun goddess, Amaterasu. He flayed a piebald colt, and threw the bloody carcass through a hole in the roof of his sister's palace. The dwelling defiled, Amaterasu's maiden weavers killed themselves by thrusting shuttles into their wombs, and the goddess fled to a cave, plunging the world into darkness.

A sign in the Japanese zodiac, horses are favorite subjects of artists. Warrior heroes are shown with their steeds. The painters Kose no Kanaoka and Hidari Jingoro depicted horses so realistically that the beasts came to life. The *sennin* Gyokushi was able to ride for thousands of leagues on a horse he made from clay. Another *sennin*, Chokaro, stabled his horse in a gourd hung from his obi. Associated with horses are masks, amulets, competitions, and humorous stories and wordplay that touch on the genital endowments of the animal.

Horse Races at Kamo *ritual*

Emperor Kimmei (r. 540-71) ordered the first ritual race at Kamo as a means of

propitiating the local gods. But over the years the races became excuses for an important festival in the aristocracy's social calendar. Whole troops of riders— representing rival families, administrative ministries, or military units—would compete in the races, more to earn the praise of their peers and the admiration of the ladies, than out of devotion to jealous gods. For artists, the horse races at Kamo could be reduced to the simplest of symbols: a leaf of a hollyhock pinned to a nobleman's headdress, or a rider's whip laid on a reed blind.

Horse-hoof Stone (*bateiseki*) *mineral*

This glassy substance, apparently volcanic in origin, is jet black and hard. It resembles obsidian, but differs in that it is more easily shaped and carved into small objects such as netsuke (miniature sculptures in wood, ivory, and other materials). A legend explains the reason for its fanciful name and its presence in the mud of Lake Dogo. A foal born to Sasaki no Takatsuna's mare fell into the lake and drowned. The distraught mother, searching for her offspring, leaped into the waters of the lake. Her hoofs struck the pebbles on the bottom, and transformed them into *bateiseki*.

The Horse That Could Run A Thousand Leagues *folktale animal*

This superlative steed could run a thousand leagues a day without being the least wearied. Takasoda of Inaba gave it to Emperor Go-Daigo (r. 1319-38). Just when it was delivered to the imperial stables, the *kecho*, a yellow bird that sat for several nights on the roofs of the palace, arrived screeching horribly. Believing this to be an omen, Fujiwara no Fujifusa, a court noble honored for his loyalty to the sovereign, predicted that calamity would befall the emperor. Subsequent events proved that Fujifusa was right.

Hoso *sennin*

"The Patriarch of Peng," as he came to be known in China lived for 767 years, dying in the last year of the Shang dynasty (?1766-1122 BCE). Hoso only needed to inhale air once every three days to satisfy his breathing requirements. He could sleep on sea waves an entire day, or lie unmoving for a year until he was thickly covered with dust. For nourishment, he ate ground up mother-of-pearl.

Hosokawa no Fujitaka *daimyo, poet, and historian*

Although a scholarly man, Fujitaka took up arms in support of Oda Nobunaga's campaigns to restore peace to the nation. When Nobunaga was murdered in 1582, Fujitaka became a lay priest, taking the name Yusai, and spending the last ten years of his life in discreet retirement in Kyoto, immersing himself in poetry and history.

Hosokawa no Tadaoki *daimyo, poet, and model of probity*

Like his father, this eldest son of Fujitaka was a poet as well as a warrior. In 1580,

for his services to Oda Nobunaga, he was made Lord of Tango. That same year he married a daughter of Akechi Mitsuhide, the general who pretended to be loyal to Nobunaga even as he plotted against him. Tadaoki's wife tried to persuade him to join her father in those schemes, but he refused to be disloyal to Nobunaga. In order to prevent her sending messages to Mitsuhide, Tadaoki kept her under close guard. Eventually, she became a Roman Catholic convert, taking the baptism name of Gracia. Tadaoki continued to serve Nobunaga's successors until he retired from the world and became a priest. He is remembered as a poet and a man of honor.

Hotoke Gozen *dancer*

At the age of sixteen Hotoke, "Lady Buddha," was already a famous *shirabyoshi* (dancer) in Kyoto. She became a concubine of Taira no Kiyomori (1118-81), displacing the incumbent Gyo Gozen. The latter became a nun and went to live with her mother and sister, also nuns, in a brushwood hut among the mountains near Saga. Gyo's history plagued Hotoke, who felt remorse for having driven the woman from Kiyomori's great mansion. In the end, she also took the vows of a nun, and went to live in the mountains of Saga.

Hozuki *plant*

A species of *Physalis,* or ground cherry, the *hozuki* is often represented in Japanese art because of its attractive scarlet fruits. It is also a magical charm—clusters of the fruits, hung at the gate, will protect a household from thunder and lightning.

A Hundred Measures *prayer ritual*

A pilgrim acquires merit for each step he ascends in a long flight of stairs leading up a mountainside to a Buddhist temple, or for each step he takes along a path leading to any sacred site. In many constricted holy places on the flat lands, walking just a hundred paces will do just as well—especially if they are repeated many times.

Huangdi *legendary Ch. ruler*

Known as "the Yellow Lord" or "the Yellow Emperor," Huangdi is one of the legendary rulers who supposedly helped create China's ancient culture. While still a young man, he led the army that drove from the country a race of inimical beings, who had human voices but bodies of beasts, foreheads of iron, and bellies that could eat dust. For his victory, the princes of the land chose Huangdi to be their king after the second ruler died.

His reign was marked by many accomplishments. Among them: the invention of instruments for studying the motions of stars and planets, which established the annual calendar and the twelve- and sixty-year cycles; the regulation of musical sounds and the casting of a group of twelve bronze bells, each of which give a

different but correct tone when struck; improvements in techniques of making articles from clay, metal, and wood; the invention of wheeled vehicles for use on land and boats for transport on rivers and lakes; the invention of the magnetic compass and the "south-pointing carriage" to move about the country; and studies into the causes of sickness among people and searches for remedies to cure them. From these researches, said the chroniclers, came the *Huangdi Nei Jing Shuowen*, usually translated as *The Yellow Emperor's Classic of Internal Medicine*. This work became the fundamental text in Chinese medicine until the last century. (Present opinion, however, believes that this text was written about 1000 BCE.) In all these endeavors, Huangdi's noble consort, Xiling Shi (J. Seiryoshi) assisted him. She taught the people how to grow silkworms, spin thread from cocoons, and weave silken fabrics.

Huangdi (also *Shihuangdi; J. Kotei*) *historical Ch. ruler*

Huangdi (221-10 BCE) ascended the throne as the first emperor of the short-lived Qin empire (221-207 BCE). He proved to be a brilliant administrator and organizer of the departments of government, but in his determination to break the hold of the past, he caused havoc among conservatives and the customs they wished to retain. He ordered "the burning of the books," by which all written records were supposed to be destroyed, except for treatises concerned with practical subjects such as divination, astronomy, medicine, and agriculture. The Seven Worthies of the Bamboo Grove and other adversaries like them may have conspired to save some of those threatened works.

But Huangdi proved also to be bigoted, cruel, and credulous. He condemned to death 460 eminent intellectuals because they opposed his reforms. He started on the construction of the immense Great Wall, intending it to be a barrier against the Hu, or Hsiung-nu, those tribes of barbarians who roamed the lands to the north, because soothsayers told him that a Hu would destroy the Qin dynasty. In Japan, as in China, artists have depicted many events in Huangdi's imperious career. Their favorite theme concerned the ancient pine tree under which he waited one day during a sudden rainstorm. Sensible of the honor and the responsibility, the old tree immediately sent forth a full crown of branches and needles to protect the Son of Heaven. In his turn, the emperor conferred on the courteous pine tree the title *tai-yu*, which means "great rank" but, in the inevitable pun, can also mean "great rain."

Ichiji Kinrin *Buddhist deity*

He is a manifestation of Dainichi-nyorai. People address prayers to him when they want to have children, or seek his protection from evil spirits and natural calamities. An image of him, in painted wood done toward the end of the Heian Period (794-1185), was made for Chuson Temple at Hiraizumi in Mutsu Province. The unknown sculptor is the first image-maker in Japan to use pieces of crystal to brighten the eyes of his statue.

Ichimoku *imagined creatures*

Although these monstrous creatures are shaped like human beings, they have only one eye, located in the middle of the brow. They dwell in a land near the northern sea. Japanese artists usually show an *ichimoku* kneeling on a *mokugyo*, a wooden slit-drum, such as is used in Buddhist temples; often the drum is in the form of a winged fish. Such a representation is an allusion to Ichimoku Nyudo—a Buddhist priest who, with his eye fixed on future incarnations, has retired from the world in order to perfect himself by prayer, meditation, and austerities.

Ichimokuren *Shinto minor deity*

Peasants in the district of Ise prayed to him at his temple during times of drought. They formed processions and—led by priests carrying branches of the sacred *sasaki* tree, *gohei* (prayer strips, usually of paper), banners, and other potent devices for

winning the god's favor—they would walk along the boundaries of their fields. Some representations of Ichimokuren show him in the form of a one-eyed dragon.

Ida-ten *Buddhist minor deity*

He is represented as a handsome young warrior, girded in armor, either carrying a halberd or resting both hands on the hilt of a sword, whose point touches the ground between his feet. Frequently he stands on the hems of his long robes, signifying that he has subdued the elements.

Images of Ida-ten were placed in refectories, so that he could preside over monks while they ate and listened to readings of the scriptures. Sometimes, Ida-ten appears in a group composed of Bishamon-ten and two of the other Four Heavenly Kings. In that event, Bishamon, colored red, takes the place of Jikoku as a guardian of the east. Ida-ten, colored green, assumes Bishamon's role as god of prayer and meditation, of peace and tranquility.

The demon Soshiki stole a *sharito,* or reliquary, that held one of the teeth of Buddha. Ida-ten swept down on a cloud and ran after Soshiki, captured him, and forced him to return the *sharito* to its proper place. Japanese, recalling this intervention from on high, praise a man who walks or runs swiftly by likening him to Ida-ten.

Iga no Tsubone *strong woman*

The "Lady of Iga" was the very strong daughter of Shinozuka, a lord from the Iga Province, himself renowned for great strength. He gave her in marriage to Masanori, the fourth son of Kusunoki no Masashige, the heroic defender of Emperor Go-Daigo (r. 1319-38) against the Ashikaga clan. Several times during the civil wars of that period, Go-Daigo and his family had to flee to Yoshino as enemy generals seized the capital. During one of those escapes, Iga no Tsubone, a lady-in-waiting to Go-Daigo's empress, helped her majesty cross a flooded river. Legend makers embellished the facts by having her uproot an enormous tree, which she laid across the raging torrent. She carried the empress across the improvised bridge. On another occasion, when two foolish warriors attacked them, she ripped up a great pine tree and, wielding it like a war club, easily drove them off.

Iga no Tsubone is known best for the way she exorcised the bitter spirit of Sasaki no Kiyotaka. He had misadvised the emperor early in the civil war, and as a result had been forced to commit seppuku (ritual suicide). His angry spirit returned each night to the palace at Yoshino, haunting the emperor in exile, accusing Go-Daigo of treating him with undeserved cruelty. Iga no Tsubone filled a lantern with fireflies (which have power over evil spirits), went out into the palace garden, and waylaid Kiyotaka's ghost. She conversed long and earnestly, and persuaded him to

stop tormenting his sovereign, saying that the emperor's councilors had been correct in ordering the sentence of seppuku. With the help of the fireflies, she banished Kiyotaka's silenced spirit into the next world.

Ikkaku Sennin *sennin*

"The One-horned Sage" was born from the mating of a learned *sennin* with a doe. He came into this world looking much like a human child except that he had deer's hoofs for feet and a single horn on his head. He studied the occult sciences with his father and, like him, grew up to be a *sennin*.

One day, when too much rain had made the mountain paths wet and slippery, Ikkaku became so annoyed that he imprisoned the Rain Dragon in a cave. The subsequent drought caused much hardship and alarm. A beautiful woman sent by the region's ruler bewitched him and he released the captive rainmaker. In his infatuation, Ikkaku even carried the lady on his back. By succumbing to the charms of the flesh, he lost all his magical powers. He was arrested and executed. Japanese artists portray Ikkaku as a rather ugly creature, with a rudimentary nub atop his head, and a woman on his back. Sometimes she is beautiful, sometimes she is almost as grotesque as he. Occasionally they show him on his knees, clasping the woman's legs.

Ikkyu *Buddhist priest*

A brilliant youth of many talents, Ikkyu grew up to be a celebrated painter, calligrapher, poet, litterateur—and apparently a most eccentric priest as well. Despite his oddness (or possibly because of it), he became the forty-seventh abbot of Daitoku Temple in Kyoto.

Invariably he is depicted as a rotund, ugly, jolly priest, wandering about the countryside. His sermons extolled the need to remember that death awaits us all. One day he encountered a beautiful young prostitute, who called herself Jigoku Reigan, Hell's Whore. She wore a kimono embroidered with designs showing the fiery torments of the netherworld. Ikkyu adopted her as his daughter and pupil, and educated her in classic literature.

Ikutama-yori-hime *Shinto myth*

The *Kojiki* relates the story of Princess Ikutama-yori, a beautiful maiden of Izumo. A splendid young man came to her bed each night and left her before dawn. She never saw him, but was soon pregnant. Her parents told her that in order to learn his identity she must sprinkle red earth in front of her sleeping mat and pass a needle holding a twist of hemp through the skirt of his garment. She did so. The next morning they found no footprints in the red earth, and only three strands of hemp caught in the hole of the door latch. They realized that the night visitor must be "a divine

youth" who had no need to set his feet on the ground. Eventually, Ikutama-yori's lover revealed that he was none other than Otataneko, a son of Okuninushi himself. Tradition has it that their descendants have provided the priests for Okuninushi's great shrine in Izumo.

Inari *Shinto deity of rice, harvest, and abundance*

The name Inari means "rice-bearer." In primitive times, Japanese believed that a female deity was the begetter of rice. They worshipped her with fertility rites performed in rice fields at the beginning of the planting season. At that time of the year foxes also copulated in the fields. As a result, people associated the animal with the deity, and regarded it as the sign and messenger of the goddess.

One day early in the ninth century, the powerful Buddhist priest Kukai (who would receive the posthumous name Kobo-daishi) met an old man in the fields near To Temple, which the priest himself had just founded. The old man carried a sheaf of harvested rice on his shoulder. He introduced himself as Inari-tomi, or Rice-wealth, and promised that he would always help Kukai in his mission if he, in turn, would raise a temple to Inari. Kukai did so. It was here that the goddess was regarded as male.

In the male aspect, Inari is usually depicted as a shrewd old man with a pointed white beard, who carries a sheaf of harvested rice. Some versions show him with two sheaves, one at either end of a carrying pole, and a farmer's sickle in his right hand. He may be accompanied by a white fox, or actually be seated on the animal. Images in Shinto shrines still recognize the female version, with long hair hanging down her back, holding a bowl in her right hand. Sometimes she stands on a kneeling fox; at other times messenger animals stand beside her.

Indigo Bridge *Ch. fabled construction*

A Chinese legend tells of this famous bridge across a river near Xian, one of China's ancient capitals. A man named Biseiko was in love. His beloved promised to meet him in secret beneath the arch of Indigo Bridge. She was late for the assignation. While he waited for her to come, the river flooded and the waters rose. Biseiko, clinging to a bridge post, preferred to drown rather than move from the place his beloved had appointed.

Inki *sennin*

It had been foretold that Laozi would arrive at Hanku gate, which barred a mountain pass, on his last journey to the western land of the dead. Inki, the guardian of that gate, waited 500 years for the sage's appearance. When Laozi finally arrived, the guardian begged for enlightenment; the master consented and instructed him in the

mysteries of the Dao. On the eve of Laozi's departure, Inki prevailed on the sage to leave him the manuscript of the *Daodejing,* a collection of the master's thoughts on Daoism, with the promise that he would preserve the work.

Inkyo *nineteenth sovereign of Japan*

Upon the death of his elder brother, Inkyo (412-53), at 34 years of age, was next in line for the throne. For two years after his brother's death, he refused to accept the honor, but finally relented and reigned for 41 years, dying at the age of 78. As he was partly paralyzed in the legs and could not walk easily, he liked to go fishing from a boat. One day, while fishing off Awaji Island, he caught nothing at all. Diviners told him that the god of the island interfered with the sport because the god wanted a ball-shaped jewel lying at the bottom of the sea. The emperor ordered all the fisherfolk of the island to bring him that jewel. They strove mightily, but in vain. At day's end, as they knelt in apology before him, the enraged emperor commanded a woman to dive again. He would kill her husband if she did not succeed. Sasaji Otome dove deep, stayed down in the water for many minutes, and at last found the jewel, lying in the folds of a large clam. Gasping for breath, she rose to the surface, laid the jewel at the emperor's feet, and fell dead beside it.

Ippen-shonin (also known as *Ensho-daishi*) *Buddhist priest*

After having become a priest of the Tendai sect, Ippen (1239-89) went on to study the doctrines of the Jodo and Nenbutsu sects. He may have left the priesthood to become a samurai or an itinerant priest, taking Buddha's message to people in the provinces. In any event, he broke away from the established churches and in 1275 founded a new order of traveling priests, called the Ji sect.

At one time, Ippen had both a wife and a concubine. They lived in the same household in apparent amity. He came home one day and found them sitting over a game of *go,* apparently having a pleasant time. When he looked closer, he saw that their faces were those of witches, and their heads were covered with writhing snakes, symbolizing the dark effects of jealousy. He fled back to the security of life in a temple. (A similar unveiling occurred to Karukaya-doshin.)

Japan's artists have represented several memorable occasions in Ippen-shonin's life, such as: the jealousy revelation, with he and fellow priests dancing in gratitude, uttering *nenbutsu* ("Hail Amida Buddha"), rejoicing at having made a convert. When Ippen traveled, he carried a staff and wore, in addition to the usual priest's robes, a tall, square, box-like hat, from which hung a long cloth flap covering his neck and shoulders. He received the posthumous name of Ensho-daishi.

Ippi

Ippi *monster*

This weird creature, which lives in countries beyond the Western Sea, is made up of two half-creatures. Each half has only one eye, one arm, one leg—either the right or the left, as the case may be. When two matching halves are conjoined, they make a whole *ippi,* able to walk and work as a true human being does. When these halves are separated, they slither along the ground like snakes.

Iris *popular flower motif*

Varieties of iris plants that have flowers in numerous shapes, colors, and sizes thrive in Japan. For centuries, the Japanese have delighted in the beauty of every part of the plant, even to the roots. Artists have made iris blooms and leaves as thoroughly a Japanese motif as the blossoms of the cherry or the plum.

Ishikawa Goemon *bandit*

He is believed to have turned to a life of crime at the age of sixteen. During his career as a brigand, he acquired wealth, a reputation for great strength and shrewdness, and the dread of the people he preyed on. In 1595 he overreached himself. Some accounts say that, disguised as a messenger from the emperor, he boldly entered the palace of Toyotomi Hideyoshi, either to assassinate the warlord or to steal a famed incense burner he owned. Hideyoshi's guards suspected the stranger in their midst, and he fled the palace. Hideyoshi sent soldiers to capture him, dead or alive. They caught him, and his family as well, and brought them back to Kyoto. While his wife was forced to watch, Goemon and his son Ichijo were executed in a new and gruesome way. According to a method recently introduced from China: they were cooked to death in a vat of boiling oil.

Issunboshi *fairy tale*

Issunboshi, whose name roughly means "One-inch Boy," is the Tom Thumb of Japanese folklore. His parents were peasants who, being childless, went to a temple dedicated to Empress Jingo, beseeching her to give them a son, even if no larger than a finger. She sent them no more than they asked for. The surprised parents were not very happy with this fingerling child, but they kept him, hoping that in time he would grow like other children. He did not, so his parents expelled him from their house. He went off carrying only a tiny wooden soup bowl, a fine needle sheathed in a wisp of straw, and one of the minute chopsticks his father had made for him to eat with. When he came to a pond, brook, or stream, he crossed it by using the bowl as a boat, the chopsticks as oars.

At last Issunboshi arrived in Kyoto. Searching for a great lord to serve, he presented himself to the emperor's prime minister, Prince Sanjo. The great man

gave him to his wife as a page. One day, as he attended Princess Sanjo during a visit to a temple, two terrible *oni* attacked her party. Without hesitation, Issunboshi drew his needle-sword from its straw scabbard and routed the demons. He blinded one in an eye, but was swallowed by the other. With his sword he pierced through the second *oni*'s stomach and found himself back in the light of day. As they resumed their journey, a servant brought to the princess a magic jade mallet that one of the *oni* had dropped as he fled. Only Issunboshi could read the tiny characters inscribed on the handle—"Tap the earth with me three times," they said, "and make a wish." On hearing this, Princess Sanjo urged him to wish to be made normal size. He asked for that boon—and "in a flash of golden light" he became big. The emperor took Issunboshi, now a handsome man of splendid size, into his service, and appointed him a high official. Prince and Princess Sanjo gave one of their beautiful daughters to Issunboshi in marriage. And of course they lived happily ever after.

Iwasa Matabei *artist*

Matabei studied painting with a number of teachers in Echizen Province before he went to Kyoto in 1600 to learn the techniques of the famous Tosa School. He developed a style clearly his own, and chose for subjects the people and scenes of his time. He once painted a demon so real that it came to life. A priest tamed it with magical incantations. The painter Yoshimori paid Matabei the admiring tribute of a fellow artist by depicting him in a moment of astonishment, as people, animals, and creatures of all sorts stepped forth, alive, from a picture he had just finished.

Izanagi and Izanami *Shinto deities*

These brother and sister divinities, Izanagi and Izanami, are the creators of all deities who dwell on the earth and in the skies between earth and the Plain of High Heaven. Their immediate progeny are the most potent forces in this world. Some of Izanagi's more distant descendants are the members of Japan's imperial family, whose ancestress is Izanagi's most powerful child, Amaterasu, goddess of the sun.

Izanagi and Izanami, (the active male principle and the passive female principle, the Sky Father and the Earth Mother) gave form and order to chaos. From their union came the islands of Japan; the many deities of water, rain, winds, trees, flowers, mountains, rocks, rivers, roads, thunder; and several other gifts of earth and air. Izanami died giving birth to the god of fire. Izanagi sought and lost her in the underworld. Like Orpheus, he looked on his beloved when forbidden to do so.

Izanagi purified himself of the pollution defiling him from the Land of the Dead by bathing in the waters of a stream. From the washings of his left eye was born Amaterasu to whom he gave dominion over the Plain of High Heaven and the sun.

From the washings of his right eye was born Tsukiyomi to whom he gave lordship of the night and the moon. From the washings of his nose was born Susano-o to whom he entrusted waters of the sea. When these delegations of authority over the parts of the world had been completed, Izanagi's labors were ended. Weary and full of years, he retired to the cave of Hi no Waka Miya and was heard of no more. Izanami became one of the deities of Hell.

Izumi no Saburo Chikahira *warrior*

Chikahira, a *daimyo* of Shinano Province noted for his physical strength, was a relative of the Minamoto clan. He fought in their wars until slain in battle. Japanese artists have depicted Chikahira carrying on his back a large flat-bottomed boat, which he did not want his enemies to use in ferrying soldiers across a river.

Izuna Gongen *Shinto deity*

Japanese artists have represented her most often as a female with bared breasts and the face of a young *tengu,* complete with a bird's beak. Surrounded by an aureole of flames, she stands on the back of a white fox, holds a sword in one hand and a noose in the other. Other versions, however, give her a human head with a ferocious countenance resembling that of the god Fudo Myo-o.

Jataka Tales *Buddhist parables*

These are Buddhist parables describing many of the 550 previous incarnations of the Buddha, especially as they relate to his spirituality and sense of sacrifice.

Jichu's Dream *legend*

Jichu, a Buddhist priest who lived in the eighth century, dreamed that he took part in a ceremony in honor of Kannon, a bodhisattva of compassion. He begged the Lord Buddha to send him an image of Kannon. Soon afterward his prayer was answered. He found a small bronze statue of the bodhisattva in a wooden pail that had floated across the waters, landing at his feet as he walked along the beach at Naniwa. Full of reverence, he lifted up the image and felt its warmth, as though it was made of flesh and blood.

Jimmu (tr. 711-585 BCE) *legendary first emperor of Japan*

Jimmu was a descendant of Amaterasu, the sun goddess, on his father's side, and of Ryujin, the Dragon King of the sea, on his mother's side. In his fifteenth year, he was chosen to be heir to his father's holdings in Kyushu. In his forty-fifth year, he and several of his brothers, with many retainers, crossed the seas to Honshu, the lands of Yamato. During the long campaign that followed, the prince lost a few brothers and a number of retainers to wounds and diseases. He continued to fight and finally subjugated the primitive people of Yamato, who had stubbornly resisted the benefits

of civilization. He then proclaimed himself ruler of all the lands of Japan, taking as his name Jimmu, or "Divine Valor."

Artists usually depict him as a bearded warrior, clad in the ancient style, with long, full, white trousers, a short jacket belted at the waist, braided hair looped over his temples, and a fillet around his head. Sometimes he is presented as an infant being carried in the arms of the Shinto goddess of flowers and Mount Fuji. Occasionally he is portrayed as a youth in search of love, when he is supposed to have met a maiden who inspired him to sing or write the first love song. A number of tales about his campaign in Yamato are most popular. For instance, when he and his warriors are awakened from a magical sleeping spell by a sacred sword, when they are guided in alien Yamato by an eight-foot crow, and when hampered by rain and a stinging cloud, they are sent a golden bird by Amaterasu, whose light terrifies the defending natives into frantic flight.

Jingo *empress-dowager*

She was Princess Okinaga Tarashi, the principal wife of Emperor Chuai (r. 192-200), the fourteenth sovereign of Japan. When the gods struck Chuai dead for not heeding their orders to make war on the kingdom of Silla in Korea, his widow resolved to obey their mandate. Suppressing news of Chuai's death, she took the name Jingo, meaning "Divine Prowess," and ruled as regent for her unborn child. Moreover, she delayed the birth of her child for two years by carrying a heavy sacred stone bound to her waist.

All the deities except Izora, god of the seashore, favored the expedition against Silla. Izora, unwilling to help, covered himself with mud. She sent him to find Ryujin, the Dragon King of the sea, to borrow that deity's tide-ruling jewels (*tama*). Ryujin loaned them gladly, thereby enabling the fleet to cross Izora's mud-covered shoals. The god of winds filled the sails of her ships, the god of fish fed her warriors, and the god of birds guided them on their way. During a terrible storm, Sumiyoshi himself, another god of the sea, protected Jingo's flagship. It is told that all the fishes of the sea gathered beneath every one of her ships, preventing the loss of a single one.

Jingo returned to Japan and, in due time, bore the withheld child. He is remembered as Emperor Ojin (r. 201-310), fifteenth sovereign of Japan. He was emperor in name only for the 69 years of life remaining to his mother. She ruled as regent, granting her son only ceremonial powers. She brought peace and prosperity to the country, and the benefits of increased contact with foreign lands. She sent Japan's first official embassy to China; and in Honshu she established a system of

post stations along major highways, each supplied with relays of couriers and horses. At her death she received the posthumous name Kashi Daimyojin.

Artists usually represent her as a militant female, clad in warrior's armor and wearing a broad white fillet around her head. The setting varies: she may be aboard her flagship, sailing for Silla; she may be on land, fishing in the Matsura River; praying to the gods above; receiving the tide-governing *tama* from Ryujin; on horseback; using the tip of her bow to write the ideographs meaning "ruler of the country." Sometimes, especially during the Tokugawa period, artists portrayed her as a regal and beautiful woman clad in the voluminous robes of a queen, wearing the high golden crown of a Korean or Chinese empress. Noble warriors attend her, carrying her banner, sword, and great golden parasol. In some instances, she shares the scene with Takeuchi no Sukune, the prime minister who, having failed to convince Emperor Chuai to attack Silla, succeeded in persuading her to comply with his ambitions. Not surprisingly, this unmaternal mother is never shown carrying her son. If the infant Ojin does appear with her, Takeuchi no Sukune is carrying him. She is also seen naked and vastly swollen with child, during that long and miraculous interval between the death of her husband and the birth of his successor-son.

Jiraiya *hero*

Jiraiya embarks on a career of crime when his father, the lord of Ogata, is murdered. On the way to rob a rich old man in a nearby town one winter evening, he stays in the hut of an old woman. Not softened by her hospitality, Jiraiya decides to kill her. His sword shatters before he can strike, and the old woman transforms herself into an old man. He is none other than Senso Dojin, the Spirit of the Great Frog. Knowing that Jiraiya is innately good, he teaches him the secrets of frog magic, thereby giving him control over frogs, but not over snakes or snails. Jiraiya departs, reminded of his teacher's injunction that he must use his new learning only for good purposes. Later he marries a girl taught the secrets of snail magic by a *sennin*. These are more potent than those of frog magic. She shares these secrets with Jiraiya. Doubly strong, he is able to kill the fearsome Orochimaru, Dragon-coil Robber, son of the Spirit of the Great Snake. In slaying Orochimaru, Jiraiya releases his prisoner, Princess Tagoto.

The Great Snake is determined to avenge his son. While Jiraiya and Princess Tagoto are resting in a temple, the snake slithers along an overhead beam and spits its venom at the hero. As he writhes in pain, the abbot sends his servant to India to fetch a vial of the only medicine that can counteract the poison. Riding on the back of a *tengu,* the servant makes the errand of mercy in time to save Jiraiya's life. He slaughters the Great Snake, aided by the Frog Spirit, the Snail Spirit, and a matchlock

musket. In recognition of the many good deeds he continues to perform, Jiraiya is made the *daimyo* of Izu.

In prints, Jiraiya is sometimes depicted in epic combat with the evil snake; sometimes at his studies with the Spirit of the Great Frog. He may be making magical signs with his hands while riding on the back of a frog, or carrying a huge blunderbuss as he sits astride a snail. The triad of a snake, a snail, and a frog illustrates the popular belief that while snakes eat frogs, and frogs eat snails, the slime of snails is lethal to snakes.

Jisshudo *sennin*

An alchemist, he succeeded in preparing the elixir of life. He offered it for sale at a reasonable price, until one day a provincial governor expressed interest in buying the potion. From him Jisshudo demanded a price many times greater, asserting that a rich man ought to be able to pay an exhorbitant sum for a substance as precious as the elixir. Angered, the governor had the *sennin* placed in a basket that was fastened shut and thrown into the sea. Currents carried the basket to another shore where two fishermen netted the object and released Jisshudo. With the help of his own elixir, the *sennin* was restored to his full physical and mental vigor.

Jizo-bosatsu *Buddhist deity*

Priests of the Shingon sect introduced the worship of this Chinese deity to Japan in the ninth century. Jizo is Buddhism's protector and, like Kannon, a bodhisattva of love and compassion, ready to help human beings in trouble. Often shown with five other guardians (*Roku-jizo*), he is easily identified. He looks like a handsome, stalwart, young priest, with a shaven head, a serene and reassuring expression, and the third eye of wisdom on his forehead.

Statues of Jizo, most placed by roadsides and graveyards, appear throughout Japan, often with small piles of stones and pebbles, put there by people hoping the time children have to suffer in the underworld will be shortened. The statues can sometimes be seen wearing tiny children's clothing or bibs, or with toys, given by grieving parents asking Jizo to help their dead children by according them special attention. Offerings are also made by parents to thank the deity for having saved their children from a serious illness.

Jizo usually stands on a lotus flower pedestal, wearing a priest's robe and holding a *hoshunotama*, a wish-fulfilling jewel, and a *shakujo,* or alarm-staff. The sound of the shaken staff calls upon believers to strive to break from desire and the world of illusion. By so doing, they will attain enlightenment that will free them from the cycle of death and rebirth into which living beings are born. Sometimes the

diety sits on a lotus throne, holding emblems other than the jewel and the staff. An ancient figure who fervently wanted to convert all in the world to Buddhism, he cloned himself many times so that he could be everywhere in the world. Depictions of *Roku-jizo* are based on this belief. As a group, the six watch over and succor both supernatural and human beings. They protect children, pregnant women, and travelers. They also govern heavenly spirits; send life-giving rain; ease the torments of demons suffering in hell and the distress of hungry and thirsty ghosts who can neither eat nor drink; watch over spirits reborn as beasts; heal sicknesses; and alleviate the pains of women giving birth. Jizo is thought to be expressly responsible for assuring long life to true believers.

In Japan, Jizo is one of the most popular of guardian deities. He is the patron of pilgrims, firemen, children, expectant mothers, and, in modern times, he is said to concern himself with watching over babies, born and unborn, a natural extension of his role as a protector of children. An image of Jizo, done in painted wood, 96.7 centimeters high, was made by the great sculptor Kaikei in the thirteenth century and is the most famous of the many representations. It shows a lean and shaven priest, his face heavily scored with wrinkles of kindness and humor. His right arm and chest are bare, in the manner of Indian priests, and his left hand is held out gracefully, palm upward, at the level of his breast. The sculpture, a realistic portrayal of a revered figure, also projects the benign and compassionate attributes of this guardian god.

Jo and Uba *legendary couple*
They are presented in art as a happily married couple who are models of conjugal felicity and longevity. They may be shown as well preserved, straight of back and smooth-skinned, or as bent and wrinkled. Almost always, Jo carries a bamboo rake, Uba a besom and fan. They may be accompanied by other symbols of longevity, such as the crane, tortoise, pine tree, and bamboo. They are the subject of a Noh play *Takasago.*

Jofuku *sorcerer and physician*
A noted Chinese sorcerer, Jofuku led an expedition to seek the elixir of life in islands rumored to be lying somewhere east of China. He may have been an earnest seeker after knowledge who discovered Japan, those sought-for islands; or a conniving charlatan who fooled the Qin emperor Huangdi (220-210 BCE) into financing the expedition; or an intellectual who fled from the emperor's campaign to stamp out "wrong thinking." Three hundred young men and three hundred young women, as well as chests full of treasures, including the books of Confucius, accompanied him.

Joga

Neither he nor any of his companions ever returned to China. They may, however, have reached Japan.

Joga *Ch. woman*

Her husband, the renowned archer Kogei, shot down with his arrows ten suns that had entered earth's galaxy, causing among other calamities, an eclipse of the moon. Seiobo, Queen of the West, rewarded Kogei with a cup of the elixir of life. Joga stole the queen's gift and took refuge on the moon. She was condemned to reside there forever. Joga is a Chinese version of the Western Old Man in the Moon.

Jogen-fujin *fairy*

Mounted on a unicorn, she descends from the heavens as part of the retinue of Seiobo, Queen of the West, on a visit to the imperial Chinese court. Lady (*fujin*) Jogen is portrayed by many Japanese artists riding on a *kirin,* one of The Four Divinely-constituted Creatures of Chinese mythology, who is sometimes represented as a one-horned beast.

Joka *Ch. legendary ruler and magician*

Chinese call her Nuwa. She was the sister, or wife, of Emperor Fuxi, and succeeded him after he died. She possessed extraordinary magical powers. Kokai, who stood eight meters tall and commanded water, rebelled against Joka. He flooded the earth, trying to drown her and all things made of wood. Joka called on her ally Shikuyu, who commanded fire. After a great battle, they routed Kokai. In the struggle, however, Kokai's head struck the Imperfect Mountain, knocking it down—as a result the pillars that held up heaven were shattered and quakes undermined the four corners of the earth.

Joka hastened to repair this damage. She cut off the four feet of a tortoise, and propped the corners of the earth on those supports. She built new pillars to hold up heaven, making them of melted stones in the five sacred colors: white, yellow, red, azure, and black. She dried up Kokai's floods with the ashes of swamp reeds. Later she found time to create precious jade and to determine the course of the River of Heaven (the Milky Way). She also made two new dragons, a golden one to guard the sun, and a blue one to watch over the portals of the east. She is seen with a woman's body and a dragon's tail. In some instances, her tail intertwines with Fuxi's.

Jomyo (also known as Tsutsui) *soldier-priest*

A martial priest, Jomyo fought for the Taira at the first battle of Uji River (1180). The rebellious Minamoto, on withdrawing from Kyoto, removed the planks from the bridge, leaving the posts and cross beams. The pursuing Taira swarmed across the remnants, leaping from beam to beam, shooting at the enemy massed on the farther

bank. Jomyo killed 23 Minamoto warriors with only fourteen arrows. A Minamoto samurai, Ichirai Hoshi, came out along the crossbeams and challenged Jomyo. The two heroes shot arrows at each other for hours, but neither could bring the other down.

Jo no Hangaku *heroine*

She was the daughter of Jo no Sukemori, a *daimyo* in Echizen Province, who in 1201 rebelled against Yoriie, the second Minamoto shogun. Yoriie called Sasaki no Moritsuna from his retirement in a Buddhist temple to suppress the revolt. When Minamoto forces besieged her father's fortress-castle at Torizaka, Hangaku helped to defend him as vigorously as his male retainers. From the fortress walls she knocked arrows out of the air with her bow and hurled billets of wood down on the besiegers. After the enemy broke through the gates, she swung at them with a tree trunk. She was taken prisoner after an arrow wounded her. Her courage persuaded the shogun Yoriie to spare her life. He gave her in marriage to Yoshito no Asari, one of his vassals. She bore Asari several sons who perpetuated their mother's notable strength and bravery.

Josakei *sennin*

He often took the form of a crane. One day, while flying in his crane manifestation, he was struck by an arrow shot from the bow of Emperor Xuanzong (r. 713-56). With the arrow still lodged in his body, he returned to his house and, resuming his human form, withdrew the arrow and hung it on a wall, telling his disciples to give it to anyone who came by to claim it.

Juri *imagined creature*

Hokusai, in his *Manga,* drew a sketch of this half man, who has a complete head, but only a single arm and a lone leg. He also lacks a skeleton, and is held together only by skin and muscles.

Kakure Zato *legendary figure*

He is the blind man who conducts the spirits of the damned to the several realms of the Buddhist hell where they have been consigned by the tribunal of Emma-o, King of Hell. Artists show him as a bent and sightless old man, holding a gnarled staff.

Kamakura Gongoro Kagemasa *warrior*

At the age of sixteen, while Kagemasa (11th century) was helping Minamoto no Yoshiie suppress a revolt in the northern province of Mutsu, an enemy's arrow struck him in the eye. Without stopping to remove the arrow, Kagemasa killed his adversary with a well-aimed shaft from his own bow. Some reports say Kagemasa died from the wound soon after he dispatched his enemy. Others say that the arrow was embedded deep in the bone around his eye, and that his friend Miura Tametsugu had to press him hard against the ground, with a foot on his chest, in order to draw the arrow from the eye-socket.

Kaneko (also known as *Okane* and *Kugutsune*) *legendary strong woman*

One day, as Kaneko trudged about her business, she saw a temple's sacred white horse trotting down the street, dragging its tether in the dust. Kaneko (whose name means Iron Child) stopped it short, simply by planting one of her big feet on the trailing rope.

Kanja *comic character in a kyogen*

Kanja, the hero of a *kyogen* (originally one-act comic interludes, sometimes written today as full-length plays), is an unsophisticated country boy come to town. He serves in the household of a most citified master. Kanja can never find the articles his master wants. He fumbles and trips and stumbles about. Neither master nor servant can understand the other because Kanja speaks a country dialect, while the master uses a city man's elegant drawl. Amid all this ineptitude, Kanja never loses his good humor. At last, the master, won over by that dazzling, invincible smile, joins his servant in a very funny dance.

Kanmei *Ch. minister-of-state*

Kanmei had a very beautiful wife. Emperor Kang (r. 1078-53 BCE) coveted her so much that he cast Kanmei into prison and took the beautiful woman into his own household. On hearing of her sad fate, Kanmei killed himself. Not long after, his wife killed herself by jumping from a high tower where the emperor had taken her to enjoy the view. In her girdle, servants found a letter begging the king to bury her in the same grave with Kanmei. Emperor Kang denied her last request, and buried her in a separate grave, as far from Kanmei's as the little cemetery would permit. Soon a single tree rose from each grave. The two trees grew together, uniting roots, branches, and twigs, to make a verdant memorial. In their commingled crowns two birds lived, singing harmonious melodies. Ever since that time Kanmei and his loving wife have been regarded as models of conjugal fidelity.

Kannon-bosatsu *Buddhist deity*

This bodhisattva of compassion was originally an obscure local deity, worshipped in a single shrine on a little island off the coast of China. Somehow, during the course of several centuries, Chinese Buddhists managed to transfer her physical attributes to the male bodhisattva of kindness and mercy known in India as Avalokitesvara. She may also be a manifestation of this *bodhisattva,* born from his eye. In any event, from a fusion of cults and needs emerged a new and thoroughly feminine deity who quickly rose to a paramount position in both China and Japan. Chinese address her as Guanyin, Japanese as Kannon. Avalokitesvara, having served his generative purpose, was forgotten except in India.

The *Lotus Sutra* (which is about as long as the New Testament) promises that, when true believers pray to her, she will come to help them in any form that is needed. In Japan she is worshipped in at least 33 manifestations, 32 of which are incarnations of Shaka. Countless temples are dedicated to her. The most famous of these is the great Senso Temple in the Asakusa district of Tokyo, popularly known as

Kanroku

"Asakusa Kannon." Also belonging to her are "The Thirty-three Holy Places" where forethoughtful pilgrims go hoping to escape the torments of hell, in accordance with the promise of Emma-o, king of the Buddhist hell.

Kanroku *Buddhist scholar*

A Buddhist priest from the kingdom of Kudara in Korea, Kanroku came to Japan in 602 during the reign of Empress Suiko (r. 593-628). He brought many books concerned with scientific and magical matters. With their help he taught Japanese students the principles of mathematics and astronomy, and methods for calculating the calendrical cycles. Although Prince Shotoku, regent of Japan, feared the effect such occult studies might exert on the growth of Buddhism, he allowed Kanroku to remain because of the practical value of his work.

Kanshin *Ch. general-hero*

Chinese call him Han Xin. Despite many hardships, Kanshin grew up to be a fine youth. One day a town bully stopped him in the marketplace, challenging him either to fight or to crawl like a coward between his legs. Rather than fight a fellow of such low birth and mean deportment, Kanshin crawled between his legs. He remembered well, however, the braggart who tested his pride so publicly.

In manhood Kanshin became a general. He supported the rebellious peasant Koso (his commoner's name was Liu Bang) who, in 202 BCE, ascended the throne as Emperor Gaozu (r. 202-195 BCE), the founder of the Han dynasty. The new emperor restored to Kanshin his family's lands, and showered him with other honors. During those years of success, he sought out the bully who had humiliated him and employed the humbled man as a servant.

The upstart emperor's excesses so repelled the aristocratic Kanshin that he withdrew from the imperial court. Gaozu accused him of treason and condemned him to death, but revoked the decree before executioners obeyed it. Gaozu's principal wife and successor, the brutal Empress Lu, was not so agreeable: she executed faithful Kanshin in 194 BCE.

Chinese have honored Kanshin as one of The Three Heroes of the Early Han Dynasty, the others being Choryo and Chinpei. (The "Three Heroes of the Later Han Dynasty" are Chohi, Gentoku, and Kanyu.) The Japanese, too, adopted him in art—and in a boys' game called "Playing at Kanshin," in which one player crawls between the legs of several others, all lined up in a row. Other paintings show Kanshin on horseback, riding alone among mountains, while in the distance an imperial minister gallops toward him, bringing Emperor Gaozu's invitation to return to his high place at court.

Kappa *legendary creature*

A *kappa* is a river child, or water baby. It is vicious and dangerous, a thing to be feared. Although its natural home is water, it can live just as well on land. In either place, it will attack and devour human beings of any size—unless they are very polite to it. Descriptions of *kappa* vary, as do artists' representations. In general, a *kappa* has the face of a monkey and either the body of an elongated tortoise, a scaly lizard, or a four-year-old human child with scales all over its back. It has long limbs, much like a frog's, with webs between fingers and toes, or has paws and claws, much like a tiger's.

The top of its head is sunken, like a shallow bowl. And in that depression it carries the fluid that gives it strength—and which is also its weakness. On meeting a *kappa,* one bows. It returns the bow, the fluid spills from the reservoir in its head, and strength flows away with it. One has time to flee. Only when the *kappa* manages to slither back into a river or lake or some other source of nourishment can it renew the supply of the strength-giving fluid. As all *kappa* are inordinately fond of cucumbers, some fortunate people have been released from their clutches after bribing them with gifts of that watery vegetable. *Kappa* are strong and quick and slippery, and easily escape the usual traps or tricks to capture them. Rokusuke of Keyamura, the strongman who served Toyotomi Hideyoshi, claimed to have caught one. He has been depicted wrestling with a *kappa*.

Karako *Ch. children*

Bare-headed, androgynous children, wearing tunics and trousers, *karako* appear as companions to Jurojin and Hotei, or as participants in tales about the quick-thinking Shiba Onko.

Kariba-myojin *Buddhist lesser deity*

The renowned priest Kukai went from Kyoto to Mount Koya in Kii Province, looking for a secluded place where he could establish a monastery. On Koya's forested slopes he encountered the god of the mountain, accompanied by two hunting dogs. The deity welcomed Kukai, conducted him along the winding trails to a number of places, and promised to protect any holy institution the priest might want to construct.

In 816, Kukai built Kongobu Temple and its monastery on Mount Koya. Not forgetting the mountain god, Kukai worshipped him too, calling him Kariba-myojin, "the illustrious deity of the place of the hunt." He is the reason why dogs are permitted to live in the many monasteries and temples that have been built on Koya since that time. Pictures or statues of Kariba-myojin depict him with two dogs, one black and one white, crouched at his feet. Some people, however, insist that those dogs accompanied Priest Kukai when he first went to Mount Koya.

Karukaya-doshin

Karukaya-doshin *recluse*

Traditionally he is known as Kato no Saemon Shigeuji, a *daimyo* from Kyushu, who lived during the Ashikaga Period (1392-1573). One day, he saw, suddenly and shatteringly, the true nature of things when he looked at his principal wife and a concubine with his inner eye. They were all smiles and congenial chatter as they played a game of Go. Beneath the powdered flesh he saw their skulls, "ugly to the bone"; and on their heads the carefully arranged hair turned to writhing, hissing snakes. Recoiling in horror, Saemon fled. (A similar epiphany is credited to Ippen-shonin.)

Telling no one about his plans, he went to Mount Koya in Kii Province to spend the rest of his life in prayer. There he took the name Karukaya. The title *doshin,* "follower of the way," told of his hope for peace. His wife and small son, Ishidomaru, searched for him far and long. One day they met a hermit on the mountain path who, like Saemon, had a mole about his left eye. The hermit denied he was Saemon and turned away from mother and son, and from the world of vanity and illusions.

Karu no Daijin *hero-victim*

Karu no Daijin was sent on an embassy to China. The emperor of China, displeased with the gifts that Karu brought, commanded that he be tortured and disgraced. Executioners cut out his tongue, stripped him naked, painted his body with whitewash, making it look like a devil's, and forced him to stand in the palace garden while holding a lantern on his head. Heartless people of the court jeered and laughed, calling him "the lantern-bearing devil."

At home in Japan, Karu's son, Hitsu no Saisho Haruhira, worried about his father's long absence. In 656 Haruhira accompanied another embassy to China. There he could not find any trace of his father in the imperial capital. One day, while walking in the palace garden, he passed a whitened statue of a devil bearing a lantern. He did not see the image, but it saw him. Karu no Daijin groaned and moved to attract his son's attention. He bit a finger until it bled and, using his blood for ink, wrote on his naked belly a poem explaining to Haruhira who he was. The devoted son implored the emperor of China to set his father free, and to take him as the lantern bearer instead. Touched by this fine proof of filial piety, the emperor allowed both father and son to depart in peace.

Japanese artists depict Karu no Daijin as a whitewashed devil holding a lantern atop his head. He should not be confused with Ryutoki and Tentoki, the lantern-bearing demons in Todai Temple at Nara, whom he very much resembles. Haruhira himself, like most other Japanese models of filial piety, does not receive much attention.

Karyobinga *legendary creature*

According to some interpretations, this imaginary creature was derived from the *kimpurusha* of ancient India. There it was given the body of a human being, the face of a woman, and the legs of a crane. It wore long filmy robes and feathers similar to those of the *ho-o,* or phoenix. Buddhists saw in the *karyobinga* a symbol for their doctrine of reincarnation, inasmuch as it united both human and animal attributes. In Japan, moreover, a dance of the Heian Period (794-1185) was also called *karyobinga.* A performer, dressed in court robes but unmasked, wore token appendages suggesting the wings, plumage, and tail of a bird. He danced to the music of Chinese melodies from the Tang Period (618-907), played on cymbals, bells, gongs, and flutes.

Kasho *disciple of Shaka*

In India the name Kasyapa has been given to several different Buddhist divinities. In Japan (where it is rendered as Kasho), the name is applied primarily to the man who became one of Shaka's Ten Great Disciples. He joined Shaka soon after the master began to preach his new precepts, and stayed with him beyond the end. After Shaka entered Nirvana, Kasho became one of The Four Great Bhikshu, or teachers of the faith. Some commentators have said that Kasho is the one who introduced the *dharma chakra,* or the Wheel of the Law, as the prime symbol of Buddhism.

Kato no Kiyomasa *daimyo and general*

Hideyoshi (1536-98), a military ruler of Japan in the sixteenth century, chose Kiyomasa as one of the two commanding generals of the army he sent to conquer Korea. Kiyomasa proved to be so fierce a warrior and so able a strategist that Koreans called him "the demon general." After Hideyoshi's death in 1598, and the collapse of the war in Korea, Kiyomasa returned to Japan. As a reward for supporting Tokugawa Ieyasu (1542-1616) in the decisive battle of Sekigahara in 1600, he received the whole province of Higo as his domain. Kiyomasa died suddenly at Kumamoto, perhaps ordered poisoned by Ieyasu.

Artists have emphasized Kiyomasa's martial aspect and heroic deeds. They always give him bushy side-whiskers and a drooping mustache, and sometimes they add a heavy beard. Whether afoot or on horseback, he wears a long, black, conical helmet, sloping back from the brow, that is uniquely his own. His unusual crest offers another clue to identify him. It is a broad disk pierced by a small central hole. This *mon* appears on the front of his helmet, on his armored corselet, and as a design in the material of surcoats and overrobes.

Two events from his service in Korea serve as popular subjects for pictures. The first is the time he killed a fierce tiger with a three-pronged halberd, and one blade

broke off in the beast's body. The second refers to the last days the Japanese soldiers spent in Korea. Besieged by Chinese and Korean armies, and suffering from cold and hunger, the Japanese awaited the ships that would take them home. Kiyomasa, one cold evening, prayed to the gods for help. The next morning, at sunrise, the gods gave their answer for the whole army to see: the peak of Mount Fuji, all golden in the dawn's early light, lifted high above the clouds. Kiyomasa, touched with awe, removed his great helmet and bowed low to Japan's sacred mountain and to the gods beyond.

Katsugen *sennin*

He escaped from a sinking ship by walking on the stormy waters. Katsugen, as well as Ryotohin and Shoriken, two of the Eight Daoist Immortals, are all depicted mounted on fans that carry them over water.

Kenenshu *sorcerer*

This famous miracle worker looked like a young man, although in truth he was hundreds of years old. He could appear in many places at the same moment. Wild beasts protected him when he searched in fields and forests for herbs to make his magical potions. The flagons in which he kept those elixirs never went dry. He could also wreak instantaneous changes. Once, when he was being received by a Tang emperor, a beautiful young court lady sneered at certain peculiarities in Kenenshu's dress. He transformed her on the spot into a wrinkled old hag. Only when, with much wailing and shedding of tears, she had implored him for pardon, did he restore her to her original form. On another occasion, after an audience with the emperor, Kenenshu shared with the throngs of poor people outside the palace gate a purse filled with silver coins that the sovereign had given him. Like his flagons of potions, the money pouch too was inexhaustible.

Kibi Makibi (also known as *Makibi, Mabi,* and especially by his posthumous name, *Kibi-daijin*) *statesman and scholar*

Because of his abilities in Chinese learning and mathematics, Kibi was sent twice on embassies to the imperial court of China: first from 716-18, then again from 752-54. He is credited, probably too generously, with introducing to Japan the Chinese four-stringed lute or *pipa* (J. *biwa*), the chesslike game of *chi* (J. *go*), and the art of embroidery. He is also credited with the invention of the *katakana,* or the squared form, one of two syllabaries (the other being *hiragana*) of 47 simple characters derived from Chinese ideograms that is used (along with others) in writing Japanese. At home in Japan he served the imperial court as teacher and minister until he retired in 769.

In China, he played a game of *chi* for high stakes, despite his ignorance of its rules. If he lost, his head was forfeit; if he won, the Chinese emperor promised

to reveal the methods that court astronomers used to calculate the lunar calendar. His mathematical genius allowed him to work out the rules and win. On another occasion, Kibi deciphered a pied group of Chinese characters with the help of a spider that crawled among the characters showing him how to read the message.

Kidomaru *brigand*

Although born into a good family, Kidomaru—disputatious, unprincipled, and erratic in his behavior—became a highwayman. After a time he entered the service of Shutendoji, a debauched and repellent creature possessed of superhuman strength, until that thing was slain by Minamoto no Yorimitsu (also known as Raiko) and his Four Faithful Retainers. Undaunted, but bearing a profound grudge against Raiko for having killed Shutendoji (or for having spoken disparagingly of him), the brigand returned to his original profession as a highwayman. His desire to destroy Raiko persisted, leading him to conceal himself in a bullock's skin and stationing himself at a spot along the route Raiko had elected to take on his way to worship at a temple of Bishamon, one of the gods of good fortune. Raiko's retainers detected the would-be assassin in the animal hide, and Kidomaru was hacked to pieces. In another version of the brigand's end, he hid in the skin while Shutendoji was being dispatched. Discovered, he lost his head to Watanabe no Tsuna, one of the retainers.

Kiichi Hogan *warrior*

Minamoto no Yoshitsune (1159-89) entered the service of Kiichi Hogan, a noted military strategist. He seduced Katsura, the warlord's daughter. She revealed to him the secret hiding place where Hogan had concealed his personal copy of a rare and excellent treatise on military tactics. With that work in hand, Yoshitsune was able to copy its most important passages in his own diary. Hogan learned of the hero's deception, and of the dishonor done his house, when he observed that his daughter was pregnant. Bullied by her father, the girl revealed everything. The enraged parent, accompanied by a number of retainers, sought to slay Yoshitsune, but the hero handily killed many of his attackers and made his escape from Hogan's domain. The unfortunate Katsura died after giving birth to Yoshitsune's child.

Kikuchi Jaka *archer*

Kikuchi Jaka, a brave and skilled archer, confronted by a gigantic and threatening dragon, calmly loosed an arrow against the beast. The projectile struck a vital spot, the dragon fell dead—and an earthquake followed, but the damage wreaked is not recorded.

Kikujido *sennin*

The Zhou king Mu (1001-946 BCE) sentenced Kikujido to exile for having committed

a breach of court etiquette. Before Kikujido departed, the ruler taught him a Buddhist mantra. Repeating it would bring him good health and long life. In the valley filled with chrysanthemums to which he had been sent, Kikujido passed his time writing with his brush the Chinese characters for the Buddha's magic formula on the flowers' petals. When dew wet the ink on the petals, an elixir was formed that conferred health and longevity on anyone who drank it. Kikujido sometimes cast chrysanthemums bearing the written phrase into a river. People downstream who retrieved them received the power to resist hunger and thirst by merely possessing the blossoms, and gained everlasting youth by drinking the mixture of water and ink that dripped from them.

Kimi and Sawara *ghost story*

The painter Sawara and the maiden Kimi, residents of a small Japanese village, fell in love. But Sawara's desire to excel as a painter led him to eventually leave the village and settle in Kyoto, where he became the pupil of a renowned painter. During his absence, Kimi also left their village. When Sawara returned after a two-year sojourn in Kyoto, his love was not waiting for him. He soon married the daughter of a wealthy farmer of the district. Some years later, Sawara and Kimi met by chance, and he told her of his marriage. Sickened by this betrayal of their former love, she committed suicide by cutting her throat.

The painter, shocked by this event and realizing the depth and integrity of the dead woman's love for him, sought to honor her by painting a portrait of Kimi as he remembered her. On the night that the painting was finished, its subject came to life and gazed mournfully at Sawara. The unnerved painter donated the haunted painting to a local temple, where the recitations of the priests soon soothed Kimi's troubled spirit, and Sawara's portrait of his first love reverted to ink on paper.

Kinko *sennin*

Kinko was a learned Chinese sage who dove into a river, surfacing with a giant carp in his hands. He can be seen on the back of the fish, sometimes holding a scroll, as they ride waves of water.

Ki no Tsurayuki *aristocrat and poet*

One of Japan's greatest writers, Tsurayuki (ca. 883-905) is remembered for his poems and for the *Tosa Nikki*, or *Tosa Diary*, a short account of his experiences while returning to Heian Kyo after having served a term as governor of Tosa Province on Shikoku Island. Between 905 and 922 he helped to compile the *Kokin Wakushu*, or *Collection of Poems Ancient and New*, written by both Chinese and Japanese authors. *Tosa Nikki* was written about 936.

An incident described in the *Tosa Diary* tells of the magical powers that people of his time still attributed to mirrors. As his ship approached the coast of Honshu, near the shrine of Sumiyoshi not far from Osaka, an angry god unleashed a terrifying storm. Prayers, uttered aloud or written on strips of paper thrown into the winds, did not appease the deity. Neither did libations of sake nor other offerings from crew and passengers. Finally, Tsurayuki brought forth a bronze mirror and cast it into the sea. The sea became as smooth as the mirror's polished face.

Kintaro (also *Kaikomaru* and *Nintoki no Sakata*) *legendary hero*

One of the most popular of Japanese folk heroes, Kintaro, the "golden youth," is Japan's equivalent of a young Hercules. The lovechild of a soldier and a titled lady of Kyoto, named Yaegiri, Kintaro was raised in a mountain retreat by either his own mother, or by a *yamauba* (old woman of the mountain), a creature of a sometimes benevolent, sometimes demoniac nature. The chief of a band of *tengu* (rough, belligerent half-human, half-bird beings) may have instructed the child-hero in martial matters. If he was the boy's mentor, he would correspond in role to Chiron, the centaur-sage who instructed both Hercules and Achilles.

From birth, Kintaro was strong of body. As a child he exerted his territorial rights with *tengu,* bears, monkeys, and any wild animals he encountered. One of his most noted feats was his successful struggle to subdue a giant carp that lived in a river just under an imposing waterfall. (Asahina Saburo and Benkei, two other Japanese heroes of great strength, also performed the same feat as boys.)

One day Minamoto no Yorimitsu (944-1021), also known as Raiko, was passing through the mountainous area where Kintaro lived. Raiko and the members of his entourage were astonished to see the golden youth uproot a tall tree and use it as a bridge to cross a turbulent river. On the spot, Raiko enlisted the boy into his service. Thereafter, Kintaro served his master well, joining him in the slaying of both Shutendoji (a monstrous creature whom the outcast Kidomaru served) and the Earth Spider (another abominable denizen of the Japanese world of the unimaginable).

Kirin *fabulous animal*

The dragon, the phoenix, the 10,000-year tortoise (*minogame*), and the *kirin* are designated by the Chinese as The Four Divinely-Constituted Creatures, an identification that has persisted in Japanese mythology. The *kirin* has been described— and portrayed—in many ways. He may resemble a large stag in its general form; but combining the body of a musk deer with the tail of an ox, the forehead of a wolf, and the hoofs of a horse. Its skin is five colors—red, yellow, blue, white, and black; and it is yellow under the belly. It is twelve cubits high. Its voice is like the sound

of bells; it has a horn preceding out of the forehead, the tip of which is fleshy, but the female is without this defense. It is sometimes drawn surrounded with fire, and other times with clouds. Alternatively the *kirin* has a horse's body, is covered with fish scales, and has two horns bent backwards. Another version gives it a deer's body, a horse's legs and hoofs, a horse's or a dragon's head, an ox's or a lion's tail, a single horn, and is yellow. Or it has a crocodile's body, a lion's hindquarters, a bushy tail, and a deer's legs.

The *kirin* is represented in art according to the whim of the artist portraying him, thereby making identification sometimes impossible. However shown, the creature is the embodiment of intelligence, grace, and virtue. It is said that the *kirin* appears once every thousand years, and then only if the reigning sovereign is a person of rectitude. This legendary animal is so sensitive that, when he visits earth, he treads with such a light step that no living creature, not even the tiniest insect, is injured when he passes.

Kishibojin *Buddhist deity*

This female deity was originally a demon, and the mother of demons, and she fed on human flesh. However, by the grace of Buddha, from whose hand she received a pomegranate, symbolizing her enlightenment, she became a benevolent deity. In Japan she is associated with procreation. She is portrayed as a woman holding a baby and either a pomegranate, a peach, or a lotus bud.

Kiyo-hime *maiden and monster*

The maiden Kiyo-hime's childish infatuation with Anchin, a most holy monk of the Dojo Monastery, turned into a blazing and unrequited adult passion. One day Anchin hid from her under the monastery's great bell, but the supports holding it up broke and the bell fell, trapping the monk underneath. Unable to get to Anchin, Kiyo-hime raged outside the bell. Her whole aspect changed. She became a dragon with the head of the demon Hannya. (In another version, she changes herself into a dragon before entering the monastery.) Coiling around the bell, she breathed fire on it and beat it with a T-shaped magic stick. Gradually, the bell became molten metal; the monk's body was reduced to a pile of ashes; and Kiyo-hime vanished without a trace.

Kiyowara no Takenori *warrior*

In the course of a protracted engagement against enemy forces, Takenori had to lead a reconnaissance mission. His group came to the edge of a swamp, and Takenori, noting that a flock of wild geese flying over the swamp veered away from its center, correctly concluded that opposing forces were hidden in the reeds, ready to ambush his men. Rejoining his troops, Takenori led them to the opposite side of the swampy

area. There they fell on the concealed soldiers and, having taken them by surprise, routed them.

Koben (also known as *Myoe-shonin*) *Buddhist priest*

Koben (1173-1232) advocated the principles of Ryobu-shinto (which considered Shinto deities to be local manifestations of universal Buddhist gods). He served at Todai Temple in Nara and then retired to a temple on Mount Takao, west of Kyoto. In 1230 the artist Enichibo Jonin painted a picture of Koben, and thereby created one of the first genuinely personal portraits ever made in Japan. He depicted Koben, lean and ascetic, with shaven face and scalp, clad in the dark gray robes of a priest, sitting cross-legged in the wide fork of a pine tree. His wooden clogs rest on the ground beside the tree; a rosary and a small incense pot hang from branches of a nearby sapling. The eyes of the saintly priest are closed as, with hands folded in his lap, he meditates in this earthly paradise.

Kobito ("little person; dwarf") *mythical creature*

Unique to the island of Hokkaido, *kobito* dwelled there before the Ainu arrived. Some of them were less than 25 centimeters in stature.

Kobo-daishi (also known as *Kukai*) *Buddhist prelate*

In both deed and legend Kobo-dashi (774-835) is one of the most eminent priests in Japan's history. Known as Kukai during his lifetime, he received the posthumous name Kobo-daishi, or Spreader of the Law Great Teacher, from Emperor Go-Daigo in 921. When he was nineteen, Kukai became a priest after many tests and austerities. Neither the rigors of fasts nor the intrusions of demons could turn him from the Way. Once, when sea monsters assailed him, a star came down from heaven to help. He placed it in his mouth, blew out its shining rays—mingled with magical incantations—upon the evil creatures, and they fled.

From 804 to 806 he studied in China, learning the rituals and precepts of Esoteric Buddhism. He introduced the new faith to Japan, founding the Shingon sect. Tradition also credits him with having invented a number of other less mystical contributions. Among these are the *hiragana*, or the cursive form, one of two syllabaries (the other being *katakana*) of 47 simple characters derived from more complex Chinese ideographs (which represent the 47 sounds required for speaking and writing the Japanese language); and the *Iroha Uta*—the ingenious poem that uses each of those forty-seven sounds only once and, in doing so, presents the quintessential message of Buddhism that all Japanese learn when first they go to school. In 810 Kukai became abbot of To Temple in Kyoto. While there he conjured out of existence a plague of wasps, and with magical chants straightened a leaning

pagoda. In 816 he founded Kongobu Temple on Mount Koya in Kii Province, which became one of the important centers of the Shingon sect. Kariba-myo, the Shinto god of the mountain, helped him choose the site. Kukai died there about a year after predicting the day of his death. The box holding his body floated through the air from the monastery to the cemetery some distance away. Rising from the coffin, he conducted his own funeral ceremonies. Many years later, a successor abbot opened Kukai's tomb to find an uncorrupted body, rotted vestments, and a beard that reached his feet. In that tomb, legend declares, Kobo-daishi's unchanging body awaits the coming of Miroku-bosatsu, the Future Buddha.

Many other marvelous deeds are associated with Kukai. In China, before the emperor himself, he painted a holy picture using five brushes at the same time, holding one in each hand and foot, and the fifth in his mouth. Also while in China, he threw a sacred object into the sea, praying that it would drift to a place in need of the Buddha's teachings. One account identifies the object as an image of Kukai himself. It drifted to Kawasaki in Japan, where three centuries later countrymen built Heigen Temple at Kawasaki to receive that image.

Kukai ended a long drought by saying powerful words while waving about Amagoi-ken, a sword with a dragon coiled around it. Near the mountain pass at Sengen, he thirsted, struck a rock with his staff, and called forth a spring. He cured people by prayer and touch, without need for medicines. He stopped the wailing of Yonakaishi, the Night-crying Rock, at Kanaya on the Tokaido highway. He merely laid his hand on a rock near Nikko, and ever since that time Tekake-ishi, the Hand-touched Stone, has protected people who touch it against all kinds of evils.

He could inscribe characters on rocks, wood, and paper, as well as air and water. Once, Monju-bosatsu, disguised as a boy, said he could not believe that Kukai could write in the air or on water. When the priest proved that he could do both, the boy transformed himself into a dragon, revealing his true identity.

Kodama Kura no Jo *naval commander*

Kodama Kura no Jo, although an excellent naval officer, professed to have reservations about certain Buddhist doctrines and practices. Those around him looked on him as an agnostic. During the course of a naval expedition, his ship was threatened by a violent storm and was on the point of foundering. Faced with this calamity, the reluctant Buddhist took from his sash a Buddhist talisman, given to him by a friend, and hurled it into the angry sea. Miraculously, the waters suddenly became still and the storm ended. Forsaking his naval career, Kodama Kura no Jo entered a Buddhist monastery.

Kokin *sennin*

As a young woman, she rejected the love of the *sennin* Koshohei, but fell in love with a mortal, Kume, who was betrothed of Omume. As a result, she lost her magical powers. Kokin and Kume settled down in Edo, but poverty plagued them. Her father, taking pity on her condition, arranged for Kume to be apprenticed to a teacher of the magic arts. The neophyte proved to be an apt pupil. The rejected Omume tried desperately to contact Kume. Exercising his newly acquired powers, Kume created a double of himself, and sent his clone to commit suicide with Omume. Thereby freed of any earthly attachments, Kume became a *sennin* and Kokin regained her former attributes.

Kokuri-baba *sorceress*

She lived near a mountain temple, stole offerings made to the temple's gods, stripped corpses of their clothing, and, on occasion, ate dead bodies.

Kokuzo-bosatsu *Buddhist divinity*

Known in Sanskrit as Akasagarbha, "Essence of the Void," this deity lives in the space above the earth, and is regarded as one of the personifications of wisdom. The bodhisattva has appeared on earth at least once before, as a female saint. For this reason, most representations of Kokuro are female, although some are male. She may be seated on a lotus blossom throne, or standing on a lotus blossom pedestal. She wears a headdress of lotus leaves, and has a halo. The *urna,* or third eye, appears on her brow. She wears the celestial scarf about her body.

Komei *Ch. counselor and general*

Komei was three meters tall, and had a mind to match his height. In the year 207 he was living as a hermit in a mountain retreat when the ambitious hero-general Gentoku came to him, through snow and cold, seeking his assistance in pacifying the war-torn land. Although Komei left his refuge reluctantly, he spent the next thirteen years helping Gentoku become Emperor Zhaolie Ti, founder of the short-lived minor Han dynasty. He reigned from 220 until 222. The Japanese call him Shoretsutei.

Komei used both magic and sense in subduing rebellious tribes in the south as well as dissident nobles in the north. Because he led his army across great distances with amazing speed, people said that he made mechanical horses and oxen to draw his supply wagons. When his soldiers lacked arrows, he put straw dummies in boats, and sent them out on a river in the morning mist. While the rowers lay low, the enemy riddled those silent figures with arrows. The rowers then took the boats back to Komei's camp, along with a fresh supply of arrows for his men.

Kompira Shrine (also known as *Koanhira Shrine*) *place*

One of the most popular shrines in Japan, it is located about halfway up the side of Mount Zozu, Elephant-head Mountain, beside the town of Kotohira, on Shikoku Island. The hill, 521 meters high, is covered with a dense forest of cedar, pine, and camphor, and other tall trees. The shrine itself is reached only after the pilgrim has mounted the famed and steep "approach of a thousand stairs," about a kilometer long.

Komuso *mendicant*

Originally the term meant "rush-mat priest," but during the Tokugawa Period (1615-1868) it was extended to include anyone who wandered about in public places wearing over his head a rather deep basket-like hat plaited from rushes. Such a covering hid the face of the wearer, supposedly going on a pilgrimage to some shrine or temple to atone for evil deeds against other mortals or punitive deities. Often, as they walked along or rested beside the road, they would play mournful tunes on a bamboo flute or *shakuhachi*. Spies, informers, fugitives, and clandestine lovers also took to hiding their identities under those basket hats. During the eighteenth century, many *ronin* who, for reasons of conscience, adopted certain teachings of the Nichiren sect of Buddhism called themselves *komuso*. Such *ronin* were regarded as being above the law, and were not bothered by local officials.

Konohana Sakuya-hime (also known as *Fuji-hime*) *Shinto deity*

Her name means "princess who makes flowers bloom," and she is a daughter of the god of mountains, Oyamatsumi, himself a son of Izanagi and Izanami, the ancestral deities. She dwelled in a luminous cloud hovering above the peak of Mount Fuji, guarding the sacred mountain against evil influences and impure people. In that guise she is known as Sengen or Asama. Worshippers built a shrine to her at Fuji's very summit in the year 806. Artists usually portray her as a beautiful, smiling young woman, wearing a wide-brimmed hat made of plaited straw, and carrying flowers of some kind. Often the flowers are wisteria blossoms, known to Japanese as *fuji*. On rare occasions, she is depicted holding in her arms the infant Jimmu, the first emperor of Japan, one of her grandsons.

Kose no Kanaoka *painter and poet*

When Emperor Uda (r. 888-97) commissioned a screen for Ninna Temple in Kyoto, Kanaoka painted a horse so lifelike that, at night, it stepped down from the screen and went to graze on vegetables growing in nearby fields. Farmers complained of thieves to the temple's abbot and priests. They were mystified, until early one morning, a monk saw the muddy hoofs and sweating coat of the horse just returned to the

screen. They settled the matter easily by painting out the horse's eyes. After that, he stayed at home. Another wandering horse that stepped out of a screen Kanaoka painted for the imperial palace was kept in its place when the artist, with brush and pigments, tethered it to a hitching peg.

Koshibe no Sugaru (also known as *Chisakobe Sugaru*) *"god-catcher"*

One day, just as Emperor Yuryaku (r. 457-79) was about to set forth from his palace, a tremendous thunderstorm began. He ordered Sugaru, a courtier, to go out and stop the bothersome storm by capturing Raijin, the god of thunder. Sugaru flung himself on his horse and, without thinking, rode furiously after the thunder god. He galloped as far as the top of Mount Abe, all the while shouting at Raijin to stop the racket. Raijin did not pay him the slightest heed, and went roaring along, flattening crops, shattering trees, terrifying people and animals alike. Suddenly, Sugaru thought of Kannon, a bodhisattva of compassion, and addressed a prayer for help to her. Immediately she delivered Raijin to him, bound and gagged. Sugaru stuffed the helpless thunder-hurler into a saddlebag, hauled him back to the palace, and deposited him at the emperor's feet.

Koshi-doshi *sennin*

Koshi-doshi collected all sorts of extraordinary things. One was a tiny turtle, no bigger than a thumbnail, which he housed in a small box. Another was a full-grown monkey, about the size of a frog. Koshi-doshi kept this pet on a silken leash, and allowed him to eat leftover foods in his own rice bowl. The greatest marvel of all was a shuttlecock in the shape of a rooster. The *sennin* would place this mechanical wonder beside his head at night, and the cock's crowing would awaken him at dawn.

Koso (also known as *Gaozu, Liu Bang*, and *Ryubi*) *Ch. emperor*

Known as Liu Bang in his youth, he was a lowly peasant who, with daring, a shrewd mind, and the support of friends—The Three Heroes of the Early Han Dynasty—rose to become emperor of China and the founder of the Han dynasty. He reigned from 206 to 195 BCE, and is known to the Chinese as Gaozu (which the Japanese translate as Koso).

Artists have depicted Koso killing a serpent (which, sometimes, they have transmuted into a dragon) that attacked one of his retainers. Occasionally they show him holding the magical mirror acquired in 206 BCE, when he captured the capital city of the kingdom of Jin. This enchanted mirror reflected both the thoughts and the faces of people gazing into it. The king of Jin used it to discover the causes of bodily diseases among his people, as well as disaffections of the spirit.

Koxinga

Koxinga (*Kokusenya*) *Ch. warlord and patriot*

Kokusenya (1624-62) was the oldest son of a Chinese father and a Japanese mother. The father, either a wealthy merchant or a successful pirate, supported the beleaguered Ming dynasty (1368-1644) in its efforts to withstand Manchu hordes sweeping in from the north. His first-born son, on reaching manhood, also served the Ming as warrior and privateer. For his loyalty he received the rank of count and the name Guo Shengyei. Japanese transliterated that as Kokusenya, and Jesuit missionaries wrote it as Koxinga.

In 1660, as the Ming empire disintegrated under the Manchu assault, Koxinga withdrew from mainland China with an army of 25,000 men. He took the island of Formosa from the Dutch, who had controlled it for 40 years. The following year, after repelling a counterattack by the Dutch, he set himself up as king of Formosa. Assuming the airs and arrogances of a tyrant, he demanded tribute from the governor-general of the Philippine Islands. In reply the Spaniards and Filipinos massacred all Chinese living in Manila. Koxinga was organizing a conquistador's expedition against the Philippines when he died in 1662.

Kudan *fabulous animal*

The *kudan* is usually represented as a creature with the body of a bull and the head of a human being. Two horns, and sometimes a third eye, are in the forehead. Six additional eyes, three on each flank, are often found. The *kudan* cannot tell a lie.

Kudara no Kawanari (also known as *Kudara no Asomi*) *artist*

When a young man belonging to his household disappeared, under mysterious circumstances, Kawanari painted from memory such an excellent likeness of the youth that the sharp-eyed police soon found him. A palace architect, who was a good friend to Kawanari, once played a practical joke on him. Kawanari could not rest until he evened the score. After much preparation, he invited the architect to visit him at home. The friend arrived, was greeted politely, ushered into the master's parlor, and almost died of shock at what he saw lying on the floor—the rotting body of a dead man. As the architect turned to run, Kawanari stepped from his hiding place and indicated that the decaying corpse was only a painting.

Kuganosuke and Hinadori *lovers*

Soga no Emishi, the supreme chief of the imperial clans, and his son, Inuka, were attempting to unify all of Japan under the rule of the House of Soga. Kuganosuke and Hinadori were members of powerful clans, and they became pawns in the complex power games being played by the Soga. Their respective clans were locked in a bitter dispute over certain lands; the two lovers were therefore not permitted

to marry. Kuganosuke was ordered to court, ostensibly as an honored vassal, but in reality as a hostage for his clan's good behavior. Hinadori was to be given as a concubine to Inuka, thus binding the Soga and her clan more closely. The two lovers met secretly and committed suicide.

Kume *sennin*

One day while flying above the earth, he saw a maiden washing clothes in a river below. Overcome with lust, he lost his magician's powers and fell to the ground.

Kutsugen *Ch. scholar-statesman*

A man of great erudition, he served his lord, a prince of Chu, loyally and honestly. Jealous rivals at court, however, filled the prince's mind with such lies that he dismissed Kutsugen. The unhappy counselor wrote a poem to his lord, asking for justice. The prince did not reply. Kutsugen drowned himself in the Miluo River. Later the people of Chu deified his spirit and worshiped him as a god of water.

Kuya-shonin *Buddhist missionary-priest*

Kuya (903-72) is known as "the Saint of the Common People" because, unlike almost everyone else in positions of authority, he concerned himself with their physical and spiritual welfare. He traveled throughout Honshu, not only preaching the power of Buddha, but also advising rural groups in such matters as opening new roads, building bridges, digging wells, and making other improvements to their neighborhoods. As he worked among the people, he showed them the way to salvation by reciting the prayer *"Namu Amida Butsu"* ("Hail Amida Buddha.")

Kuya was in Kyoto in 951 when a pestilence broke out. He carved a large statue of Eleven-headed Kannon, a bodhisattva of compassion, mounted it on a platform, and had it carried through the city's streets. Because of Kannon's intercession, the god of plagues ended the pestilence immediately. Kuya and his disciples then built Rokuhara-mitsu Temple to receive the wonder-working image. It is still worshiped there. When that labor was done, Kuya went back to the northern provinces to be a missionary.

Kyoshinkun *sage*

Conceived after his mother dreamed that a *ho-o*, or phoenix, placed a pearl in the palm of her hand, Kyoshinkun grew up to be a pleasure-loving youth, until one day he was filled with remorse while watching a doe lick the dead body of a fawn he had shot with an arrow. He became an ascetic, learned in Daoist matters. As a provincial governor, he was a model of benevolence, giving gold he had made from base metals to the poor, and causing water to issue forth from rocks. As a protective talisman against fire and flood, he painted a pine tree on the wall of a house. At the age of

136, he was taken into paradise with all the members of his household, including his dog and rooster. (Ryuan's dog and rooster also joined their master in paradise.)

Kyoyu and Sofu *ascetics*

They are famous examples of philosophers who completely rejected the things of this world. When Emperor Yao (r. in legendary times) offered to abdicate in favor of Kyoyu, then an imperial counselor, the horrified man rushed to a river, where he washed his ears, thus symbolically cleansing them of the infection of ambition. Following Kyoyu's example, his friend Sofu washed his own ears and then his eyes. Noticing his ox drinking water downstream, Sofu hastened to pull the beast away from what he considered to be polluted water. Kyoyo usually drank water from the palm of his hand. A kindly person gave him a gourd to drink from, but Kyoyu hung it in a tree near his hut. The wind passing through the gourd made such a pleasant sound that he, being a true ascetic, disposed of it.

Lady Yodogimi (1569-1615) *wife of Toyotomi Hideyoshi*

She perished with her son Hideyori and thousands of samurai and retainers loyal to them, in the siege and holocaust set in motion by Tokugawa Ieyasu that destroyed their great castle at Osaka.

Laozi *(Roshi) "founder" of Daoism*

Most data about Laozi lack credibility. His mother conceived him when she saw a falling star, and bore him 81 years later (in 1321 BCE), by caesarian section performed beneath a plum tree. He came into this world already old and wise, with a gray beard and hair; big eyes in a wrinkled face; unevenly spaced teeth in a wide mouth; a nose with two ridges; ten toes on each foot (but the usual five fingers, although each hand was marked with ten deep lines); ears so big that each had three auditory canals; and a head with a deep depression in its top.

Chinese scholars maintained that he lived about the end of the sixth century BCE (not in the fourteenth, as his birthdate implies), and that he was employed as a keeper of records in Luoyang, the capital city of the Eastern Zhou (771-256 BCE) dynasty. While there he wrote a treatise entitled *Daodejing* (*The Way and Power Classic*), from which the teachings of Daoism have been drawn. He foresaw the fall of the Zhou dynasty in time to leave Luoyang before the debacle. Eventually, after wandering about, he arrived at the Hangu pass, near China's western boundary. Laozi gave the

scrolls of his treatise to Yin Xi (J. Inki), guardian of the gate at Hangu. The world owes thanks to Yin Xii for having preserved and preached the Way of the Dao.

Leaving Hangu, Laozi rode off into the west, the realm of the dead, never to be seen again. Some disciples said that he went on the back of an ox, others that he sat in a cart drawn by two black oxen. In any event, many artists have portrayed him sitting on an ox, and either reading from a scroll or carrying one in his hand. Other artists have depicted him giving his treatise to Yin Xi, or talking about philosophical matters with his near-contemporaries, Confucius and Shaka. A reclining ox, resting after having taken Laozi on the last journey to the west, is his emblem. But it must not be confused with the ox of Sugawara no Michizane, nor with that of Ninomiya Sontoku.

Lion Dance (*shishimai*)

This ancient dance is similar to the Chinese performance, still seen at New Year festivals, from which it is derived, but is tamer and simpler in all respects. In Japan, until about the late seventeenth century, only one man performed the *shishimai,* wearing a big mask representing a lion's face and mane. A drummer who beat out the cadence and collected alms from generous bystanders accompanied him. During the eighteenth century, a larger troupe of entertainers was involved: two men danced—one inside the ferocious head, the other at the comical tail end; and several musicians, playing flutes, gongs, and drums, accompanied them. By the nineteenth century, however, the *shishimai* lost its appeal for adults and had become little more than a spectacle for entertaining children.

Li Bai (*Rihaku*) *Ch. poet*

This great Chinese poet (699-762) and carouser has been a favorite among Japan's literati ever since they first read his poems. Both the poems and incidents from his hedonistic life have served as themes for Japanese writers and artists. Many painters and engravers, for example, depict him standing below the famous waterfall of Xianglu, in the Lu mountains, conveying in their pictures the same mood that Li Bai captured in his famous poem on that subject.

Other artists depict the Eight Immortals of the Wine Cup, a drinking club consisting of Li Bai and convivial friends; or Li Bai (cold sober) being honored at court by Emperor Xuanzong (r. 1426-36) and his beautiful concubine, Yang Guifei. The most poignant incident of all was the ultimate one when, joyously drunk as usual, Li Bai leaned too far over the side of his skiff, trying to touch the reflection of the moon on the surface of the river. He fell over and drowned.

Living Ghost (*ikiryo*) *superstition*

A woman can hate someone so much that, even while she is alive, her spirit can leave her body, and possess and torment the person she hates. The woman whose spirit sets out on this evil mission may not be aware that this is happening. A living ghost of this sort is indeed a thing to be feared, because it can kill its victim, and can strike at any time of day or night. (On the other hand, the evil spirit of a dead woman—which is called a *shiryo*, or dead ghost—can appear only at night.)

The most famous example of a malevolent living ghost is presented in *Genji monogatari* (*The Tale of Genji*). It is the envious spirit of Lady Rokujo, mistress to the youthful Genji. She is so jealous of the other women in his life that, without her conscious self being aware of it, her living spirit takes possession of several competitors over the course of many years, and kills them off, one after the other. Even after Lady Rokujo has died, her dead spirit returns from the other world, for one last time, to kill Lady Murasaki, Genji's greatest love and the heroine of the novel.

Lizard *medicinal creature*

The sleek and sinuous lizard is regarded as an erotic animal, and therefore a symbol of sexual activity. Many a boastful man declared his prime interest by wearing a netsuke (miniature carving in wood, ivory, or other material) in the shape of a lizard. Others, less fortunate (or perhaps merely older), hoped to restore virility by drinking a potion prepared from the ashes of lizards. All drug stores sold small earthenware jars in different sizes, containing varying amounts of this invaluable elixir. Then, lizard ashes; today, Viagra.

Lobster *symbol of longevity and potency*

As its back is curved, like that of a very old man or woman, the lobster is an obvious emblem for long life. When it is cooked, the shell turns bright red, the color of life, and therefore the lobster's hue suggests vitality and virility. For these reasons, a lobster, alive or cooked, makes an excellent gift during the New Year season. For some people, however, it has erotic connotations during any season.

Long Nu *Buddhist minor deity*

One day, as he swam about in the form of a fish, a son of Ryujin, Dragon King of the sea, was caught in a fisherman's net. Seeing this from her vantage above, Kannon, a bodhisattva of compassion, ordered one of her handmaidens to hasten down to earth and free the captive fish. Ryujin chose Long Nu, a daughter of the rescued dragon prince, to take a luminous pearl to Kannon, as a token of the family's gratitude. Long Nu was so captivated by Kannon's beauty and grace that she begged to be allowed to stay with her forever, and to learn from her the message of the Lord

Buddha. That is how Long Nu, once a dragon child, became a disciple of Kannon. Artists depict her standing at Kannon's right side, holding in both hands the glowing pearl she brought from her grandfather as a gift.

Lotus

Buddhist artists in Japan employed the lotus symbol in every possible way. They opened the great fleshy blossom itself, making it a throne or a pedestal for an image of a Buddha or a bodhisattva. Spirits of the holy dead, who have become *buddhas* and now dwell in the Western Paradise of Amida, sit on lotus blossoms growing in the lake at Sukhavati. So, also, do the *buddhas* who have come before, as well as the *buddhas* yet to come. Buddhas, bodhisattva, their acolytes and disciples, *rakans,* and sanctified spirits in lesser categories, may hold a lotus blossom in one or two hands. Shaka's last act, as he lay dying, was to twirl a small lotus flower held between his thumb and forefinger. As a result, the blossom serves as an emblem of the *chakra,* the Wheel of the Law. Lotus plants, shown whole or in part—flowers, leaves, roots, seeds, and seedpods—serve as motifs for decorations, designs, and crests.

In general, lotus blossoms are white, although a less common variant produces pink flowers. Throughout the Orient, where white is the hue of mourning, the white lotus is an emblem of death as well as of salvation. In pictures of paradise, however, lotus blossoms may be depicted in all colors.

Magatama *ornament*

Magatama were fashioned from polished stones, clay, or semiprecious minerals, such as jadeite, nephrite, agate, jasper, serpentine, chrysoprase, and other materials generally green or blue in color. Sovereigns and nobles wore the ornaments as insignia of rank during ancient times in Japan, Korea, and parts of northern China. Most *magatama* were comma-shaped, but some are notched, toothed, legged, or even made to resemble pregnant women or animals. They range in length from one to eight centimeters. A hole bored through one end allowed these jewels to be strung on cords and arranged as simple pendants, in clusters, or in long necklaces.

Magic *traditional beliefs*

The Japanese, too, believe that magic words, rituals, charms, and places may help in predicting the course of events or in affecting their conclusions. In ancient times, they practiced both white magic and black. Magical rituals performed in temples and shrines comfort uneasy souls and sometimes serve as the only therapy for ailing bodies. The Japanese recognize lucky and unlucky directions, hours, days, months, years, ages, agents, events, portents, and creatures. They fear vengeful spirits, both human and animal, which might take possession of human beings; and they try to exorcise those spirits with magical rites, incantations, or talismans. To help them in times of stress they utter words invested with magical power or avoid others that,

because of their sounds, are fraught with danger. They put up images and symbols in their homes, to keep misfortunes from entering. The gods around them—great or small, always watching, always demanding the respect that must be shown them— have to be placated with offerings, prayers, and magical spells.

A Shinto priest may bless a house before construction ends, in some cases even before it began. At New Year's, the very decorations fastened to the entrance gate—the *kadomatsu* made of small branches of bamboo and pine and a length of plaited rice straw known as *shimenawa*—are intended to bring happiness and longevity to both residents and visitors. Children are protected from spirits of diseases that wander up and down the streets in search of victims by a pair of small *zori*, or straw sandals, hung on the main door of a family's house. This signifies that the children are safely at home, guarded by all the agencies their parents invoked against demons of sickness. This display of the small *zori* in the home must not be confused with those immense *warazi* that hang on the inner walls of a *niomon*, the entrance gate to a great temple. Those tremendous sandals, plaited from thick ropes, are offerings to the gods from companies of pilgrims, who are asking that their feet and ankles be strengthened for the long wearying journeys they must take through life.

Mako *sennin*

She served as an assistant to her brother, Oen, and his pupil, Saikyo, both of whom were astrologers. She is shown as a young woman, dressed in a mugwort-leaf costume, and bearing a blossom-laden bough on her shoulder, scattering grains of rice. Those are transformed into cinnabar on the ground in front of Oen and Saikyo. She should not be confused with Mojo, another *sennin,* who is depicted as a maiden bearing pine and peach boughs.

Mandala (J. *mandara*) *mythico-religious symbol*

The literal meaning, in the Sanskrit context, is "platform" or "altar." The term has been extended to imply "perfect completeness." Some historians believe that a work of Buddhist art called a mandala is a representation of the Buddhist paradise as imagined by a visionary still living in this world. Others maintain that it is a kind of visual aid used by priests of Esoteric Buddhism as a magic representation of the Buddha world, which can instruct them in the doctrines and mysteries of their sect. Still other interpreters regard it as a union of deities disposed in a circle, or in some other arrangement, in which the grouping is a symbol of the universe. Some cultural anthropologists declare that (because all peoples throughout the world have made mandala-like symbols) it is an elaboration on the concept of the sun wheel, the symbol of the Solar King, and therefore of the Circle of Life, first imagined and

first drawn, in its simplest form, by primitive people at the dawn of their recognition of the sun's role as the source of life. Jungian psychologists think of it as being a pictorial representation symbolizing the wholeness and unity of the psyche.

Mandalas can be made of any medium. Most are painted (on wood, stucco, silk, or paper), embroidered or woven. A few are sculptured, either in high relief or as statues in the round carefully arranged in a prescribed order. In wealthy temples some mandalas are fashioned of metal, notably of brass, gilded brass, bronze, or gold. Some mandala paintings or embroideries are huge, covering an entire temple, while others are small enough to hold in one hand. Of paramount importance in Esoteric Buddhism are the Mandala of the Womb World and the Mandala of the Diamond World.

In Japan, the mandala has been an important form of religious art since the sixth century, when Buddhist missionaries introduced their rituals and their panoply. Most of the earlier mandalas made in Japan are crowded with figures—of people, animals, plants, buildings, clouds, mountain peaks, demons, and divinities—either copied from nature or created in imagination. Others are studded with geometric designs of greatest intricacy and mesmerizing detail. With this richness they reflect the exuberance of their Indian or Chinese models.

Whatever they may include, they are pictures telling a story, and communicating a message to the initiate if not to the casual visitor. In most mandalas the principal deity is Dainichi-nyorai, and all other divinities, whatever their name or rank, are but manifestations of him. Yet, in some mandalas, *buddhas* other than Dainichi, or deities of lesser rank than a buddha may be placed at the center, surrounded by their subordinate manifestations.

The Mandalas of the Two Worlds, usually done in paintings on silk, are representations of two different mandalas. One is hung on the left wall, the other on the right, in the lecture hall of a temple belonging to the Shingon sect of Esoteric Buddhism. The paired paintings are known as the Mandala of the Womb World and the Mandala of the Diamond World. They are visual aids for the instruction of novices and for contemplation by initiates.

The Womb World (also known in English as the Material World or the Matrix World) is called *Taizoku* in Japanese. The information presented in the Mandala of the Womb World is derived from the *Dainichi-kyo,* or *Vairocana Sutra,* composed in western India about the seventh century. The mandala itself is a complex arrangement of symbols that present the sutra's message. At the very center of this square mandala is a circular arrangement of eight images enclosed within a rectangular border. Each

of the eight images sits on a lotus petal, and each image is enclosed within a circle. Four are Buddhas and four are bodhisattva. At the heart of the circle they form sits a larger image of Dainichi-nyorai.

Mandorla

Not to be confused with a mandala, a mandorla is the almond-shaped device that many of Asia's artists placed behind an image of a deity as a physical representation of his or her spirit power. Some mandorlas were made to resemble flames. Others bore designs suggesting flowers, angels, water, or small images of *bodhisattvas* or *buddhas*. The idea of representing the nimbus started among Zoroastrian artists in Persia and spread from there to both East and West.

Manga *artists' sketches*

Nowadays, *manga* refers to a cartoon, a comic strip, or a book, often featuring post-atomic motorcycle gangs and giant robots. During the Tokugawa Period (1603-1868) it denoted a casual sketch or drawing. *Manga* were made at random as fancy prompted, or as a record of an artist's impressions. Such a quick study could be a representation of a natural thing, such as a rock or a horse, or of some imagined creature, such as the sickle weasel. It could also be a caricature intended to be comical or satirical.

Mannentake *mushroom*

This edible mushroom is known to mycologists as *Polyporus lucidus*. In Japan and China it is an emblem of happiness and longevity. It is often represented in art by itself or in association with other such symbols.

Manyoshu *anthology of poems*

An anthology of Japanese poems, the *Manyoshu* was compiled in about 750, under the direction of Tachibana no Moroe (684-757), a court noble and adviser to emperors. The *Manyoshu—The Collection of Ten Thousand Leaves,* or, as some people prefer, *The Collection of Myriad Leaves*—is considered to be the first and best anthology of poetry ever made in Japan. The works of about 500 men and women, numbering exactly 4,496 poems, are included.

Manzai *dance*

In olden times, this kind of fertility dance was performed only at the imperial court. After the Nara Period (645-794) commoners added it to their less inhibited forms of antic and phallic ritual. By the eighteenth century it had become the property of street performers, usually traveling in pairs, who made it a special presentation during New Year festivities. By that time *manzai,* or *banzai* (meaning "ten thousand years"), had become the favored New Year's greeting among city folk. The principal member of the pair, called *tayu* or *manzai,* danced with a fan in hand, endlessly chanting the

word of greeting. His partner, called *saizo,* tapped out the rhythms on a *tsuzumi,* a small hand drum shaped like an hourglass, held on his shoulder. Sometimes these performers wore fertility masks, thereby recalling the original purpose of the dance.

Maple *art motif*

More than twenty species of maples grow in Japan. Screen and scroll painters, as well as netsuke (miniature sculptures in wood, ivory, and other materials) sculptors, usually only depicted maple leaves in the autumn, already fallen or clinging to branches. A few artists showed groups of people sitting under the bending boughs of a many-colored tree, warming bottles of sake at a fire made from its leaves, while beyond, partly hidden in the foliage, a soft-eyed deer gazes out at them.

Marishi-ten *deity*

This is the Japanese version of the Hindu divinity Marichi Deva, one of the daughters of Brahma. In India she is worshipped as the goddess of light. She has three faces, all fierce and warlike. The one at the right is given the snout and tusks of a boar. She is also frequently shown standing on the back of a boar. Both face and mount indicate that she is an Asian variant of Europe's dread and potent sow-goddess—a manifestation on earth of the White Goddess, the moon as queen of heaven and therefore of death. Some artists in Japan and China have given Marishi-ten the dragon as an emblem, sometimes alone or with the boar. Others have placed her on a lotus chariot being drawn by seven harnessed pigs. Her home is said to be one of the stars in the constellation Westerners call the Great Bear, or Ursa Major. The king of the Great Dipper, who is her husband, and their nine sons live quite a distance away, in Sagittarius.

Marubashi Chuya *rebel*

A samurai from Dewa, Marubashi rebelled against the Tokugawa government. He wanted revenge because Ieyasu, the first Tokugawa shogun, had beheaded his father in 1615 for opposing the dictator's rise to power.

The police of Ietsuna (1641-80), the fourth Tokugawa shogun, soon caught Chuya in Edo. They chained him in a cage, built around one of the fierce *nio,* or guardian kings, standing beside the entrance gate to a temple. Furious with shame and frustration, Chuya tried to escape, kicking out bars, hurling pieces of splintered wood at bystanders. He did not escape. The shogun's police crucified him at the execution grounds in Shinagawa.

Masks

In ancient times, Japan's shamans, hunters, and warriors, like their analogues in other lands, wore masks in magico-religious rituals. Secular uses for masks were developed

only relatively recently, probably during the Asuka Period (552-645). The oldest masks now surviving in Japan date from the sixth century. The oldest theatrical masks in the world are those used in Gigaku dances performed in 752 at Todai Temple in Nara, during the "eye-opening" ceremonies for the Great Buddha. About 170 of those masks are still preserved in the Shoso-in of Todai Temple. Many of those relics, with their exaggeratedly long noses, resemble the phallic masks worn by performers in pagan Greece and Rome.

Today, the greatest range of types is seen in Noh masks. Good Noh masks, meant to endure, were made from hard woods carefully carved by master craftsmen. Depending on the effect desired, the faces could be left untreated, or could be tinted, painted, lacquered, and given additional features, such as horns and gilded fangs for demons, mustaches for dashing heroes, and wispy beards for old men. Masks for performers of Gagaku dances at the imperial court were made of brocades, sometimes stiffened with heavy fabric or pieces of thin wood to give the effect of beaks. Warriors' masks were fashioned from metal, painted black on the outside and red within. Masks for commoners were carved from wood or molded in papier-mâché. People presenting offerings of food or drink to superiors or to the gods wore masks made of cloth, called *zomen*. Such a covering prevented the bearer's breath from defiling the offering.

Masuda Munesuke *armorer*

In 1155 Emperor Konoe (r. 1142-55) became seriously ill. The cause of his sickness, according to the court diviner, Abe no Seimei, was an old white fox with nine tails that had taken the guise of one of the emperor's concubines. Abe's powerful incantations drove the evil fox-spirit from the palace into poisonous lands around Mount Nasu. Two expert bowmen, Miura no Suke and Kazusa no Suke, tried in vain to kill the creature. Finally in a dream the gods answered their prayers for help; both must wear armor fashioned by Masuda Munesuke (fl.1150-90) of Izumo, and one of their horses must be bridled with a bit forged by Munesuke.

They did exactly as the gods instructed and rid the country of that evil spirit. By command of the emperor, Munesuke took Myochin as his professional name. Under this celebrated name, more than 150 of his descendants prospered for almost 700 years. Helmets, corselets, sword guards, and other kinds of warriors' accouterment bearing their distinguished signatures are highly prized. The oldest surviving sword guards made in iron were fashioned by members of this family.

Matano no Goro *warrior and wrestler*

Kagehisa, a samurai's son, grew up to be a wrestler as well as a warrior. For wrestling

matches he took the name Matano no Goro. One day a comrade-in-arms, Kawazu no Saburo Sukeyasu, defeated Matano in a match between the two. Matano's chagrin soon grew into hatred, until he could think of nothing more than taking revenge on Sukeyasu. He became part of a conspiracy that ended with the murder of Sukeyasu, although a confederate, Kudo Saemon Suketsune, delivered the deathblow. Thus started the chain of cause and effect that in Japan is known as the Soga Brother's Revenge.

When the Genpei War began in 1180—it ended in 1185—Matano fought for the Taira. In 1181, just before the battle of Ishibashiyama, Matano saved the life of his commander, Oba no Kagechika, by foiling a night attack on the sleeping Taira soldiers. In the following year, however, Oba and Matano, outnumbered by the Minamoto, were captured and beheaded.

Usually Matano is shown wrestling in the fateful match with Kawazu no Sukeyasu, or throwing a huge rock at Sanada no Yoichi, a warrior of the Minamoto during their night attack on the Taira camp at Ishibashiyama.

Matoi *insignia*

Today the term is associated with the insignia of the different societies of firemen that were organized during the Edo Period (1615-1868) in the bigger Japanese cities. Each fraternity had its own standard bearing long black and white leather strips on the end of a pole. Each fraternity's *matoi* differed from those of the others in the design of the finial and the decorations painted on it and on the strips of leather. During a fire, the *matoi* bearer would stand on the roof of a burning building, encouraging his comrades, with flourishes of the insignia, to keep sending up more buckets of water. Many a standard-bearer lost his life, and his *matoi,* in such displays of bravery.

Matsumura-so *priest*

Matsumura-so, a Shinto priest, while on a visit to Kyoto to obtain funds for restoring his decaying shrine, helped to free the unhappy spirit of a woman who, about 300 years before, had been thrown into a well to drown. Ever since then, a poison dragon living in the well had forced her to lure people who came to draw water into its depths. Matsumura-so saved the woman's spirit by rescuing her relics, if not her bones, from her watery grave. For this kindness, she rewarded him. In return for the bronze mirror that was the most important of her possessions, one of her descendants—the reigning shogun, Ashikaga no Yoshimasa (1436-73)—presented Matsumura with enough money to repair his shrine. Moreover, because the woman's spirit warned him in time, Matsumura-so left his temporary abode in Kyoto just before a violent storm blew it down.

Matsuo Kotei *"human pillar"*

Matsuo, a page to Taira no Kiyomori (1118-1181), offered his own life as sacrifice to an angry dragon, in place of the 30 lives the diviners said the dragon demanded in return for ending his attacks on the foundations of an artificial island that Kiyomori's engineers were trying to construct. According to one account, the diviners sealed Matsuo Kotei, still alive, in a stone coffin, and lowered it into the waters as the basis for the new island. Another account says that the youth, mounted on his horse, rode out from shore until both disappeared in the depths of the sea. However, he died and his sacrifice pleased the dragon. In 1173 Kiyomori's engineers completed the island, called Tsukushima, near the site of the present city of Kobe.

Matsushita Zenni *exemplary mother*

This woman, in order to set a good example to her second son, Hojo no Tokiyori, performed many humble tasks, such as mending the torn paper in the shoji of her palace apartments. Although the boy protested her behavior, the man remembered his mother's teachings. When he became civil ruler of Japan, from 1246 to 1263, Tokiyori governed with a strong sense of economy.

Matsuura no Sayo-hime *loving wife*

Emperor Senka (r. 536-39) ordered one of his generals, Otomo no Sadehiko, to lead an army against the kingdom of Shiragi, in order to "improve matters" in the Korean state, whose ruler was being inhospitable to Japanese merchants who had settled there. When the Japanese expedition sailed from Matsuura in Hizen Province, Sayo-hime, Sadehiko's wife, grieved over her husband's departure. She climbed to the top of the steep cliffs above Matsu Bay and stood there for a long time, waving her obi, weeping until her sleeve was wet with tears. The gods took pity on her and changed her into stone. To this day it is known as *bofuseki,* "weeping-wife stone."

Mikoshi *portable shrine*

A *mikoshi* is a movable and temporary abode for the *mitama-shiro,* the physical manifestation on earth of the gentler spirit of a Shinto deity. The *mikoshi* is occupied by the *mitama-shiro* only when the deity goes on a progress among the people, as on festival occasions. In general, deities emerge from their sanctums twice a year during purification rituals held for the people. Most *mikoshi* are similar to palanquins in shape and size. They are sturdily built and beautifully decorated. Some *mikoshi* are set on wheeled platforms, so that they can be pulled over long distances. *Mikoshi* without wheels are mounted on platforms that are borne by men on their shoulders. The burden may draw blood from their shoulders and exhaust their bodies, but the excitement of the experience—the sharing of the duty with so many other

bearers, the sound of their rhythmic chanting—frequently pushes them into a state of exaltation.

Mikuni Kojoro *heroine of a ghost story*

Mikuni is one of the victims in a drama entitled *Shisanni monogatari (The Tale of Shisanni)*. A certain lord in Kii had so angered a witch woman known as Shisanni that she resolved to ruin him and his whole family. She made him fall in love with Mikuni Kojoro, a prostitute. In his mad infatuation with "Little Harlot," the lord bought her freedom. Shisanni's hatred, however, prevented the lovers from ever meeting again. The witch sent a monster to kill Kojoro on her way to the palace of her lord. Afterward, the monster assumed the appearance of the murdered girl. In short order, the monster caused the death of the infatuated nobleman.

Military Banners *war implements*

Toward the end of the fifteenth century, commanders of troops began using long upright banners as rallying points in battle and on the march. The banners' colors, crests, ideograms, and other designs, made them conspicuous battle standards—and motifs for artists to use. Military aides, heralds, and mounted messengers actually wore small banners fluttering from poles attached to harnesses strapped to their backs. Those smaller insignia were called *sashimono*. As innumerable *ukiyo-e* (popular pictures) depicting city scenes reveal, civilians soon adopted the idea of the *hatajirushi,* and employed them for advertising Kabuki plays and other kinds of theatrical entertainment, teahouses, whorehouses, restaurants, noodleshops, secular and religious festivals, and ultimately, merchants' shops, stores, and special sales.

Million Prayers *Buddhist rite*

The name of this ceremony, *hyakumanben,* meaning "million prayers," is not to be interpreted literally. The ritual itself is an ingenious Japanese variation on the Tibetan prayer wheel. The purpose of a prayer wheel, as in this ritual, is to achieve as many expressions of an invocation as possible. Japan's expeditious (and inexpensive) method employs many people at one time, instead of one wheel revolving most of the time. In a temple courtyard all the petitioners, usually arranged in a rough circle, hold fast to a single rope. In effect, the rope is like the strand of a rosary, and the people are like the beads strung on it. Off to one side, a priest beats rhythmically on a huge gong or a great drum. With each signal everyone participating in the ceremony utters the prescribed prayer and passes his portion of the rope to a neighbor. Whenever a participant tires and drops from the line, a new worshipper takes his or her place. Other temples hang a huge rosary on the walls and, at the sound of the signal, devotees move from one bead to the next.

Minamoto no Mitsunaka

Minamoto no Mitsunaka *warrior*

One day, while hunting, Minamoto no Mitsunaka (912-97), a son of Tsunemoto and father of Yoritomo, went to sleep under a tree and dreamed that the daughter of Ryujin, the Dragon King, asked him to protect her from a huge snake. He promised to help her and, in gratitude, she presented him with a perfect horse. After spending eight days in prayer at the famous Suminoe shrine, Mitsunaka went forth and slew the demonic creature with an arrow. Some representations show him killing a demon in the forest rather than the symbolic snake.

Minamoto no Sanetomo *poet; Yoritomo's younger son; third Minamoto shogun*

When the decadent Yoriie was exiled to Izu in 1203, Minamoto no Sanetomo (1192-1219) succeeded him as the family's figurehead. Sometime between 1206 and 1213, Sanetomo read the *Manyoshu*. The thousands of poems in the ancient anthology profoundly affected both his philosophy and his style. He wrote more than 700 poems, mostly *waka*, known collectively as *Kinkai Wakushu*, or *Poetical Works*, of Sanetomo. They are considered to be among the literary treasures of Japan. Early in 1219, his nephew Kugyo, who thought that Sanetomo had stolen his place in the line of succession, murdered him. Kugyo fled, but was tracked down and killed. It was also reported that he not only beheaded his uncle, but also ran away with the bleeding prize clutched in his hand.

Minamoto no Tametomo *warrior; uncle of Yoritomo*

Minamoto no Tametomo (1139-79) was the eighth son of Tameyoshi. He was a ferocious youth, who inspired exaggeration as much as he provoked violence. At the age of fifteen, according to legend, he was 2.1 meters tall, and had the round eyes of a rhinoceros, with two pupils in each. His left arm was ten centimeters longer than the right because he used it to draw his bow. The bow itself, 2.4 meters long, required the strength of three ordinary men to bend it. His arrows were made in proportion, being 1.5 meters long in the shaft and tipped with iron points as large as the spearheads used by regular soldiers. Having the strength of 50 men, Tametomo could bend that great bow until the string was eighteen hands' length away from the arrow's tip.

Tametamo's life was filled with violence, heroic feats, exile, and mutilation— the tendons and muscles of his bow-bending arm were cut by order of Taira no Kiyomori, but they regenerated. He sank an enemy warship sent against him with one arrow, and then he went home, set fire to his house, and, sitting amid the flames, committed seppuku (ritual suicide). Legend has it that he did not die, but escaped to the Ryukyu Islands, where he became the king. On his way there he visited Oni

Island, the abode of ogres and demons, and subdued them. Nothing could kill a man so strong. A crocodile saved him from drowning after a shipwreck. When he fell down a cliff in the Ryukyus that was several hundred meters high, he got up and walked away without even a scratch. In works of art he is usually portrayed shooting a huge arrow against the ships of his enemies, or chastising the demons of Oni Island. Bakin's novel about Tametomo, entitled *Yumikari Tsuko,* or *Bent Bow,* is a collection of older legends and many new ones. In 1875 one of the first banknotes issued by the Meiji government bore his picture.

Minamoto no Tameyoshi *warrior; grandfather of Yoritomo*

Much of Minamoto no Tameyoshi's life (1096-1156) was spent quelling or inciting violence. In 1123, as the imperial government's official in charge of police, he was able to momentarily suppress the militant monks who lived in temples on Mount Hiei, thereby stopping their predatory raids on Kyoto. In 1156, during the Hogen War that brought the Taira family to power, Tameyoshi backed the losing faction. The new Emperor Go-Shirakawa (r. 1156-58) ordered his execution.

Minamoto no Tsunemoto *warrior*

During most of his life (894-961), Minamoto no Tsunemoto served in military campaigns against several rebellious clans and perennially unfriendly barbarians in the northern part of Honshu. In 961 he was awarded the name Minamoto for himself and his descendants. In the autumn of 932, when a huge stag that showed several signs of being a demon—notably, red eyes and a large mouth set with sharp, daggerlike teeth—prepared to leap from the roof of the imperial palace onto the sovereign, Tsunemoto shot it down with a single arrow fitted with a turnip-shaped head.

Minamoto no Yoriie *warrior; Yoritomo's elder son; second Minamoto shogun*

Minamoto no Yoriie (1182-1204) was seventeen years old when his all-powerful father died. He seems to have been a spoiled and vicious youth, able enough in the martial arts, but corrupt as a person. Recognizing Yoriie's defects, his mother, the formidable Hojo Masako, and her father, the Hojo Tokimasa, kept control of the government. When Yoriie reached his twentieth year, Emperor Tsuchimikado (r. 1199-1210) conferred on him the title of shogun, but his grandfather forced Yoriie to abdicate as shogun. The nominal head of the civil government, Tokimasa compelled Yoriie to become a monk and exiled him to a mountain village in central Izu. In the following year, his agents murdered Yoriie.

Minamoto no Yorimasa *warrior* and *poet*

Minamoto no Yorimasa (1106-80) in 1153 showed his skill with bow and arrow when, with a single shot, he rid the imperial palace of the *nue.* This monster—which had the

head of a monkey, the claws of a tiger, the back of a badger, and a tail like a snake with a head at its tip—had been flying above the palace for several nights, shrieking horribly. Court physicians declared that it was the cause of Emperor Konoe's serious illness. After Yorimasa's arrow brought the *nue* to the ground, his retainer, Ii no Hayata Tadazumi, rushed forward to kill the loathsome creature. Even as he thrust his sword into its body, the snake's head at the end of its tail bit Tadazumi's cap.

In 1180, in revolt against a Taira emperor, Yorimasa and 300 supporters established themselves on the eastern bank of the Uji River, south of Kyoto. In the bloody battle that followed, men died by the hundreds, some for the Taira, more for the Minamoto. Two of Yorimasa's four sons perished in the fray. Once again the Taira triumphed. When he saw that defeat was certain, Yorimasa, bleeding from many wounds, withdrew to the Byodo-in, the beautiful temple nearby. There he committed seppuku (ritual suicide). According to legend, his spirit issued forth in the shapes of fireflies burning with spite.

Minamoto no Yorimitsu (also known as Raiko) *warrior-hero*

Minamoto no Yorimitsu (944-1021), the first-born son of Mitsunaka, seems to have been an able warrior who, with his companions in arms, rid Kyoto and the neighboring countryside of thieves, bandits, and other lawbreakers. Raiko rid the imperial palace of a dangerous demon, this time in the shape of a fox. The fox spirit made his home in the thick cypress-bark roof of the palace, until Yorimitsu shot it with his bow and arrow. Yorimitsu also had a dream in which a beautiful foreign lady appeared to him. She introduced herself as Shoka, daughter of China's famous archer Yoyuki, and explained that she came to him because her father had taught her the secrets of his skill, which she wished to convey to worthy men still living in this world. When Raiko awoke, he found beside him a bow and arrows he had never seen before.

In bringing law and order to the capital city and its neighboring provinces, Yorimitsu was helped by the *shiten,* or Four Faithful Retainers: Watanabe no Tsuna, Sakata no Kintoki, Usui no Sadamichi, and Urabe no Sentake. The five companions met with many adventures. Among the most famous of these were their meeting with Kintoki's mother; the tracking down of the monster Shutendoji; the destruction of Tsuchigumo, the Earth Spider; and their escape from the robber Kidomaru.

Minamoto no Yorinobu *warrior*

The fifth son of Mitsunaka, Minamoto no Yorinobu (968-1048) led an expedition against the fortified town of Chiba in Shimosa Province. He succeeded in this campaign because he discovered a shallow passage across an estuary near Chiba, which his warriors used to reach the town from an unexpected direction. Inasmuch as

he always exercised the calm good sense that enabled him to make that observation, he is regarded as one of the *hyaku shoden,* or hundred gods of wisdom, who are invoked whenever a man needs help in overcoming obstacles. Usually he is depicted studying the approach to Chiba from a hill overlooking the estuary.

Minamoto no Yoritomo *warrior; creator of shogunal form of government*

In 1159, at the age of thirteen, Minamoto no Yoritomo (1147-99), third son of Yoshitomo, inherited the rank and responsibilities of head of the Minamoto clan when his father and both elder brothers died in their rebellion against the Taira. Although Yoritomo was taken prisoner, Taira no Kiyomori spared the boy's life and banished him to remote Izu. While growing into manhood, Yoritomo improved his skills as a warrior and controller of men, becoming the head of his dispersed clan in fact as well as in name. He also suborned Hojo Tokimasa, one of the wardens the Taira had set to watch him, and seduced Tokimasa's daughter Masako. In 1180, when Minamoto no Yorimasa and others rebelled against the Taira in Kyoto, Yoritomo responded to his uncle's call. He directed the campaign that, by 1185, drove the Taira clan from power and all but annihilated them. With the Taira out of the way, he turned on his own relatives and allies, destroying those who did not offer him absolute obedience. By 1189 Yoritomo was master of Japan. In 1190, he received the title of superintendent of Japan's 66 provinces as testimony to that power. In 1192 Emperor Go-Toba bestowed on him the relatively modest position and title of *sei-i-tai-shogun,* or great general sent against barbarians. Other men before him had born the title of shogun on occasion, but Yoritomo was the first one who established an effective bureaucracy to manage the country in accordance with his dictates. He created so efficient and pervasive an administration that, with only occasional adjustments, it sustained his successors in the office of shogun as the real rulers of Japan for the 676 years that followed.

Many facts drawn from his life, and a number of legends, became motifs for screens, picture scrolls, prints, netsuke (miniature sculptures of wood, ivory, and other materials), statues, novels, songs, and plays. A popular tale recounts the time when, fleeing from defeat in an early battle against the Taira, Yoritomo hid from pursuers in the hollow trunk of a great tree. One of the hunters, Taira no Kagetoki, saved Yoritomo's life when, having seen him in the hollow tree, he shoved his bow into the space above, scaring two wood doves from their nest. The doves enabled Kagetoki to assure his companions that no one was hiding in the tree.

In 1199, while Yoritomo attended rituals celebrating the opening of a new bridge across the Sagami River, a sudden thunderstorm burst overhead. Loud claps

of thunder (or, as some people said, the spirits of Minamoto no Yoshitsune and all other relatives he had murdered) so frightened Yoritomo's horse that it jumped into the river and drowned. Regarding this as a bad omen, priests and soothsayers recommended all kinds of measures to prevent misfortune, including changing the name of the river. Despite these precautions, Yoritomo died that same year of injuries received when another horse reared suddenly and threw him to the ground.

Minamoto no Yoriyoshi (995-1082) *warrior*

In the summer of 1057 Minamoto no Yoriyoshi's army suffered many hardships because of a persistent drought. On the seventh day of thirst, after praying to Kannon of the Thousand Hands, Yoriyoshi struck a rock with his bow. Clear water gushed forth. (The same story is told about Yoriyoshi's son Yoshiie, and about a Chinese general, Quangli).

Minamoto no Yoshiie *warrior-hero*

Minamoto no Yoshiie (1041-1108) was a master of the martial arts and served his emperors well. He was unsurpassed as a warrior. He could send an arrow though six thicknesses of armor. His bow, striking a rock, brought forth water for his thirsting soldiers. His daring often rescued himself, his father, or companions from the attacks of enemies.

One day during a military campaign, Yoshiie observed that a flight of wild geese, just about to settle to earth, suddenly veered and flew off again. Suspecting that they had noticed a group of soldiers lying in ambush, he divided his forces and surprised the hiding enemy from the rear. He is often represented on horseback, riding among fallen cherry blossoms before the barrier gate of Nakano. No doubt his greatest feat was the taming of the Edo River, which flows between the provinces of Shimosa and Edo. On his way to a campaign in northern Honshu, he had to cross the river in a boat. The current was so swift, the rapids so strong, that the vessel almost overturned. Yoshiie threw his armor into the water. The river-god accepted the sacrifice. The torrent was quieted.

Minamoto no Yoshimitsu *warrior, musician*

A younger brother of Yoshiie, Minamoto no Yoshimitsu (1056-1127) was a celebrated musician. Artists often depicted him playing an instrument, usually the *sho,* or thirteen-reed mouth organ.

Minamoto no Yoshinaka *warrior, cousin of Yoritomo*

In 1184 Minamoto no Yoshinaka (1154-840), leader of the Minamoto clan in Shinano Province, and his army took possession of Kyoto after the Taira had abandoned it. The former Emperor Go-Shirakawa welcomed him as a rescuer. Success on such a

scale turned Yoshinaka's head. He ignored orders from Yoritomo, managing the war from Kamakura; he affronted the former Emperor; he did not control his troops as they abused the people of Kyoto; he took for himself the position of shogun; and he enjoyed too fully the rewards of victory. Yoritomo sent his brother Noriyori and his half-brother Yoshitsune, with an army of 60,000 men, to chastise Yoshinaka. They set on him twice, and in the second battle they killed him.

Minamoto no Yoshitomo *warrior; father of Yoritomo*

Minamoto no Yoshitomo lived from 1123-60. During the Hogen War in 1156, he sided with the Taira. By doing so he fought against other members of his family, most notably his own father, Tameyoshi. When Taira no Kiyomori ended the rebellion and condemned its leaders to death, Yoshitomo pleaded for his father's life. Kiyomori replied that if Yoshitomo did not arrange to behead his father, then Taira executioners would do the job for him. Yoshitomo asked one of his own retainers to kill his father rather than allowing him to be publicly executed.

Four years later Yoshitomo joined other disgruntled warriors in another attempt to overthrow Kiyomori, but this insurrection was also quickly suppressed. Yoshitomo fled eastward, accompanied by his three eldest sons. He sought refuge in Owari Province, with Osada no Shoji Tadamune, his father-in-law. Instead of sheltering Yoshitomo, Tadamune contrived to assassinate him. Yoshitomo fathered nine sons, of whom the third, Yoritomo, and the youngest, Yoshitsune, are the most famous of all Minamoto.

Minamoto no Yoshitsune *warrior-hero and son-avenger*

Of all Japan's heroes, Minamoto no Yoshitsune (1159-89) is the best beloved and most romanticized. The Japanese delight in him not only for his exploits, whether military, amatory, or utterly imaginary, but also because they recognize in his story the implacable influences that led to his tragic death.

Yoshitsune, the last of Yoshitomo's nine sons, was born in the year before the Taira clan assassinated his father for rebelling against their hegemony. Taira no Kiyomori spared the lives of Yoshitsune and his two elder brothers on condition that they become monks. From his sixth to sixteenth year the boy lived in a monastery on Mount Kuruma, about twelve kilometers north of Kyoto. Planning even then to avenge his father's murder, he learned the martial arts from mercenary warriors employed by the temple. (Legend has transformed these warriors into *tengu,* fantastic creatures resembling birds.) Occasionally, Yoshitsune stole away from the temple to make forbidden excursions into Kyoto. During one of those sorties, as he sauntered along the Fifth Avenue Bridge across the Kamo River, Benkei Musashibo demanded

his long sword. But in a brief fight, Yoshitsune defeated the aggressor. Benkei, recognizing the youth's quality, fell to his knees and swore eternal fealty.

At the age of sixteen, Yoshitsune escaped from Mount Kuruma. He and Benkei walked to Honshu's northeastern corner to seek the protection of Fujiwara no Hidehira, an ancient *daimyo* who lived beyond the reach of the Taira. Biding their time, Yoshitsune and Benkei lived there for five years. In 1180, responding to Minamoto no Yoritomo's call for help in his rebellion, they rode down from the north to join him, bringing 2,000 mounted warriors. Only then did Yoshitsune meet his half-brother Yoritomo.

Yoshitsune soon proved his mettle as warrior and leader. The most daring of Minamoto generals, and the most popular, he helped to destory the Taira in the three great battles fought at Ichinotani, Yashima, and Dannoura (1185) that brought the savage war between the Minamoto and the Taira (known as the Genpei War) to an end. But, in gaining success and fame, he drew on himself the suspicions of his half-brother. Yoritomo turned on Yoshitsune, determined to destroy him.

For almost five years Yoshitsune and a few loyal retainers—Benkei foremost among them—were hunted men. They found sanctuary once again with Fujiwara no Hidehira in the far north. As long as he lived he safeguarded them. As soon as Hidehira died, his sons, fearing Yoritomo's enmity, slaughtered Yoshitsune and his little band. As proof of their allegiance, the Fujiwara sent Yoshitsune's head, pickled in sake, to Yoritomo in Kamakura.

Yoshitsune's dramatic life afforded many themes for artists in all media. Since samurai sons chose him for a model, his image is placed among those exhibited for Boy's Day festivals. Favorite events from his childhood and youth include: the flight of his mother from Kyoto with him in her arms, while his two elder brothers struggle beside her through deep snow; the *tengu* of Mount Kuruma teaching him the martial arts; and his meeting with Benkei Musashibo on Kyoto's Fifth Avenue Bridge. His military prowess is depicted as he leads a cavalry charge down the steep cliff of Hiyodorigoe to surprise the Taira from the rear at the battle of Inchinotani; as he directs the Minamoto attack on the Taira at Yashima while a typhoon rages; and as he makes his famous "eight-boat leap" at the naval engagement of Dannoura.

Most touching of all are the incidents during his flight from Yoritomo's assassin. These include the time when he and his companions were sailing across the Inland Sea, and the spirits of the Taira dead rose from the waters to assail them but were routed by Benkei's prayers; Yoshitsune's poignant parting from his mistress Shizuka at Yoshino; the moment when Yoshitsune and Benkei come upon the beautiful

blossoming plum tree at Amagasaki; the ordeal when Yoshitsune and his comrades, disguised as *yamabushi* and porters, must pass the police barrier at Ataka that is alerted to arrest them; and the deaths of the band in their household at Takadachi, when they are cut down by Fujiwara soldiers.

Miroku-bosatsu *Buddhist deity*

This bodhisattva, or enlightened being, will be the next incarnation of the Buddha. He is known in Sanskrit as Maitreya, in Japanese as Miroku. "The Future Buddha" is now waiting in the Heaven of Happy Gods, and will be born again in the five thousandth year after Shaka entered Nirvana. His task is to bring all worthy beings to the state of enlightenment.

Miroku usually can be recognized by his meditative posture. Rather than sitting cross-legged in the lotus seat, as do Shaka and other bodhisattva from eastern countries, he sits on a high throne, with his right leg raised so that its foot rests on the left knee, his right elbow rests on the right knee, and the middle finger of the right hand touches his chin. (Buddhists refer to this position as "the half-lotus seat." Japanese call it *hanka*, or "half-locked.") To complete his image, either a great halo rises behind his head or a splendid mandorla seems to float behind him.

Mirrors *symbolic objects*

In the centuries before glass was introduced to Japan, mirrors were made of flat stones or cast metal, highly polished on one side to give a reflecting surface, and usually much decorated on the reverse. In primitive times, these *kagami* were treasured more for the magical properties attributed to them than for any utilitarian purpose. They were the possessions of divinities, sovereigns, and shamans; and at first only a few members of a single family, the Ishikoridome, knew the art of making them. Even today the mirror is a symbol of supernatural power to believers in Shinto—in the sanctuaries of many shrines, the only visible sacred object is a polished mirror, the physical manifestation of the deity being honored there. Because they were rare and magical, mirrors are the subjects of many myths, legends, and works of art. The most famous of all is the Yata no Kagami, one of the three sacred treasures of the imperial family.

Mirror of Hell *folkore object*

This magical mirror can be used by Emma-o, King of Hell, to learn more about the past life of a spirit being judged by his tribunal. As Emma-o and his colleagues look into this truthful mirror, it reveals all crimes and evil deeds ever committed by that spirit while he or she lived, in exactly the order they were committed.

Mirume

Mirume *demon*

Rightly named "All-seeing Eye," Mirume is a female monster, one of the entourage whose members help Emma-o, King of Hell, in judging the spirits of the dead.

Mitsukuni (also known as *Otake Taro*) *fearless retainer*

After Taira no Masakado died in his failed rebellion in 940, his daughter Takiyasha continued to live in the ruins of the family's castle-fortress. The spirits of soldiers killed in that doomed uprising haunted the place. Whenever they appeared, Mitsukuni, faithful to the family of his lord, would defy the ghosts with looks, gestures, and execrations until they departed. A painting done by Kuniyoshi shows him sitting quietly, not at all bothered by a skeleton standing beside him.

Mitsume-kozo *legendary creature*

Mitsume-kozo's portrait appears in Hokusai's *Manga*. In it, he has three eyes, the extra one being placed in the middle of his forehead. He is sitting patiently before an oculist, who is adjusting for him a set of spectacles with three lenses, all arranged in a very smart black frame. Mitsume-kozo was sent by the King of Demons to kill Minamoto no Yorimitsu, while he lay sick with a fever. Despite those three eyes, Mistume bungled the job, and Yorimitsu wounded him with his trusty sword. When Yorimitsu and his Four Faithful Retainers followed Mitsume-kozo's bloody trail, it led them straight to the cavern of Tsuchigumo, the dreaded Earth Spider.

Miura no Yoshiaki *warrior-hero*

Yoshiaki (1093-1181), when he was close to ninety years old, fought for the Minamoto against the Taira. When Taira forces besieged his stronghold, preventing him from going to the aid of Yoritomo, Yoshiaki rode against the enemy without armor or weapons, and died under a hail of arrows. His example encouraged his few soldiers to fight on, but it did not save them from death when the Taira burned down their fortress. Artists usually show Yoshiaki in the company of other heroic or interesting old men, such as Saito Sanemori and Urashima Taro.

Miyagino and Shinobu *folktale*

Miyagino and her sister, Shinobu, were left penniless as children when Shiga Ganshichi murdered their father. Miyagino sold herself to one of the "entertainers" houses in the Yoshiwara quarter in Edo, while her sister remained in the countryside, working for a poor family. Some years later, Shinobu, now grown to young womanhood, went to Edo to see her sister, but when she saw the elegantly attired Miyagino, she was so taken aback by her sister's magnificence that she could not speak her own name. Instead, she was forced to trace her name's ideographs in the dust on the floor. She and her sister later sought out her father's murderer, challenged him to combat, and

slew him—Miyagino welding a halberd, Shinobu employing a sling.

Miyajima *island and Shinto shrine*

The island lies in the Inland Sea, a few kilometers southwest of Hiroshima. Taira no Kiyomori and his family developed it into one of the principal Shinto shrines. Rising from the shoreline of a cove on the island's northwest coast, the complex of shrines is dedicated to the three daughters of Susano-o, the sea god, who are called Tagori-hime, Takitsu-hime, and Itsukushima-hime. The structures along the shore rest on piles, so that at high tide the sea flows beneath the buildings. Here, too, standing in the sea, is the most famous *torii* (free-standing arch) in the world. It was first erected in 1674 and has been rebuilt several times since. It is 13.5 meters high and 9.4 meters wide at the crossbeams. To the Japanese, Miyajima is one of their *sankei,* or three most beautiful views in the land.

Miyamoto Musashi *celebrated swordsman*

Shichinosuke (1583-1647) was his boyhood name, and he was the son of Yoshioka Tarozaemon, a famous short-sword fencer. Despite his father's example and instruction, Shichinosuke grew up to be an unruly youth. At the age of fifteen he ran away from home. After a number of adventures, including the killing of a fencing master he did not like, Shichinosuke met a friend of his father's who saw some merit in the wandering son. Miyamoto Bunzaemon taught the young man not only a method of fencing with the long sword, but also the more difficult art of self-discipline. The young man learned so well that Bunzaemon adopted him as his own son. Bunzaemon's lord, the *daimyo* of Kumamoto in Kyushu, gave his new retainer the personal name Musashi. He is believed to have been the first samurai to fight in duels with both swords, creating the style called *nitoryu.* When Musashi's real father was killed in a duel with Sasaki Genryu, a swordsman of ill repute, Musashi tracked the man down and slew him.

In maturity, the tempered Musashi, under his artist's name of Niten, created paintings of Shoki (the demon-queller of China) and Daruma (the Indian sage who introduced Zen Buddhism into China). In addition, ink paintings and drawings of subjects native to Japan are attributed to him, such as the one entitled "Shrike on a Dead Branch," now in the National Museum in Tokyo.

Miyoshi Yuki *storybook heroine*

Yuki's widowed father, having fallen in love with a prostitute, bought the woman her freedom and married her. The stepmother forced Yuki to serve the household as a kitchen maid. Rebelling against such treatment, yet unable to run away, Yuki vowed that she would never marry or be like other women. Instead, she dressed and

behaved like a man whenever she went out on errands. Calling herself Yakko no Koman, "that fellow Koman," she imitated the *otokodate,* young men who ventured to protect the city's commoners against police, gangsters, thieves, samurai, and other predators. Artists depicted Yuki, the *onnadate,* or "upright woman," dressed in a man's kimono and carrying a flute in the manner of the more refined *otokodate.*

Miyuki *fictitious heroine*

Yamada Kakashi's novel, *Iki utsushi Asagao nikki,* or *The True Story of Asagao,* is a romance about the beautiful Miyuki, daughter of a high-ranking samurai in western Honshu. One summer night, while she and a maidservant are admiring fireflies, Asajiro, a handsome young samurai, saves them from a gang of ruffians. He and Miyuki fall in love and, after further acquaintance, intend to marry, but before that event, Asajiro disappears without farewell or explanation. Half mad with despair, Miyuki leaves home to search for him. By the time she wanders into Kyoto, poverty, sickness, and hunger have made her weak and blind. In order to survive, she becomes a singer, taking the name of Asagao, or Morning Glory. The name appeals to her because Asajiro had given her a fan bearing a painting of that delicate flower; moreover, it shares its first syllables with his name.

Meanwhile, Asajiro—whose real name is Kumagawa Jirozaemon—passes through Kyoto on his way home from an important mission to Edo for his lord. He stops at the inn where Asagao is employed, but does not recognize her. Even so, he is moved by compassion for the blind singer. Before departing, he takes a costly medicine that will cure blindness from his traveler's case and places the packet on a fan adorned with a painting of an *asagao.* He then writes a brief message of encouragement, and signs it with his private name, Asajiro. The innkeeper delivers the medicine to Asagao, reads the message, and describes the fan. Asagao is filled with joy. New hope joins with Asajiro's medicine to restore her sight. An old family servant, after searching for many months, discovers her and takes her home. Asajiro comes in honor to claim his bride; Miyuki and Jirozaemon are wed. Of course, they live happily ever after.

Mojo (also known as *Mogyoku*) *sennin*

She is represented as a young woman of wild aspect, with long thick hair on her head, arms, and legs, and clad in skins, leaves, or a combination of both. Two men, traveling in China's Shu mountains, who encountered her as she attended a male *sennin,* learned that she had been a maid of honor in the palace of the last Qin emperor. On the fall of the Qin dynasty in 207 BCE, she fled to Mount Huayin. Since she only ate pine needles, she became so light in weight that she was able to fly.

Artists usually depict her carrying emblems of longevity, such as branches of pine or peach trees, or with fruits and blossoms, such as peaches and loquats, in a basket slung on her back.

Moki *sennin*

A hermit of Seika, he subsisted on cinnamon leaves gathered at the foot of a mountain. The Emperor Shuko, wishing to honor this ascetic man, sent him a scepter inlaid with precious stones. Moki loved this gift so much that he would not put it down. He stroked and polished it constantly—until one day it wore through and broke in his hands.

Momotaro *folk figure*

One day, as a woodcutter's wife washed clothes in the river flowing past their house, a huge peach came floating by. When the husband cut it open, Momotaro stepped out from its seed. He grew up the perfect son—big, strong, helpful, and kind to parents, neighbors, and animals. Aided by a dog, a monkey, and a pheasant, with whom he had shared his lunch of rice dumplings, he drove the demons from Onigashima, Island of Demons, and claimed their hoard of treasures. Returning home, with his faithful companions and all the treasures, Momotaro gained even more honor and respect from the people in his valley.

Mon *family crest*

Like European crests and standards, *mon* were devised as easily recognizable insignia to serve as rallying points for warriors following a lord in procession or towards battle. By Tokugawa times innumerable *mon* had been designed as military families rose to prominence. For various reasons, many crests were either identical or very similar. By the seventeenth century the craze for crests had so proliferated that Shogun Iemitsu (r. 1622-51) required that they be registered and, in an early trademark-protection decision, he prohibited unauthorized use. About 3,000 *mon* were registered during the years before 1945. Today, new kinds of *mon* are very conspicuous in the Japanese scene. Almost every business firm, whether small or large, has its identifying logo/crest.

Mongols

After having conquered China in 1273, Kublai Khan lost no time in mounting an attack on Japan. His first attempt, made in 1274, ended when a typhoon dispersed the invasion fleet. In 1281 he tried a second time, sending about 150,000 men to Japan. Kublai Khan's generals actually succeeded in putting ashore at Hakata Bay on Kyushu Island great numbers of Chinese, Korean, and Mongol warriors. Stout resistance by Japanese forces contained the Mongol beachhead for 50 days. Once again a timely

typhoon destroyed most of the Mongol ships and warriors, terminating the invasion. The Japanese believed that their gods, either Shinto or Buddhist, had sent those *kamikaze,* or "divine winds." A picture scroll describing the second invasion was painted soon after the threat ended. After that, many other paintings and prints, concerned with the invaders, or with the roles played by Raijin, the thunder god, or by Nichiren, the prophet-priest, depict the fearsome Mongols.

Monju-bosatsu *bodhisattva*

Known in Sanskrit as Manjusri, Monju is Buddhism's supreme divinity of transcendental wisdom that holy men strive to attain. He may have been a real person, perhaps a favorite disciple of Shaka, or possibly a Buddhist missionary to China in the tenth century. In representations of Buddhist trinities in which Monju-bosatsu appears, he stands at Shaka's left, while Fugen-bosatsu stands at the right. When alone, artists generally depict Monju seated on a *shishi,* or Buddhist lion, before an ornate mandorla. The bosatsu's long hair is tied in five chignons, which are symbols of the five celestial Buddhas; otherwise he wears a five-pointed crown, which has the same significance. Emblems of his nature are the cutting sword of wisdom, the sacred book of knowledge, the pure lotus growing from mud, and other such symbols.

Monkey *in folklore*

In primitive times the Japanese worshipped a monkey god, whom they called Saruta-hiko no Mikoto. He was the guardian of roads. Later, after Saruta-hiko submitted to the rule of Prince Ninigi, he was relegated to a subsidiary position as the servant-messenger of Okuninushi no Mikoto. In that role he received the name Sanno, Mountain King (who may have been a separate deity according to some), and as such was worshipped in his monkey guise at a number of shrines. The most important of these were built on Mount Hiei, and on a hilltop in Edo (that today the rebuilt shrine shares with the Tokyo Hilton Hotel). The animal also figures in the Japanese zodiac. Occasionally, a *sarumawashi,* or monkey-showman, would train a monkey to perform tricks and beg for food or money. A monkey appears to amusing effect in anecdotes about two important personages.

Toyotomi Hideyoshi kept a pet monkey that was so spoiled it became a pest. He bothered those waiting for an audience with his master. One day, Date no Masamune, a *daimyo* from Mutsu Province, became thoroughly annoyed by the beast's behavior, and hit him hard. The monkey fled to his master's side in an adjoining room—and carefully avoided Masamune when he appeared before Hideyoshi. The dictator, not knowing what had happened in the anteroom, concluded that his pet sensed a

man of power in Lord Date. Accordingly, Hideyoshi treated the *daimyo* with greater courtesy. Kato Kiyomasa, one of Hideyoshi's ablest generals, also kept a monkey. This one was better tempered. When Kiyomasa came home one day, he found his pet sitting in his place, imitating him "reading" one of his books.

Monkeys with long arms decorate scabbards of short swords. Favorite subjects are those depicting a monkey stealing food from the basket of a sleeping *sarumawashi;* a monkey with his fingers caught in a crab's claw or in the tight-shut lips of a huge mollusk; a monkey struggling to free himself from the clutches of an octopus; a monkey poking a stick into a hornets' nest; a monkey dressed in the costume and hat of a Sambaso dancer; a monkey holding a staff decked with *gohei* (strips of paper representing lengths of cloth once donated to Shinto shrines). When a monkey is holding a big peach, both he and the fruit are meant to be erotic symbols.

The Monkey and the Boar (*Saru to buta*) *fairy tale*

Angered at his useless, impish monkey, a farmer vowed to kill it. Buta the boar, useful as a scavenger and sire of piglets, learned of this threat and hastened to warn his friend Saru. They devised a scheme whereby Buta would steal the farmer's baby and Saru would rescue it. The plot worked exactly as planned. The baby's father and mother, eternally grateful to the heroic Saru, could never do enough for him. But because Buta had endangered their precious child, they slaughtered the boar and ate him. Saru shared in the repast.

The Monkey and the Jellyfish (*Saru to kurage*) *fairy tale*

One day Ryujin, Dragon King of the sea, became ill. His physician, Tako the octopus, declared that the liver of a monkey was the only remedy for Ryujin's ailment. Kurage the jellyfish, one of Ryujin's retainers, was ordered to swim to land and capture a monkey for his master.

In those days, Kurage had bones, four legs, and a hard shell, like a turtle's. He succeeded in luring a monkey onto his back, with the promise of taking him for a ride. When he learned of the jellyfish's purpose, Saru said: "You should have told me so before we started because I left my livers at home, hanging in a tree beside the house. You see, we monkeys have five livers. And they're so heavy that we hate to carry them around when they're not really needed." Taken in by this story, Kurage took Saru back to land in order to fetch his weighty livers. The instant they touched the shore, Saru leaped to safety. The Dragon King was so furious with Kurage's stupidity that he commanded soldiers to tear the carapace from his back, rip the bones out of his body, and beat the rest of him into jelly, making of him what he is today.

Moon

Moon

Shinto myths tell how Izanagi, the father-creator, made Tsuki, the moon, with washings from his right eye (just as he had made the sun from his left eye), and installed as its deity "the Moonlight Night-possessor," Tsukiyomi no Mikoto. Some people hold that Tsukiyomi is a female divinity, whom Japanese called Joga, identical with the Chinese goddess Imo. Some artists depict her as a feminine presence enthroned on clouds, bearing the moon in her hands. Others maintain that Tsukiyomi is a male deity. Buddhist priests settling in Japan introduced Indian and Chinese lore about the moon. They taught the Japanese to see a hare, a frog, or even a cicada in the moon, rather than a man or a woman, as Westerners do.

The hand of the god Indra set Kinu, the golden hare, on the moon. Wishing to spare an old hermit the pangs of hunger, the animal laid himself down on the sage's cooking fire. The hermit was Indra. Quickly he pulled the hare from the coals, before he was injured, and tossed him up to the moon to cool his seared flesh. There he serves forever as an illuminating example of selflessness to people here on earth. The Japanese put him to pounding rice in a mortar, preparing the flour from which *mochi* cakes are made. In his spare time, this hare also polishes up the face of the moon, keeping it as bright and clean as a virtuous man's conscience by scouring it with a handful of horsetail plants.

Needless to say, the moon itself as a motif in art is found in all periods and in all kinds of works. It was chosen both for its beauty and, especially in *ukiyo-e,* as a symbol of the evanescence of things in this floating world. Among designers of *ukiyo-e,* Hiroshige probably was the most devoted moon-viewer of all.

Morihisa *warrior*

Morihisa (ca. 1180-1200) was one of the few Taira adherents who survived the war with the Minamoto and its vindictive aftermath. He escaped from the debacle at Dannoura (1185) and returned in secret to Kyoto. At the great temple of Renge-o (now better known as Sanjusangendo) he prayed to the Thousand-handed Kannon for help. Minamoto agents discovered him and sent him to Minamoto no Yoritomo in Kamakura. The vengeful conqueror commanded that he be beheaded.

Twice in a row the executioner's sword broke, even before it touched Morihisa's neck. At this juncture Yoritomo's wife, Masako, intervened. Claiming that Kannon had instructed her in a dream to save Morihisa, Masako persuaded her husband to pardon the captive warrior. Reprieved by Kannon's mercy, Morihisa became a loyal official in the Minamoto government.

Mori Jizaemon and His Image of Jizo-bosatsu *cautionary tale*

For many generations Mori Jizaemon's family owned a beautiful image of Jizo. A priest from a neighborhood temple was so fond of the image that Jizaemon agreed to lend it to him. The happy borrower took the statue home. Hordes of ants, however, devoured the offerings of food he set before it. He moved the image to the temple hall, but the ants followed. They ended their raids only when the priest returned Jizo to his proper place in Mori Jizaemon's house.

Yet Mori loaned the statue to another priest. This time the borrower was afflicted not only with swarming ants, but also by torments directed at himself. As he lay in bed that night, an invisible force seized him by the ears and shook him violently. The next morning he hurried to return the statue to Jizaemon. And Jizo, no longer being disturbed, ceased his protests.

Morinaga *warrior-prince*

Morinaga (1308-35), son of Emperor Go-Daigo (r. 1319-38), was imprisoned for over a year in a small damp cave at the foot of a hill in eastern Kamakura. When it was ordered that he be killed, he bit off the point of his killer's sword as it came near him. The assassin finally dispatched the prince with the *kozuka,* the small knife that is attached to a sword's sheath, and hacked off his victim's head with the blunted sword. Fuchibe threw the prince's head into the bushes nearby. In 1869 the Meiji emperor honored Morinaga by erecting a shrine dedicated to his spirit directly in front of the cave that had been his prison cell.

Mound of Ears (*Mimizuka*) *war memorial*

The Mound of Ears (or, as some people call it, Hanazuka, the Mound of Noses) in Kyoto recalls Toyotomi Hideyoshi's attempt to conquer Korea from 1592 to 1598. In this mound are buried the ears and noses cut from the heads of about 30,000 Chinese and Koreans killed in battles with the invaders from Japan. Hideyoshi's generals sent those lighter trophies home to Japan rather than the bulky heads. Buddhist priests gave them decent burial in the enclosure of Hoko Temple (founded by Hideyoshi himself), and later raised the monument above them.

Mount Hiei (*Hieizan* or *Hieiyama*) *sacred mountain*

A few kilometers northeast of Kyoto, Hiei's peak rises to a height of about 830 meters. Since ancient times it has been the abode of the Shinto deity known variously as Hie, Hiyoshi, and Sanno. He is the god Okuninushi no Mikoto, whose major shrine is located at Izumo. Inasmuch as the northeast is an unlucky direction, from where evil forces and spirits come, the deity of Hieizan, and the holy mountain itself, protected residents of Kyoto from those malign influences.

Mount Horai

In 788 the priest Saicho (who later took the name Dengyo-daishi) built the first Buddhist temple on Hieizan. He called it Enryaku-ji, and it became the seat of the powerful Tendai sect. Gradually Buddhist priests of several other sects erected temples and monasteries in the neighborhood. By 1571 dozens of religious communities crowded the slopes of Hieizan. Despite the influx of Buddhists, the ancient Shinto deity kept his place, respected by the newcomers. So did the *tengu*, those imaginary birdmen who live on forested mountains.

The hordes of priests, monks, mercenaries, and ambitious prelates who lived on Mount Hiei were perpetual threats to peace and stability in Kyoto, Nara, and places in between. At last, in 1571, the dominant warlord of the time, Oda Nobunaga, could no longer tolerate their arrogance and interference. At his orders, soldiers set fire to every temple and monastery on Hieizan, and slaughtered every priest, monk, mercenary, novice, and prelate they could find in the welter. After that carnage, Hieizan was no longer a source of trouble. The Tokugawa regime (1603-1868) allowed the rebuilding of only a few temples. Today new forests cover most of the scars left by those earlier temples and the purging fires of 1571.

Mount Horai (*Horaizan*) *vision of paradise*

Horaizan, an important concept in Chinese and Japanese folklore, probably was invented by Daoist mystics, with some help from Indian precursors. Daoists envisioned three isles of paradise, lying somewhere in the Eastern Sea, beyond the coast of China. On one of these islands, called Horai, soars a craggy mountain called Horaizan. The whole island rests on the back of an enormous tortoise of unimaginable age that stands on the ocean floor. The island's inhabitants are the genii who prepare the elixir of immortality, which flows from the Fountain of Life, to course in streams down the sides of the sacred peak. On the fringing plains and the flanks of Horaizan dwell all the plants and animals that are themselves immortal and therefore, serve as symbols of longevity: pine, plum, and peach trees; groves of bamboos and beds of sacred mushrooms; storks, cranes, and herons nest in the trees; and thousand-year tortoises swim in the crystalline streams. A species of tree that grows only on Horaizan has leaves of jade and bears flowers and fruits of precious stones that perfume the air.

Many Japanese legends and fairy tales refer to Horaizan. Among these are the tale of Jofuku the explorer from China; Sentaro, the man who did not want to die; some versions of Urashima-taro's life; and a vision in the breath of a clam. These tales, and many more, are illustrated in all forms of art. An often seen symbol tells the story of Horaizan at a glance—a *minogame*, or thousand-year turtle with its

streaming "tail" of aquatic plants, bearing on its back a jagged rock representing the mountain, atop which rest three *tama,* or sacred jewels. This emblem of longevity is called *san gyoku no kame,* or turtle of three jewels. Small models of Horai Island, with all its promises of longevity, are exhibited at wedding receptions. In many Japanese gardens, six carefully placed rocks serve to represent the long-lived turtle.

Mukan (also known as *Fumon, Daimyo-kokushi,* and *Busshin-zenshi*) *Zen priest*

After having studied for many years in China, Mukan returned to Japan and lived in Tofuku Temple in Kyoto. At that time the imperial palace of Higashiyama was haunted by demons, and Emperor Kameyama (r. 1260-74) called on Mukan for help to chase them away. The priest told him that demons fear pure virtue and cannot live where a priest lives—a thoroughly self-serving assertion as it turned out. The emperor ordered that a temple should be erected within the precincts of the palace, and there he installed Mukan who, with a good roof over his head, was free to be as virtuous as he wished.

Mukei *legendary creature*

Although a *mukei* has no stomach, it eats dirt. It lives in a hole in the ground, which becomes its tomb when it dies. But the *mukei* does not stay dead; it soon returns to life, continuing that same gnawing existence. A *samban,* resident in another country, lives in much the same way, except that it eats stones.

Muko *sennin*

He lived during the reign of Kang Jia of the Xia dynasty. Muko ate only garlic, and his ears were seven inches long. When the King of Tang deposed Kang Jia, he offered the vacant throne to Muko. The sage refused the position. In order to end further persuasions, Muko placed a heavy stone under his robe and drowned himself in a nearby river. About 2,000 years later, during the reign of the emperor Wu Ding, Muko returned to this world. Accordingly, artists sometimes depict him being carried from Mount Horai on the back of a tortoise, a symbol of longevity.

Mule

When the mule is seen in Japanese art, it is almost always a symbol of disgrace or, at least, of irony. Thus, Dong Po, the famed Chinese "Hermit of the Eastern Slope," known in Japan as Toba, rides into exile on a mule. Sankan, another Chinese poet, is so enchanted by the beauty of the scene he is departing that he sits backward on his plodding mule to get a longer view of the place he has left. Chogen, abbot of Todai Temple, the great Buddhist enclave at Nara destroyed in the Genpei War (1180-85), exchanges his temporal splendors for the back of a mule, when he goes out into the provinces of Japan to solicit funds for Todai's restoration.

Murakami no Yoshimitsu

Murakami no Yoshimitsu *warrior-hero*

When Prince Morinaga, wishing to restore power to his father Emperor Go-Daigo (r. 1319-38), attempted to wrest control from the dominant Hojo clan, two brothers of the Murakami family joined his imperial cause. In 1332 the Hojo army, bigger and better equipped, defeated Prince Morinaga's forces at Akasaka in Kawachi Province, and captured the imperial banner. They were rejoicing over their prize when, suddenly, appearing out of nowhere, Yoshimitsu (?-1332) rode into their midst, seized the banner, and dashed off before a single Hojo soldier thought to stop him. The sacred insignia, restored to Prince Morinaga, heartened his troops during their retreat toward the mountains of Yoshino. Not long afterward, Yoshimitsu sacrificed himself helping Morinaga escape. Wearing the prince's armor, he led the Hojo horsemen in another direction. This time they killed him.

Murakami no Yoshiteru (also known as *Murakami no Hikoshiro*) *warrior-hero*

Like his brother Yoshimitsu, Yoshiteru (1308-32) gave his life so that Prince Morinaga might escape. After the Hojo had defeated the imperial army at Akasaka, the survivors retreated to the rugged mountains of Yoshino, southeast of Nara. They built a small fortress, hoping it would shelter them until more allies came to their assistance. The Hojo army, however, arrived instead. As the siege neared its end, Prince Morinaga's lieutenants begged him to escape while yet he could. Morinaga slipped away through the misty forest. Yoshiteru, wearing the prince's armor and insignia, climbed to the parapet of the little fort and defied the Hojo forces. He removed the imperial armor and robes, baring his body to the hips. Using the short sword, he cut open his belly and, still standing, tore out his entrails and flung them at the awestruck soldiers below. Only then did he permit himself to die. Soon after, the fortress fell. The victors cut off Yoshiteru's head thinking it was Prince Morinaga's. They sent it to the regent Hojo Takatoki in Kyoto. When he saw it, Takatoki knew that it was not the head of Prince Morinaga, and that the war was not yet over.

Murasaki Shikibu *novelist*

Almost nothing is known about her, not even her real name. Apparently a member of the dominant Fujiwara clan by both birth and marriage, she served as lady-in-waiting to her cousin Empress Akiko, the second consort to Emperor Ichijo (r. 987-1011). After Ichijo's death, Akiko became empress-dowager, and Lady Murasaki continued in her service. About the year 1001, probably soon after her husband died, Murasaki began to write *Genji monogatari* (*The Tale of Genji*). The first genuine novel to be written anywhere in the world, it is still one of the greatest novels ever produced in any language.

In telling the story of Hikaru Genji, "the shining prince," and of his relationships with ancestors, friends, lovers, enemies, descendants, and gods, Murasaki describes the culture of Heian Kyo at its very zenith, capturing in words not only the setting of the imperial capital, but also the spirit of the elegant, exquisite, effete, and ephemeral society that ruled it. Ever since she wrote the 53 chapters of *The Tale of Genji* it has been an inexhaustible source of inspiration for Japan's artists.

For about two years, probably from 1008 to 1010, Murasaki also kept a diary about life at the imperial court; it is known as *Murasaki Shikibu nikki*. Murasaki's contemporaries recognized her great achievement in *The Tale of Genji* during her lifetime, as have her countrymen ever since. She has been depicted often, as poet and novelist, either alone or in the company of her 35 immortal compeers in literature. Apparently still attached to the court of the empress-dowager, Murasaki died sometime between 1015 and 1031.

Murata Juko *first teamaster*

Juko (1422-1592), a Zen priest, was incorrigibly lazy, terribly bored, or chronically ill—he was always falling asleep, especially in the midst of prayers and meditations. In the hope that tea would keep him awake, he took to brewing the beverage, and shared it with fellow priests and visitors. Drinking tea helped him somewhat, but even so, he failed to perform his priestly duties satisfactorily. His superiors dismissed him from the temple.

The eighth Ashikaga shogun, the spendthrift Yoshimasa (1436-90), enjoyed Juko's company as well as his ceremonious way of serving tea. Yoshimasa (who built the beautiful Ginkaku Temple, or "Silver Pavilion," in Kyoto) gave the discharged priest a house in the city and arranged to release him from his vows. Happily "secularized," Juko gave lessons in *chanoyu,* the tea ceremony, to interested pupils. He is regarded as the first man to run such a school in Japan.

Mu Wang *(Boku) legendary Ch. emperor*

When he was only seventeen years old, he visited the palace of Seiobo, Queen of the West, and was lavishly entertained. As emperor, he led numerous military expeditions against unruly "barbarians," riding in a specially made war chariot drawn by eight horses.

Naga *Indian motif*

Snakes are not conspicuous in the native fauna of Japan. The idea of the *naga,* imported
from India with Buddhist art, does, however, appear on occasion. Representing the
inflated hood of an aroused cobra, the motif accompanies many renderings of
India's gods. It was also incorporated in some Buddhist sculptures and paintings.
Indian gods who were endowed with the shapes of serpents are presumed to be the
equivalents of China's gods who were given the forms of dragons. In Buddhist art,
those Indian gods who are protecting bodhisattva or human beings are often shown
as *naga,* either rising beside the figures they are guarding or following close behind.

Nanten *plant*

An attractive shrub, *nanten* (*Nandina domestica*) is much honored in China and Japan,
where it is native. As its leaves are always green, even in coldest winter, like those
of the bamboo and the pine, it is a symbol of longevity, and like them is often used
in New Year decorations. Because it is so trim and neat, *nanten* is regarded as an
emblem of cleanliness. For this reason, many people plant it outside a privy or at the
front entrance of a well-ordered household. Moreover, if you have a bad dream, it
will never come true if, at the first hour of the day, you tell it to a *nanten.* The plant
is represented often in art, because of its elegant lines, delicate leaves, and clusters
of small fruits. The white flowers are inconspicuous, but the berries they produce

are attractive, although otherwise useless. Some plants produce white berries, others yield red ones.

Nangyo Koshu *sennin*

She lived in the time of the Han emperor Yuan Di (r. 48-32 BCE). During the troubles caused when Yuan Di's nephew usurped the Dragon Throne, Nangyo Koshu retired to Mount Hua. There, dwelling in a hut she built with a servant, she cultivated virtue. After about a year of such austerity, Nangyo Koshu climbed to the mountain's summit and, from that sacred spot, ascended to heaven on a cloud. The servant, seeking her, found only her red shoes turned to stone. They realized that Nanyo Koshu had become immortal.

Nanzen *Zen monk*

Abbot Nanzen was called on to decide which of two neighboring monasteries had the exclusive rights to a roaming cat. When neither group would give up its rights to the animal, Nanzen took up a short sword and cut the cat in half, giving one part to each monastery. Another version has the priest killing the cat because neither of two factions in his temple could produce convincing arguments as to whether a cat has a Buddha nature. Sentimental artists depict Nanzen holding the cat intact, threatening to cut it. Realists show him dividing it with the sword.

Narita no Tomenari *warrior*

In 1176 a few bored young samurai of Kyoto aroused the wrath of Taira no Kiyomori by troubling certain soldier-monks who lived on Mount Hiei. They shot arrows into a temple and struck the image of Hiyoshi, the ancient deity from whom the mountain received both its power and its name. Kiyomori, furious at such sacrilege, decreed that the culprits be executed. Shigemori, the oldest of his eleven sons and the most temperate of all Taira, persuaded his father to banish the offenders rather than kill them. Perhaps the fact that one of those endangered youths, Narita Tomenari, was his foster-brother probably persuaded Shigemori to speak on their behalf.

A number of Tomenari's friends held a farewell dinner for him the night before he was to set out for exile. The conversation and too much drinking made everyone tearful by dinner's end. A companion, wanting to show his affection, cut off his warrior's topknot and laid it before Tomenari. A second friend, thinking that a hank of hair was inadequate testimony, sliced off his nose. A third, to prove his greater devotion, cut open his belly, laying both blood and life at Tomenari's feet. Tomenari and all the others, seeing now what must be done to keep them together forever, committed seppuku. The innkeeper, afraid that he would be held accountable for this gruesome conclusion to the party, set fire to the house and (sensibly) ran away.

Nawa no Nagatoshi

Nawa no Nagatoshi *warrior*

In 1333, when the Ashikaga clan rebelled against the weakening Hojo government, Emperor Go-Daigo returned to Honshu from exile in Oki where he had been banished by the Hojo regent. Nawa no Nagatoshi met the sovereign at his landing place. Artists recall this event by depicting Nagatoshi's carrying the emperor ashore in his arms. He himself commemorated the occasion in the design he chose for his family's crest—a ship with its single mast and a bellying sail.

Three years later, Ashikaga Takauji brought the civil war into Kyoto, forcing Emperor Go-Daigo to take flight once more. In the turmoil, Nagatoshi and 300 horsemen fought their way through the city toward his own mansion. After engaging the enemy at seventeen different barriers, he and 31 surviving warriors succeeded in reaching his home. Nagatoshi bade farewell to his beautiful abode, helped his men set it afire, then fled for refuge among the temples on Mount Hiei. Later that same year, when he and Kusunoki no Masashige tried to regain Kyoto for the emperor, Nagatoshi was killed in battle.

Neiseki *legendary Ch. philosopher*

Despite his fine education, Neiseki could not support himself and his family. Putting his mind to work, he drove about town in an ox cart, singing verses criticizing the government. As he sang he tapped an accompaniment with a stick on the horns of his ox. The Duke of Qi heard Neiseki's verses, and invited him to become an adviser to the government. In art, Neiseki and his ox are inseparable. He is sometimes depicted with a coolie's hat of plaited straw on his shoulders and a small stick in his hand, sitting on the beast's back; at other times he is standing beside the ox.

New Year Observances

Shogatsu, "the Right Month," marks the start of a new year and brings the greatest of all festival seasons to Japan. In olden times the celebrations extended through almost the entire month for wealthy people; and even today, during the weeklong holiday, only the most essential labor is performed.

To the Japanese the arrival of a new year is the obvious time for starting things afresh by setting right their relationships with people in this world, and with gods and spirits in the next. Families clean their homes more thoroughly than usual. They pay old debts; purify bodies and spirits; don new clothes; visit shrines, relatives, friends, and employers, always presenting gifts or symbols of good luck. Until relatively recently, everybody, all at once, became a year older on New Year's Day, no matter on what date he or she was actually born.

The decorations they put up at the doors to their homes are made with symbols

of happiness and longevity. To the basic *kadomatsu*—branches of bamboo and pine bound together by a *shimenawa,* a rope plaited from rice straw—they add a number of other components, such as fern fronds, oranges or tangerines, pieces of charcoal, a crayfish or a small lobster, and leaves of sweet daphne. These, and other things, because of their appearance, durability, or the sounds of their names, signify long life or good fortune.

Ni *legendary tree*

This tree of fable, a thousand feet high, blossoms only once in a thousand years, and its fruits need 9,000 more years in which to ripen.

Nichiren *priest; founder of Hokke sect of Buddhism*

This son of a fisherman took the name Nichiren (1222-82), "Lotus of the Sun," when he became a priest of the Shingon sect. According to a legend, he called himself Nichiren because his mother dreamed that the sun entered her body while she was carrying him. More likely, the name symbolizes the synthesis of native Shinto beliefs and imported Buddhist precepts that he strove to achieve. In his 31st year he began to preach a new doctrine, based on the teachings that Shaka uttered during his last days, which are preserved in the *sutra* called *Myoho-renge-kyo,* the Book of the Lotus of the Wonderful Law. From this title, and from his belief in the efficacy of prayer, evolved the formula that Nichiren gave the members of his sect—that salvation can be achieved by chanting "*Namu myoho renge kyo*" ("Glory to the salvation-giving book of the Law"). With this simple dogma, so easily understood by ordinary people, he gained many converts. The sense of power his converts gave him made him assume a dangerous militancy.

So violently did Nichiren criticize both the government and members of other Buddhist sects that Hojo no Tokiyori, the dictator at Kamakura, banished him to Izu for a term of 30 years. Within three years, intercessors gained him a pardon. He renewed his assaults on the "false teachings" of rival sects. For this, Hojo no Tokimune, the new dictator, condemned Nichiren to death. On the killing ground at Koshigoe, Nichiren knelt before the executioner. With the rosary in his hands, he uttered his invocation to the Buddha. The executioner's sword broke in pieces as it touched the protected neck. A ray of light streamed down from heaven to illumine the praying saint. At that very moment, lightning struck the Hojo palace in Kamakura. Awed by these miracles, Tokimune cancelled the death sentence, but exiled Nichiren to windswept Sado Island off the northern coast of Honshu. After two years, Nichiren returned to Honshu, going first to Kamakura, then to Minobu in Kai Province. There he built Kuon Temple, which became the central seat of the Hokke sect.

Nichiren's Image

Numerous legends and true stories commemorate Nichiren and his teachings. All provide material for artists. To members of his faith he is an incarnation of the bodhisattva Jogyo, one of Gautama Buddha's first disciples. He is the greatest of the Buddhist saints produced so far in Japan. To most Japanese he is the prophet who, in 1266, eight years before it happened, foretold the first attempt to invade Japan by Mongol warriors from China. Almost everyone credits him with having called forth the *kamikaze,* the "divine winds" of the typhoons, that destroyed two Mongol fleets, the first in 1274 and the second in 1281. Utagawa Kuniyoshi illustrated scenes from Nichiren's eventful life in a whole set of colored prints.

Nichiren's Image *folktale*

A wooden image of Nichiren, founder of the Buddhist Hokke sect, housed in a monastery, began to recite holy texts. The distrustful abbot found the image unable to answer certain questions about religious matters put to it. He struck it with an axe; it toppled over; and from behind it, a badger scurried away. The animal was captured and killed.

Night-crying Stone (*yonaki ishi*) *legend*

At a mountain pass near Nissaka, the twenty-sixth station on the Tokaido, a pregnant samurai's wife on her way to join her husband in an eastern province was raped by a common soldier. She resisted him, and he stabbed her until she was near death. Before she died, she gave birth to a boy. Jizo-bosatsu protected him through childhood. When he had grown, the son sought out the soldier who had murdered his mother and killed him. Ever since then, the place where the mother died has been marked by a stone and a fir tree, both of which groan during the night like spirits suffering in hell.

Nightingale *bird in folklore*

Cettia cantans—as it is known to ornithologists, and bush warbler to watching amateurs, is called Japan's nightingale mostly because, like its counterpart in the West, it sings in the night, and is the favored bird of poets and lovers. The Japanese say that it is a religious bird because it starts its song with a *"no-ke-kyo,"* the name of a Buddhist sutra.

Nightingale in the Plum Tree *story*

During the time of Emperor Murakami (r. 947-67) a plum tree in the palace garden withered and died. He wanted to replace it with a beautiful tree he had seen growing in the garden of the daughter of Ki no Tsurayuki, the famous poet. When a messenger delivered his request, Lady Ki was most unhappy. A pair of nightingales had made their nest in the crown of that very tree. How could she bear to disturb them? Yet

how could she refuse the emperor's command? Finally, she addressed a poem to the emperor, asking what reply she should give to the nightingales if they asked her what had become of their nest. The emperor deferred to the nightingales.

Nihongi (also known as *Nihon-shoki* and *Yamato-bumi*) *historical text*

Aston, who first translated this work into English, entitled it *The Chronicles of Japan*, adding as a subtitle "From the Earliest Times to 697." It is a compilation based on earlier works (since lost), and was completed in 720. It is the oldest of Japan's "official histories" to have survived. Its historical value is questionable, but it has been an inexhaustible source of myths, legends, themes, and motifs for Japan's artists.

Nii no Ama (also known as *Nii no Zenni* or *Nii Dono*) *grandmother of emperors*

Tokiko, wife of Taira no Kiyomori, was grandmother of the boy-Emperor Antoku and of his successor Go-Toba. She was given the title Nii no Ama ("Nun of the Second Rank"). At the naval battle of Dannoura (1185), when she saw that the Taira were doomed, proud Nii no Ama refused to allow her grandson Antoku to be captured by the Minamoto. Holding the child in her arms, she leapt into the sea.

Nikki Danjo *legendary villain*

As the arch-criminal in a Kabuki drama called *Sendai Hagi,* or *The Stripping of Sendai*, Nikki Danjo baffles his adversaries by changing into an enormous rat whenever he needs to escape them. He is a favorite subject for artists, who depict him in a posture of splendid malevolence, calling on rats to come to his aid. Many famous Kabuki actors have posed for artists in the costume worn for the role of Nikki Danjo.

Nikko-bosatsu and Gakko-bosatsu *Buddhist lesser deities*

"The sunlight bodhisattva," whom Japanese call Nikko, seems to have been a solar divinity before Buddhism claimed him. Similarly, "the moonlight bodhisattva," whom Japanese call Gakko, seems to have been derived from a Vedic deity of the moon. In Japan both Nikko and Gakko serve as attendants to greater deities.

Ninigi no Mikoto (also known as *Amatsuhiko-hiko no Ninigi*) *mythological personage*

The sun goddess Amaterasu sent her favorite grandson Ninigi down to earth to wrest the islands of Japan from the control of descendants of her ill-mannered brother, Susano-o, god of the sea. Accompanied by many retainers, and the three sacred treasures his grandmother presented him, Ninigi first set foot on the summit of Mount Takachiko in Hyuga on Kyushu Island. Later, he married Princess Kono-hana-sakuya of Satsuma. Their great-grandson Jimmu is recognized as the first emperor of Japan, and the founder of the dynasty that has ruled the country since 660 BCE.

Ningyo *mythical sea creatures*

Japan's *ningyo* ("human fish") are human in their upper half, fishlike in their lower

half. Often they are shown listening to large shells, resembling a conch, eager to learn the secrets of the sea. Sometimes one holds a *tama*—a jewel signifying purity to Buddhists, and command over the forces of the sea to Shintoists—instead of a shell. *Ningyo* should not be confused with *ama*, or divers for abalone. Although they may be equally undressed, *ama* have legs, not tails. Most *ningyo* depicted are female.

Ninomiya Sontoku *agriculturalist*

The son of a poor farmer in Sagami Province, Sontoku (1786-1856) read as many books as he could borrow, and he used his good mind to observe and think. He became an agricultural expert. His lord, Okubo no Tadasune, *daimyo* of Odawara, gave him the task of improving some of the poorer lands owned by the Okubo family. Sontoku succeeded so well in increasing yields that other officials consulted him. In 1854 the shogunate employed him to improve the land holdings of 89 villages near Nikko, whose income supported the Tokugawa mausolea in that area. Sontoku wrote more than 60 books centered on a scientific approach to soil conservation, reclamation, and other aspects of efficient land use. He gained wealth as well as fame, but he gave away most of the money.

Sontoku, a modern kind of hero, is often depicted with an old-fashioned plowman's ox. Whether walking behind the beast, or seated beside it, Sontoku always carries an open book. During the Meiji era (1868-1912) his picture was printed on covers of writing tablets and textbooks as an inspiration to schoolchildren. All over Japan small statues of him were set up, showing him as a boy with book in hand and a heavy load of firewood borne on his back—a model of diligence.

Nintoku *sixteenth emperor*

Nintoku (313-99?) is one of Japan's most beloved sovereigns because of his active concern for the welfare of his people—commoners and nobles alike. He ruled from the town of Naniwa (since absorbed by the metropolis of Osaka), favoring programs that promoted agriculture, canals for drainage, dikes against floods, and granaries for storing rice during times of plenty.

In art he usually is depicted standing on a balcony of his palace, looking out over the countryside. This theme alludes to the time when, gazing out from that vantage, he saw smoke rising from such a small number of cooking fires that he understood at once how poor his people had become. Accordingly, he relieved farmers from the need to pay taxes for three years. After the tax relief ended, smoke from numerous cooking fires showed him how well his generous policy had worked—even though during that time his own palace had fallen to ruin, and he and the imperial family were reduced to wearing old clothing. Perhaps because of his kindness, the largest

of all imperial burial mounds in Japan was raised for him near Naniwa. It is carefully preserved to this day.

Nio *guardian deities*

The term *nio* means "benevolent kings" but, because of another interpretation of the sound *ni,* it has been corrupted to the more popular "two kings." Either interpretation refers to those paired guardians of ferocious mien and threatening attitude who stand at either side of the entrance gate to most Buddhist temples. They are Japanese versions of the Hindu *deva,* or heavenly kings, who themselves (according to some theories) may have evolved from Greek representations of Hercules. Their details have been much modified by their passage through China and their adoption in Japan.

When newly made, they are painted. An open-mouthed red one, standing on the west side of the *niomon,* or two-kings-gate, represents Indra, and in Japan is known as Misshaku Kongo. A green one, with closed mouth, standing on the east side, is supposed to be Brahma, and in Japan is known as Naraen Kongo. Because of their frightening countenances, athletes' musculature, and violent gestures, they are popularly viewed as demons—"the red *oni*" and "the green *oni.*" In reality, they stand guard in order to prevent evil spirits, demons, infidels, barbarians, unregenerate sinners, thieves, foreigners, and other sorts of troublemakers from entering the temple's precincts. Naturally, *nio* are fascinating subjects for Japanese artists. The more grotesque or humorous the portrayal, the better people like it. With such treatment, however, both the identity of the kings and their different attributes are apt to be lost. Often they are shown dueling with each other, using wooden swords, or engaged in the indoor sports known as neck-pulling and arm-wrestling, rather than performing their proper duties as guardians against Lord Buddha's enemies.

Nitan no Tadatsune *warrior*

Tadatsune, one of Minamoto no Yoritomo's trusted vassals, excelled as a hunter. He is often depicted thrusting his short sword into a wild boar's neck. This alludes to an incident during a hunt Yoritomo had arranged on the slopes of Mount Fuji. He also was sent to subdue the monsters that lived near the summit of Mount Fuji. Carrying his sword in his right hand, a torch in his left, Tadatsune entered a great cavern at the top of the mountain, and found a shining being there, who smiled and congratulated him for his bravery. She was Kannon, and ever since then an image of the bodhisattva of compassion has stood in the grotto that Tadatsune discovered.

Nitta no Yoshioki *warrior*

This second son of Nitta no Yoshisada followed his father in supporting the cause

of the exiled emperors of "the southern court" at Yoshino. Like his father, Yoshioki (?-1358) died for his fidelity. Enemies captured him after a futile battle and drowned him in the waters of a nearby river. Later, after the Ashikaga had forgotten, a shrine dedicated to Yoshioki was built near the place where he was killed, and he was given the posthumous title "Mitta Daimyojin." A romanticized account of his death, invented for the Kabuki theatre, provides artists with more dramatic moments to portray. Yoshioki, in flight from the Ashikaga, is induced into believing that allies await him at the river's farther shore. He pushes off from the bank in a boat that appears to be sturdy, but has been prepared to sink under his weight. As it subsides, Ashikaga soldiers shoot arrows at the helpless man, wounding him before he drowns. Immediately his enraged spirit calls forth such a furious storm that the men who betrayed him, as well as many warriors, are killed. According to this tale, the shrine honoring Nitta Daimyojin was built to placate his angry spirit.

Nitta no Yoshisada *general; model of fidelity to emperor*

Yoshisada (1301-38) helped Prince Morinaga, a son of Emperor Go-Daigo, overthrow the decadent Hojo family, which had governed Japan since 1199. In 1333, leading an army of 20,000 men, Yoshisada captured the Hojo capital of Kamakura, thereby ending their domination.

The imperial army approached the city from the west, along the seacoast, but was stopped by defenses built to the water's edge and by hundreds of warships anchored in the bay. Yoshisada stood on a cliff, prayed to the deities of heaven and ocean to aid the emperor's cause. Then he threw his long sword into the waves as an offering to Ryujin, the Dragon King. That night the waters of the bay withdrew, taking the Hojo ships more than two kilometers away from shore. Yoshisada led his army across the exposed beach and entered Kamakura.

In the battle that followed much of the city was destroyed and the last of the Hojo regents was killed, together with many relatives and retainers. At Fujishima, in Echizen Province, Nitta Yoshisada died in the last battle that finally gave the Ashikaga victory. Legend claims that, after an arrow struck him between the eyes, Yoshisada cut off his own head.

Many incidents from Yoshisada's heroic life are themes for artists. Foremost among them is the moment he offers his sword to the Dragon King off Kamakura. His helmet, and its dragon crest, given to him by the emperor, is also a common motif. A representation of it in any medium is enough to remind the viewer of Yoshisada. Important also are representations of Yoshisada's severed head, impaled on a spear, exposed publicly in Kyoto. Among the people who saw it were his wife

and their two young sons. They had not known that he was dead. After sending her sons to safety, Lady Nitta entered a nunnery. She herself appears in pictures of happier times. As she played on a harp in her father's home, Yoshisada passed by. On hearing the music, he peered through an opening in the garden wall—and fell in love with the beautiful maiden. Another picture depicts her holding his dragon helmet over fumes from an incense burner, in the hope of protecting him against evil influences.

Dramatic scenes from Yoshisada's successful campaigns are more popular, however. He is shown in one battle, wielding both his famous swords, Onikiri and Onimaru, cutting down flights of arrows. In another, where the retreating enemy had demolished a bridge over a river, he ordered his soldiers to repair it with boards torn from nearby houses. His groom and horse, while trying to swim the river, were caught in its swift current. Fortunately, Kinryu Saemon, a warrior noted for his strength, pulled them to safety.

Noh *classical theatre*

The word *noh* means "skill" or "talent," and *nohgaku* means "skill and music." Either term identifies the stateliest and most austere form of Japan's theatrical presentations. Created by Kanze Kiyotsugu (1354-1406), who is better known as Kanami, it was firmly established by his son Kanze Motokiyo (1375-1455), better known by his pen name, Seami. Both father and son enjoyed the patronage of Ashikaga shoguns, and the friendship of ranking priests and aristocrats of elevated taste. A Noh play is a short poetic dance-drama that seeks to impress on its viewers a message about a worthy example or an edifying thought. Most of a play's verses are recited or sung by narrator-musicians, rather than by actors, although at moments of great intensity a principal actor may declaim a few especially poignant lines. The actor is primarily a mime, expressing in his motions the feeling of the text as it is being explained by narrators and emphasized by musicians. Paul Claudel once said: "In Western drama, something happens; in Noh, someone appears."

Numerical Categories

Comparing, characterizing, cataloguing, codifying, and categorizing facts and things is a national passion among Japanese. Although they acquired the notion from China's scholars of long ago, the Japanese have carried this intellectual delight to extraordinary lengths. They have categories for everything, from the Eight Hundred Myriad Gods (who flourished before Japan's history ever began), down to a list of the Five Champion Sumo Wrestlers, and the Three Most Polluted Intersections in Metropolitan Tokyo.

Nyoi

In a society where every individual should know exactly what his or her position is in relation to everyone else (and is expected to keep it), this system of evaluation is a powerful aspect of Japanese social control. Strict numeration locks into place, forever, the relationships among comparable entities of all sorts—for instance, Kabuki actors, baseball pitchers, pop singers, movie stars, tunnels, skyscrapers, companies, universities, mountains, and scenic views. Once the *sankei,* or three most beautiful views, were ordained back in the seventeenth century, no Japanese has dreamed of changing that listing. It is established, inviolable, for all time, and refers to Matsushima, Miyajima, and Ama no Hashidate.

Nyoi *ceremonial wand*

The *nyoi* is a wand or scepter carried on ceremonial occasions by high-ranking Buddhist priests, especially by those of the Zen sect. Certain Buddhist saints may also be shown carrying them. Flat at the foot, often curving to a swollen tip or tips, it is made of beautifully grained and polished wood, jade, or some other valued material. Usually it is carved in intricate patterns or inlaid with plaques of semiprecious stones. Sometimes it is shaped like a *reishi,* the mushroom of immortality, or engraved with the mushroom motif. Just as in China, where the *nyoi* is the emblem of Shou Lao, the god of longevity, in Japan it is the emblem of his counterpart, Fukurokujin. These associations, as well as the shape, indicate that the *nyoi* is derived from a phallic symbol honored in more ancient times.

Obuzawa Sensaburo *brigand*

Artists liked to depict Sensaburo, a famous bandit, at the moment of his capture by police officials: bound with a cord, but still defiant in posture and countenance.

Octopus

Squids and octopi have been important foods in Japan, and frequently are depicted in art. They represent both good and evil influences. Artists delight in depicting them with human traits, or in ludicrous situations peculiar to human beings.

Among the manifestations of evil are Umi-bozu, "priest of the sea," so named because an octopus presents the baldhead and staring eyes of a gross prelate. Umi-bozu drags sailors into the depths of the sea during storms; he seizes girls and children near shore; rampages about in farmers' fields, terrifying them and eating their vegetables. A many-armed octopus represents Kiyo-hime, wrapping herself around the temple bell in which Anchin has taken refuge from her insane lust. The *tako,* as Japanese call the octopus, is a phallic symbol much used in religious and erotic art. Sometimes it is transmuted into the head of Fukurokujin, the phallic god of longevity, wealth, and prosperity. A popular subject for artists in the Edo period was an *ama* (diving woman) and an octopus in sexual union.

The sounds of the word *tako* also mean lucky, blessed or happy. Therefore, the captured creature itself, alive or dead, fresh or dried, whole or sliced thin, is always

a generous gift. The tentacles signify children, who assure happiness. The tentacles also are good gifts to offer an active man. A proverb says, "a busy man needs eight arms, like the *tako*." A wise *tako* serves as physician to Ryujin, the Dragon King, who lives in a palace at the bottom of the sea.

Oda Nobunaga *general and warlord*

During the last 50 years of the Ashikaga shoguns (who officially ruled from 1338 to 1573), Japan was ravaged by civil wars as one ambitious *daimyo* after another rose in rebellion against the weakening central government. The general who won the contest for supremacy was Oda Nobunaga (1534-82), a lesser *daimyo* from Owari Province (and a remote descendant of Taira no Kiyomori, tyrant of Japan from 1260 to 1281).

Nobunaga, a forceful warrior but an erratic leader, was helped in his rise to power by a brilliant young commoner, known at that time as Tokichiro, who proved to be a genius at military strategy and tactics. (Tokichiro would change his name several times more in his own climb to the top, and is best known as Toyotomi Hideyoshi.) Nobunaga's success in subjugating several provinces drew the attention of Emperor Ogimachi (r. 1558-86). In 1562 he invited Nobunaga to "pacify the land." Nobunaga accepted the charge, but by no means ended the turmoil. In 1571, impatient with the machinations of abbots and mercenaries gathered in the temples of Mount Hiei, a few kilometers north of Kyoto, Nobunaga ordered an attack on those nests of intrigue. His warriors burned every temple and barrack on Hiei to the ground, and slaughtered almost every one of its priests, monks, novices, and mercenaries. Yet that ruthless policy did not quiet warriors in remoter parts of the country. Nobunaga was still trying to subdue them when one of his own trusted generals, Akechi no Mitsuhide, assassinated him.

Ofushi *sennin*

A Chinese sage who learned his skills from the *sennin* Shori, Ofushi lived without the need for food. He supported his whole family by compounding fine medicines for patients. One day, as he and several companions walked beside a placid river, they noticed his reflection showed that he had two bodies. When they marveled at this phenomenon, the sorcerer demonstrated that, in truth, he cast ten shadows. The emperor, hearing of this terrible thing, ordered his soldiers to throw Ofushi into prison. Ofushi escaped miraculously and disappeared forever.

Ogishi *scholar*

A famous Chinese calligrapher, Ogishi devised a style for writing ideograms that is used in both China and Japan. He is regarded as "the father of writing" because he

established a code of rules for writing and classifying characters, decreed the number of brush strokes needed to inscribe each ideogram, and set the order in which those strokes should be placed. He is usually depicted brushing characters on the face of a convenient rock. Beside him, holding the inkstone, is a boy, probably his son, who also became a noted calligrapher.

Oguri-hangan *warrior-hero*

Oguri-hangan was the son and heir of a *daimyo* who served the government as a *hangan,* a judicial agent. When young, a stepmother tried to dispose of him by the usual means of slander and poison. He survived, but only to live out a complicated and misfortune-strewn existence. His betrothed, the beautiful Teruta-hime, was kidnapped, but she escaped. And despite brutal hardships and menial toil, she preserved both virtue and beauty because she carried in her obi an image of Kannon, a bodhisattva of compassion, who saved her from every peril. When she was finally united with Oguri, he was ill with an ugly skin disease. She placed him in a beggar's cart, and drew him over 804 kilometers of rugged roads (taking more than a year to do so), until they arrived at the warm sulfurous waters sacred to Yakushi-nyorai. Healing baths, prayers, and the devoted attention of Terute-hime restored Oguri-hangan to health within a week. The pair returned home to eliminate their enemies and claim his heritage. Their troubles did not end there: civil wars, assassins, and relentless adversaries continually beset them, denying them the chance to live happily ever after. Nonetheless, they survived all those harryings, and even managed to behead the man who had murdered Terute-hime's kind old father. After Oguri-hangan died, Terute-hime, faithful beyond the end, became a nun. She built a shrine beside her husband's grave, and in it placed the image of Kannon she had carried through all her trials.

Oguri-hangan's story has given Japanese artists a number of dramatic themes. Most often they depict him demonstrating his superb horsemanship. In a Hokusai print, for example, Oguri-hangan is shown astride Onikage, his spirited steed, whose four hoofs are set daintily in the center of a tiny *go* table. Other prints picture him standing beside Onikage atop a high cliff, looking for signs of the pirate Kazuma Hachiro. A guaranteed heart-wringer of a print depicts Terute-hime dragging him along in their famed *kurumazaka,* while he hunches pathetically in that beggar's cart.

Ohan and Choemon *ill-fated lovers of fiction*

Choemon, a fabric seller in Kyoto, was 40 years old when he fell in love with fourteen-year-old Ohan. She returned his passion, despite their difference in age, but her parents opposed the match. Determined to be together in death, if not in

Oho

life, they drowned themselves in the Katsura River. Artists depict him carrying her on his back, under a weeping willow tree beside a flowing river. Sometimes they are represented as a pair of affectionate cats, sitting side-by-side, embracing each other—as the legend goes, they were reborn as kittens.

Oho *sennin*

He studied the mysteries of Daoism on Mount Hua. The gods rewarded his diligence by giving him a feathered chariot, which carried him to all the fairylands and on explorations of the heavens. Artists depict him, with a nimbus about his head, riding in a flying chariot—or seated in a wheelbarrow borne on clouds.

Oiran *courtesan*

Among the assorted prostitutes in the Yoshiwara of Edo, an *oiran* attained the highest rank and the greatest fame. Most *oiran* were very beautiful, and all were splendidly dressed. Outer kimono were made of the costliest brocades, coiffures were bedecked with many expensive pins and ornaments. In flamboyant defiance of the rules that bound ordinary women, *oiran* wore the enormous bow of the obi in the front of their costumes, rather than having a small one in the back.

Artists exercised all their abilities in depicting such a "bride of one night" mincing along in procession through the Yoshiwara's streets, accompanied by a retinue of servants, or by young apprentices who carried umbrellas, cosmetic cases, and other articles advertising the woman's worth and station.

Okada *character in a morality play*

Okada, a *ronin* from Akita, enjoyed going hunting with the new muskets recently introduced from Europe. His two daughters, being devout Buddhists, were worried by their father's zeal for killing animals. They decided to teach him a self-destructive lesson. One night, when Okada went out to stalk the white cranes that frequented a beach near his home, his daughters covered themselves with white robes and followed him. Just as they planned, he mistook them for cranes and shot both of them. When he discovered what he had done in his benighted ignorance, he understood at once how his daughters had sacrificed themselves for the sake of his spirit. He cremated their bodies on the spot where they had died, then went off to become a monk. He spent the rest of his life praying for their early release from the Six Realms of Rebirth.

Okatsu *ghost story*

Yurei Waterfall in Kurosaka is the abode of ghosts. Even the Shinto shrine beside it, dedicated to Taki Daimyojin, god of the waterfall, is so haunted that no one dares go near it after dark. Okatsu, a proud woman, nevertheless thought that she

could visit it without being harmed. She promised her doubting neighbors that she would bring back the shrine's moneybox as proof that she had been there. Okatsu strapped her baby son on her back, and walked the dark and difficult path. As she picked up Daimyojin's moneybox, a voice from the waterfall, full of menace, called her name twice. She did not ask what the voice wanted of her. Okatsu returned happily to the village. The neighbors gathered around, praising her courage. Then they noticed the red blood wetting the back of her kimono. They lifted her small son from the wrappings in which she carried him—and discovered that his head had been torn off.

Okazane *victim in ghost story*

Okazane was the jealous wife of Yoemon, a peasant of Meguro near Edo. One day she so enraged Yoemon that he killed her with a sickle and dumped her body into the nearest river. When he remarried, however, Okazane's spirit returned in fury, staring at him with one bulging eye, and biting angrily at the blade of a sickle like the one that had taken her life. Yoemon had to call on the Buddhist priest Yuten to pacify Okazane's rancorous spirit with prayers and sutra readings. Artists have treated Yoemon's murder weapon with considerable license, making it anything from a scythe to a bamboo cutter's knife. Sometimes they depict Okazane's hideous form, always with the staring eye, amid the flames of a fire beside which Yoemon is sitting.

Okiku *heroine of ghost story*

Two versions of Okiku's life are told. In the first, she is cruelly punished by her master for having accidentally broken one of ten valuable plates his parents had bought from the Dutch merchants of Nagasaki. Half-crazed with remorse and hunger, Okiku escapes from the cell where her master has locked her, and drowns herself in a well. Each night thereafter everyone in the household hears her voice issuing from her watery tomb, as she counts plates—until, having reached the ninth, she utters a cry most desperate because she cannot find the tenth.

In the second version, presented in a Kabuki play, Okiku's master hides one of the plates, hoping to frighten her into yielding to his sexual advances. When she rejects him, he kills her and throws her body into the well. Her spirit returns each night to haunt him, as she counts those plates, over and over again, searching for the missing one. Only the intercession of the priest Mitsukuni-shonin quiets her plaintive spirit. It passes into the body of a small insect, whose head looks like that of a phantom with long straggling hair.

Okuni *dancer, founder of Kabuki theatre*

Okuni began her extraordinary career by serving as a *miko*, or dancing priestess,

at the Grand Shrine in Izumo that is dedicated to the Shinto god Okuninushi no Mikoto. She fell in love with a samurai, Nagoya Sanza, and in 1603 went with him to Kyoto. In order to support themselves, they organized a small group of dancing girls, who presented shows for the city's commoners. Until that time merchants, artisans, craftsmen, laborers, and peasants had enjoyed no theatrical entertainments comparable to Noh. That was reserved for nobles, the gentry, and warriors.

Okuni, a woman of admirable adaptability, perseverance, and foresight (and apparently of beauty and talent as well) gave her first performance at Kitano Temmangu Shrine in northern Kyoto. Later, she set up her theatre on the dry pebble-strewn bed of the Kamo River, near Shijo, or Fourth Avenue. Okuni's new kind of show—full of pleasing songs, dances, comic turns, and racy dialogue in the vernacular, often referring to current events or popular fads of the moment attracted large audiences. Their applause, and the small but helpful sums of money they paid to see the troupe's performances, encouraged the company. Soon they added to the repertory a variety of short dramatic sketches, drawn from history or fable, in which Okuni herself frequently played the hero's role, dressing and acting like a man. Such seductive novelties drew even more customers to see Okuni's *shibai,* or make-believe plays.

Numerous artists have depicted Okuni in many costumes and poses, although only a few did so during her lifetime. The most recognizable representations of her depict her in a girl's kimono and a scarf, its ends tied under her chin. The kimono bears her crest: the famous *karigane no maru,* a highly stylized silhouette of a goose enclosed in a circle.

Okuninushi no Mikoto *Shinto deity*

According to one account, Okuninushi was the youngest of 80 brothers, all mean and violent except for him. Amiable and kind-hearted, he found no peace at home and so went off to stay with Susano-o, god of the sea and a distant relative. There he fell in love with Suzeri-hime, Susano-o's beautiful daughter. But the father frowned on the idea of their marriage until he had tested this unaggressive youth.

The *Kojiki* records that Susano-o put Okuninushi into a room filled with bees, centipedes, and snakes. He emerged unscathed from this ordeal, saved by the power in several of the magical scarves given to him by the sun goddess. With the help of a friendly rat, Okuninushi passed other tests—a trial by fire (during which he hid in an underground cave the rat had found) and the retrieving of a hidden forfeit, an arrow, (brought to him by the same useful rodent)—and won Princess Suzeri as his wife.

Okyo *sennin*

He served as governor of a western province in China during the Zhou dynasty. On the first day of each month, he regularly appeared at court to confer with the emperor. To everyone's amazement, he arrived in Beijing from his far-off headquarters without riding a horse or being carried in a carriage. The emperor and his advisers, suspecting that Okyo transported himself by magical means, resolved to put him to the test. One day, the emperor suddenly summoned him to the palace, and Okyo appeared immediately. On the following day, the same thing happened, but, just after Okyo appeared, watchers saw two drakes flying off to the west. On the third day they laid snare nets across the palace roof and captured a strong gander. Okyo disappeared—and the gander was transformed into an old shoe. Artists depict him traveling through the air, either upright or alone, carried on a pair of drakes, or on a gander. Okyo bears a strong resemblance to another *sennin,* Oshikyo.

Omori no Hikohichi *warrior*

On reaching his new post at Matsuyama on Shikoku Island, where he was to serve as governor of Iyo Province, Hikohichi arranged a series of celebrations for the important people to be held on successive nights. One evening, while going to see a play, he met a beautiful woman on the secluded path who said she was lost. As he guided her toward the festival she sighed with weariness, so he carried her on his back.

While crossing a quiet stream, he saw the reflection of the burden he was carrying—Hannya, a female demon, with fangs for teeth, a pair of sharp horns, great glittering eyes, and a face that made him cry out in horror. His shouts, and her mad screams as she struggled to drag him off, brought his retainers out just in time to rout the demon. Some people believed that she was the daughter of Kusunoki no Masashige, come to seek revenge for her father's death because Hikohichi had helped to defeat him at the battle of Minatogawa in 1336.

Oni *legendary creature*

The word, translated variously as devil, demon, imp, and ogre, is applied to several kinds of imaginary beings. The usual domestic form is a pest, a troublemaker, who shares your home or neighborhood, always at someone's cost. He delights in bothering people, but is rarely deadly. From a distance it looks more or less a human being, but a true *oni* can be identified by these telltale features: two short stumpy horns growing from the forehead; three fingers on each hand (and those tipped with talons rather than nails); and very scanty dress, consisting of little more than a length of cloth or a tiger's striped skin twisted about its loins. He will flee from the prayers

of good priests, the might of Shoki the demon-exterminator (when not teasing that dedicated but inept hunter), and during the exorcising ritual in which dried beans are scattered and the imprecation "*oni yarai*" ("Demons out!") is repeated.

Ono no Komachi (834-900) *poet*

In her younger years, she was beautiful, talented, proud, selfish, envied, and hated; when she grew old, she became ugly, ill in body if not of mind, and miserably poor. Still, she is famous as one of the *rokkasen,* or six most famous poets of the ninth century. Komachi appears often in art, in all eras, styles, and media. Out of her legend has grown a whole iconography, dominated by seven incidents, each one related to a poem she wrote. They are:

One—During a poetry contest at the imperial palace, an envious male rival accused Komachi of having stolen her verses from the *Manyoshu,* or *Collection of Myriad Leaves,* compiled about a hundred years before. To prove his charge, he produced a copy of the *Manyoshu,* opened to the page of the disputed verses. Komachi called for a basin of water and washed away fresh ink from the page, leaving unaffected the older entries. Shown as a cheat, the man confessed that he had heard Komachi reciting the poem to herself, and had written it into a copy of the *Manyoshu.* (The Noh play *Soshi-arai komachi* dramatizes this incident.)

Two—She sits on a cushion-mat, or *seki,* like the kind rich temples provide for the comfort of important guests.

Three—She visits Kiyomizu Temple in eastern Kyoto.

Four—She demands that a suitor, who wants to marry her, must bed her on 100 consecutive nights before she will consent to wed him. He arrives faithfully for 99 nights, but not for the hundredth—because he froze to death on the way to her side.

Five—The beauty of her verses brought rain to drought-stricken land, although the prayers of priests had failed to do so.

Six—Emperor Yozei (r. 877-84) sent her a note in verse, asking how she fared. She parroted his poem in her reply, changing only one character, but one that turned the question back on him.

Seven—Old and ugly, clad in rags, supported by a staff, she sits on a *sotoba,* or grave post, laid flat on the ground. She may be ready for death, begging for alms, or doing penance for having caused the death of the suitor.

Ono no Michikaze *calligrapher*

Michikaze (896-966) is regarded as one of Japan's three greatest masters of calligraphy. A frog taught him to persevere. While working as a government official in Kyoto,

he applied seven times for promotion, always to be passed over. (Some accounts say he failed to advance because, in his younger years, his writing of complicated Chinese characters was illegible.) Deeply discouraged, he planned to resign when, one day, while walking in the rain, he came on a little frog trying to reach some willow leaves hanging over a stream. Seven times the frog hopped up and failed, but on the eighth jump he succeeded. Taking this as a message from the gods, Michikaze did not resign. Not long afterwards he gained his promotion. Eventually he served as minister to two emperors, Shujaku (r. 931-46) and Murakami (r. 947-67). Artists find a favored theme in Michikaze and the frog. Usually they depict him in Heian court dress, with wide sleeves and a high curved black hat, holding an umbrella against the rain, standing beneath a willow tree, contemplating the frog in the mud below.

Ono no Oki *warrior*

Oki, a bodyguard to Emperor Yuryaku (r. 457-79), pursued and killed Komaro, a fearsome robber and magician who preyed on the people of Yamato Province. Artists usually portray Oki carrying Komaro's bloody head.

Ooiko *strong woman*

A farmer-neighbor, once foolish enough to quarrel with her, lost his whole rice crop when she tossed a huge stone into the watercourse that irrigated his fields, thereby cutting off his share of water. The famous wrestler, Saeki of Echizen—while on his way to Kyoto to take part in a grand Sumo tournament at the imperial palace—met Ooiko on the bridge at Takashima. For some reason, he slipped his arm under hers. In an instant, she clamped down on his arm, hauled him off to her house, and locked him up in a room. For food she gave him balls of rice that she had prepared by squeezing them so hard that they were as solid as rocks rolled along a river's bed. Rather than die of hunger in that shameful prison, Saeki exerted all his strength to break apart those compacted rice balls and chew those gritty morsels. Ooiko, not without humor, knew exactly what she was doing. She kept Saeki on that diet for a whole week before she released him. By then he was so strong that he defeated all opponents at the matches in Kyoto.

Ooka no Tadasuke *administrator and judge*

Tadasuke (1677-1751) served as civil governor of Edo during the time of Yoshimune, the eighth Tokugawa shogun (r. 1716-45). Tadasuke gained much respect for his shrewd inquiries and fair judgments—all achieved without recourse to torture, the technique usually employed by other magistrates. A book entitled *Ooka meiyo seidan* describes 43 of his more celebrated cases. Besides illustrating both his methods and his sagacity, they serve also as themes for many woodblock prints.

Through ingenuity, he found the thief who had robbed a pickler of *daikon* (who hid the stolen money-pouch at the bottom of a crock of fermenting *daikon*) by rounding up all the neighbors and smelling their hands. He detected the man who had stolen a gold tobacco pipe by ordering him to fill its bowl. The man fumbled so much, using too little tobacco one time, too much the next, that he could not possibly have been the owner. He determined which of two women who claimed a pretty child was the real mother by promising them that, if they could pull her apart, each could keep the portion of the girl that came away in her hands. The true mother stopped pulling at the child's first cry of pain. A cuckolded husband, driven to frenzy because he could not identify his wife's lover, took his problem to Tadasuke. He suspected a certain handsome young man, but could not prove him guilty. Tadasuke summoned to his office the husband, the wife, the suspect, a few neighbors, and the couple's cat. The cat climbed onto the suspect's lap, rather than onto his master's. Although the young man protested his innocence, Tadasuke forced him to admit his adultery.

Ooka no Tadasuke is also remembered for having been the governor who, in 1719, organized the firemen of the city into 48 well trained brigades. They became famous for their skill at extinguishing the beautiful but destructive "flowers of Edo" that blossomed so often in that great city. Some prints depict Tadasuke, mounted on a white horse, supervising the activities of the fire brigades.

Opening of the River (*kawabiraki*) *festival*

On the twentieth night of the seventh month, soon after the end of Obon—the festival for the dead—the common people of Edo would gather along the banks of the Sumida River, near the Ryogoku Bridge, and on the river itself, to celebrate the approaching harvest season. Pleasure boats, bearing colored lanterns, musicians, geisha, and other passengers, all regaled with food and drink, moved up and down the river. Other people held parties along its banks. The climax of the evening brought displays of fireworks fastened to the sides of the bridge as well as rockets blossoming in the dark sky above. Many artists, among them Hiroshige, depicted this colorful event.

Orange *as symbol*

Blossoms, leaves, fruits, and the tree itself serve as motifs in Japanese art. Other species of citrus are regarded almost as highly as the orange. As these plants are evergreen, they are symbols of longevity and good fortune. For this reason, one of the two consecrated trees growing in the great forecourt of the imperial palace in Kyoto is an orange (the other being a cherry). A favorite subject of artists is a

partly hollowed orange enclosing two seated sages playing a game of *go.* A comment in *Genji monogatari (The Tale of Genji)* indicates that since Heian times, the orange blossom has been a flower of remembrance.

Orangutan *as imagined*

Most Japanese never saw genuine orangutans, but imagined them (as they did elephants, lions, tigers, and other tropical beasts) from descriptions by the few travelers who had seen these animals in their native haunts. Artists who depicted orangutans gave them a vaguely anthropoid body, a human head with a child's face, and long reddish hair. Storytellers added the faculty of speech—with the voice of an infant.

Orchid *as symbol*

Japan's native species of orchids, known in general as *ran,* are neither plentiful nor ornate, as are the tropical kinds, but have always been admired for their fragile elegance. They are symbols of grace included in the Four Plants Loved by Artists. (The others are chrysanthemum, bamboo, and plum.)

Oshichi (also known as *Yaoya-Oshichi) juvenile delinquent*

When a greengrocer's store, at the front of his house in Edo, accidentally burned down, the owner sent his family to live at Ichigo Temple while a new house was being built. While there Oshichi, the greengrocer's thirteen-year-old daughter, fell passionately in love with a handsome novice named Kichisaburo. In the midst of this affair, Oshichi's father called the family back to their new home. In her longing for Kichisaburo, Oshichi deliberately set fire to the new house. A vengeful neighbor, whom she had rejected as a lover, saw her commit this criminal deed and reported it to the police. Despite her youth, Oshichi suffered the penalty exacted by law for arson: death by fire. On the day of her execution, Kichisaburo, a true son of a samurai, dressed himself in white robes of death and went to the place where she was to die. Kneeling on the ground near the stake, he committed *seppuku.*

Oshitsu *sennin*

Chinese know him as a Daoist patriarch, and their story about him is probably one of the earliest of the world's legends based on the Rip Van Winkle theme. They say he lived during the Jin dynasty, and that he was a woodcutter in the Quzhou Mountains. While working there one day, he entered a cave where he found several old men, bending over a game of *go.* After he had watched them for a while, one of the ancients offered him something that resembled a date seed to eat. Its taste was pleasing, its effect profound. He lost all sense of time, all need for food or drink. Hundreds of years passed. Then one of the chess players aroused him, saying,

"You've been here a long time. Now you should go home." Oshitsu found that his ax had rusted away, its handle crumbled into dust. His clothes hung about him in yellowed tatters. Only he had not aged. When he returned to his village, he found that his family and friends had died. Thus made aware of the illusions of this world, he retreated to the mountains and devoted the rest of his life to studying the Daoist mysteries. There, at last, he attained immortality.

Osho *sennin*

He was a pupil of the fairy Choyo Soshi. When Osho retired to a hermitage on Mount Tesa, about 34 miles from his teacher's abode, Choyo dispatched written messages to her pupil tied to the handle of an open umbrella which she sent sailing through the air. Osho is depicted, sitting on the ground, watching the umbrella-courier as it descends from the sky. Some artists, apparently mistaken, have shown him riding astride a furled umbrella, using it to carry him through the air.

Osono *martial female*

The only child of Ichimisai, a noted swordsman of Kyoto, Osono learned how to handle warriors' weapons and gained a certain fame of her own. Hokusai, in Volume 12 of his *Manga,* drew this Japanese amazon besting Benkei Musashibo on Gojo Bridge in Kyoto. Benkei challenged Osono to a passage at arms, but she, unimpressed, caught his spear under her arm and held it in an unbreakable hold. Benkei yielded to her the victory. More than likely this encounter took place only in Hokusai's imagination—having been suggested by Benkei's meeeting on Gojo Bridge with the boy Yoshitsune. Later, when Kyogaku Takumei slew Osono's father in a duel, she took up his sword and—while one of Ichimisai's pupils held off Takumei's henchmen—killed the killer.

Osugi and Otama *singers*

Like many others living along the highway leading to the Grand Shrines at Ise, Osugi and Otama depended for their livelihood on pilgrims going to and from the shrines. When Shunman, Edo's famous designer of colored prints, visited Ise, the two women attracted his attention. He immortalized them in one of his long narrow *surimono*—colored prints carefully produced for New Year greetings or special announcements—showing them sitting in a thatched booth by the side of the road, playing on *samisen* (a three-stringed, banjolike instrument) and singing for coins tossed to them by people passing by.

Otake *holy woman*

Otake, a very religious old woman who was a servant in a household in Edo, gave all her meager earnings to people less fortunate than herself. She ate very little, being

content with the bits of food she collected from the kitchen washtubs by means of a hempen bag tied over the inlet to the drain. A piece of that kitchen drain is preserved at Zojo Temple in Tokyo, where people still venerate Otake for her charity and piety.

Otokodate *"upright men"*

Late in the seventeenth century, after more than 50 years of the Tokugawa peace, the morale of the country's warriors was deteriorating, especially among samurai who lived in the big cities. To give them some purpose, and to help ease the warriors' boredom, a number of concerned leaders founded fraternal organizations, whose members were supposed to help the poor and weak against the oppression of powerful men. A single leader, known to his disciples as "father," headed each fraternity, and he ruled his men according to a code as rigid as that by which a *daimyo* governed his samurai. Commoners soon found a name for such champions of justice: *otokodate,* "men who stand up" above the ordinary, or "upright men." As the years passed these fraternal societies degenerated, becoming a kind of auxiliary police force for the shogunate, filled with racketeers, informers, procurers of laborers, and bosses of gangs. Eventually, the government suppressed the groups.

During their heyday, *otokodate* fascinated everyone, especially themselves. Artists depicted them in every medium, usually as heroes. During the Genroku Era (1688-1704), before the edict of suppression, many of the younger and wealthier showoffs vied with each other and with members of rival fraternities to be as conspicuous as possible in manner and dress. They wore expensive kimono in ostentatious, even bizarre, designs; and they walked arm-in-arm through the streets, talking loudly.

Otokomai *dances done by women dressed as men*

In the time of Emperor Toba (r. 1108-23), a female entertainer in Kyoto dressed herself in the robes of a nobleman while she performed certain dances that, until then, had been presented only by aristocratic males at the imperial court. Other women soon adopted this departure from the rule, performing the dances wearing cumbersome garments; high, curved, black headdresses; and, tucked under their belts, the small dagger and fan of a courtier. Later, other entertainers wore a full white tunic over the court robes. For this reason the dancers were called *shirabyoshi,* a punning term meaning "white cover" and "white rhythm maker." As times and customs changed, so did the apparel. In gaudier eras the dancers appeared in more sumptuous brocades, heavy with gold and silver, and stiff headdresses made of gold net.

Otoma *woman in doubt*

Otoma was a waitress in a teahouse beside a pond near the temple of Kanda-Myojin

in Edo. Two young men wanted to marry her, but she liked both equally well and could not choose one over the other. Otoma resolved their problem by drowning herself in the pond, which ever since has been called Otomagaike, Otoma's Pond. Artists portray her brooding beside a boiling teakettle as she ponders her dilemma.

Otsu-e *pictures in Otsu style*

Around 1700 a number of paintings appeared, depicting subjects taken from ordinary life, done in bright colors with figures strongly outlined in black ink. The artist, whose name is still unknown, portrayed common people, such as a young falconer, or a servant girl with wisteria blossoms, or fanciful creatures, such as a demon at his prayers. Some critics consider them to be more in the nature of caricatures than true portraits. The paintings were sold to travelers passing through the town of Otsu, the last station on the Tokaido before reaching Kyoto. People bought them as talismans to ensure good fortune and safe travel. Pictures in this bold style are still being produced.

Owl *as symbol*

In Japan, as in China, an owl is considered to be an ungrateful thing, capable of eating its own mother. Obviously, a bird so malign must be feared. Artists rarely used it as a motif, except as a talisman against evil.

Ox

Ushi, the word for ox in Japanese, is applied to several species as well as breeds of cattle, including the water buffalo. It does not distinguish whether the creatures are male, female, or neutered; horned, humped, or sleek. All these *ushi* have been depicted in art, but the favorite one is the ox. It was the primary beast of burden in old Japan, harnessed for pulling the nobleman's carriage or the farmer's plow. Even a peasant could ride on its back, as did priests, monks, hermits, merchants, sages, and poets. Whereas the horse was the steed of a warrior, the ox bore a man of peace.

Along with the blossoming peach tree and the flowering plum, the ox of the farm became an emblem of spring and of agriculture. It was chosen to be one of the twelve signs of the Eastern zodiac, thereby giving its name to one of the years in the duodecimal calendar, and to one of the double hours of the day. The ox served as a prophylactic talisman against many diseases, and as an emblem of good luck for drawing customers into a merchant's shop. A picture or carving of a resting ox, holding between his horns an image of Daikoku, the god of wealth, safeguarded a merchant's property and assured his prosperity. A boy playing a flute while riding on the back of an ox is the perfect representation of the pure heart expressing quiet joy at having found the Way. A reclining ox recalls the death of Laozi, when the

helpful beast ended its service after having carried the master to the west. Images of resting oxen, carved in stone or cast in bronze, lie before the shrines of Sugawara no Michizane in his apotheosis as god of literature: a black ox was Michizane's favorite mount in life; and when he died, the ox drawing his body to a distant graveyard chose Michizane's actual burial place by lying down in the middle of a road and refusing to go farther.

Pageant of Amida's Welcome (*mukaeko*) *Buddhist living tableau*

This enactment of the *raigo*—Amida Buddha's descent from paradise to welcome the newly released spirit of a true believer—was introduced by the priest Genshin (942-1017) at his temple on Mount Hiei, a few kilometers north of Kyoto. By the year 1018, a temple in Kyoto was presenting this edifying pageant at times when the *Lotus Sutra* was read to audiences of aristocratic laymen. Before long the idea of giving such a tableau spread to other temples, even to some in the provinces. In Kyoto, presentations became more elaborate with the years. As many as 30 "celestial cherubs" and 28 bodhisattva appeared in one production to the accompaniment of music from bells, drums, flutes, and other instruments. All performers wore painted masks and beautiful robes. Many *mukaeko* masks, carved from wood and artfully painted, are preserved in temple treasuries.

Pagoda *structure*

The pagoda originated in India as an edifice having only two or three stories built in or near a temple compound. The Indian pagoda is derived from the more ancient form of religious memorial known as a *stupa*, in which Buddhists preserved a relic of Shaka or of a holy successor. The several stories in a pagoda are symbols of the several heavens of Mount Sumeru, where bodhisattva dwell until they are reborn as Buddhas. The central pillar, which connects the firm earth in a pagoda's foundation

with the successive levels of the storied heavens and the aspiring finial, is the axis on which the world turns. In other words, it is the same as the shamanic ladder by which the spirit ascends from this world to heaven, and returns again when its quest is ended. Since a pagoda is such a direct link between earth and heaven, benevolent forces diffuse from it into the surroundings, holding off evil influences and bringing good fortune to the people. By the time Buddhism reached Japan, the pagoda had lost its original function as an enlarged *stupa,* and was built (much as spires on Christian churches) to serve as nothing more than a symbol of the Buddha's universe—and as evidence to men here below that the Buddha and his law are paramount.

The graceful finials at the tops of Japanese pagodas follow a prescribed pattern that is rich in symbolism and, at the same time, both practical and beautiful. The seven parts of a finial (ranging from bottom to top) are: (1) dew basin and (2) inverted bowl—these prevent seepage of water from dew, rain, or snow into the central supporting post, and symbolize the heavenly palaces in which Buddhas and bodhisattva dwell; (3) lotus flower—symbol of Buddha's throne; (4) nine rings or "umbrellas"—emblems of Buddha's sovereignty over the universe; (5) water-flames—the original symbolism of which has been forgotten in Japan, although they may have served to protect the structure from fire; (6) dragon vehicle—emblem of the spirit ascending to the heavens; and (7) shining above all things and all men, the sacred jewel, or *tama*—the emblem of purity and of Shaka's teachings. All these seven parts are fashioned from brass, copper, gold, or other gleaming and durable metals that reflect the light of the sun.

Pans on the Head *custom*

Adultery among samurai was forbidden and punished by death, but it seems to have been treated with more tolerance among commoners in some places. In the town of Tsukumi in Omi Province, according to a doubtful story, a woman who had committed adultery could not worship at a certain temple unless she wore on her head an iron pan for each secret lover she had taken. The reason and practicability for this quaint custom is unknown. Carved figures showing this revealing kind of headdress are called *nabe kaburi*—"pan heads" or "pot heads."

Paulownia (*Paulownia imperialis*) *as symbol*

The phoenix, a most fastidious bird, would rest only on the branch of a paulownia tree (the bird also restricted its diet to bamboo seeds). As a design, the leaves of the paulownia are everywhere to be found in Japanese art.

Peacock *in art*

This colorful bird was not introduced into Japan until the end of the seventeenth

century, and therefore was not well known to artists or the populace before that time. A few artists, however, managed to see one of the resplendent creatures in China, or a picture of it, or merely a tail feather, and from these glimpses created opulent paintings for reigning shoguns, wealthy *daimyo*, and great temples.

Peony *as motif*

Although Chinese fanciers developed many horticultural varieties of *Paeonia mutans* before the Japanese took an interest in it, the peony has been adopted in Japan, both as an important ornamental plant and as a motif in art. Enthusiasts in the two countries have bred dozens of hybrids that produce flowers of many sizes, shapes, and colors. Blossoms, buds, and leaves are represented not only in paintings, but also in decorations—especially those done in the style of the Momoyama Period (1573-1615)—for ceilings, beams, posts, sliding screen-walls, armor, sword guards, porcelain, and lacquer ware. Also, stylized to different degrees, they entered into the crests of many families. Both Chinese and Japanese use it to represent spring and as a symbol of wealth, honor, and good fortune.

Persimmon *tree of many uses*

The persimmon tree is beautiful at any time of year, but is especially so in the fall, when a few leaves, golden yellow, or lime green, or red against the lowering sky, still cling to the bough. The fruits, orange-yellow when ripe, with shiny skins, are painted in still-lifes or in pictures showing them being used as bait for monkeys. The fruits of a persimmon tree caused a feud between a cheating monkey and an annoyed crab. Dried persimmons, wrinkled and sugared, are offered to household gods and good friends at the New Year.

Phallic Symbols

These can be seen in wayside images, carved in stone or cement, of coupling deities; in festivals to celebrate their presence among humankind; in offerings of fruits, vegetables, or stones of phallic shape laid before images at local shrines; in talismans for potency sold at certain shrines; in wood carvings of certain gods of happiness (notably Fukurokuju, Benten, Saruta-hiko, and Uzume); in the *kokeshi* dolls that tourists buy by the thousands; in natural "man-stones" and "woman-stones," either lying where the gods deposited them or moved to shrines; and in memorial stones and tombstones of definitive shape. All of these, and many more, served as motifs in art as well as being objects of art in themselves.

Pheasant *as symbol*

Several varieties of this game bird are native to Japan. All are handsome, with their varicolored plumage. The *Kojiki* called the pheasant "the true bird of the moor."

Painters like to depict it among blossoming cherry trees, as symbols of spring. A pheasant became one of Momotaro's loyal companions in their war against the ogres of Onigashima, Island of Demons.

Picture Horses *votive offerings*

Great lords and rich commoners presented living horses to the deities of shrines and temples, as inducements to favor their requests. Poor men gave pictures of horses. These *e-ma* (literally, "picture horses") were drawn, painted, or printed on pieces of paper, cardboard, or smooth wood. They could be purchased in the precincts of the shrine or commissioned elsewhere. Such vast numbers of hopeful donors offered *e-ma* that many institutions had to construct special halls, or *e-ma-do,* to accommodate them. Smaller and less substantial *e-ma* soon disappeared, but many of the more sturdy paintings, done on wood, have survived for centuries. Eventually, pictures of things other than horses were presented, their subjects differing according to the interests of the petitioners. Nonetheless, whether a picture showed a huge fish or a diseased organ of the human body, people still called it an *e-ma.*

Pillar of Gensuke *human sacrifice*

When the *daimyo* of Izumo Province ordered his retainers to erect a bridge across the swift Matsue River, the water god washed out the stone foundations as fast as the masons made them. A sacrifice was needed, and a man named Gensuke was chosen to be buried alive in the foundation of the central pier. On the morning of his death Gensuke did not know that he was to be sacrificed. The diviners, leaving the choice to karma, said only that the first man who came along wearing a *hakama* (a wide-shouldered surcoat), over his kimono, but not a *machi,* or stiffener, beneath the formal overskirt, would be the one the god had chosen. Gensuke walked into the end his karma had ordained for him. The water god was satisfied with the offering and the bridge completed without further mishap. On moonless nights, Gensuke's spirit causes the central pillar to glow with a soft red light—or so it is said.

Pine *as symbol*

Several species of *Pinus* are native to Japan, and all are important features in the landscape as well as in the customs of the people. Everything about pine trees is auspicious. Since they are evergreen and able to live for centuries, they symbolize strength, endurance, longevity, and good fortune. They are the trees that appear most often in legends and fantasies. Their needles have the power to fend off demons and to dispel misfortunes. The gum of a pine tree, after a thousand years, changes into valuable amber. Twigs or branches are used in making *kadomatsu,* decorations for all significant occasions, especially for the New Year season. Designs employing both

cones and needles are used in most elegant ways, in making beautiful family crests, kimono patterns, brocades for obi, and objects of art. In Noh theatre, a splendid ancient pine tree, either real, growing in a tub, or represented by a painting, is, with painted cypresses, the only prop on the stage.

The red pine, *akamatsu* (*P. densiflora*), and the black pine, *kuromatsu* (*P. thunbergii*), are the most often depicted. Usually they are portrayed with other emblems of longevity, such as storks and tortoises, and bamboos and plums. The "pine of the sea," *umimatsu* (*P. karaiensis*), found only as a fossil now, is reclaimed from waterlogged places along seacoasts. Pieces of it are highly colored, yet mottled or even translucent in spots.

Plum Tree *as symbol*

Since it is the first tree to blossom in a new year, sometimes while snow still lies on the ground and on its branches, the plum is honored as the herald of spring. The flowers are a favored motif in art. Blossoms are produced in three color varieties: a pink so light that it is almost white; a pink and white; and the rare brilliant red. (A single tree will bear only one of these color varieties.) For the Japanese, the model plum tree is one that is old and gnarled, twisted, angular, leafless, having twigs almost as sharp as spines, a bark mottled with lichens or whitened with snow—the whole composition stark against a wintry background, yet showing proof of life in a single branch that has burst into bloom.

The plum is an emblem of hardiness and longevity. As one of "the three companions of the deep cold," it appears often with its related emblems, the pine and the bamboo. It is the motif for innumerable variants used as crests. In art, as in nature, plum petals always have rounded tips, while those of the cherry almost always end in two little points.

Pomegranate *as symbol*

Since it was introduced relatively late in the Far East, the pomegranate is a rather unusual motif in Japanese art. Nonetheless, in Japan, as in China, its abundance of seeds (all of which are viable) makes the pomegranate symbolic of a family blessed with many children. In consequence, it is the fruit of happiness. It is also the special attribute of Kishi-bojin, the Buddhist divinity who protects children. A few families adopted it as the motif for their crests.

Praying at the Hour of the Ox (*ushi toki mairi*) *ritual of black magic*

Women driven mad with unrequited love—or with hate—had recourse to this malevolent exercise in black magic. A priestess or the vengeful woman herself would go to a shrine at the hour of the ox (between 2 and 4 o'clock in the morning), when

the good forces of earth and heaven are at their lowest ebb and the evil ones are strongest. She would carry in her right hand a hammer and some nails, in her left a puppet made of straw, representing the faithless lover, or some other enemy she wished to destroy. Just to be sure that no mistake was made, he was identified by name and rank, clearly written on a length of pure white paper. Like a *miko*, or female shaman, she would be wearing loose white robes and high wooden clogs; her hair would be hanging disheveled about her face and shoulders; and on her head she wore an iron crown holding three lighted candles. She would nail the effigy to a sacred tree growing in the shrine's compound. As she did so, she would utter the prayers that asked for the death of her enemy or for whatever lesser misfortune she wished to befall him. In her prayers, she must be careful to promise that, as soon as the petition is answered, she herself will draw out the nails that are giving hurt to the god in the tree. If she performed this baleful rite for several mornings in succession, her prayers would certainly be answered, for surely the god, to save his tree, would strike down the hated enemy.

Praying Mantis *as symbol*

This weird and fragile insect, resembling a thin stick with four, long angular legs, is an emblem of military courage in both China and Japan because it always advances and never retreats. The banners of learned generals sometimes showed a device combining a praying mantis, a cicada, and a spider, the symbols of a good leader's major virtues—courage, humaneness, and skill. Artists who depicted a praying mantis with a carriage wheel (usually broken and abandoned) are illustrating the old Chinese legend that teaches the lessons exemplified by this resolute creature.

Precious Things (*takaramono*)

These are the gifts that the *takarabune,* the treasure ship bearing The Seven Gods of Good Fortune, is supposed to bring when it comes into port on New Year's Day. In some representations, these treasures are stuffed into the capacious bag of Hotei, the god of happiness. In others, they are heaped aboard the ship, with or without the attendant gods.

According to Hokusai, among these precious things are: the hat and cloak of invisibility (protection against evil spirits); sacred keys to the gods' storehouse (wealth); books (wisdom); flaming sacred jewels (purity in mind and spirit); and a number of other things like cash and coral that symbolize wealth and abundance in all things.

Prostitutes *as an institution*

Prostitutes (*joro*), of all ranks and degrees of wealth, beauty, and fame, are subjects

often shown in *ukiyo-e*—pictures of the "floating world," a name given by the Japanese to neighborhoods where sex is for sale. Several clues help to distinguish *joro* from other women. In general, *joro* are likely to be wearing kimono of unusually rich materials that flaunt eye-catching designs. Grand *oiran* added to this basic apparel the confection of an enormous obi, worn at the front of her body rather than on its back. *Joro* are also distinguished by elaborate coiffures—thick black hair worn in long manes arranged in a variety of elaborate styles and bedecked with costly hairpins or other ornaments of inordinate length. The company *joro* keep and—when they are off-duty—their relaxed postures and informal clothing also help to identify them.

Quail *as symbol*

A symbol of autumn, the quail is shown in combination with other signs of the season, such as flowering grasses, ripening millet, and persimmons on the branch. The bird has a reputation for amorousness. The old superstition that rats, mice, shrews, and other small rodents can transform themselves into quail was rarely illustrated.

Rabbit *in folklore*

Like the fox, the rabbit of folklore lives for a very long time. When it is 500 years old, it turns white. (Some accounts say it turns blue, and only becomes white in its thousandth year.) The rabbit is not malicious, and possesses none of the fox's magical powers. It is the Japanese Man in the Moon, as well as one of the twelve animal symbols of the Eastern zodiac.

The rabbit is the distinguishing emblem for several divinities worshipped as moon deities. Gessho-ten, goddess of the moon, holds a white rabbit in her hands. Gat-ten, one of The Twelve Heavenly Kings, a moon god derived from the Brahmans' Chandra, regent of the moon, holds in his right hand a full moon in which a white rabbit is enclosed. Jigaisho, "the remover of difficulties," supports with both hands a crescent moon, on which rests a white rabbit. The theme most often represented in Japanese art shows the rabbit in the moon with the elixir of life, or pounding rice-flour with which to make cakes (*mochi*).

Radish *as symbol*

The long white root of *Raphanus sativus* (called *daikon*, or great root, by the Japanese) is an important food, either in its fresh state or when pickled. Unmistakably phallic in shape, it is an obvious symbol of longevity and vigor. As such, it is offered as a New Year gift to family deities. The best of the pick are laid in approved positions before

wayside images of Dosojin, the coupling god and goddess, or on altars in Shinto shrines. The *daikon* is also the symbol of Shoten, the elephant-headed god.

Ragyo *legendary priest*

At least 800 years before Buddhism was introduced to Japan, a storm-driven ship carrying seven passengers from India arrived at Kumano, on the eastern coast of Kii Province. After the storm abated, six of those strangers sailed away, but one remained at Kumano. His only garment was a *kesa,* a sort of scarf knotted over the left shoulder that Buddhist priests wear. For this reason, the people of Kumano called him Ragyo, or naked person.

Ragyo went up into the mountains of Kii, until he came to the waterfall at Nachi. (One of the highest in Japan, it plunges for 130 meters into a deep pool.) For 700 years he dwelled there, standing beneath the plunging water each day, sitting beside it each night, practicing austerities, praying, waiting. At last a small bronze image, borne on a cloud, rose out of the pool. Ragyo received it with gratitude and carried it to a safe place nearby. He built a small wooden shrine for it and worshipped this heaven-sent statue until he died. With him gone, the shrine decayed; the image fell amid the moldering ruins; even Ragyo was forgotten.

During the seventh century, about a hundred years after priests from China and Korea brought Buddhism to Japan, Ragyo appeared in a vision to a man named Shobutsu, telling him to look for a bronze image beside the pool of Nachi. Shobutsu searched long and hard before he found it. He recognized it as an image of eleven-headed Kannon, a bodhisattva of compassion. When Emperor Kotoku (r. 646-54) heard of this miracle, he commanded that a new temple be built where Kannon might be worshipped beside the waterfall. The gilt bronze statue, 31.5 centimeters in height, is now preserved in Tokyo National Museum. A larger wooden version of this sacred image stands in Seiganto, the temple beside the pool of Nachi Falls, which is the starting place for pilgrims who visit The Thirty-three Holy Places of Kannon in the western provinces.

Raigo Ajari (also known as *Jitsusobo*) *vengeful priest*

Raigo, a member of the proud Fujiwara clan and a priest in Mii Temple near Lake Biwa, served as adviser to Emperor Shirakawa (r. 1072-86). In consequence of Raigo's prayers on behalf of the childless emperor and empress, Crown Prince Atsuhisa was born in 1079. The grateful sovereign offered Raigo any reward he wished. The priest asked for one of the few things the emperor could not give—a dais for his temple, from where his priests could offer up their prayers. Ancient privilege reserved this right for a temple on Mount Hiei, whose unruly soldier-priests would have protested

Raijin

violently at the loss of their temple's distinction. Shirakawa was forced to decline Raigo's request.

Raigo returned to Mii Temple and locked himself in his cell. Despite the emperor's efforts to soothe him, he would not relent nor return to court. He died in 1084—having starved to death. Soon afterwards, Crown Prince Atsuhisa followed him into the world of darkness. Raigo's spirit, not yet appeased, entered into a thousand rats. They ravaged Mii Temple, devouring everything in sight, including flowers on the altars, sacred books, priestly vestments, even the fish-mouthed drums.

Artists have portrayed Raigo as an ugly, raging old man, spewing a stream of curses into the air, ripping to shreds a letter from the emperor, while in the background cowers the court noble who brought the placating message from the palace.

Raijin (also known as Raiden) *thunder god*

Sometimes he is depicted, along with Futen, the god of wind, as a companion attendant to Thousand-armed Kannon. Most of the time, in Japan, he is little more than a nature god and a subject for jokes. Raijin resembles a furious demon, with a choleric countenance, bulging eyes, mouth opened to roar, an unclothed body made of knotted muscles and vehemence (sometimes painted red and white), claws rather than fingers and toes, two horns on his head, and an absolute detestation for peace and quiet. Loudly announcing his presence wherever he goes, he beats on either one huge drum or on a whole battery of smaller ones, hung in a chain around his neck, or flung in an arc above his head. For drumsticks he uses thunderbolts, one in each clawlike hand. When he bangs on those drums, causing thunder to roll and storms to roil, great damage is done to the works of man for miles around. Additionally, strange creatures called *raiju* are knocked out of the clouds and add to the damage.

Raicho, the thunderbird, rarely seen but often heard, resembles a huge crow. His spurs are big and fleshy, and he beats one against the other while he flaps around in the murky sky, making frightening sounds. Raicho and *raiju* are not the only things one has to fear during a thunderstorm—Raijin liked to chew on people's navels.

Artists have not treated Raijin respectfully. They have made him little more than a bumbler, always falling out of clouds, breaking a drumskin, losing his thunderbolts, or doing something equally stupid. They almost always portray him rubbing whatever part of his body has been hurt in falling from the sky—from lumps on the head to a bruised bottom.

This is something of a paradox when one considers that Raijin, with some help from Futen, saved Japan when the Mongol hordes of Kublai Khan invaded; or that he can strike terror into the hearts of the flippant, and smite the wicked with

destruction. Sugawara no Michizane, in the year 909, borrowed Raijin's might when he stormed through the imperial palace, blasting into the next world one of his worst enemies. In 1160, also in the holy city of Kyoto, at the very instant of his beheading, the spirit of Minamoto no Yoshihira transformed itself into Raijin and, with a blaze of lightning, killed his executioner.

Rakan (*Skt., arhat; Ch., lohan*) *Buddhist saint*

Arhat, lohan, rakan—each of these words means "deserving" or "worthy" or "meritorious," and to Buddhists the epithet identifies a sanctified man. *Rakan* are therefore holy men who, by study and meditation, have conquered all passions and desires, thereby freeing themselves from the ties of this world and from the bonds of rebirth in future incarnations. For those reasons alone they are deserving of worship, but even more important is their willingness to obey Shaka's instructions to delay achieving that bliss for the sake of the people who have not yet attained enlightenment. *Rakan* must remain on earth during the 5,000 years that are to pass between the death of Shaka and the arrival of Maitreya, the Future Buddha.

Rakan are often represented in Japanese religious art, either alone, in small groups, or as attendants on Shaka. Most share a number of attributes that help to distinguish them as a group: the shaven head of a priest (except for Rakora-sonja, the son of Shaka, who is only partly bald, still keeping wavy locks over his ears and neck); a big halo; enlarged earlobes, the sign of great wisdom; long bushy eyebrows, denoting venerable age (again except in Rakora's case); and the priest's light cloak, knotted over the left shoulder. In sculpture, one or more of these clues may be omitted.

Ranha *sennin*

Recently appointed as a minister to serve one of the late Han emperors, Ranha appeared at the palace for his first audience. The emperor offered him a cup of wine. Instead of swallowing the beverage, Ranha sprayed it from his mouth, toward the southwest. The emperor demanded an explanation for such uncouth behavior. Ranha explained how, at that moment, he perceived that his house in far-off Sichuan was burning and that he was using the wine to put out the flames.

Rashomon *historic gate*

The great portal at the center of the southern wall surrounding Heian Kyo, through which people entered or left the capital at that end of the city, was named Rashomon, or Silk Castle Gate. Between 794, when the city was founded, and the start of Emperor Enyu's reign (r. 970-84), Rashomon was maintained properly. After Enyu began to rule, however, it became little more than a decaying ruin. Kyoto's poorest people lived in the adjoining wards; and bandits, thieves, beggars, cutthroats, outcasts,

cripples, and other misfits gathered around Rashomon by day and used it by night for their lawless commerce. Uninvolved citizens kept away from this "Gate of Hell," and preferred to believe that "demons" and "ghosts," rather than predatory human beings, committed the crimes that made decent folk shun the place. The gate itself, and many people and legends associated with it, have been dramatic subjects for artists of all eras. Perhaps the legend of Watanabe no Tsuna and the demon of the gate is the one most often encountered in Japanese art. The gate has served as an important setting in two classic Japanese films, *Rashomon* (1950) and *Jigokumon* ("Gate of Hell," 1953).

Rat *as symbol*

The rat, a Japanese zodiac animal, is the messenger and companion of Daikoku, the god of wealth, and as such was thought to attract the god to one's house. Rats, and their smaller relatives, mice, became favorite motifs. As both the Chinese and Japanese believed that rats could transform themselves into quails, some jesting artists created a fantastic hybrid, having the body of a quail, the four feet of a rat, and the long queue of a Chinese man.

Revenge in Ueno (also known as *Kazuma's Revenge*) *seventeenth-century vendetta*

In Ueno, the chief town of Iga Province, lived Watanabe Kazuma, a samurai. Nearby, in Yamato Province, lived Araki Mataemon, also a samurai. Mataemon married Kazuma's sister, and the two men were fast friends. In 1631, in an outburst of temper provoked by a misunderstanding over an heirloom sword, a samurai named Kawai Matagoro killed Kazuma's brother, Yukie. Kazuma asked his lord to release him from service while he avenged his brother's murder. Mataemon asked for the same release from his lord. Together the two *ronin* hunted down Matagoro, who had fled from the scene of his crime. Four years later, in 1635, they found him and took their revenge. Their liege lords welcomed them back into service as samurai, and raised the annual income of each to 1,000 *koku* of rice. The long and involved story of the reasons causing Matagoro to commit his violent deed, and the course of events leading up to Kazuma's revenge, provide the plot of a famous Kabuki play, *Igagoe Dochu Sugoroku,* or *Through the Iga Pass,* written in 1783 by Chikamatsu Hanji.

Rhinoceros Horn *medicinal ingredient*

Like their neighbors in Asia, the Japanese prized the hard and upright rhinoceros' horn. Powder scraped from that rare and costly thing possessed many virtues. It was much in demand as an aphrodisiac. Suspicious rulers used it to detect poisons slipped into their food and drink. Physicians prescribed it, believing it to be efficacious in treating certain kinds of maladies. During Heian times aristocrats and court people

(the only ones who could afford such costly imported articles) hung rhinoceros horns above one end of sleeping platforms to prevent sickness. (A pair of mirrors was hung at the platform's other end to prevent evil spirits from entering.)

Rihappyaku *sennin*

This Daoist immortal lived for more than 800 years during the span of three imperial dynasties. He practiced austerities and studied alchemy; the elixir of longevity he compounded undoubtedly explains his great age. At the end, he simply disappeared from this earth, leaving no trace. His Japanese name celebrates his ability to travel 800 *ri* (one *ri* = 2.44 miles) in a single day.

Riko *legendary archer*

Japanese storytellers lifted the famous Riko from Chinese texts, clad him in samurai's armor, and artists depicted him in a memorable exploit. At dusk, while riding homeward on his horse, he thought he saw a tiger slinking through the tall grass. Riko whipped out his bow and arrow, aimed, and sped a shaft toward the target. When he approached the animal, prostrate on the ground, he discovered that it was a great rock—pierced through by his arrow.

Rinnasei *poet*

Lin Hejing (*Rinnasei* in Japan), a good poet, was so unassuming that he never wrote his verses on pieces of paper to pass among friends, or to accumulate in his desk. He recited those verses, once or twice, and for him that was reward enough. He did not approve of men so vain that they published their scribblings, thereby burdening future generations with works that did not merit being read or remembered. He is usually shown gazing on his favorite plum trees, in the company of one or two cranes—all symbols of the immortality his modesty has won him. Sometimes he is paired with Sugawara no Michizane, Japan's great poet and god of literature, who also loved plum trees more than all other kinds.

Rinreiso *sennin*

In his youth he studied to be a Buddhist priest, but was so unruly that the elders dismissed him from the temple school. He then turned to Daoism, and became an adept in its rituals. He claimed his supernatural powers could control the weather, causing rain to fall or sun to shine as he willed. In 1116 the Song Emperor Huizong (r. 1101-26) added Rinreiso to his staff of magicians. Soon he exerted great influence over the emperor, converting him to the Dao. Before long, emperor and magician were conspiring to destroy Buddhism in China. But in 1120, when repeated floods threatened the imperial capital, Rinreiso's vaunted powers failed to protect the city. He fell from grace, was banished, and died within the same year. The most famous

incident in Rinreiso's career occurred while he still enjoyed the emperor's favor. One day, the twelve court magicians demonstrated their abilities before the assembled officials and the emperor. Rinreiso surpassed all his colleagues. He blew a spray of water from his mouth. The droplets coalesced into five-colored clouds, one bore a golden dragon, another a lion, and each of three others a stork. (Later, the people saw those storks hopping and crying in front of a temple.)

Even such a triumph did not satisfy Rinreiso's vanity. He contrived the death of his chief rival, Oinsei. Although in many respects Rinreiso was a malignant man, people could not deny that he was a powerful magician. Artists have portrayed him with long hair and a beard, seated sideways on the back of a resting *kirin*. Sometimes two storks are added to the group.

Rinzo *revolving Buddhist library*

This "turning library with eight faces" is both a storage cabinet for sacred writings and an elaborate kind of prayer wheel. Every time it is turned, every word enclosed in it is "repeated." It can be made either of wood or of metal.

Rinzu *type of textile*

Around the year 1600, silk weavers in Kyoto developed techniques enabling them to work into the designs of their fabrics seemingly endless repetitions of a chosen motif. Favorite patterns of the time for *rinzu* employed stylized geometric motifs, such as keys, tiles, commas, sticks, lozenges, rectangles, and flowers, especially chrysanthemums, plums, and irises.

Roben *Buddhist priest*

The gods chose Roben (689-773), a farmer's son in Omi Province, to be a great priest. When he was only two years old, an eagle swooped down on the child, plucked him from the spot where his mother had placed him while she worked in a nearby field, and flew with him to Kasuga Shrine in Nara, more than 100 kilometers away. The abbot of the shrine raised the boy to be a learned priest, who took the name Roben. In the course of his long life Roben became a renowned writer and painter, and also helped to unite Buddhist and Shinto beliefs in the doctrines of the Ryobu-shinto. In 746, during his term as the first abbot of the great new Todai Temple in Nara, Roben supervised the installation of the immense bronze image of the Buddha that is one of the glories of the Nara Period. Many other carved images made at Roben's direction are still preserved.

Rocks and Stones *in folklore*

In addition to obviously phallic stones, many other rocks or stones are subjects of legends or objects of respect because of a distinctive shape, color, or location. Spirits

may dwell in them. Some are considered to be *fukuishi,* good luck stones. Such a stone stands near Enoshima, the island near Kamakura. Thousands of pilgrims touch it each year in hope of improving their fortunes. Rocks set in gardens are thought to be guardians against the intrusion of malevolent forces.

The frog stone, on Enoshima itself, has been famous for centuries. The *myotonoseki,* the pair of "married stones" rising from the sea at Futamigawara, are thought to represent the creator couple Izanagi and Inazumi. They are joined across a considerable distance by a huge shimenawa (rope) of plaited rice straw. The *bofuseki,* "weeping-wife stone," at Matsuura, is a proof of the wifely devotion shown by Princess Sayo-hime as her husband sailed away to war.

A rock at Izumo, they say, talks like a human being; and at Sayo no Nakahama, another stone cries out at night like a man in torment. The Noh play entitled *Sesshoseki,* or *Death Stone,* in which Tamamo no Mae is the bewitching heroine, tells of the poisonous stones that are strewn about the slopes of the volcano, Mount Nasu.

Many rocks and boulders, impervious to ordinary mortals, have allowed heroes to pierce them with arrows or slice them with swords, and some have even gushed water at the touch of a great man's bow, spear, or staff. Benkei Musashibo drove spikes into a boulder, using his bare fists as a hammer. And near Kyoto stood the *kagami iwa,* "mirror rock," a tall boulder whose one side was so smooth that people could see themselves in it. Yamaguchi Soken painted a famous picture portraying a pretty young woman studying her reflection in this natural mirror.

When the wife of Ariyaku Saemon (the first man to climb to the top of a high mountain near his home) set out to repeat his deed despite the gods' decree that women should not stand on the summits of sacred mountains, the deities of heaven stopped her. The block of stone into which they transformed her lies on the side of Mount Take. It is called *obaishi,* "woman rock."

Some of the famous gardens in Japan were made during the Muromachi Period (1392-1573), under the influence of Zen masters. These gardens are celebrated as much for the manner in which their stones are arranged as for the ponds of water or the shrubs and trees that adorn them. Perhaps the most celebrated garden of all is the one at Ryoan Temple in Kyoto. It consists of nothing more than fifteen handsome stones perfectly placed in a bed of raked gravel. To the perceptive, these fifteen rocks, set in five places, in groups of five, three, and two, resemble islands in a lake. Other Kyoto gardens that display rocks and stones to beautiful advantage can be found at Katsura Detached Villa, the Gold and Silver Pavilions, Daitoku Temple, and Saiho Temple (better known as Kokedera, the Moss Temple).

Rogyoku

Rogyoku *sennin*

She was the daughter of Mu Wang, fifth emperor of the Zhou dynasty (c. 1000 BCE). She accompanied her father to the gardens of Seiobo, Queen of the West. Artists represent Rogyoku clad in sumptuous robes and playing on a harp, while being carried through the air on the back of a phoenix.

Rohan *Ch. strong man and engineer*

Rohan lived about the time of Confucius. He was a most ingenious craftsman. When men from the state of Wu killed his father, Rohan carved a wooden image of a genie with an outstretched hand, and placed it so that its accusing finger pointed towards Wu. A drought lasting for three years afflicted Rohan's enemies. Not until they begged him to remove that baleful figure—and paid him blood money for his dead father—did he relent. He cut off the effigy's hand, and at once rain began to fall on parched Wu.

Rohan also built a stone bridge across a stream near the castle of Chang-tan. While he stood under the finished structure, inspecting it, a braggart named Choshin came along, riding on a donkey. He claimed he could make the bridge tremble. He urged his donkey so furiously that its hoofs scratched the flagstones paving the bridge. But Rohan, under the arch, grasped the piers so firmly that the marks of his fingers were pressed forever into the stones. The bridge did not tremble. The Chinese regard him as the protector of carpenters and masons.

Rokurokubi *legendary creatures*

These grotesque goblins live in caves in the westernmost provinces of China, and eat only reptiles for food. *Rokurokubi* may have tangled hair or be bald; their robes may be plain or have simple designs. The most amazing thing about one of these creatures is its neck, which can be extended or shortened, like a coiled spring. The creature can twist its head about in any direction, and enjoys thrusting its ugly face, often upside-down, into the vision of contemplative monks, diligent students, even sleepers lost in dreams. Sometimes a *rokurokubi* is shown towering over the diminutive figure of a cowering human being.

Rokusuke (also known as *Magohei Muneharu) warrior*

A retainer of Toyotomi Hideyoshi, Rokusuke was famous for two achievements: his great strength as a wrestler; and his phenomenal good fortune in having captured a *kappa,* a kind of water demon. Some artists have pictured him in the midst of that experience because he is one of the very few men who have lived to tell about it.

Ronin *samurai without a lord*

Ronin means "wave-man." The word expresses the Japanese conviction that a warrior

who has no lord to care for him is like a piece of wreckage on the sea. A samurai became a *ronin* for a number of reasons. Some men chose to be set free, preferring to drop out of the system in the only permitted way. Sometimes a lord himself (or the clan council in his name) released a samurai from allegiance, usually for reasons of economy or punishment. On rare occasions the central government intervened to degrade a single warrior or to eliminate a whole clan. Such a judgment abolished the Ako clan, and created the lordless samurai who became the famous Forty-seven Faithful Ronin.

A *ronin,* by definition, lost caste and place. He could remain a warrior of sorts, supporting himself as a bodyguard or mercenary. If he gave up his samurai's profession and status, he sank in the social scale to be absorbed into the despised merchant class, the abused peasantry, or the withdrawn, unnoticed religious brotherhoods. Government officials tolerated *ronin* who abided by the law. But if they became troublesome, as did the worse brigands and more inept rebels, the government eliminated them by exile or execution. The regimented society of Japan viewed all *ronin*, whether good men or bad, with suspicion.

Some *ronin,* after enjoying freedom for a while, returned meekly to the establishment—if they were fortunate enough to be accepted into the service of the old lord, or of a new one. Many, to be sure, succeeded in more peaceful careers. Chikamatsu Monzaemon (1653-1724), for example, became a great writer of plays for Noh and Kabuki; Kyokutei Bakin (1767-1858) became one of Japan's foremost novelists; Mitsui Sokubei (?-1633) started a soy sauce and sake brewery that ultimately, with the help of his wife and many able descendants, grew into the immense complex of enterprises that still bears his family's name. After the Meiji Restoration in 1868, dozens of young samurai, eager to study foreign ways, chose to be *ronin.*

Rosary *religious implement*

Buddhists, too, use strings of beads to help them count their prayers. The Japanese have developed several variations on the original Indian chaplet. The most common form in Japan links 112 beads in a single chain, four more than the standard Indian or Chinese model. Some devout folk add shorter chaplets to this long chain. Shorter rosaries exist as well: portraits of priests and saints portray them holding on the wrist the short *"rakan rosary,"* made with only eighteen beads. The rosaries of poor people are made of seeds or cheap glass beads. Richer people, and church prelates, use costlier materials: semiprecious stones, gold and silver, precious jewels, pearls, amber, jade, ivory, or (in a nice touch of humility) common seeds or beads interspersed with gems.

Rosei's Dream *fable*

This Chinese fable concerns Rosei, a man with large ambitions but small experience. Dissatisfied with the dull life in his provincial town, he decided to be a counselor to the emperor. Along the way to the capital he met a man named Roko who, after hearing his story, gave him a pillow. Although Rosei did not know this, Roko happened to be a wizard, and the pillow possessed certain magical powers. That evening, while Rosei waited at an inn for his dinner of millet soup to be prepared, he eased his tired body by taking a short nap, resting his head on Roko's pillow. He dreamed of fame, glory, food, women, power, riches—every enjoyment he had ever wanted, even to the point where he was about to mount the Dragon Throne as the Son of Heaven. And then the innkeeper awakened him with word that his supper was ready. Having learned in one easy lesson the wisdom of the sages—that life is no more than a dream, and that everything in it is as fleeting as the warmth in a cup of millet soup—Rosei went home, sadder but smarter. Artists portray him napping, his head resting on Roko's pillow, often holding a fan over his face, while dreams of glory are revealed in vaporous clouds above his body or on the fan itself.

Ryobu-shinto *creed*

This tactful philosophy, meaning "both paths to salvation," declares that Shinto and Buddhism are but different manifestations of the same gods and their laws. The gods of old, honored by Shinto, were actually *gongen,* temporary and local versions of the even older and more powerful Buddhist deities, according to Buddhist preachers. This synthesis of beliefs worked to the advantage of Buddhism until 1868, when the promoters of the Meiji Restoration (strongly influenced by nationalist scholars of the eighteenth century and by chauvinists of the nineteenth) established Shinto as the state religion. Buddhism has not yet recovered from that blow. Naturally, in art as in religion, Ryobu-shinto allowed a rich mixing of themes and motifs previously segregated according to creed.

Ryochu *monk-warrior*

Ryochu, a member of the Fujiwara clan, was a monk who entered the service of his friend Prince Morinaga, the martial son of Emperor Go-Daigo (r. 1319-38). During the war between the Ashikaga and the Hojo clans, Ryochu helped the imperial family as both messenger and soldier. While assisting the emperor in fleeing from Kyoto, Ryochu was captured by Ashikaga troops and imprisoned. He broke down the door of his cell and escaped to the side of Prince Morinaga. This is the incident from his short life most often depicted. Later, when weak-willed Go-Daigo delivered his son Morinaga into the hands of the Ashikaga, loyal Ryochu was one of the 30 retainers

who accompanied the prince into captivity and death.

Ryoko *empress*

Known as Lu Hou in China, she was the principal wife of Emperor Gaozu, founder of the Han dynasty (221 BCE-220). Vicious and vindictive toward almost everyone, Lu Hou is remembered especially for her savage treatment of Lady Zi, one of Gaozu's concubines. Lu Hou poisoned Lady Zi's son while the emperor still lived; and, as soon as Gaozu died, she put Lady Zi to the most brutal torture. Executioners first cut off her hands and then her feet, after which they tore out her eyes, tongue, and ears. They tossed her body, still alive, on to a dung heap. Lu Hou called her own son, the new emperor, to look on at this "human sow." The young sovereign went mad at the awful sight, and stayed demented until he died. During those years Lu Hou ruled as regent. With his death, Lu Hou proclaimed herself empress and, through a policy of terror, bribery, and calculated wickedness, reigned until she died (180 BCE).

Ryokyo *sennin*

Ryokyo, an herbalist, went often into the mountains to gather medicinal plants. One day, on Mount Taigyo, he met three old men who also were collecting herbs. They invited him to join them, and to test some of their remedies and potions. Ryokyo stayed with them for two instructive days. When he returned to his village, he learned that 200 years had passed since he had left home. Of all of his family, only one very ancient man professed to be a descendant. After teaching him his magical skills, Ryokyo departed, entering the realm of the immortals.

Ryujin *dragon king*

The Japanese borrowed Ryujin from China, the dragon country, and gave him the sea for his kingdom. They put two pearls, or *tama,* in his hands, as symbols of his control over the tides. With his two daughters, Toyotama-hime and Oto-hime, he lived in a wondrously beautiful palace at the bottom of the ocean. At least twice Ryujin loaned the tide-controlling jewels to deities who needed them for a while: first to Hikohohodemi no Mikoto, the husband of Toyotama-hime; and later to Regent Kogo, the mother of Emperor Ojin, who was a descendant of Princess Toyotama, and therefore of Ryujin himself.

Ryujin is usually portrayed as an old man with a green complexion, a fierce countenance, and a long beard. As befits his origin, he wears robes in the Chinese style. Sometimes he is shown with a dragon's body and tail, but more often he is given a human body, identified by a dragon-shaped crown or other headdress of some sort. He may hold the tide-governing jewels (*tama*), one in either hand, or an attendant may carry them. His two principal servitors have curly hair, but an octopus

rides on the head and shoulders of one, a dragon on those of the other. Lesser servants, if they are depicted, look much like *oni,* those two-horned demons, or are given the heads of different kinds of fish; and their robes may be decked with shells, sea weeds, fish, and other products of the ocean.

When put out, quick-tempered Ryujin blows up sudden storms at sea, as the stories about Princess Tachibana and Ki no Tsurayuki prove. On the other hand, if Ryujin is approached properly, or simply takes a liking to a mortal, he can be very kind, as the tales about Urashima Taro, Tawara Toda, and Nitta no Yoshisada attest. In the year 806, for example, he assisted Jinsoku, the noted swordsmith, in forging a blade for Emperor Heijo (r. 806-9). Ryujin's underwater palace, with all its marvels, is often depicted. Some artists liked to show it as a *shinkiro,* a mirage or vision, appearing in the breath of a clam.

Ryuko *sennin*

He served as governor of a province during the time of the Western Jin dynasty (265-316), and ruled with such benevolence and justice that his people enjoyed a long period of prosperity. He was, however, afflicted with a competitive wife, and found less peace at home than his people did in their households. His wife, Han, joined him in studying the secret lore called *dojitsu,* under the tutelage of a great magician. Both Ryuko and Han became skilled in the occult sciences. One day Ryuko agreed to his wife's proposal that they demonstrate their respective talents. He began by setting fire to a small house with a mere glance from his eyes. Han conjured up a rainstorm to quench the flames. He spat into a bowlful of rainwater, causing living fish to appear. She spat, waking an otter that ate all the fish. She climbed into a peach tree and, at her command, the ripe fruits settled quietly into a basket. Ryuko could not equal this feat. Becoming more intense now in their vying, the pair flew off to wild Mount Shimei, and descended amid a pack of fierce tigers. Ryuko bade them to be still, and they obeyed. Han outdid him again. Swiftly she bound them with ropes and made a couch of their bodies, on which she rested, as if on a bed at home. With this display of puissance, Ryuko gave up. He climbed a nearby tree, intending to take off for heaven. She, no sportswoman, simply ascended from her tiger's couch, and passed him on the way.

Sacred Fungus *art motif*

Daoists esteemed this fungus (*reishi*) as a symbol of longevity because of its hardiness. It is a brightly colored, erect, slightly branched, and fleshy organism. Known as *Polyporus lucidus,* it (like most mushrooms) draws its nourishment from the dead roots of trees. Its shape provides a motif for artists, who use it alone or in combination with other emblems of longevity, such as cranes, tortoises, flying bats, or branches of the plum, bamboo, or pine. Many examples of the *nyoi,* the scepter of Buddhist prelates, were carved in the shape of this fungus, or else this motif was engraved on the prelates' wands.

Saga Sadayoshi *heroine of moral tale*

Sadayoshi, a poor woman of Kanagawa, unwound the raw silk from cocoons and spun it into threads for others to use in weaving. One winter day she went to pray at a temple near her home. An image of Jizo-bosatsu standing in front of the temple looked so cold that she took pity on it. She went home and made a warm cap that she placed on its head that same day.

A few years later, Sadayoshi died. To the amazement of family and friends, her body did not become stiff and cold. Even more astounding, she revived after three days. Her spirit had been in hell, she explained, awaiting judgment by Emma-o and his tribunal. Since she had killed countless silkworms during the years of her

labor, by dipping their cocoons in boiling water, the tribunal condemned her to being boiled in a vat of molten metal. At that moment Jizo-bosatsu appeared and begged Emma-o's judges to pardon Sadayoshi's small transgressions because she had been kind to a stone image of him. The tribunal consented, and Jizo himself led her back into the world of living creatures.

Saginoike Heikuro Masatora *strong man*

Heikuro, a farmer's son, grew up to be a youth of such prodigious strength that a rich townsman, Saginoike Kuroemon, adopted him. Heikuro could withstand the force of a mighty waterfall crashing down on him from a great height. With a blow from one hand, he could shatter a sword rack made of deer antlers.

Saibo *end of the old year*

During Saibo, the last ten days of the waning year, preparations are made for the new year's festivities. Wealthy families display in their homes arrangements of fresh fish, with hothouse flowers or dwarfed plants forced into early bloom. Ordinary folk settle for representations of these symbols in paintings, colored prints, and carvings. The favored fish is a salmon, carp, or bream; the preferred flower is the plum.

Saicho (also known as *Dengyo-daishi*) *monk*

At the age of twelve, Saicho (767-822) became a Buddhist priest. By the time he was 21 he had established Enryaku Temple on the slopes of Mount Hiei, a few kilometers north of Kyoto. In 802 Emperor Kammu (r. 782-805) sent Saicho on a mission to China. There he visited many temples, acquiring much learning, chests full of sacred books and church furnishings, a taste for tea, and (according to tradition) either seeds or seedlings of tea plants. After returning to Japan in 805, he fostered the growing of the country's first tea plants, taught the new doctrines learned in China, and made Enryaku Temple the center of the Tendai sect. He was also a painter, and he carved an image of Yakushi-nyorai that is still preserved in Enryaku Temple. Just before he died, this holy man received the name Dengyo, by which he is known posthumously; and in 866 Emperor Seiwa (r. 859-76) elevated him to the status of *daishi,* or great teacher of Buddhism.

Saigyo-hoshi (also known as *Sato no Norikiyo*) *priest-poet*

Norikiyo (1118-90), related to the Fujiwara clan, grew up to be an expert bowman and poet. For several years he served the former Emperor Toba as a retainer, until 1141 when Toba chose to become a priest in a secluded temple. That same year Norikiyo abandoned wife, children, and the delusions of the world to become a wandering priest. He took the name Saigyo. A number of incidents in his long life provided artists with themes. His most famous poem—"Praise to Fuji, O mountain

beyond compare"—was the subject of many printmakers, who showed him gazing up at the perfect peak. A picture of a traveling priest standing before Fuji, with a twisted staff in his hand and a large round hat hanging down his back, is certain to be a portrait of Saigyo, as is a representation of a priest standing beside a lake or pond, watching a woodcock take flight. This is a reference to Saigyo's poem written when he visited a swamp near Oiso on the northern shore of Sagami Bay.

Saihai (also known as *zai*) *military baton*

More a symbol of authority than of rank, the *saihai* was carried by an officer who commanded a group of warriors, or by one who was transmitting orders from a superior to his subordinates. The baton was a smooth rod about 40 centimeters long, bound with a sheaf of strips of white paper or leather at one end, each strip being about half as long as the baton. The other end of the stick could be left bare, or decorated with silken cords and tassels. The *saihai* is an elegant Japanese adaptation of the primitive baton used by Chinese generals—a yak's tail bound to one end of a stick.

Sainen and His Mistress *ghost story*

Although Sainen, a priest, had squandered a fortune on his mistress Otane, she tired of him and went back to her own home. Sainen returned to the righteous path and became a model of piety. Not for long. Soon he fell ill. Otane went to his bedside at the temple to beg his pardon. Sainen was so glad to see her that he seized both her hands in his, stood up in bed, and died. Yet even in death his fingers would not release their hold on Otane. Only after his fellow priests cut off those clutching hands at the wrists was Otane freed.

Sometime later, Sainen's spirit, still yearning for Otane, possessed Tarohachi, a townsman. Raging like a madman, Tarohachi ran to Otane's house and carried her off to the nearby forest. Then he returned to the town and became his usual self again. The next day searchers found Otane's body, lying under a tree. The spirit of Sainen, with help from the possessed Tarohachi, had taken Otane's spirit to be with him in the land of the dead. Many of Tarohachi's neighbors vouched for this—they had seen Sainen in the street, holding out those bloody stumps, instead of hands.

Saio and His Woes *Ch. fable*

Saio was rich enough to own a small farm and a horse of sorts. One day this bucking animal tossed Saio's older son from his back, hurting the youth. In a furious rage, Saio chased the ungrateful beast out of his compound. The next day the creature ambled home, bringing with him a stray horse. For this gift from heaven Saio rejoiced—until the second horse kicked his younger son, forcing him, too, to take to bed. Saio was

cursing whimsical gods and stupid sons and vicious horses, when an officer from the provincial army strode into the yard, accompanied by his staff of minions, all hunting for young men to drag off to the wars. Even they could see that, in their present condition, Saio's sons would not be of any use as soldiers. So the officer allowed them to stay at home on the farm—for at least another year.

The point of the fable is that isolated events cannot be judged by themselves. One has to observe how a series of events unfolds before one can determine if it is favorable or not.

Saion-zenji *priest*

In the mountains above Ame no Hashidate, Saion (ca. 700) built a small chapel in which he offered his devotion to Kannon, a bodhisattva of compassion. Here he found peace; and the peasants and mountain folk who came on occasion to pray at the temple also shared his joy in the beautiful carved image of the *bodhisattva* that gazed down on them from the altar.

During a terrible winter Saion almost died from hunger and cold. Then, one day, he found a deer frozen in the deep snow just outside his chapel. Despite the Lord Buddha's precept against eating meat, Saion knew that he would be forgiven for breaking this rule. He cut a piece of flesh from the deer's haunch, and made a broth with it. This sustained him until, a few days later, warmer weather melted some of the snow on the paths to the chapel. Concerned neighbors came to his aid, bringing food to share with him, and were surprised to find him looking so well. He told them the story of the frozen deer, opened the pot to show them the soup he had made. To their astonishment they saw, floating in the broth, a piece of wood, gilded on one rounded surface. Turning to the image on the altar, they saw the place from where that piece had come. Then they understood how compassionate Kannon had transformed herself into the rescuing deer.

Saito no Sanemori *warrior*

Although the Kabuki drama *Koman* makes Sanemori (1111-83) a retainer of the Taira clan at the time when the widowed Lady Aoi gave birth to Minamoto no Yoshinaka, history maintains that Yoshinaka was two years old when his father perished in battle, and that Sanemori was a trusted retainer of the Minamoto at the time. Sanemori, however, did save the boy's life. He had been ordered by Taira agents to kill the child (because his father had been a rebel). Instead of doing so, Sanemori sent him to Nakahara Kaneto, in the mountains of Kiso, who raised the boy to manhood.

In 1183, in Saito Sanemori's seventy-third year, when his hair had turned white and his skin was wrinkled, he fought for the beleaguered Taira at the battle

of Shinowara. Toward the end of the fray several soldiers serving in the army of Minamoto no Yoshinaka took Sanemori prisoner. When asked his name, he refused to give it—his severed head would serve for identifcation.

The soldiers took Sanemori's head to Yoshinaka. He looked long on the features of a man he did not recognize. He thought the head might be Saito Sanemori's, except for the jet-black hair. He had known the warrior as a young man, and even then his hair was white. One of Sanemori's servants told them how he had dyed his master's hair a young man's black, because after it turned completely white no one feared him anymore. Yoshinaka ordered a retainer to wash the hair. Only then was it indeed clear that the head was Saito Sanemori's. Some artists have chosen to show Yoshinaka killing a white monkey, rather than a white-haired old man—the monkey stands for the old man; Yoshinaka, a symbol for the violence of war.

Saji *sennin*

A powerful (and brash) magician, Saji served the Duke of Wei. He performed his most famous act of magic when the duke wanted to eat some of the delectable carp that lived in a distant river. Saji called for hook and line, and drew several plump carp from a bowl filled with pure water. But the duke soon tired of Saji's insolence. Their relationship came to an end when, by magical means, Saji removed the pulp from some fine oranges, leaving their skins intact around a core of emptiness. The duke complained, being especially irked after he had seen Saji eating the juicy flesh from his full orange. Saji explained that he taught in parables. The meaning of this one, he said, was obvious: the duke's mind was as empty as were the oranges. The enraged ruler ordered soldiers to beat Saji and then to behead him. Saji's magical powers deflected the soldiers' staves and the executioner's sword. When the guards cast him into a fiery furnace, he escaped unscathed. Transforming himself into a goat, he joined a passing flock. The soldiers beheaded all the goats, but of course Saji was not among them. Before disappearing forever from Wei, Saji restored life to the goats. Being in a bit of a hurry, he put some male heads on female bodies, and vice versa.

Sakaki *sacred tree of Shinto*

A branch or twig of the *sakaki* tree, affixed to a stand, a post, held in a vase, or waved about by a Shinto priest, sanctifies a place, or purifies the people gathered in it. In most parts of central Japan the *sakaki* is identified as *Cleyera japonica*, an evergreen tree with beautiful dark-green, glossy, smooth-edged leaves. Botanists believe it is a relatively unchanged survivor of the archipelago's primeval flora. In other sections of the country, however, where *Cleyera japonica* does not grow, pragmatic Japanese use branches of cedars, maples, camphor, camellia, or similar substitutes instead. The

true *sakaki* was the tree that The Eight Hundred Myriad Gods placed just outside Amaterasu's cave. In its 500 branches those clever deities hung the jewels, the mirror, and all the other gifts and ornaments with which they hoped to beguile the angry sun goddess.

Sakura Sogoro *peasant hero*

Sogoro (1597-1645) served as headman in the village of Kozo, one of the domains in Shimosa Province that the Tokugawa shoguns had awarded to the great Hotta family. Knowing that he put his life in jeopardy, Sogoro led a movement, supported by more than 200 village headmen, protesting the unendurable taxes that Lord Hotta no Masanobu demanded of peasants and merchants living in his fief holds. When polite representations, first to the young lord's advisers, then to the shogun's council in Edo, failed to lighten the burden, Sogoro resolved to commit the unthinkable deed—he went to Edo and presented a petition for relief directly to the shogun himself.

Kneeling beside the road where the shogun was being carried in a palanquin, Sogoro proffered the petition on a forked stick held in his mouth. For this shocking public act of disobedience to the clan's wishes, and especially for the shame of being questioned about the matter by the shogun, Lord Hotta imposed a savage punishment. Sogoro and his wife were crucified and, while they hung on the crosses, were compelled to watch executioners behead their three young sons.

In his agony, Sogoro cursed Lord Hotta for being so cruel, and vowed that his spirit would avenge him. The gods allowed the spirits of both Sogoro and his wife to return. They haunted Lord Hotta's castle at Sakura. Lady Hotta died of fright, as did her son soon afterwards, and those ghastly spirits drove Lord Hotta insane. As a result of this madness, he killed another *daimyo* in the shogun's palace. The shogun stripped him of his estates and banished him to Kyushu. Thus avenged, the quieted spirits vanished.

The common people did not forget Sogoro. They deified his spirit and later they raised a shrine to him at Kozo, calling it Sogo Jinja. Thousands of people visited it each year, honoring this martyr to the commoners' cause.

Salmon *as symbol*

Like most other fish, salmon are fecund, and therefore symbols of longevity. They make ideal gifts for the New Year season. Whether fresh, pickled, salted, or smoked, they are usually prettily wrapped, but in prints or other kinds of pictures they are shown uncovered. A small card, bearing the name of the giver, was attached to the fish by means of a cord drawn through its gills.

Sambaso *dance*

In olden times, before the principal play of the day could be presented in a Noh or Kabuki theatre, two masked dancers performed the *sambaso,* a propitiatory ritual asking the favor of the gods for the actors of the company and their offerings. The *sambaso* was first danced in 808 at Nara, to placate the angry gods who, suddenly, with thunderous roaring and fearsome earth shakings, caused a great crack to open up in the ground, from which awesome flames and smoke issued.

Samurai *warrior*

Originally, the word meant simply "one who serves." Later it signified a caste, a rank, and a profession—the honorable and honored one of warrior. It was reserved for gentlemen by birth (or, in a very few exceptional cases, by elevation), who were trained as soldiers to fight in the armies of their liege lords. The warrior caste—which included all aristocrats, the landed gentry, and their armed retainers—was the most esteemed, and the most privileged, of the four social classes recognized in Japan. The women and children of samurai shared their code of honor and discipline, if not their military duties.

In art a samurai can always be recognized by the two swords he carries at all times when he is out of doors. Either they are thrust under his obi or held in his hands. If a battle scene is being depicted, his armor offers another clue. During the peaceful Tokugawa Period (1615-1868), a samurai adopted other distinguishing characteristics, notably the style in which he dressed his hair (with the top-knot worn like a helmet's crest at the back of his head, and the front of the head shaved clean in any one of a variety of styles), and the elegant wide-shouldered *kataginu,* or surcoat, worn over his kimono on formal occasions.

Sanada no Yoichi (also known as *Sanada no Yoshitada) warrior*

Yoichi (?-1181), a youth noted for his strength, served the Minamoto clan, and took part in a night raid on a Taira camp near Mount Ishibashi. His attempt to kill Oba no Kagechika, the Taira general, was foiled by Matano no Goro, the wrestler. They grappled for a while before some of Goro's retainers came to his rescue and killed Yoichi. Artists, in sympathy for the loser, have depicted Yoichi, wielding his short sword, about to cut off the head of a supine Goro. They have also portrayed the strength of the two adversaries by showing Yoichi standing at the bottom of a steep slope, catching an enormous boulder that Goro has hurled down at him.

Sanada Saiemon no Yukimura *warrior*

As lord of Shinano Province, Yukimura (1570-1615) served Toyotomi Hideyoshi until the warlord died in 1598. After that he supported Tokugawa Ieyasu. Ieyasu's policies

and person did not, however, win Yukimura's loyalty, and in 1600 he did not fight for Ieyasu's side in the fateful battle of Sekigahara (1600) that raised the Tokugawa to supreme power, their Shogunate lasting until the Meiji Restoration in 1868.

In consequence, Ieyasu, the victor, deprived Yukimura of title and estates, banishing him to Kii Province. In 1615, however, Ieyasu gave him a second chance, calling him to serve in the war against supporters of Hideyoshi's son, Hideyori. Once again Yukimura perferred to remain loyal to the Hideyoshi family. Hoping to assassinate Ieyasu, he hid in a lotus pond beside the road the dictator was expected to take, but Ieyasu rode along another path, and Yukimura failed. Soon afterward he died in battle, while fighting against the Tokugawa army that destroyed Hideyoshi's son and his adherents.

Sanbokojin *deity*

A fierce looking, three-faced being, Sanbokojin is the guardian of the hearth. In his four hands, he holds a wheel, a jewel, and a pair of *vajra,* or thunderbolt-sticks.

Sano no Tsuneyo and His Bonsai *modest warrior*

Toward the close of a bitterly cold day, two wandering priests knocked at Tsuneyo's gate, asking for shelter. One presented himself as Doso, Abbot of Saimyo Temple, the other as Doun Nikaido, his friend. Tsuneyo and his wife made them as comfortable as possible in their simple country house. The guests could not help but be impressed by their host's refined manners. When asked about the samurai's rusting armor and dulled weapons that he treasured, he said that he did not expect to use them. Several years before, Tsuneyo's father, having offended the Hojo regent of the time, had been deprived of position and estates, and Tsuneyo was still being reproved for his father's faults. Early the next morning, as the priests prepared to leave, Tsuneyo perfumed their robes with twigs cut from his favorite dwarfed plants, a flowering plum, a bamboo, and a pine. In doing so, he destroyed the graceful shapes into which he had trained those bonsai. When Abbot Doso protested this sacrifice, Tsuneyo merely expressed regret that his poor home could provide no proper incense for such eminent guests.

About a year later the Kamakura government sent out a call for warriors to suppress a minor rebellion. Tsuneyo rode all the way to Kamakura, unattended by servants, wearing his ancient armor, sitting on a nag that made all fighting men burst out laughing when they saw it. They stopped when he announced his name at the barrier. They took him into the presence of the regent himself, Hojo no Tokiyori. As Tsuneyo knelt on the mat, to bow in homage to the ruler of Japan, he recognized him as the Abbot of Saimyo Temple. Tokiyori made amends for his predecessor's

injustice to Tsuneyo's family by restoring to him the lands and office that had been taken from his father. For Tsuneyo's own sake, Tokiyori gave him three other estates, the names of which included the characters for plum, bamboo, and pine.

Sansho *pepper plant*

This small aromatic shrub, known as *Xanthophyllum piperitum,* yields a pleasant spice. Both new leaf-shoots and fruits are used as condiments. On the last day of the year, the traditional drink is a tea made peppery with *sansho* leaves. Although it is small, and easily overlooked, the *sansho* is used frequently as a motif.

Sanzo-hoshi (also known as *Gensho*) *Ch. Buddhist priest*

In 629 Sanzo went to India to acquire books of scriptures, images, and sacred relics for his temple. Fortunately, three faithful disciples assisted Sanzo-hoshi on his perilous journey: Songoku, a monkey; Chohakkei, a boar; and Shago-gyo, a demon. Once, for example, when Priest Sanzo was required to submit to 108 tests of holiness, Songoku helped by blowing into the air that exact number of hairs plucked from his own body, each of which was transformed into a replica of the priest. Each replica passed the test applied to him. Later, of course, those 108 walking, talking, eating images of himself rather slowed Sanzo's journeying, but he managed to get rid of them when a friendly *sennin* transformed them again into monkey's hairs.

After living in India for seventeen years, Sanzo-hoshi went back to China with 657 volumes of sacred writings and many holy images and blessed relics. Some artists have reduced the whole arduous journey to mere symbols by showing Sanzo-hoshi carrying all those precious things on his back, while sea gods bow in admiration. Usually they dress Sanzo-hoshi in white robes and set in his forehead the *urna* of a bodhisattva, which he has not yet earned. Chinese writers, recognizing the wonders of his achievements, wrote the story of Sanzo's adventures soon after he returned. About a thousand years later Bakin, the great Japanese novelist, translated the Chinese book into his native language, calling it *Saiyuki,* or *Journey to the West,* and Hokusai illustrated it in his own imaginative fashion.

Sanzu River (also known as Sozu River) *legend*

The Sanzu River, which flows through the Buddhist hell, is like the River Styx in the Greek Hades. Although the Sanzu is both long and wide, the spirits of the dead can cross it in only three places. This explains its name, which means the River of Three Paths.

The first place, Sensuise, is a shallow ford, where the water is less than knee-deep. Those spirits who committed only minor offenses in their previous existences will cross here. Kyodo, the second crossing, is a bridge made of gold, silver, and

all manner of precious minerals, such as rock crystal, rubies, emeralds, corals, lapis lazuli, malachite, jade, and amber. Kyodo can only be used by the spirits of those who have been virtuous in this world. At the third place, Goshindo, throngs of spirits are forced to gather. Here gather wicked, wayward, and malicious persons. The waters are deep, the waves are high. At every moment they drag away and tumble about the damned spirits. Great boulders, swept along by the rushing flood, crush their bodies, bruise their flesh black and blue. Poisonous snakes bite them. Demons and furies pierce them with sharp arrows that lacerate the flesh. For seven long years this torment must by endured (unless prayers by the living win intercession from the bodhisattva and the gods above). Yet even after seven years have passed, their troubles are not ended: howling demons drag them from the river and toss them down before the hideous witch, Shozuka-baba, who tears off their rags of clothes and sends them on the next stage along the path of retribution.

Sao-hime *princess*

Sao-hime, granddaughter of Emperor Kaika (r. 157-98? BCE) and a consort to Emperor Suinin (r. 31 BCE-70?), was approached by her ambitious brother, Prince Sao, who yearned to be emperor. He wanted her to murder Suinin, and for this fell purpose gave her a dagger eight times tempered. Sao-hime, however, loved the emperor, whose child she was carrying, and would not kill him. One day, while the emperor dozed with his head in her lap, Sao-hime's tears of woe fell on his brow. He persuaded her to reveal the cause of such sorrow and, having heard about the plot, sent soldiers to seize Prince Sao.

During the ensuing consternation, Sao-hime fled to her brother's side. Suinin, out of love for her, delayed the attack by his warriors, begging her to return to him. Sao-hime, feeling the guilt of Prince Sao resting heavy on her, would not go back to the imperial palace. She did give the emperor the child she bore him, a son she named Homutsuwake. She set the baby outside the gate of Prince Sao's citadel. Then she went back into the castle of Sao, and died in the flames that killed her traitorous brother and his supporters.

Artists represent Sao-hime sitting with the emperor's head in her lap, or looking sadly at a spider's web in a box—the perfect symbol of the web of deceit her brother is weaving about them.

Sardine *as symbol*

Fresh or dried, sardines are presented as gifts at the New Year festival. The dried head of a sardine, skewered on a sprig of holly and affixed to the gatepost, protects a household against demons.

Sarugaku (also known as *sangaku*) *ancient dances*

Sarugaku, or "monkey music," refers to a group of comic dances that entertained Japan's populace until about the fifteenth century. Musicians playing on flutes, drums, gongs, and perhaps other instruments, accompanied the dancers, while singers recounted the story being presented by mimes. The oldest *sarugaku,* their stories, and probably the music as well, seem to have come from China. The Japanese soon adapted the techniques to native themes, even those relating to Shinto deities such as the goddess Uzume no Mikoto and her encounters with the god of roads, the Monkey Prince, Saruta-hiko.

Sarugaku, no doubt vulgar and noisy (and possibly erotic in intention), were supplemented on festival occasions with *dengaku,* or "field music," and with performances by acrobats, jugglers, magicians, and other wandering showfolk. During periods of drought, both *sarugaku* and *dengaku* were performed to call down rain. At the beginning of the fourteenth century, *sarugaku* was apparently evolving in the direction of realistic historical drama. That tendency was checked by the rise of the Noh theatre and, later, by the creation of Kabuki. The raucous *sarugaku* survived for a while longer, but eventually died out, being replaced by local dances more characteristic of districts or provinces.

Saruta-hiko no Mikoto (also known as *Koshin*) *Shinto deity*

He is called the god of roads because, when Prince Ninigi no Mikoto came down from heaven to rule Japan, Saruta-hiko, already there, offered to be his guide. Then Saruta-hiko changed his mind, blocked all the roads, and would not stir. The goddess Uzume no Mikoto, a member of Ninigi's entourage, "displayed her charms" and slept with Saruta-hiko. After that, all ways were open.

Although he has the body of a man, Saruta-hiko has the face of a monkey—with an unusually pendulous nose (seven hands long, according to the *Nihongi*) and "eyes that shine like mirrors." His nose of enviable length, monkey face, name (*saru* means monkey in Japanese), and especially his relationship with Uzume, indicate that he must have been one of Japan's autochthonous phallic deities. Saruta-hiko, as his unchanging self, and Uzume no Mikoto, transmuted by popular demand into fat, jolly, and pudenda-faced Okame, the so-called goddess of mirth, are still paired in rural festivals, as they have been in mythology, and in art almost since the day they met.

In some of his later guises as Koshin, Saruta-hiko keeps his simian face, but acquires many attributes of Buddhist deities, such as multiple arms and eyes. One statue represents him as six-armed, with each hand holding a different emblem,

such as a monkey, serpent, sword scepter, wheel, and rosary. Three opened eyes are set vertically in the middle of his forehead. His hair is swept up in a high crown ornamented with small images of monkeys. Serpents coil around his wrists and ankles. He stands on a pedestal decorated with carvings of monkeys, often the mystic three who hear, see, and speak no evil.

In rural Japan, however, Koshin still retains his ancient and indigenous aspects. Rudely carved stones are set up beside roads, marking distances and especially identifying crossroads. The carvings are frankly phallic, often executed crudely, representing either front or rear views of monkeys, or apelike humans. Some of these stones show both male and female figures, in varying degrees of intimacy. These are none other than Saruta-hiko and Uzume no Mikoto. The images are called Dosojin. In rural Japan, moreover, the *enoki* tree is sacred to Saruta-hiko.

Koshin is also the name of a star and of Kanoe, "the Day of the Monkey," the seventh calendar sign, which occurs once every two months, when two events in the sexagenary cycle happen to coincide. In earlier eras, the Day of the Monkey was celebrated with festivals at Shinto shrines, complete with offerings to Saruta-hiko, both at his altars and at wayside images. Many people believed that, during the night before the auspicious day, they were extremely vulnerable to evil influences emanating from the star Koshin. Accordingly they forced themselves to stay awake the whole night through, worshipping the deity in the star, while they feasted, drank, sang, and danced to ease the strain of waiting. That enjoyable vigil they called *Koshin machi,* or "waiting for Koshin."

Sasaki no Moritsuna *warrior*

In 1184 Moritsuna, a general of the Minamoto forces, found a way to drive the Taira from their refuge on Kojima peninsula in Bizen Province. He learned that the Fujito straits, separating Kojima from the mainland, could be forded at low tide. Although his attack early one morning surprised the Taira, most of them managed to escape across the Inland Sea, to Yashima in Shikoku. Minamoto no Yoritomo rewarded Moritsune for his victory by making him lord of Iyo, the district where Kojima lay. When Yoritomo died in 1199, his successor in Kamakura, Hojo no Tokimasa, took away from Moritsuna both estate and title. The dispossessed warrior shaved his head and became a priest, using the name Sainen. He did not abandon his loyalty to the Minamoto clan. In 1201, when Yoriie, the second Minamoto shogun, asked for Sainen's help, he led a band of soldiers who exterminated the rebelling Jo clan in Echigo Province. During that engagement he captured Hangaku, daughter of Jo no Sukemori, who was renowned for her skill in the martial arts.

Sasaki no Shiro Takatsuna *warrior*

Takatsuna was one of Minamoto no Yoshitsune's favorite companions. Takatsuna is remembered for being the first warrior to cross the Uji River at the battle fought there in 1184. Usually he is depicted riding hard on Ikezuki, the horse loaned to him by Minamoto no Yoritomo, while he holds a long bow between his teeth.

When Minamoto no Yoritomo finally succeeded in murdering Yoshitsune, Takatsuna sickened of the world and became a priest in a temple on Mount Koya. The Sasaki family's crest features the *yotsume,* or "four eyes," consisting of two groups of four hollow squares.

Sato no Tsuginobu *warrior*

During the battles of Yashima (1185), he took a Taira bowman's arrow that was intended for Yoshitsune, commander of the Minamoto. As Yoshitsune knelt beside the dying warrior, Tsuginobu spoke of his regret that he would not live to see his lord's triumph. Then he died.

Sato no Tadanobu (also known as *Minamoto no Kurokitsune*) *warrior-hero*

As one of Minamoto no Yoshitsune's four principle retainers, Tadanobu (1160-87) gave him valiant service, especially during the flight from the assassins whom Minamoto no Yoritomo sent against his half-brother. With his great bow and arrow, Tadanobu drove off ships trying to intercept Yoshitsune's passage to northern Kyushu. At Yoshino, when some warrior monks (greedy for rewards they expected from Yoritomo) attacked the fugitive party, Tadanobu exchanged armor with Yoshitsune, thereby allowing his master to escape. Tadanobu and four warriors held off the rabid monks and brought down their huge leader, Yokogawa Kakuhan, who wielded a spear 2.7 meters long. Tadanobu "split him in two like a melon," hacked off his head, and, holding it before him, rushed at the other monks, who panicked and ran away.

Tadanobu and his band hastened toward Kyoto. He sought a hiding place in the home of his former mistress, Koshiba Oguruma, but she betrayed him to Yoritomo's agents. One night, while Tadanobu slept, 200 armed men broke into Oguruma's house. He could not even begin to fight them because she had tied his swords to their scabbards. In a rage, he picked up the nearest thing, a heavy *go* table. With it he broke the neck of treacherous Oguruma, and knocked down several assassins. A wishful legend says that he escaped from that trap to be with Yoshitsune, but, in truth, Tadanobu slit open his belly in that bloody house, and died hurling his entrails at the enemies.

Ordinary people, wanting to find an explanation for Tadanobu's valorous

deeds, believed him to be a fox-man. As time passed, the legends grew—he was the son of a fox-woman; her skin was the one stretched across the two heads of the *tsuzumi,* or shoulder drum, that Yoshitsune had given to his mistress, Shizuka Gozen, when they were forced to part in Yoshino. Some people even said that Tadanobu, the dutiful son more than the loyal retainer, had accompanied Yoshitsune and Shizuka, because he wanted to claim from that drum the skin of his fox-mother.

In any event, many artists have represented Tadanobu not as a man, but as a fox wearing a warrior's armor. In this guise they call him Kitsune-Tadanobu, "Fox-Tadanobu," or Minamoto no Kurokitsune, "the Black Fox of the Minamoto." Sometimes the fox is ready to give battle, at others it holds a *tsuzumi* in its paws. Other prints show Tadanobu wielding that *go* table in his last fight.

Selobo *Ch. Daoist deity*

To the Daoists she is the Queen of the West. She dwells on the slopes of Mount Kunlun, among the fairy people, which is why she is also known as "Queen of the Fairies." In her palace garden grows the peach tree whose fruits confer immortality on those who eat them. Twigs from that wondrous tree have magical powers; its gum, mixed with the powdered ash of mulberry wood, can cure all ailments. Seiobo herself brought some of those peaches to two great emperors of China, Muwang (r. 1001-946 BCE) and Wudi (r. 140-86 BCE). When she visited the court of Wudi with her fairy troupe, Seiobo brought ten peaches. The fairies neglected to guard the fruits, however, and Dong Fangshuo, the emperor's magician and adviser (whom the Japanese call Tobosaku) ate three of them. In drawings, paintings, and carvings, Seiobo is always a most beautiful young woman, ethereal and graceful, clad in gorgeous raiment, and wearing many jewels.

Sometimes her sisters, Seiobo no Shiji and Seishin-fujin, accompany the Queen of the Fairies. At least four fairy maidens attend her, with one holding the dish of peaches being brought from the mountain in the west. When an artist portrays Seiobo on her visit to Emperor Wudi, two birds with azure wings are much in evidence, because (as the tale relates) they perched on his shoulders. Sometimes she is seated in a chariot, drawn by handmaidens, a stag, or a white dragon, the two latter being symbols of longevity.

Seishi (also known as *Daiseishi*) *bodhisattva*

Usually Seishi is encountered as one of Amida Buddha's attendants. Standing, kneeling, or sitting, he is at the Buddha's left side, while Kannon-bosatsu takes an identical pose at the right. They are presented in this relationship in many celebrated Amida triads, called Amida *sanzon* in Japan. Among the earliest of those made in

Japan is the group in Lady Tachibana's Shrine, now preserved at Horyu Temple near Nara. When it is present, a "holy flask" set in Seishi's coronet helps to identify him.

Sei Shonagon *courtier and writer*

Lady Sei, a woman of prickly personality, was the daughter of court noble and noteworthy poet Kiyowara no Motosuke, and when Sadako died in the year 1000, Lady Sei probably retired from the court. A contemporary was Lady Murasaki Shikibu, the other great writer in imperial service at the time. Even though the two ladies shared many intellectual interests, as well as duties and acquaintances about the court, neither could develop much admiration for the other.

A quick mind, an aggressive personality, and a sharp tongue made her something of a trial not only to other ladies-in-waiting, but also to many self-important men, regardless of their rank or relationship to her. We can conclude as much from the few strained comments about her that contemporaries recorded in letters and diaries, but especially from the pages of her own journal, *Makura no soshi—Pillow Book,* or, better *Pillow Sketches.* This work is a fascinating account of life at the imperial capital viewed by a witty observer established in its very midst. Written, as she said, "to solace the loneliness of my life at home," it is detailed, revealing, and entertaining—mostly because Sei, unlike most of Japan's writers of her time and since, introduced a refreshing note of bitchiness into her journal. No one knows what happened to Sei Shonagon after she left court. Some accounts say that she became a nun, a most unlikely career for a lady who loved having lovers; others believe because of her troublesome tongue, she ended her years, like the poet Ono no Komachi, neglected and in misery.

Seitaka-doji and Kongara-doji *Buddhist minor deities*

These two *doji,* or "boys" as the Japanese call them familiarly, serve the god Fudo Myo-o. Because they are so young, and therefore biddable, they are symbols of his authority. Red-faced Kongara stands at Fudo's right side, holding a diamond-pointed scepter (originally a *vajra,* or "thunder-stick"). He is violence barely contained, and therefore dangerous. In contrast, Seitaka, white or pink of face, serene and kind, almost feminine in contours and posture, stands at Fudo's left, in the position of honor. Sometimes he holds a lotus blossom; at other times his hands, joined in prayer, support a diadem made of lotus petals. Seitaka and Kongara assist Fudo in his role as god of waterfalls. They are manifestations of the *bodhisattvas* Kannon and Miroku, and probably are intended to symbolize both the benefits and the perils of waterfalls. Seitaka and Kongara must not be confused with Shozen and Shoaka, the

doji who serve the bodhisattva Jizo. Moreover, in some temples, Fudo is attended by three, five, or eight *doji,* rather than by only these two.

Semimaru (also known as *Semimono*) *poet-musician*

Although blind, Semimaru was a fine poet and an admired musician. He served as an attendant to Prince Atsuzane, a son of Emperor Uda (r. 888-97). When Atsuzane died in 966, Semimaru retired to a small house near Osaka, with only his flute for consolation. Every day for three years he refused to accept as a pupil the young noble Minamoto no Hiromasa, a grandson of Emperor Daigo (r. 898-930). Finally he yielded, conquered by the young man's perseverance. Sometimes Hiromasa is shown hiding behind the garden gate, where—according to another version of this tale—he went every night for three years, just to listen to the revered master playing on his flute. Sometimes, too, Semimaru's instrument is depicted not as a flute but a *biwa* (a lute).

Senkyo *legendary creatures*

These strange things, who live in the land of Tso-i, are shaped much like human beings, except that each has a hole in the middle of his chest. They pass long poles through these holes, on which the richer citizens of their country can ride, much as Chinese ride in palanquins.

Sennin *Daoist immortals*

Most of the *sennin,* or "mountain beings," shown in Japanese art were taken from Chinese sources. Preponderantly male, *sennin* were human beings at one time, who through meditation, adherence to Daoist precepts, or the attainment of outstanding virtues were granted a temporary release from the cycle of transmigration of souls. Edmunds neatly describes them as "human beings who 'enjoy rest.'" Although referred to as immortals, because they live for many centuries, they too die when the time comes for them to reenter the universal round of transmigration.

They share a number of common attributes: they are magicians, alchemists, solitaries, or mountain-dwellers; they usually live for several centuries; and when the time arrives for them to be reborn, a cloud, a dragon, a phoenix, or some other miraculous agent comes to carry them off into the heavens. Many of them searched for the elixir of life; others were able to concoct preparations that allowed men to fly, to be changed into cranes. Some *sennin* had potions of rejuvenation, and were able to perform other kinds of magical feats.

In art they are shown with large ears, usually with elongated lobes (a sign of wisdom in East Asia), and in garments ranging from Chinese mandarins' robes to mantles or loin wrapping made of leaves. Baird (p. 198) notes that "Gourds, peaches,

and loquats are associated with them, as are feathered fans, clothing that confers invisibility, castanets, flower baskets, and flutes." Sometimes a representation of a *sennin* is mistakenly identified as a *rakan*. Like *sennin, rakan* are human beings, but differ in that their degree of spiritual enlightenment has freed them completely from the cycle of transmigration.

Sen no Rikyu (also known as *Soeki*) *tea master*

The son of a wealthy merchant, Sen no Rikyu (1521-91) developed an unerring if austere taste in matters of art, dress, furnishings, and decorum. He adapted to his own rather ascetic inclinations the techniques of the tea ceremony that had been taught by Murata Juko (1422-1502), and himself became a *chajin,* or tea master, to a coterie of friends and disciples. The military ruler of Japan, Toyotomi Hideyoshi, became one of his pupils.

In 1586 Hideyoshi ordered the construction of an opulent castle-palace in Kyoto. People called it Jurakudai, the Mansion of Assembled Pleasures. He invited chosen *daimyo,* samurai retainers, and one commoner—Sen no Rikyu—to build their residences in the neighborhood of Jurakudai. *Daimyo* and samurai, imitating as much as possible the style and appointments of Jurakudai, if not its scale, raised ostentatious mansions that displayed all the architectural and decorative status symbols that Hideyoshi's sumptuary laws allowed them.

Sen no Rikyu made no attempt to keep up with his neighbors. In the midst of all the conspicuous splendor, he put up a low, simple, modest, house—something like that of a poor country samurai, or a cautious merchant. Sparsely furnished, undecorated, almost severe by contrast, it consisted of little more than paper walls, *tatami* mats, smooth unpainted posts, and gleaming wooden floors in the passageways. It was absolutely different from all its neighbors. Its quiet elegance of understatement demonstrated the virtue that Japanese call *sakui*—creativity and originality. It may have been the very first expression of what is known as the *sukiya* style of architecture. It was much copied thereafter, well into the 20th century. It was, in fact, the prototype of "the typical Japanese house" as Westerners imagine it. Today, unfortunately, few examples of the *sukiya* style remain, and no more are being built.

In 1591 Hideyoshi's regard for Rikyu turned to enmity. Gossips said that Hideyoshi was jealous (or suspicious) of the favor Emperor Go-Yozei (r. 1587-1611) was showing the aged tea master. Others said that the dictator was displeased with Rikyu because he would not force his beautiful widowed daughter to submit to Hideyoshi's attentions. Whatever the cause, Hideyoshi accused Rikyu of accepting bribes and asked him to commit seppuku. Rikyu calmly arranged some flowers,

enjoyed the spirit-strengthening ritual of the *chanoyu,* and then, as disciplined as a samurai, obeyed his lord's command.

His style of *chanoyu* has been captured by successors in a system so codified and so revered that true disciples consider any departure from it nothing less than heretical. The Senryu, or Sen style, is taught and followed with precision to this day. His name is attached to many things related to *chanoyu* or to *sukiya* architecture, either because he created the original versions or used the articles in the tea ceremony. Among these are certain kinds of kitchen utensils, and doors, fences, windows, even shapes and patterns, he devised or liked.

Sentaro *fable*

This moral fable tells of Sentaro, who did not like the thought of having to die. He prayed to the Daoist magician Jofuku to make him immortal. Jofuku arranged to transport Sentaro on the back of a paper crane to Mount Horai, on one of the Daoists' isles of the blest. At first Sentaro was thoroughly happy in his home for eternity. Before long, however, he became bored with the place, dissatisfied and despondent with his prospects for the future. He took to swallowing poisons, slitting veins, hanging himself from trees, seeking all ways to end his pointless round of repetition—all in vain, for he could not die. Finally, in despair, he wished for the paper crane to come and carry him back to the wonderful, fascinating, changing, exciting, and fatal land of Japan.

Jofuku heard him, and sent the paper crane. On the return flight to Haneda, Sentaro began to have second thoughts. His perplexity caused the paper crane to become uncertain of its course. It swooped too low, and great waves in the sea reached up to claw it down. Sentaro cried out in fear—in fear of death. In that moment, he awoke from his dream, to find a great rat running along his back.

Sesshu (also known as *Oda no Toyo*) *painter*

Toyo (1421-1507) was sent to Kyoto for training. At the age of thirteen he became a priest of Hofuku Temple, taking the name Sesshu. After that he went to Shohoku Temple to study drawing and painting with the priest Kotoku-zenji. One day, being somewhat of a boy still, Sesshu did not complete his tasks. In order to teach him the virtue of self-discipline, if not of obedience, the teacher tied him by his hands to a pillar and left him alone to think about his faults. That evening the priest came to release the boy, and was struck with horror at the sight of a number of rats playing about his feet. He tried to chase them away and found that they were pictures of rats, painted by the youth with a brush held between his toes. From 1467 to 1469 Sesshu studied art in China. The Chinese emperor, impressed by his ability, commissioned

him to paint three views typical of Japan. Sesshu chose to depict Mount Fuji, the port of Miho, and Seigen Temple near Shizuoka. On returning to Japan Sesshu went to Suo Province and founded his own school of painting at a home he built and called Unkoku-an. He became one of Japan's greatest artists and popularized the Chinese manner of landscape painting. He produced many fine paintings of people, birds, flowers, horses, cattle, and landscapes in summer and winter. Often he drew the outline of a subject with a single stroke of his brush. He preferred to use only Chinese ink, and rarely employed colors. His works combine certain features of the Chinese tradition with characteristics of his own, chief of which are "purity, simplicity, and directness."

Seven Evils

According to the *Nio-o Sutra,* these are earthquake, flood, fire, demons, war, robbery, and sickness.

Seven Good Fortunes

The *Nio-o Sutra* identifies these as honor, long life, many servants, carriages, rice and money, silken robes, and a fine home.

Seven Gods of Good Fortune (*shichifukujin*)

Under this general heading the Japanese used to think of two distinct groups of deities, one ancient, indigenous, and Shinto in derivation, the other borrowed or invented little more than 300 years ago. The second group quickly became so popular that it replaced the older heptad.

The newer group of seven seems to have been assembled during the first quarter of the seventeenth century. Japanese artists have treated The Seven Gods of Good Fortune with familiarity, often making them look vulgar, putting them into situations as libidinous as merchants' revels, or as riotous as peasants' festivals. They share two attributes in common: an earthiness that makes them very endearing; and big earlobes, which signify they are very wise. The gods are:

Fukurokuju—His name means happiness, prosperity, long life. He is a god of longevity. He is generally represented as a short, squat old man, having no neck at all, with a bald head. He is often bearded; usually the expression on his face is good humored, but it can vary from benevolent to malicious. Usually, he is dressed in ancient Chinese fashion. His insignia, all symbols of longevity, are a crooked staff (or sometimes a *nyoi,* the priestly scepter of power), a crane, or a stag, or a "long-tailed" turtle. Sometimes he holds a peach, another symbol of longevity, although some artists have mistaken it for a *tama,* or jewel, signifying purity or wealth, and have drawn it as such. He is also often attended by a group of boys.

Seven Gods of Good Fortune

Daikoku—He is the god of wealth. The earliest known representations of Daikoku in Japan seem to support an Indian origin: he stands on a lotus leaf, is black, and his features are not Japanese. Like Fukurokuju, he is generally short compact, plump, and jolly, with twinkling eyes and a smiling mouth. His beard is short, and trimmed to a point. Dressed in ancient Chinese fashion, he wears a kind of floppy beret. In his right hand he holds a hammer or mallet, the *konton no tsuchi,* or hammer of chaos; in his left hand, a sack, usually slung over his left shoulder. He always stands, sits, or leans on two great bales of rice, or *koku*. The bales of rice refer to a bountiful harvest; the sack over the shoulder, to precious jewels drawn from the earth; and the mallet (an insignia of miners), to the wealth in gold, silver, copper, lead, iron, and other valuable minerals that earth can yield. A rat or two are often shown gnawing at those rice bales or scampering about Daikoku's feet. (The Day of the Rat was regarded as Daikoku's.)

He is considered the protector of business establishments. He and Ebisu, the deity of daily food, are joined in a guardian team. Their images, printed on paper, carved in wood, or shaped in clay, can be bought at temples and fairs. He may also be seen as Sanmen Daikoku, or Three-Faced Daikoku, a literal fusion of three of the good-fortune gods. The central figure is Daikoku, laughing. On the right stands Bishamon, and on the left Benten. Daikoku, as usual, carries mallet and sack, and stands firmly on two bales of rice. Bishamon holds a three-pointed spear and a scepter, Benten a key and a jewel. This trinity, usually called The Three Gods of War, reveals the darker aspects of these deities.

Ebisu—The only one of the Seven Gods native to Japan, he is given a number of popular epithets: the Laughing God, the Smiling One, the God of Daily Food, and the Deity of Honest Dealing. He is revered in every home. A carving or picture of him is placed on the kitchen god-shelf, because he makes sure that food in abundance will be available to the household, and he watches over the manner in which meals are prepared.

As a god of happiness, Ebisu has been given the plump body and jovial countenance of a good-humored peasant. He wears a short beard, and a peculiar high bonnet with two peaks at the front, which fishmongers and other kinds of shopkeepers might affect. His girth, that cap, and the fish he almost always carries serve to distinguish Ebisu from his colleagues. Usually the fish is a red *tai*. In humorous presentations, the fish may be almost as big as Ebisu, while he lugs it around, tries to stuff it into a basket too small to hold anything larger than a sardine, dances with his fellow gods with the *tai* strapped on his back, or fights off Daikoku's hungry rats with

a fishing pole. Obviously he is a patron god of fishermen, both at sea and on land; and in that role is given a fishing rod and tackle to carry, and a basket to put his catch in. Legends say that, being somewhat deaf, he is the one who started among people the practice of clapping their hands loudly when they pray at shrines and temples, in order to draw the attention of the gods to the entreaties being sent up to them.

Benten—The only female among The Seven Gods of Good Fortune, she is unmistakably a young and beautiful woman. Her attributes are the *biwa,* or Chinese lute, the dragon, and the white snake. She appears in various manifestations. As Benzai-ten she stands in majesty, holding in one hand a sword with a hilt in the shape of a thunderbolt, in the other hand the *tama,* or sacred jewel. As Happi Benten (Eight-armed Benten), she is seated on a rock, around which a dragon is coiled. Her several hands hold a sword, spear, scepter, rope, key, bow, arrows, and a *tama.* As Jashin Benten, the goddess in her snake form, she has only two arms, one holding a sword, the other a *tama.* The upper part of her body is emerging from the waves of the sea, and the lower part is coiled and snake-like. As Kongo Myo-o Ten, "the Goddess of the Heavenly Voice," worshipped at the temple on Chikubu Island in Lake Biwa, she is standing, and has eight arms holding the usual martial insignia. This time, though, the sword is upright, rather than lifted over her head, and the *tama* is in her lowermost left hand. Instead of a crown she wears a very distinctive headdress—a white snake coiled beneath a Shinto *torii* (free-standing arch). Many gems are scattered on the ground around her.

Bishamon—He is considered a deity of prosperity. Temples dedicated to Bishamon are scattered throughout the country, where he appears as one of the *shi-tenno,* or Four Heavenly Kings; as one of the *juni-o,* or Twelve Heavenly Kings; or as one of the *rokubuten,* The Six Gods of War. In all these forms, he is beyond doubt a guardian deity, the protector of temples, fierce of countenance, and bearing in his right hand either a lance, halberd, sword, or scepter, and in his left hand a small pagoda.

Hotei—A god of contentment and of moderation in desires, and therefore of happiness. In most representations he is seen as a fat, laughing, shaven-headed priest, with huge ear lobes hanging down to his shoulders. He is dressed in the loosest of Chinese robes that reveal an ample belly. He usually carries a big belly-shaped sack over one shoulder, or reclines against such a bag, which is filled with "the seven precious things" that Hotei, the god of happiness, carries in his sack: gold or silver, lapis lazuli or emerald, coral, agate, rock crystal, and pearl or amber. Depending on the teller of the tale, other kinds of gifts, of lesser or greater worth, may be present in Hotei's bag.

He is fond of children, and they are often shown with him, climbing over his portly person, clinging to his robes, trying to peer into that bag of wonders, sleeping in his bag, being borne by him on a carrying-pole, or pulling him along in a sagging handcart. Sometimes he sleeps in the bag, or carries a clamshell as a beggar's bowl, while he leans against his sack of riches meant for others. He is often portrayed wrestling in Sumo style with Daikoku.

Jurojin—The most anomalous and the least essential of the seven gods, Jurojin is the deity of success in studies—and also, apparently, another god of longevity. He is sometimes confused with Fukurokuju. Sometimes, he is completely supplanted by a female deity, Kishijoten, a sister of Bishamon. He is not an engaging sort of personage: an old man, lean of body and solemn of mien and clad in the robes and square-topped hat of a Chinese scholar. Other attributes help to distinguish him from Fukurokuju—he holds a fan in one hand and a long twisted staff in the other. One or more scrolls are tied to the staff, and sometimes its upper end is carved in the form of a dragon's head. Sometimes a white stag accompanies him, or carries him on its back. In this case, the stag is the emblem of promotion, a consequence of success in scholarship. When Jurojin is being depicted as a god of long life, he holds a peach of longevity in one hand, and is accompanied by a white deer, a white crane, or a turtle, all of which are symbols of longevity.

Seven Herbs of Autumn (*aki no nanakusa*) *as symbols*

Singly or in combinations, these seven plants, esteemed for the beauty they add to the autumnal landscape, are favorite motifs in all forms of Japanese art. Their shapes and hues inspire designs to be worked into fabrics used in making kimono and obi. Unlike the Seven Herbs of Spring, these of fall were not eaten. The plants are: either *obana* (*Miscanthus sinensis*) or *suzuki* (*Eulalia japonica*), two species of grasses that bear attractive plumes; *nadeshiko* (*Dianthus superbus*), a pink; *hagi* (*Lespedeza bicolor*), a "bush clover"; *kusu* (*Pueraria thunbergiana*), another legume; *fujibakama* (*Eupatorium chinensis*), a daisy-like composite; *ominameshi* (*Patrinia scabiosaefolia*), a relative of valerian; and *asagao* (*Ipomoea purpurea*), a morning glory.

Seven Herbs of Spring (*haru no nanakusa*) *as symbols*

After the long, cold winter, the early plants of spring were gratifying to both the eye and the belly—the herbs were once made into a thick, hot, rice gruel to be eaten as a protection from sickness during the rest of the year. The identity of the seven herbs varied with locality, availability, and family taste. In general, the seven herbs of spring included plants like these: *seri*, a kind of parsley; *nazuna*, a shepherd's purse; *suzuna*, turnip tops; *suzushiro*, radish tops; *gogyo* and *hahako*, two species of cottonweed; and

habobera, a kind of wild celery.

Seven Poets of the Pear Chamber (*nashitsubo no shichikasen*) *writers*

A courtier of a later generation gave this fanciful name to the most distinguished writers of the mid-Heian Period (794-1185). (The Pear Chamber was the apartment in the imperial palace where ladies of the court lived.) These seven "poets" were ladies-in-waiting to the two principal consorts of Emperor Inchijo (r. 987-1011). Murasaki Shikibu, Izumi Shikibu, Akazome Emon, Ise no Osuke, and Uma no Naishi served Empress Akiko (988-1074), at least until Emperor Ichijo's death. Sei Shonagon and Ko-Shikibu (daughter of Izumi Shikibu) served Empress Sadako (977-1000). These ladies of many talents wrote novels, journals, diaries, "pillow books," and short stories, as well as poems.

Seven Worthies of the Bamboo Grove (*chikurin shichikenjin*) *Ch. literary sages*

These Chinese intellectuals are favorite subjects in both Chinese and Japanese art. Tradition makes them out to be little more than eccentric wastrels, who strolled, drank, and chatted in the pleasing coolness of a bamboo grove. Still, one account suggests that all their light-hearted conviviality was really a pretense. They met in the security of the bamboo grove in order to preserve and share their knowledge of China's culture after most books in the realm were burned in 213 BCE.

The members of this reclusive club were:

Genshiki, a scholarly official who loved music and his mother. He was so devoted to her that he wept tears of blood when she died. On other occasions Genshiki used those eyes to disconcerting effect, exposing the whites to people he hated, and only looking fully on those he liked.

Keiko, who got drunk so often, he wished he could afford to hire a gravedigger to follow him about, ready to bury him immediately should he fall dead. His sign is an open book.

Kyoshin, an artist, judging by his emblem—an unrolled picture scroll.

Oju, once a minister of state, he gave up his rank to settle in his estates near this famous bamboo grove. He was a very miserly man. Every one of the fine plums from his orchard was robbed of its seed before it went to market, so that no scheming rival could ever grow that variety of fruit. Plums are his emblem.

Santo was a minister of state and a great patron of young scholars and artists. He is portrayed as an old man holding a long staff.

Ryurei, who, besides being an official and a musician, practiced magical arts under a willow tree. One night he conjured up a spirit with a tongue more than two meters long. On seeing him Ryurei merely yawned, blew out the lamp, and said, "I am not afraid of

you—just disgusted by your ugliness." The rejected spirit slunk away. For his powers as a wizard and for teaching heresy, the government beheaded Ryurei. Imperturbable to the end, he tuned his lute while sauntering to the execution ground.

Shachihoko *fabled fish*

The ridge-beams of tiled roofs on the soaring towers of some of Japan's great castles are capped with dolphin-like creatures at each end of the ridge-beam. The Japanese call this graceful imaginary fish *shachihoko*. A similar but rarer roof ornament is composed of a dragon's head, a fish's tail, and an indeterminate sort of body nicely covered by curling waves.

Shaka (also known as *Sakyamuni* and *Gautama* Buddha)

Gautama Buddha (tr. 563-483), that is to say, Gautama the Enlightened One, is "the historical Buddha" who founded Buddhism. In Buddhist doctrine he is only one of many people who have attained enlightenment in this world, and, in so doing, has gained release from the cycle of rebirth.

The Japanese know Gautama Buddha as Shaka (which is their version of Sakya, the patronym of his family). His father, Suddhodana of the Sakya, was king of Kapilavastu, a small country in northeastern India, near Nepal. His mother, Maya, was a daughter of another prince of that noble family. Suddhodana and Maya named their son Siddhartha Gautama. In his early years, he led a worldly and often sensual life, but later he pondered on the mysteries of existence and sought wisdom until his thirty-fifth year, when he attained enlightenment. After that his disciples called him the Master.

Innumerable incidents in his life, from the moment of his conception until the time of his death, have provided motifs for art. Japan's artists have depicted all of them, far too numerous to list here. They have settled on a kind of synthesis of his career, which they call "The Four States of Shaka." They are:

The Birth of Shaka—depicts the newborn child announcing his arrival in this world. Standing on a lotus flower, with his right hand pointing upward, his left hand downward, he declares: "In heaven and on earth, I am the most venerable of beings."

Shaka on the Mountain—portrays him as a recluse seeking the way to salvation through prayer and austerities. Still a young man, he stands barefoot on a mountain top, with hands joined in prayer while cold winds whip at his robes. He has a short beard and a partly shaven scalp. The *urna,* or third eye, is evident on his brow, and the *usnisa,* or bump of knowledge, is visible at the crown of his head. Variations on this state represent him as being gaunt from hunger and self-torture, sometimes almost hideously emaciated.

Shaka the All-wise—depicts him around the age of 35, soon after he had attained enlightenment through the kinder course of meditation. He is seated cross-legged on a lotus throne, his left hand lying open in his lap, his uplifted right hand, palm outward, making the gesture of reassurance. He is beardless; and the short, tight whorls of hair on his head do not conceal the *urna, usnisa,* or enlarged lobes of his ears (these being only three of the 32 signs of wisdom his body bears).

The Death of Shaka (which Japanese call *Nehan Shaka,* or the Nirvana of Shaka)— shows his body in the moments after his death, when his spirit prepares to enter into Nirvana. His disciples have brought the aged and ailing Master to a bower of beautiful teak trees, and have laid him down on the couch that will be his bier. He lies on his right side, head pillowed on a lotus blossom. (Sometimes he is depicted lying in a coffin.) Many disciples gather around, expressing grief at his dying, or joy in his release; so, also, do representatives of all species of animals except for the selfish, indifferent cat. Ensconced in heaven's clouds, looking down in compassion on her son's body, is Maya, attended by choirs of angels. (In other representations, she is shown beside the bier or the coffin.) To the onlookers, it is said that Buddha appeared alive, with 1,000 halos gleaming from his head. He told his mother that all laws are imperishable, but that he was leaving behind all the law necessary for posterity. Shaka's spirit then entered into Paradise.

Many other representations of Shaka have been made, ones that show him at other times in his life, or in the glory of his apotheosis. Every Buddhist temple in Japan displays at least one small image of him, as well as paintings and mandalas in which he is the dominant figure. Distinguishing representations of Shaka from those of other *buddhas* is not always easy. To put the problem another way, not every representation of a buddha depicts the one known as Shaka. Confusion arises from the fact that several other *buddhas* are recognized in the Buddhist canon. At least seven of them, as well as Shaka, are often met in Japanese art. Four of these are Taho, Ashuku, Dainichi, and Yakushi. All have, as part of their names, the suffix *nyorai,* meaning "the Tathagata, the Thus-come." Together with Shaka, they constitute the *go-chi-nyorai,* or The Five Gods of Wisdom. In addition to those *Buddhas* from the past, one who is expected to arrive in the future is also depicted. He is Miroku-bosatsu, or Maitreya, who will arrive on earth in the 5,000th year after Shaka enters into Nirvana. Helpful hints to differentiating the several *buddhas* can be found in the postures they assume; the *mudras,* or gestures with hands and feet, they display; the symbols, signs and attributes they bear; and their spatial relationships with respect to other figures with whom they are associated.

Shakkryo

Shakkryo *dance*

This is a magical dance-ritual that has survived from ancient times. Performers wear wigs of red or tawny hair, long enough to reach their ankles, and have peonies in their hands and headdresses. The dancers represent lions, prowling and roaring among peonies that grow in sacred valleys. The peonies are symbols of worldly power, the lions of spiritual strength.

Shakra (also spelled *chakra; rimbo*) *Buddhist symbol*

Shakra is a Sanskrit word signifying "the Wheel of the Law." In Buddhist art the wheel is the symbol of the *Buddha's* doctrine, and in Buddhist speech the expression "to turn the Wheel of the law" means "to preach the Law of the Buddha." The *shakra*, in consequence, is one of the signs of wisdom. The teaching gesture, so characteristic of priests, sages, and *buddhas*, is called "the *mudra* of turning the Wheel of the Law." The *shakra* is an extremely important motif in both religious and secular art. In the earliest years of Buddhism it was represented in its simplest form, nothing more than a circle or a smooth-rimmed wheel. Later versions, progressively more ornate, acquired spokes, knobs, excrescences, and other elaborations, sometimes to the point where the symbol of the Buddha's wheel was almost hidden under the encrustations. In representations of Buddhist divinities with the *shakra*, they may carry the *shakra* in their hands or on their bodies or garments. Temples dedicated to Fudo Myo-o use the motif in ornamentation much more than other Buddhist temples. Devout Buddhists choose it for their crests. The warrior-priest Benkei Musashibo was one such person.

Shakujo *"alarm staff" of a Buddhist priest*

This long and heavy staff could be made of wood or iron, and always bore a number of loose metal rings near the top. Those jangling rings were intended to warn all creatures to get out of the way, lest the heavy foot of the priest should crush them. In Japanese art, Jizo-bosatsu almost always holds a *shakujo*, as do certain mortal priests engaged in their missions. Occasionally a bodhisattva or a *rakan* is depicted leaning on a *shakujo*.

Shark Man *fable*

Samebito, a shark who could assume the shape of a human being, was saved from death by Totaro, an ordinary man. Grateful Samebito showered his rescuer with much wealth, in the form of silver and gold coins. Totaro could never be satisfied. He always wanted more and more from the generous shark man. One day, at the temple of Mii, Totaro saw Tamana, a beautiful young woman, and decided that she must be his wife. He asked Samebito for some jewels as a marriage gift. Sorrowing

over his savior's greed, Samebito wept tears of blood into a bowl. As they touched the cool vessel, his tears turned into 10,000 rubies.

Sharito *reliquary*

Among the ashes of a saintly man, his survivors would find remnants that had not been consumed by fire. These relics look like water-worn stones, or rounded pebbles of quartz or chalcedony. Japanese call them *shari* (a term derived from the Sanskrit *sarira*). Pious folk preserve them in small shrines, or *sharito,* fashioned in the form of a *stupa*. A *sharito* would be placed on a temple altar as proof that the deceased had led a holy life. Some *sharito,* made of gold, silver, bronze, and precious jewels, are beautiful works of art.

Shennong *legendary ruler*

Many of the discoveries and inventions that enabled China's primitive inhabitants to advance from barbarism to civilization are attributed to this legendary ruler. Shennong's father was a dragon, his mother a human being. Wild beasts on the sacred mountain Lieh Shan fed him during his childhood. While teaching his people the arts of agriculture, the "Divine Farmer" (the literal meaning of his name) invented the wooden plow. In founding the science of botany, he discovered the medicinal properties of many plants. For centuries, the Chinese worshiped him as the God of Agriculture, and as the God of Medicine. He also invented the five-stringed harp, and in doing so revealed the laws of music—attuned to the pentatonic scale. The first geometer, he measured the earth's dimensions while riding in a cart drawn by six (or eight) helpful dragons. Shennong also made great contributions to intellectual pursuits: he increased to 64 the eight sacred trigrams a dragon had revealed to his predecessor, Fuxi; and he improved the art of writing by adding many new pictograms to the few that Fuxi had devised. Shennong's contributions to writing gave his people the chance to become literate.

Artists depict Shennong as a rather primitive man, having a large head with two rudimentary horns just above the brow (inherited from his dragon father), a long flowing beard, and nails on fingers and toes that resemble talons. Sometimes they clothe him in garments made of leaves, at others in flowing robes of ancient emperors. They may show him holding (or eating) a product of China's agricultural riches—such as an ear of rice, or sheaf of wheat, or a mushroom, or even a blade of grass. Some present him in the act of writing on a tablet the eight trigrams of Fuxi.

Shiba Kishu *Ch. fortune teller*

Shiba Kishu lived during the Song dynasty (960-1279), and told fortunes in the streets of his city. He is remembered for certain oddities of appearance. He looked like a girl,

but had a beard three feet long, as black and lustrous as a raven's wing. Artists have portrayed him, bearded yet girlish, seated at his portable table, on which rest a jar holding the yarrow sticks he used in divination, the book of explanations for those messages from heaven, and other bits of paraphernalia needed in his profession.

Shiba Onko *Ch. historian and administrator*

While still a child, this distinguished scholar of Song times began his life of service in auspicious fashion. He and his playmates were crowding around a huge porcelain jar filled to the brim with water, watching goldfish swimming about in its depths, when a smaller boy fell in. All the other children ran away, screaming for help, but not Shiba Onko. He picked up a big stone and broke the jar, allowing both water and fish to pour out, but saving his friend from drowning. This incident, suggesting the idea of quick thinking, provided a favorite motif for netsuke (miniature sculptures in wood, ivory, and other materials), sword guards, and other objects.

Shiba Shotei *sage*

Shotei (713-56), a Chinese Daoist magician, lived with several other recluses in a monastery high in the mountains. One night, as Shotei slept, his startled companions heard the voice of a child reading sacred texts and saw a faint light glimmering all about them. A man braver than the others traced the light to its source—a small sun glowing on Shotei's brow. And the voice, too, emanated from Shotei's head.

Shibata no Katsuie *warrior*

Katsuie (1530-83) was Oda Nobunaga's brother-in-law and trusted vassal as *daimyo* of Echizen and Kaga. In 1570 Katsuie and his warriors, besieged in the castle at Chokoji in Omi, were suffering from hunger and thirst. He took his men to the storeroom holding the last jars of water and bade them drink their fill. He himself took not a drop. When they were done, he broke every jar. Inspired by such resolution, his soldiers charged out of the castle and routed their besiegers.

Thirteen years later Katsuie's life came to a glorious end. After Oda Nobunaga's assassination by Akechi Mitsuhide in 1582, Katsuie plotted against Toyotomi Hideyoshi, the general who took Nobunaga's position and power. Hideyoshi sent his armies to attack Katsuie's stronghold in Echizen. Katsuie knew that this time he could not defeat the enemy. As Hideyoshi's troops moved to capture his castle, Katsuie dismissed those of his warriors and servants who wanted to live, and ordered a great feast to be served for those who remained in the castle to die with him.

While the faithful warriors ate and sang and laughed, devoted servants spread dry straw and gunpowder through the donjon's rooms. Beyond the walls, Hideyoshi's men listened in amazement to those carefree revels. Katsuie killed his

wife, concubines, sons, and daughters, and then calmly knelt on the white-covered mat to cut open his belly. A trusted retainer, with a single stroke, sliced off his lord's head. Another touched a flame to the gunpowder on the floor. About 30 samurai and servants perished that day, together with proud Shibata no Katsuie and his family.

Shibi (also known as *kutsugata*) *ridge-end ornament*

Each end of the roof ridge of Todai Temple of Nara, 48 meters above the ground, is decorated with a high curving ornament covered with gleaming gold. The Japanese liken them to a *shibi*, the tail of the bird they call *shi*, the golden kite; or to a *kutsugata*, a shoe pattern, because it suggests the tip of a curved slipper worn by aristocrats and priests in ancient times. When Todai Temple was constructed, between 745 and 752, both the Chinese and the Japanese people believed that *shibi* on a roof ridge would protect the building from fire.

Shiganosuke *warrior*

A cousin and vassal of Akechi Mitsuhide, lord of Hyuga, Shiganosuke (?-1582) realized that he was doomed when he heard that Mitsuhide, after assassinating Oda Nobunaga, failed to safeguard their position by eliminating Toyotomi Hideyoshi as well. Rather than wait for messages from Hideyoshi that would order him to take up arms against his cousin and liege lord, Shinganosuke donned his heavy armor, mounted a favorite horse, and rode out into the waters of Lake Biwa. Some accounts say that Shiganosuke had been a member of the conspiracy against Oda Nobunaga, and that, before he drowned himself, he killed his wife and children by setting fire to the family castle.

Shiiki (also known as *Iiki* and *Kiyoku*) *sennin*

Shiiki made the arduous journey from his home in India to China, during the reign of the Han emperor Wudi (r. 141-87 BCE). On reaching the bank of a river in Xianyang, he asked a ferryman to take him across. The ferryman, repelled by the traveler's ragged filthy robes and dirty body, refused to do so. He pushed off into the river, leaving Shiiki behind. When this judgmental ferryman reached the other shore, he was astonished to find the mysterious stranger already standing there, petting the heads of two tigers.

Shimamura Danjo Takanori *warrior*

Shimamura (?-1532), a vassal of Hosokawa no Takakuni, commanded his lord's troops during one of their perennial battles with warriors of the *daimyo* of Awa. The two armies met in battle near the straits of Akamagaseki (now better known as Shimonoseki). Shimamura and all his men were slain. Their spirits, unable or unwilling to leave the scene of such a terrible disgrace, entered in the bodies of a

species of crab living along the seacoast. Since that sad day the face of an anguished warrior has been impressed on the carapace of each crab. The people of that region call them Shimamura's crabs, *shimamuragani,* or *heikegani* (Taira crabs), a name that recalls the defeat of the Taira at Dannoura (1885).

Shimenawa *Shinto symbol of sanctification*

This is a protective device used in Korea and Okinawa, as well as in Japan proper. It is made of two strands plaited from rice straw, each being twisted tightly about the other, the pair making a double helix. According to later interpretations, one strand represents yang, the positive or male principle, while the other represents yin, the negative or female principle. Such a rope, stretched across doorways, before shrines, or around trees, rocks, or spaces, attracts the benevolence of the gods and safeguards the object or site against evil influences. At the same time it identifies the thing or place as being sacred. Although the twisted cordon alone offers protection enough, people have supplemented it with small pendants made of rice straw, or of bands of white paper folded so as to present a zigzag pattern. These pendants always consist of three, five, or seven lengths of straw or strips of paper. The Eight Hundred Myriad Gods put up the first *shimenawa,* stretching it across the entrance to the cave from where they had just lured Amaterasu. The power-charged rope, a taboo signifier, prevented her from going back into the cave.

Shinansha *compass-bearing vehicle*

The name means "south-pointing cart," and refers to a wheeled vehicle holding a compass. The needle of the compass aligned along a north-south axis, no matter in which direction the cart was drawn. Tradition claims that "the Yellow Emperor," Huangdi (who reigned early in the third century BCE), invented the compass to assist him and his generals during a war in which an ape-like magician conjured up fogs and clouds to baffle his adversaries. Illustrations of the *shinansha* present an image of a man, mounted on a small wagon or cart. The image's face, arm, or whole body moved in accordance with the needle's direction, always pointing toward the south— the luckier quadrant to the ancient Chinese.

Shinobugusa *umbelliferous plant*

This tender herb, with its very fine stems and delicate leaves, often provides the motif for a lacy background in lacquerware, ceramics, and other small objects.

Shinozuka *warrior*

Shinozuka (?-1348), lord of Iga, and one of Nitta no Yoshida's chief retainers, saved his master's life during a battle by picking up an attacker and hurling him ten meters away. Shinozuka's strength, however, could not win the war for his side. In 1341,

when he and a few warriors were besieged in the fortress at Seta in Iyo, he tore the posts out of buildings and cast them down on the enemy below. At the last moment, just as the fortress was about to fall to the besiegers, Shinozuka escaped to a boat. As arrows hissed around him, he unmoored the vessel, pushed out from shore, and raised sail. The sail took the wind and bore the exhausted warrior away. He put his fate into the hands of the gods and lay down to sleep. The gods wafted that fragile ship to tiny Oki Island. There, among farmers and fishermen, Shinozuka lived in peace for the rest of his life.

Shinran-shonin (also known as *Kenshin-daishi*) *Buddhist priest; founder of Jodo-shin sect*

In 1224, during his fiftieth year, Shinran (1173-1262) publicly rejected the teachings of both the Tendai and Jodo sects and founded one of his own, the Jodo-shinshu, or True Pure Land sect. Only the mercy of Amida can save a man, Shinran declared. Neither good works nor prayers will save his soul; and certainly celibacy, fastings, abstinence from meat, and other such austerities will be of no avail in gaining salvation. Yet the mercy of Amida is within the reach of anyone who asks for it, insisted Shinran, and in order to ask for it all we need to do is say *"Namu Amida Buddha"* with a sincere heart. Shinran's democratic doctrine, and especially the zeal with which he preached it, won converts among commoners, but also aroused powerful enemies in the established churches. At their urging, the secular ruler of Japan, Hojo no Yasutoki, banished Shinran to Echigo Province.

Friends won him a pardon after five years of exile. On his way home to Kyoto, he stopped at a hospitable Jodo temple in Edo. Before departing, Shinran thrust his walking staff, made from the wood of the *icho,* or gingko tree, into the ground, saying, "the strength of the faith and the salvation of the people shall be like this staff." Immediately it took root and sent forth bright new leaves. Today, in that same spot, an immense gingko tree flourishes, said to be the very one that grew from Shinran's walking stick. The tree, called "the Staff Icho," towers above the courtyard of Zempuku Temple in Tokyo.

Ten years after Shinran's death, the principal temple of his sect, built in Kyoto by his daughter and grandson, received the name Honganji, or Temple of Amida's Original Vow. Today it is called Nishi-honganji, or Western Hongan Temple. The huge structure, with many auxiliary buildings and gardens, is a repository for innumerable works of art, among them whole rooms transported from Hideyoshi's short-lived palace at Momoyama. Shinran-shonin himself, and events in his life, have provided themes for many artists. Possibly the most unusual of those art objects is an image of the seated Shinran, believed to have been carved by himself during his

seventy-first year. After he died, his ashes, mixed with lacquer, were applied as a holy varnish to the statue. Doubly sacred, it is a relic much venerated by members of his sect. During the Meiji Restoration in 1868, Shinran-shonin received the posthumous name Kenshin-daishi, Great Teacher Who Saw the Truth. Above the entrance to the sanctuary holding the Great Teacher's image hangs a memorial tablet inscribed with the two Chinese ideographs that mean *ken* and *shin*. The Meiji emperor wrote those two characters.

Shinto *native religion*

Shinto, "the way of the gods" or "the way of the spirits," is the religion that the aboriginal people of Japan developed for themselves. They, too, worshipped the forces of nature in all their varied manifestations; and they, too, endowed each of those phenomena with *shin,* or spirit-power, uniquely its own. To "The Eight Hundred Myriad Gods" that the universe presented them, they added, in the course of time, the less mysterious *kami,* supernatural beings or deities. Human beings judged worthy of deification were designated *kami.* Included were all sovereigns who had ruled over the land of Japan, and a judicious selection of estimable ancestors, warrior-heroes, admired scholars, and exemplary priests.

In the beginning, as now, the rocks, trees, mountains, or streams where the gods dwelled were venerated. Much later, when political power among people was vested in a supreme authority (now called the emperor), the responsibility for proper rituals of worship (and for the rewards or failures of his petitions) was imposed on him. His dwelling became, for a while, the central and paramount shrine. Still later, national shrines were established in places far removed from the imperial palace. The dominant ones are the Grand Shrines at Ise, dedicated to Amaterasu and Toyoukebime, and one at Izumo, consecrated to Okuninushi. In these, and in all other shrines, a hierarchy of priests serves the resident deities. The reigning emperor, however, is the high priest of Shinto, because he is a lineal descendant of the sun goddess herself and therefore an incarnation of divinity.

The gods, although invisible most of the time to human beings, are material to some extent: they can eat, drink, make love, have children, enjoy pleasures and suffer sorrows, and, when their purpose is fulfilled, they can die. After death they become invisible spirits, or *mitama.* In this stage they are able to assert themselves only through the mediation of other gods, or by influencing susceptible human beings, such as a priestess-medium, a purified priest, or a visionary of any class fortunate enough to receive these communications.

A *mitama* is supposed to reside most of the time in an earthly shrine, where

usually is found a sacred object, such as a sword, mirror, stone, or piece of wood, which the spirit may have been associated with during its lifetime. This sacred object, the most hallowed thing in the shrine, is called the *shintai,* the body of the god. Usually, it is enclosed in a casket or ark, but sometimes, as in the case of a mirror or sword, it may be fully exposed to the view of worshippers. At festivals and major ceremonies the *shintai,* or the casket in which it reposes, may be carried among the people in a portable shrine, a *mikoshi.*

Shinto priests, called *kannushi,* are distinguished by their vestments, which appear to have been adopted during the Early Nara Period (645-710), when Buddhism had become an established threat to the native religion. A *kannushi* wears a long, full white robe with wide sleeves (itself derived from the court robe adopted from China); a broad sash girdling the waist; a heavy surcoat, also in white; a high glossy black *eboshi,* or court noble's cap made of lacquered net, tied under the chin by a conspicuous white band; and glossy black shoes, with wooden soles and arched lacquered fronts.

Shinto teaches only one rule: "Follow the impulse of your nature, and obey your emperor." Westerners have been puzzled by the evident simplicity of Shinto dogma and doctrine. For Japanese—whose impulses are carefully controlled by family and state—this precept is quite enough.

Shirakawa, *emperor*

Shirakawa, the seventy-second sovereign, ruled officially from 1072 until he abdicated in 1086, but he continued to control the government unofficially during the reigns of his son and grandson for 43 more years until, to everyone's relief, he died. A very devout Buddhist, he enforced the precepts against killing animals, even to the point of ordering officials to destroy thousands of fishermen's nets and release pet birds and hunting hawks from their cages. He spent such huge sums on building temples and furnishing them with holy images and costly vessels, that he all but depleted the imperial treasury.

Shishi (also known as *kara shishi*) *"lion"*

This creature, usually small and unprepossessing, and looking more like a petulant Pekingese dog than a true king of beasts, is the Chinese artists' concept of the lion, an animal not native to their country. The product of their imagination, it was conceived of as an animal with a wide-nosed face, protruding eyes, tightly curled tufts of hair on neck and haunches, and long tail spirals. The *shishi* symbolizes the power of the good law of the Buddha. For Buddhists who revere Manjusri, it also serves as that bodhisattva's throne and emblem.

Pairs of *shishi,* usually carved in stone, are placed near the entrance gates to most Buddhist temples in Japan. They are supposed to assist the *nio,* the two guardian kings, in repelling demons and other evil influences. One member of the pair of *shishi* is a male, recognized by the horn on his head, the open mouth, and a "ball" caught under one front paw. The Japanese, seeing him for what he actually is, call him *kama inu,* or Korean dog, rather than a lion. The female, called *ama inu,* or heavenly dog, keeps her mouth closed, rests one forepaw on a tiny cub, and does not have a horn. The pair of lions also represents the completeness of spirit that comes to a man who has faith and who worships his gods properly. The open mouth of the male is saying *aum,* the first of the Sanskrit vowels; while the closed mouth of the female is saying *um,* the last vowel. To Buddhists, *aum* and *um* are symbols for the beginning and the end, just as alpha and omega are for Christians. The "ball" under the male's paw is really the *tama,* the jewel of omnipotence (or of purity) in older Buddhist imagery. In the newer teachings of Manjusri, the *tama* also connotes emptiness—the goal of no desires that a holy man strives to attain. When expressing this meaning, the surface of the *tama* bears a pattern made up of the cheap copper coins called "cash," each with a hole through its center, and of the "spirit-flying streamers" that Chinese called *lingfei.*

Artists also depict *shishi* in circumstances that have shed their more obvious religious meanings. Lions prowling amid peonies, in a setting made even more romantic by cliffs, stones, trees, waterfalls, and clouded peaks, provide a favorite theme, apparently the same as that expressed in older versions of the *shishimai,* or lion dance. Even more frequently illustrated is the old fable telling worried parents how to recognize the perfect child. They must do, in a figurative sense, what lions are said to do in reality. Father Lion, atop a high cliff, throws his cubs into a ravine. The perfect offspring, instead of getting killed, or spending his time just mewling around at the bottom, climbs all the way up to the top again to rejoin its parents.

Shizuka Gozen *heroine*

In 1182 Shizuka, one of Kyoto's most beautiful and admired dancing girls, became the mistress of Minamoto no Yoshitsune, the brilliant young general. Three years later, when Yoshitsune's jealous half-brother Yoritomo began his relentless campaign to kill him, Shizuka accompanied her lover in his flight from Kyoto. They were forced to part at Yoshino, because she was pregnant and unable to keep pace with him. Yoshitsune placed her in the care of Sato no Tadanobu, one of his four trusted retainers, while he and other companions pushed on, not knowing where they would find refuge.

Sato no Tadanobu and his small contingent of soldiers intended to take Shizuka Gozen back to Kyoto but, somehow, Yoritomo's agents captured her. In the spring of 1186 they delivered her to the tyrant at Kamakura. He planned to execute her at once, together with the child she carried, but his wife, the formidable Masako, persuaded him to heap further humiliation on Shizuka Gozen and the fugitive Yoshitsune.

At Yoritomo's order, a great dancing stage was erected before the shrine of Hachiman at Tsurugaoka in Kamakura. On 29 April 1186, Shizuka Gozen was made to dance before Yoritomo, Masako, and the assembled court. At first she refused to comply; but then, thinking that by yielding she might help Yoshitsune, she appeared at last, and danced. While singing the words to the music being played, she improvised a plea to the tyrant to spare her lover's life. Such presumption angered Yoritomo all the more. Once again only Masako's intercession saved Shizuka from the executioner. Shizuka Gozen's dance is one of the most poignant themes in Japanese art.

Yoritomo never relaxed his guard over her. A few weeks after Shizuka bore Yoshitsune's son, the dictator ordered the infant killed, lest he grow up to be a threat to him and his line. After Yoritomo murdered her son, he ceased to worry about Shizuka Gozen and the harm she might do him. He allowed her to return to Kyoto, where she entered a convent as a nun. She died in her nineteenth year, before Yoshitsune met his violent end in the far north.

Shodo-shonin *Buddhist priest*

In 767, Shodo, a recluse seeking greater solitude, built the first Buddhist temple in the beautiful place now known as Nikko. Four strange clouds, each of a different color, rising high above the tall cedar trees growing on the steep mountainsides, drew Shodo to this valley from afar. When he reached the brink of the gorge through which the River Daiya rushes, he could go no farther. Yearning to cross the abyss, he prayed for help. Suddenly, on the opposite bank, a huge figure appeared, clad in robes of blue and black, wearing a necklace of skulls. In a loud voice, heard above the thunder of the waters, he called out to Shodo-shonin, promising to help him just as he had helped Sanzo-hoshi on his perilous journey from China to India. The god then threw two great serpents, one black, the other green, across the ravine. Arching their long bodies, stiffening as though exposed to winter's cold, they made a double path that Shodo-shonin walked across without fear. In the instant he stepped on the farther shore, the god and the bridge of serpents vanished. Pressing on through the thick forest, Shodo found the place where the four clouds ascended. There, at the spot called the Mount of the Gods of the Four Quarters, he built his simple hut. At

the same spot, in time, rose Shihonryuji, the Temple of the Four Dragons, which occupies the same site to this very day. In that first temple at Nikko, Shodo set up an image of Senju Kannon, a bodhisattva of compassion with a thousand arms, who had put him in this world in answer to his parent's fervent prayers.

Today the graceful red and gold Mihashi, or Sacred Bridge (or, as some people prefer to call it, the Shinkyo, the Divine Bridge) spans the Daiya River at the very place where the courteous god and his serpents enabled Shodo to cross the raging river. The bridge is used only on very important occasions, such as the visit of an emperor, or a ceremony in memory of the two Tokugawa shoguns whose ashes are entombed not far from Shodo's retreat. In art Shodo-shonin is most often depicted in the act of crossing the Daiya Gorge on an arch of serpents. Sometimes he is portrayed in a deliberate recalling of Sanzo-hoshi's journey to India toiling up a steep mountain trail, carrying on his back a bundle of books and a sacred image.

Shogi *game*

Similar in method and equipment to chess, *shogi* was introduced from China in the eleventh or twelfth century. The board is divided into 81 squares. Each player begins with twenty pawns. These are flat, made of wood, bone, or ivory, and resemble stubby lance tips or blunt arrowheads. The values of the pawns are indicated not by color or configuration, but by Chinese ideograms painted on their faces. They range in power from several common "soldiers" to a single "king." Each player endeavors to capture the other's king. The pawns, with their simple shapes and intricate ideographs, make attractive motifs for *mon* (family crests) and netsuke (miniature sculptures in wood, ivory, and other materials).

Shogyo-bosatsu *bodhisattva*

Shogyo-bosatsu is a divinity of special importance to members of the Nichiren sect. At his temple in Tokyo devotees honor him in a ritual that early European visitors considered to be very odd. A worshipper would bring a small bundle of rice straw tied into something resembling a brush, wet the brush in water, and rub it on a part of Shogyo-bosatsu's image. This being done, the worshipper would hang the straw brush on the temple wall as a more durable offering to the bodhisattva—and as a reminder that he or she had been there. This act is the age-old and widespread device of using the agencies of pure water and touching to transfer the aches and pains being felt by the petitioner to the corresponding part of the deity's image.

Shohaku (also known as *Botan-ka*) *Buddhist priest*

Shohaku (1443-1527), a youth who loved flowers, literature, and sake, chose the name Botan-ka, Peony Flower, when he became a priest. He rode about the countryside on

a bullock with gilded horns bedecked with flowers, especially with peonies when they were in bloom. This is the manner in which most artists have depicted him. Others, however, show him riding backwards, the better to see where he has been, or happily reading a book while the ox plods on. When he grew older Botan-ka traveled less, and changed his "three affections" slightly: to sake, flowers, and the compounding and testing of different kinds of incense.

Shojo *legendary beings*

These fat and fuddled creatures are insatiable in their craving for sake. Always happily drunk, they can be found dancing about immense tubs or cups filled with sake, from which they take their potations with long-handled dippers. Some, in their eagerness, even fall into those inexhaustible vats, yet they never drown, but float contentedly, unsinkable as empty gourds. Although they sometimes are shown resembling apes when seen from afar (orangutans are also called *shojo*), they also may appear with fully human bodies. In either case, they usually have faces of pudgy people. Their long, lank, bright red hair will yield a brilliant dye. Sometimes, they wear brightly colored robes. Righteous people always point to *shojo* as horrible examples of the evils of drinking too much sake. That admonition is rarely taken seriously in Japan. Social occasions from small gatherings to large celebrations are enlivened by substantial consumption of sake, beer, whiskey, and other spirits.

Shoki *legendary person*

Although Shoki the Demon-queller, the sad protagonist of a Chinese tale from the Tang dynasty (618-907), was almost ignored in China, the Japanese responded to him with affection. He is a ubiquitous figure in Japanese and Chinese art. According to a Tang fable, a student who, having failed to pass the imperial examinations, committed suicide rather than go on living in disgrace and poverty. Emperor Gaozu (r. 618-27) declared that the student be given an honorable burial. His grateful spirit dedicated itself to the task of subduing and routing all the demons of China. He even rescued Emperor Minghuang (r. 712-56) from the grip of the fever demon. After recovering from his illness, Minghuang—who had seen the spirit of his rescuer—described him to a court artist. The artist painted him in exactly the way the emperor had perceived him—as a ragged old man with a wispy gray beard, attended by a bat (which is a symbol of longevity and happiness).

In Japanese art, Shoki is often shown in his assumed role as guardian of Buddhist law. In this guise, he is a powerful being, tall and bearded in an ornate gown, carrying a large sword and a gourd, and imposing himself—and the law—on a demon. He is also represented as a comic figure, as if the Japanese, knowing very

well that no person or spirit can quell all the world's demons, found him laughable. In this manifestation, he may be a huge, bemuscled, bemused figure, as bumbling and ineffectual as a moronic giant. He is dressed in a Chinese general's robes, complete with military cap bearing a long flapping ribbon at either side, shin-high boots made of soft leather, and a heavy double-edged sword. He may be depicted hacking in vain with that sword at gleeful imps dancing around him, much as a man will swat at mosquitoes without ever hitting a one. A demon may be seen perched on his head covering, or clinging to the back of his robe.

Shokuin *fabulous being*

Shokuin is an enormous red dragon that lives in China. His serpentine body, of great length, has the head of a horned man. His breath makes the seasons wax and wane. It may be so cold that earth shrinks under its wintry blast, or so hot that earth bakes like a chestnut beside a fire. When he closes his eyes, night falls; when he opens them, day begins. Earth's only comfort is that Shokuin never needs to eat.

Shokuro and Chiyo *fable*

Shokuro wanted to capture Raijin, the thunder god. For bait he needed the one lure that Raijin could not resist—a navel from a human being. Bait of this kind being hard to get, Shokuro decided he would have to use the navel of Chiyo, his mistress. So he killed her, cut out her navel, and threw her body into a ditch. Then he tied the bait to a kite and sent it aloft into Raijin's realm. Meanwhile as Raijin looked down on the world, he saw Chiyo's beautiful body. He restored her to life with a spare navel he happened to have tucked away in his cheek, and swept her off into the clouds.

At this moment Shokuro's kite flew up, dangling its lure. Chiyo recognized the navel as hers and screamed in righteous fury. Raijin rushed down the kite string to avenge her—and, in a most humiliating fight, got beaten up for his pains. After Raijin brought Chiyo back to earth, Shokuro talked her into forgiving him and taking him back as her lover.

Shoryobune *"spirit-boats"*

Each summer the Festival of the Honorable Dead, or O-Bon Matsuri, lasts for three days. During this time, the spirits of recently departed family members come back to visit the people and places they knew in life. On the evening of the third day their reprieve ends, and the spirits must return to the world beyond. To help them make that journey, the living prepare "spirit-boats" in the shape of fishing vessels, fashioned mostly from plaited rice straw. In some localities, the boats may be made of bark, reeds, oiled paper, bamboo, or any other materials that will float.

The little craft may range in length from twenty centimeters to two meters or

more, and must be big enough to accommodate certain essential furnishings: O-Bon offerings remaining from the family altar, wrapped in lotus leaves and laid in the vessel's hold; a mast fitted with a paper sail on which is inscribed the posthumous name of each spirit being ferried away; a dish of pure water; a lighted oil lantern or wax candle at the bow; and a smoking stick or two of incense at the stern. Sometimes banners bearing the *migimanji,* or swastika with crossed arms turning to the right (or, more rarely, the *hidarimanji,* with arms turning to the left) are set aboard larger craft. At twilight the respectful family sets the spirit-boat on a current of water, and watches in silence as it drifts off, toward that distant place, the Paradise of the West.

Shosei (also known as *Hosho*) *sennin*

Since he could send forth lightning from his eyes, he kept them shut in the presence of his twenty disciples. One day, however, giving in to his followers' persuasions, he opened his eyes, whereupon his disciples were deafened by a noise like thunder, and stricken senseless by lightning bolts.

Shoshi *sennin*

A sage who was favored for his talents as a musician, Shoshi lived during legendary times. His wife, Rogyoku or Sangyoku, was a daughter of the Prince of Mu. They made beautiful music together when he played on either a flute or a *sho* (the mouth organ of many reeds) and she played on a *sho*. One day, as they performed the tune called "Homei," or "Voice of the Phoenix," a phoenix actually descended from the skies and alighted beside them. The delighted Prince of Mu ordered construction of a special terrace for the comfort of this celestial visitor. Some time after this event, Shoshi and Rogyoku ascended to heaven, he seated on a dragon, she on a phoenix. Artists usually depict them playing on their favorite instruments as they are carried away.

Shotoku Taishi *prince-regent*

People believed that Shotoku Taishi (572-621) was an incarnation of Kannon, a bodhisattva of compassion. Still in his masculine form in the year 571, Kannon appeared in a ray of light slanting in from the west and illuminating the whole imperial palace. There he begat the wonder-working child by entering the mouth of the princess-mother. When Shotoku was thirteen, his earthly father ascended the throne as Emperor Yomei, the first of Japan's sovereigns who accepted the Buddhist teachings. Yomei reigned for only two years. War followed his death, caused as much by religious fanaticism as by the usual maneuverings for political power. The young prince Shotoku, only fifteen years old, led the Soga forces and Buddhism to complete victory over the Mononobe-Shinto faction. At the climactic battle of Mount Shigi,

Bishamon appeared in a cloud, assured the prince that he would help the cause of righteousness, and presented Shotoku with the arrow that killed Mononobe no Moriya, leader of the Shinto party.

Twice Shotoku refused the honor of being named *taishi,* heir presumptive. On the second of those occasions, in 593, he chose to serve as regent for his aunt Suiko, Japan's first empress (r. 593-628). He proved to be a remarkable administrator as well as the powerful convert needed for Buddhism to be established in Japan. He reformed the functions and departments of government, developed a code of laws, and created a new system of ranks for nobles and officials of the court. He built and adorned a number of Buddhist temples, most notably the Horyuji. He studied, according to the *Nihongi,* "the Inner Doctrine," or Buddhism, and "the Outer Classics," or Confucianism, and in doing so, gave his support to Mahayana Buddhism as the religion of the court nobles, if not yet of the common people. He died untimely, at the age of 49. The nation mourned the loss of one of the greatest men it would ever know. The state bestowed on him the posthumous name Shotoku, Holy Goodness, and the title Taishi that he had declined during life.

Shotoku is often represented in Japan's art. A relatively straightforward portrait of him with two young sons is preserved at Horyu Temple. Slight of body and prim in countenance, he is dressed in a long, white, Chinese-style robe, girdled at the waist. A single long sword hangs by cords from his belt. With both hands lifted at chest level, he holds a *shaku,* the spatulate tablet identifying a man's rank that (in conformity with his regulations) an aristocrat must carry when appearing at court. The prince's sons, almost miniature replicas of himself, down to their diminutive swords, stand with hands tucked into their wide sleeves.

Shotoku is also portrayed in a variety of devotional situations, and at various ages. Both pictures and sculptures present him as an androgynous child, holding a long-handled incense burner at waist level. Such images refer to the time Emperor Yomei became very ill. Shotoku, then fifteen years old, emerged from the palace carrying a censer, faced the east, prostrated himself on the ground, and asked the Lord Buddha to make his father well. A statue of him "expounding the sutras with marvelous wisdom at the age of seven" shows him sitting cross-legged, beneath a Chinese canopy, holding the fan of a Chinese sage in his left hand, with his hair braided and looped in the fashion of boys in the Fujiwara Period (897-1185). This statue was carved in 1069 by Enkai, and painted by Hatano Chishin. It is preserved at Horyu Temple.

Certain other legends are promoted in pictures. During the war with the

Shintoists, for example, Shotoku and a single retainer hid from pursuing enemies in a tree that opened up in answer to his prayers. In 608 he journeyed to China to recover a precious manuscript he had left in the monastery of Nangaku, while studying there in a previous existence. He and a large retinue made the voyage to and from China riding on the back of a blue dragon. Other representations show him as a youth in armor, standing on a high tower, directing troops in the battle of Mount Shigi; or as a mature statesman giving a fine garment to a half-naked, half-starved beggar, who is supposed to be Bodhi Dharma uttering the message of the Lord Buddha.

Shozen-doji and Shoaku-doji *godlings*

These two "boys," who are sometimes called acolytes, accompany Jizo-bosatsu on his missions, just as Kongara-doji and Seitaka-doji attend to Fudo Myo-o. As they are so similar, one pair of *doji* may be confused with another. Shozen is supposed to have a white face and holds a white lotus, symbol of the blessings that good people receive from kind gods. Shoaku has a red face, and carries a *vajra,* or thunderbolt, symbol of the curses and troubles that bad people draw from chastening gods or tormenting demons.

Shozuka-baba *mythical being*

She is the hag of hell, 4.8 meters tall, possessing huge eyes that enable her to see everything happening in her domain. She is the old woman who presides over the spirits of the newly dead, as they arrive at the banks of the Sanzugawa, the River of the Three Paths that flows through the underworld. With her filthy talons she strips the clothes from the dead (unless someone above has been forethoughtful enough to bribe her with three coins). Then, when the dead are bare and indistinguishable from each other, she sends them along on the paths that Emma-o and his tribunal have decreed for them. The three paths lead to heaven, to deeper and more horrendous hells, or back to this world of illusions, for rebirth in some other form other than the one that has just been terminated. She flings all their garments, whether they are beggars' rags or princes' robes, onto the branches of the dead trees lining the banks of the river of hell, and there they hang until they rot.

Shubaishin *a compassionate man*

Scholarly Shubaishin, a seller of firewood, devoted every spare moment to study, to the point of reading books while carrying bundles of faggots to town. His wife, bored by his lack of attention to her and fretting over his lack of interest in business, ran away with another man. Shubaishin's erudition, however, gained for him a deserved reward—within a few years the emperor appointed him governor of his native province.

Shujushi

One day, while engaged in a tour of inspection, the governor and his retinue came on two scavengers pawing through the rubbish of a town. Beneath the rags and the dirt Shubaishin recognized his former wife and her lover. Recognizing him as well, they knelt in the mud, begging his forgiveness. Full of compassion, he gave them money and sent them home to their ragpicker's dwelling in his sedan chair. His former wife, grieved at having offended so good a man, and ashamed at having to accept his bounty, stole out of that hovel and hanged herself from a tree. Shubaishin buried her with solemn obsequies, and consoled her lover with a purse full of silver coins.

Artists have depicted the young Shubaishin reading from a book while bent under a load of firewood, as well as in that moment when, as the great governor of a province, he encountered his runaway wife and her scavenging lover.

Shujushi *sennin*

He was a pupil of the Daoist priest Genshin. One day Shujushi watched in wonder as two splendid dogs glided across a wide ravine and disappeared into the ground beneath a clump of shrubs. The next day he and his master returned to look for the dogs. They found no living creatures but, after digging deep in the earth, they did discover two very hard roots resembling shriveled dogs. They boiled them for three days and three nights. After they drank this magical decoction, Shujushi and Genshin could fly through the air like birds.

Shuko *Buddhist priest, tea master*

While serving as a priest at Daitoku Temple in Kyoto, Shuko (1422-1502) created his own style of serving tea. This method, and his conversation, gained him the companionship of many connoisseurs of the arts, as well as of the tea ceremony. He is credited with having introduced the use of powdered green tea, or *macha*.

Shumoshiku (also known as *Shuboshiku*) *Ch. poet*

Shumoshiku is said to have been the first man to compose a poem expressing wonder that the lotus plant, rooted though it may be in foul black mud, can yield a blossom so immaculate and so white. He is portrayed, garbed in scholars' robes, seated beside a lotus pond, brush and paper in hand, writing the celebrated poem; or simply standing beside the flowering plant, contemplating the mud and the miracle.

Shunga *erotic pictures*

The word itself means "spring pictures." It is the euphemistic term for drawings, and especially for woodblock color prints, which present erotic scenes of spectacular explicitness. *Shunga* offers examples of pornography at its inflammatory best, or at its corrupting worst, depending on the attitude of the beholder. Paradoxically, they

must be recognized as being the least naked instances of erotic art in the history of mankind.

Shunjobo Chogen *Buddhist priest*

At the start of the Genpei War, in 1180, Taira no Shigehira ordered his warriors to set fire to both Todai Temple and Kofuku Temple in the city of Nara, because many of their priests and prelates favored the rebellious Minamoto. Shunjobo Chogen (1121-1206), a priest of Todai Temple at the time, refused to despair over the disaster. Riding humbly on a mule, he traveled throughout Japan, asking for contributions to rebuild the temple. His efforts were successful and the temple complex was rebuilt over many years. When Chogen was a very old man, and a high priest, one of the many sculptors employed in the restoration of Todai's auxiliary buildings and statuary made an image of him in painted wood. Chogen's body is gaunt, the shoulders are rounded with age, the neck sinking forward under the weight of his head. The downcurved mouth, leathery cheeks, and pouches under his eyes denote a man both tired and ill. His indomitable faith is shown in his seated composure, cross-legged, telling the beads of his rosary. This masterful portrait of Chogen is preserved in one of the smaller buildings of the great temple he worked so hard to rebuild.

Shunkan *exiled Buddhist priest*

In 1180, Shunkan (1142-83?), the chief temple secretary of Hosho Temple in Kyoto, joined with Minamoto no Yorimasa and others in a conspiracy against Taira no Kiyomori and his oppressive rule. As with so many earlier plots, this one was also discovered and suppressed. Kiyomori banished Shunkan and other conspirators to Kikaigashima, a small barren isle only twelve kilometers in circumference, about 40 kilometers directly south of Satsuma Province. Later, Shunkan's companions were pardoned, but he was left in his lonely exile.

This sad story, told in the *Heike monogatari* and in the Noh play *Shunkan,* is the subject of print makers, painters, and other kinds of artists. They portray the wretched priest, clad in rags, sunk to his knees on a rocky shore, waving a forlorn farewell to his departing friends, sailing for home in a ship.

Shutendoji *legendary ogre*

Probably "Great Drunkard Boy" was a real, although monstrous, man who has been transmuted by folklore into an inhuman monster. He may have been one of the bandits who afflicted the people around Kyoto during the middle of the tenth century. He is represented, both in story and in art, as a huge fat oaf, who robbed men, raped woman, and ate the broiled flesh of all his victims, washing it down with copious draughts of sake. He lived with his troop of evil followers in a stronghold

known as Oeyama, Devil's Mountain, only descending from it to raid helpless peasants and passing merchants.

Emperor Murakami (r.947-67) sent his trusted vassal, Minamoto no Yorimitsu, to put an end to this gang. Raiko (as Yorimitsu was better known to his contemporaries) and his *shiten,* or four principal retainers, all disguised as traveling priests, went in search of the bandits, not really knowing where to find them. On the way they met an old man (in truth the spirit of the god Sumiyoshi), who showed them the path to Devils' Mountain. He presented Raiko with a cap that would protect the wearer against all harm; a sleeping potion dissolved in a jarful of sake; and a silken cord to bind Shutendoji when he had swallowed the drugged beverage. With the help of those agents, and the support of Sumiyoshi himself, Raiko and his *shiten* entered the robbers' den, slew the monster and his minions, freed all their captives, and, bearing the ugly head of "Great Drunkard Boy," returned in glory to Kyoto.

Shuyu *legendary warrior*

One day, in the mountains, the soldier Shuyu observed two birds eating small black grains that seemed to have fallen to the ground from heaven. Being very hungry, Shuyu also ate some of those black morsels. As soon as he had swallowed them he became exceedingly thirsty and sick to his stomach. As he bent over a spring to quench his thirst, a spirit appeared. She told him to eat leaves from a small pine tree growing nearby. He followed her instructions and was cured.

Sickle Weasel (*kamaitachi*) *imaginary creature*

Japanese blame one of these sly invisible beasts for inflicting cuts, tears, bites, and scratches on peoples' bodies or possessions, when they can remember no apparent cause—or do not choose to offer any explanation. A *kamaitachi* has talons as sharp as sickles. He is carried about by cold winds or typhoons. Yet, paradoxically, he is found also in warm beds and on public roads.

Six Bodhisattva *Buddhist guardian deities*

These are attendants to the Buddhas of The Four Cardinal Points. More than likely each Buddha was given a pair of such attendants, but records at Horyu Temple can identify only six: Nikko, Gakko, Kannon, Seishi, Fugen, and Monju. Japan's oldest images of these six bodhisattva, carved in wood between 650 and 700, are those preserved in the Treasure Museum of Horyu Temple.

Six Gods of War (*rokubuten*)

These martial divinities are not native to Japan, having been borrowed from India by way of Buddhist lore. They are Bon-ten (who is Brahma in India), Taishaku-ten (who is Indra), and the *shitenno,* or four heavenly kings—Jikoku, Komoku, Zocho,

and Bishamon, guardians of the eastern, western, southern, and northern quarters, respectively.

Six Patriarchs of the Hosso Sect (*hosso rokuso*) *Buddhist saints*

These six priests are supposed to have established their sect in Japan during the Nara Period (645-794). The Japanese names usually given to them are Gembo, Gempin, Gyoga, Joto, Shin'ei, and Zenju. Around 1189 the sculptor Kokei carved lifelike wooden images of all six for Kofuku Temple in Nara, the Hosso sect's principal institution in Japan.

Six Poets (*rokkasen*) *literary grouping*

These are the six most famous poets of the ninth century, not the six greatest in Japan's long history. The array most generally accepted, first chosen by Dainagon Kinto in the eleventh century, includes the court nobles Ariwara no Narihira, Otomo no Kuronushi, and Fumiya no Yasuhide; the priests Sojo-henjo and Kisen-hoshi; and the court lady Ono no Komachi.

Later critics, disagreeing with Kinto's selection, dropped four of his nominations and replaced them with their own favorites, all court nobles: Abe no Nakamaro, Kakinomoto no Hitomaru, Ki no Tsurayuki, and Yamabe no Akahito. Only Ariwara no Narihira and Ono no Komachi are shared in common. Both Abe and Kakinomoto, however, lived in the eighth century, and do not belong among those who flourished in the ninth.

Six Realms of Rebirth (also known as Six Regions of the Impure Land; *rokudo*) *Buddhist doctrine*

Buddhist doctrine teaches that until a spirit inhabiting a living being attains enlightenment (and thereby the opportunity to enter into nirvana), it cannot escape from this impure world. Emma-o, King of Hell, and his tribunal condemn the imperfect spirit to be born again and yet again, in the cycle of reincarnations that Buddhists call the Wheel of Birth and Death. Whenever the spirit is born again, it enters into a form belonging to one of six categories: sufferers in hell; hungry ghosts; angry demons; beasts; human beings; and heavenly beings. These categories, or realms, are listed in ascending order of improvement. The first three realms are "bad," in that they are even worse than this world can ever be. The other three are "good," in that they offer a spirit a chance for improvement and release.

The karma of a spirit—the cumulative record of good and evil deeds that it has amassed during all past incarnations—will determine which realm it will be born into in the next stage of its progress, and how happy or miserable that period will be.

Six Tutelary Bodhisattva of the Six Districts *Buddhist deities*

During the Heian Period (794-1185), a number of temples in the six districts of Kunisaki peninsula in northern Kyushu promoted the worship of the bodhisattva Kannon: Nyoirin, Kokuzo, Miroku, Nimmon, Yakuo, and Yakushi. Nimmon, an original Japanese contribution to the ranks of bodhisattva, was a saintly priest who lived and taught in Kyushu during the late Nara Period (710-94). After he died, people regarded him as an incarnation of Hachiman, the Shinto god of war (whose first shrine had been established at Usa, not far from Kunisaki).

Slit-eyes, hook-nose (*hikime-kagihana*) *technique*

During the Heian Period (794-1185), artists deliberately made the human face as impersonal and as passionless as possible, by rendering an eye or a mouth with a single thin line, a nose with the merest hook. In a further repudiation of individuality and personal beauty, artists gave all their subjects, whether male or female, child or adult, the same plump cheeks and vacant expression. In consequence, all the creatures they depicted looked alike—and, to Western tastes, at least, deplorably unattractive. Some historians maintain that pictorial artists restricted themselves to a rigid and stylized manner of representing features—as well as costumes, houses, objects, and whole landscapes—because they wished to suggest universal emotions, actions, and spaces, rather than to depict a single specific instance.

Snail *as symbol*

The snail rarely appears in Japanese art except in netsuke (minature carvings in wood, ivory, or other materials), or as one of the *sansukumi,* the three cringing creatures.

Snakes and Serpents *as symbols*

Japan's older literature, created before the dragon became fashionable, mentions an immense serpent about 240 meters long that swallowed elephants; another serpent, named Uwabami, that devoured mounted warriors, armor, horses, and all; and a sea monster named Ayakashi that lived in the ocean off Shikoku Island. The latter was so long that it needed two or three days to slither aboard a ship it had captured. During that time, it secreted immense amounts of a fatty substance that the terrified sailors had to continually throw overboard to prevent the ship from sinking under the burden.

Several of Japan's greatest heroes have confronted serpents, not always victoriously. Notable among these are Yamato no Takeru, challenged by the potent deity of Mount Ibuki, who assumed the shape of an enormous white serpent; Priest Nichiren, tempted in his monk's cell by lewdness taking the form of a seductive woman; and Minamoto no Yorimitsu, assailed by the bandit Hidomaru, who could

transform himself into a serpent named Yasusuke, snorting fire and smoke on his adversaries.

On the other hand, in Japan as in other countries, the little indigenous snakes are emblems of certain autochthonous deities. Okuninushi no Mikoto, for example, could transform himself into a snake. Suijin, the god of wells, sometimes takes the form of a snake. A few ancient portraits of Saruto-hiko, the monkey-faced, long-nosed god of roads, show snakes coiled around his wrists and ankles. Bishamon, as guardian of the north, is sometimes accompanied by a serpent. A serpent coiled around a pheasant or a tortoise (both are incarnations of Vishnu) is a portrait of evil impeding the god in his efforts to help mankind.

In Asia, as in Europe, the ability of snakes to slough off their skins as they grow makes them symbols of health and longevity. For this reason, people in many parts of Japan regard them as being sacred, especially in those places around Benten's shrines. Living snakes, therefore, are promises of good things, but dead snakes are harbingers of evil. To dream of a living snake is indeed auspicious. Yet the snake is also demeaned, being put into the company of a frog and a snail, as one of the *sansukumi,* or three cringing creatures. Still, it is a well-respected member of the Japanese zodiac.

Snow Woman (*Yuki-onna*) *legendary creature*

She is the ghost of someone who perished long ago in snow, returning now to bring death. Robed in snow, glittering with ice, she comes during winter's coldest days. Some people see her in the flurries of blizzards; others find her in the spray torn by winds from lofty peaks, or hovering above avalanches sliding down steep mountain slopes. No one denies that she appears as a woman, with long trailing hair and the shifting features of a phantom. Some reports say that she is young, beautiful, alluring. Others insist that she is old, a hag with a weird face, and that her body is taller than the trees. Everyone agrees that she is treacherous and cruel: the mere sight of her may not kill, but her touch, her very breath, bring death. She may seem to be frail and wan, a thing made of swirling vapors and lacy snowflakes, but she is strong enough to rend huge pine trees, and to split green and supple bamboos. Her icy lips can suck the life from a human body.

A handsome young woodcutter named Minokichi actually met Yuki-onna face-to-face one bitter cold evening—and lived to tell the tale. For reasons that he did not learn till many years later, she let him go unharmed, on condition that he would never tell anyone that he had seen her. Only too willing to promise her anything she demanded, he nodded and fled.

Sobu

A few weeks later Minokichi married a beautiful girl whose name was Oyuki, Honorable Snow. They lived happily together for ten children's worth of time. Then, one winter's night, when all the children were asleep, and the snow lay deep around their house, the wind moaning through the naked trees, Minokichi, sitting warm beside the kitchen fire, thought to tell his loving wife about the time he'd met the Snow Woman, so long ago. To his horror he saw his own familiar wife turn into icy, glaring, freezing Yuki-onna herself. Raging at him for not having kept his promise, she put out her talons to kill him, then and there. She glanced at those ten beautiful children he had sired, and her rage turned to pity, and she spared him once again. Transforming herself into a hiss of steam, she sped through the smoke vent and disappeared forever from Minokichi's sight.

Sobu *model of fidelity to an emperor*

Sobu, sent by the Han emperor Wudi (r. 141-87 BCE) on an embassy to the Xiongnu of Mongolia, was not permitted to return to China for nineteen long years. The barbarians forced him to take care of foul-smelling goats, sheep, and geese, and often threatened him with death unless he foreswore allegiance to Wudi. He would not yield. The emperor, meanwhile, not knowing what had happened to Sobu, thought that he had perished on his mission.

Finally, Sobu thought of a way to inform the emperor of his plight. He wrote a message on a slip of paper, and tied it to the leg of the kind of wild goose that he had seen so often at home in China. Just as he hoped, the goose flew south in the autumn and was captured. The message it bore was delivered to the emperor's officials. Wudi sent an embassy to the Huns, demanding that they release Sobu. The khan of the Xiongnu was astonished that the distant emperor should know where Sobu was and how he fared. Fearful of such a powerful ruler, he released Sobu.

Sobu is represented as a ragged old herdsman watching a wild goose taking wing, with a piece of paper fastened to its leg. Sometimes the old man is portrayed squatting forlornly amid geese, presumably in the moment when he first thinks of using one of them as his winged messenger.

Soga Brothers' Revenge

The motive of two brothers, Soga no Juro and Soga no Goro, to slay Kudo Saemon Suketsune, whom they believed to be the killer of their father, Kawazu no Saburo Sukeyasu, is but one element in a complicated history of a stolen inheritance (involving Suketsune), the bruised ego of a bested wrestling champion (Matano no Goro), differing allegiances in the Genpei War (1180-5), and sundry power struggles in the Minamoto and Taira families. Yet Japanese artists, seeing the Soga Brother's

act of vengeance as an example of appropriate filial responsibility, have made of this minor event a bravura feat. Their favorite scenes are the brothers' journey on horseback to the camp where their enemy was to be found, and the killing itself.

Soga no Iname *noble; imperial minister*

In 552 the king of Kudara, a country in Korea, sent several Buddhist images as gifts to Emperor Kimmei of Japan. Of the emperor's three ministers, only Iname (?-570) advised him to "venerate the gods of the western countries." The other ministers, especially Mononobe no Ogishi, strongly opposed accepting those alien images. Emperor Kimmei resolved the problem by giving them to Iname. He built for them, in his own household, the first Buddhist temple in Japan.

Soga no Iruka *court noble*

Both Iruka (?-645) and his father, Soga no Emishi (?-645), as ministers to the sovereigns of the time, acted in their own interests rather than those of the emperors they should have served. At last nineteen-year-old Prince Nakano Onie and his friend Nakatomi no Kamatari decided to rid the court of that unscrupulous pair. During a grand ceremony, while empress Kogyoku (r. 642-45) was receiving an embassy from Korea, the conspirators assassinated Soga no Iruka. At the same moment their supporters murdered Soga no Emishi in his home.

In this bloody way the power of the ruthless Soga was ended. Thus began the power of a new house. Nakatomi no Kamatari was the founder of the great Fujiwara family, which ruled Japan for several hundred years, to a degree far beyond the imagination of the Soga.

Soga no Umako *noble; imperial minister*

Umako (?-626), son of Iname, shared his father's interest in Buddhism. After Iname died, Umako led a faction at court that advocated the new religion, and opposed the conservative Mononobe clique, which favored the native Shinto order. The controversy led to open warfare. In 587, after a single battle in which the Monobe faction was defeated, "Buddhism triumphed with the Soga."

Sohei *temple mercenaries*

Toward the end of the eleventh century the abbots of several wealthy Buddhist temples near Kyoto and Nara began to employ troops of soldiers to protect their institutional properties from bandits, masterless warriors, raiding *daimyo,* and other predators. By the middle of the twelfth century those bands of *sohei* themselves had become predatory, destructive, and on occasion even seditious. Bands of the fanatical hirelings would descend on Kyoto from Mount Hiei, shouting demands for "correction of abuses," while they pillaged the city and, not incidentally, killed

off "enemies" among government officials, townsmen, and priests belonging to rival sects. The rise of the Taira and Minamoto clans is due in part to the fact that several emperors called on them to protect Kyoto, and indeed the imperial court, from ravaging *sohei*. In 1180, when the *sohei* rose in support of the Minamoto rebellion against Taira no Kiyomori, he sent his warriors to Mount Hiei to subdue the mercenaries. The Taira troops burned down the temples, and killed or dispersed the *sohei*—but not for the last time.

Many mercenaries were both priest and soldier. Militant priests usually commanded those private armies and their smaller units. When they were not out terrorizing the countryside, *sohei* lived in temple compounds, continuing to train themselves in the martial arts while performing other and more pacific duties.

The fighting priest distinguished himself from the unordained mercenary (clad in the usual armor) by wearing a rather womanish headdress, a kind of soft beret fitted with long flaps hanging to his shoulders at the sides and the rear. A soft gray, a delicate mauve, or an intense purple seem to have been the favorite colors for this bonnet. The commander of a group, however, wore a sort of cowl, whose lower part was long enough to cover his chin and mouth.

In 1571 Oda Nobunaga totally destroyed the mercenaries of Mount Hiei, putting a permanent end to their machinations.

Sojobo *legendary creature*

He is the supreme chief of all the colonies of the birdlike creatures known as *tengu*, and is addressed as *dai tengu* (great *tengu*) or *tengu-sama* (master *tengu*). He is known also as Sojobo of Mount Kurama, his dwelling place north of Kyoto. He is identified by a full gray beard hanging almost to his waist, a long drooping mustache, and by the fan of seven stiff feathers that is the insignia of his office. Neither heaven nor hell will receive Sojobo, because he deliberately disobeyed the Buddha's precepts. Many pictures show him presiding over his colony of *tengu,* or over the few who are instructing Minamoto no Yoshitsune in the martial arts, performing his penitential task of carrying food to the head priest of Saijo Temple on Mount Kurama, or brandishing a halberd as he rides a wild boar.

Sojo Henjo (also known as *Yoshimune no Munesada*), *poet-priest*

Munesada, a descendant of imperial princes, served Emperor Nimmyo (r. 834-50). When the sovereign died, Munesada became a priest, taking the name Henjo. Later, he attained the rank of *sojo*, or bishop. His verses, often humorous, pleased succeeding generations enough for them to honor him as one of the *rokkasen,* or six most famous poets of the ninth century. A popular print shows him—having been

thrown from his horse—portly and laughing, sprawled on the ground amid masses of yellow flowers called *ominaeshi*. A saddled horse looks down on him in disdain. Sojo Henjo chose to die in an extraordinary way: his fellow priests laid him, alive, in a small vault, into which air could only enter through a narrow bamboo tube. Then they covered with earth the vault that soon became his tomb.

Sompin *Ch. legendary general*

Sompin and Hoken studied with the same mountain sage. When their time of training ended, the king of Wei appointed Sompin to command his army, and Hoken to be a minister of state. Hoken was so jealous of Sompin's remarkable successes as general, rainmaker, and, eventually, as governor of a province, that one dark night he tried to kill him. He failed—he cut off both of Sompin's legs, but not his life. Fortunately, an emissary from the king of Qi rescued Sompin, took him home, bound his wounds, and restored him to health. Though he was legless, he was still a powerful person. The king of Qi made him commander of the army he was training to make war on Wei.

The new general of Wei's army was none other than Hoken. Toward the end of the first day of battle, Sompin and his aides pretended to flee the field. Mounted on swift horses, they sped up the slope of a wooded valley. Near the pass at the valley's head, one of his lieutenants nailed on a tree a sign that Sompin had written. "The scoundrel Hoken will die on this spot," it proclaimed. Hoken and his eager companions reached the sign just before twilight. Seeing his name written so large, Hoken stopped short, wanting to learn the whole message. As he read his fate, Sompin's warriors leaped from the bushes and trees, and slaughtered Hoken and his warriors.

Artists have illustrated several episodes from Sompin's history. Among them are the times his rituals caused rain to fall on the parched lands of Wei, and when his magical spells unleashed a tempest on two brigands who attacked him in the mountains. Hoken, too, is pictured in the moment when he and his lieutenants, drawn up before the fatal sign, are reading the notice that will bring them death.

Songoku *The Monkey King*

The adventures of Songoku, The Monkey King, known to the Chinese as Sun Wu Kong, are chronicled in a Chinese work of the Ming Dynasty, known best in English as *Journey to the West*. Published anonymously (its author may have been Wu Cheng-en), it is one of the four great classical novels of Chinese literature. Overflowing with magic, demons, gods, immortals, and rousing adventures, the novel recounts the journey of a Buddhist priest Sanzo-hoshi who journeyed to India in 629 to collect sacred articles and sutras for his temple in China. He had three companions, of

which the most famous (perhaps notorious would be a better word) was Songoku, a bold, daring, and mischievous human-sized monkey.

Without The Monkey King's magical powers, Sanzo-hoshi would never have been able to cross the mountains to India. When guardians of the road demanded that the priest perform 108 tests of holiness at the same instant to prove his worthiness, Songoku pulled exactly that number of hairs from his own body and blew them into the air. Each became a replica of Sanzo-hoshi, and all of them performed the tests of holiness. Later, of course, those 108 walking, talking, eating images of himself rather slowed Sanzo's journeying, but a holy man and magician met on the road transformed them again into monkey's hairs. The Monkey King could also turn himself into a fly, a tree, or a beautiful girl. The travelers returned to China with scrolls recording Buddhist law and many holy images and blessed relics.

The adventures of Songoku and his fellow travelers were translated into Japanese by the great Japanese novelist Bakin as *Saiyuki*, or *Journey to the West*, and Hokusai illustrated it in his own imaginative fashion. Songoku is mostly depicted in Japanese art creating the 108 clones of Sanzo-hoshi. An English-language version by Arthur Waley bore the title *Monkey*, which falls short of conveying Songoku's abilities and appeal. But his personality is at the heart of a video game called *Journey to the West* released in 1992, and a stage musical of the same name presented in Manchester, England, in 2007.

Sorori Shinzaemon (also known as *Soyu*) *shrewd commoner*

Shinzaemon, a scabbard maker, rose high in this world because he studied the weaknesses of other men, including those of the great warlord Toyotomi Hideyoshi, another commoner whose shrewdness exceeded his own. Shinzaemon made an arrangement with Hideyoshi that he would lick his ear while the warlord presided over a council of *daimyo*, generals, and high officials. In doing so, Shinzaemon immediately convinced everyone present that he was whispering information about some of them to his master. Thereafter they showed their great respect for the scabbard maker with personal attention whenever they met, and expensive gifts delivered in secret to his home. Sorori Shinzaemon became a very rich man in a very short time.

Sosenon *sennin*

This old wise woman traveled about the country accompanied by a young girl and a dog. When they came to a broad river one day, the ferryman refused to take them aboard his boat. Sosenon conjured up a storm and, borne on the river's waves, crossed to the farther bank with her two companions.

Soshi (*Ch. Zhnangzi, older form Chuang-tsu*) *philosopher*

Soshi was so witty a man, with a mind so full of fantasy and paradox, that few people could understand him or his teachings. Several stories told about him serve as themes for artists. The one most frequently represented has him lying asleep on the ground, as a butterfly hovers above him. This is an allusion to a dream, in which he thought he was changed into a butterfly. He told his disciples that he could not be sure whether he was a man dreaming he was a butterfly or a butterfly dreaming he was a man.

Soso *warrior*

During the time of the Three Kingdoms in China, the aggressive general Soso made himself a prince of Wei and deposed the legitimate empress in order to raise his own daughter to that eminence. Japanese artists have depicted him aboard a boat, drifting down the Yangtze River, on the way to fight a battle. They see two crows fly across the face of the moon. Scoffing at this ill omen, Soso composes a poem and then issues battle orders for the next day. In that engagement his army is defeated, and Soso is killed.

Sotan *sennin*

She lived happily with her old mother in a house of their own while she studied magic with a learned neighbor. One day, while she swept the courtyard, her mother asked Sotan why she was so remarkably serene. Sotan answered that she was about to be transformed into a fairy-spirit. She informed her mother that a dreadful pestilence would ravage the land within a year, and promised that she could escape the sickness only if she ate the leaves from the orange tree growing in front of their house, and drank only the water drawn from their well. Soon afterward a five-colored cloud descended from heaven and carried Sotan off to the Realm of the Immortals.

Sotoba *Buddhist monument*

Sotoba is the Japanese version of the Sanskrit word *stupa*. Both terms refer to the five-tiered monument under, or in which, Buddhists preserve sacred relics, such as the bones, teeth, hair, ashes, or robes of Shaka himself, or of saints who came later. In Japan *sotoba* are also used as grave markers. The poet Ono no Komachi is often shown as an old, haggard woman standing by, or seated on, a graveyard *sotoba*.

Sotori-hime *princess*

This younger sister of Princess Osaka no Onakatsu, consort of Emperor Inkyo (r. 412-43), was so esteemed for her great beauty and talents as a poet that Inkyo installed her in a separate residence, the Fujiwara Palace. To protect her, he created

the Fujiwara-*be,* a guard composed of warriors who came from all the provinces. Princess Sotori is credited with having introduced silk weaving from China, and therefore, is depicted sitting at a loom, or holding a shuttle. In addition, some people regard her as a goddess of poets.

Sparrow *in folklore*

Pictures of the sparrow alone or in small groups make it a symbol of the farmers' industriousness, whereas flights of sparrows indicate friendliness and grace of movement. It often appears in art, both in its natural shape, and also in a stylized "expanded" form, with outspread wings and flared tail, which is called *fukurasuzume.* The crests of several clans are composed of two or three fukurasuzume, arranged either one above the other, or beak-to-beak, with the tips of the tails serving as arcs to a circle.

People believe that some aggrieved or vengeful spirits might be reborn as sparrows. Mononobe no Moriya, the champion of the Shinto faith, was so full of hatred for the Buddhist religion, that, after being killed in the battle of Mount Shigi, he returned as a sparrow and alighted only on the roofs of Buddhist temples, causing them to burst into flames. Japanese called this baneful bird *terasuzume,* temple sparrow.

The sparrow is the hero of a well-known fairy tale, "*Shitakira Suzume,*" or "The Tongue-cut Sparrow." His true name was Bidori, "beautiful bird," and a kind old man kept him as a pet, not shut up in a cage, but flying about as freely as he wished. One day, while his master worked in the fields, Bidori ate some of the starch grains being dried in the sun by his master's shrewish wife. She punished him by cutting out his tongue. The bird flew off to his family home in the forest.

After much searching, the old man found him. Bidori and his kin entertained him with food, drink, and song, and performed for him the *suzumeodori,* or sparrow dance. When his foster-father prepared to go home, Bidori set two baskets before him, one big and heavy, the other small and light, inviting the old man to take whichever one he wished. Modest and unselfish as always, he chose the smaller one, saying that, because he was so old, it would be easier for him to carry. Amid sincere farewells from the sparrow clan, he returned to his village. At home he opened the basket to find it filled with jewels, gold and silver coins, and rolls of beautiful silks. Best of all, no matter how many treasures he removed from it, the basket always remained full.

The envious wife decided that she must share in this good fortune. She, being greedy as well as cruel, chose the larger of the two baskets Bidori set before her. Moreover, being impatient, she did not wait until she reached home before opening

it. In the middle of the forest she tore it open. A swarm of demons poured out of it, and killed her.

Spider *in folklore*

A spider can be an emblem of industry and skill, or an omen of witchery and betrayal. It can be regarded as an exemplar of the weaver's art, and as an intercessor with the Weaver Maiden during the Tanabata Festival. It can also be monstrous and evil—like the Tsuchigumo, the Earth Spider killed by Raiko and his followers. Some Japanese generals honored the Chinese triad that signified the virtues of a good military commander: the skillful spider, the courageous praying mantis, and the humane cicada.

Spirit God of the Three Treasures (*sambo-kojin*) *Buddhist deity*

Sambo-kojin protects people and their homes from evil. He is so powerful that a mere image of him installed in a household warns off those who would harm its members or steal their possessions. Inasmuch as most families in olden days put up Sambo's image near the cooking hearth (if only because that is the only room all members of the household shared in common), almost everyone refers to him as "the kitchen god." He has three faces and four hands, which hold a jewel, a wheel of the law, and two thunderbolts.

During the eighteenth century irreligious people in Edo gave the name *sambo-kojin* in jest to a packsaddle fitted with a bag or box at either side. Carvers of netsuke (miniature sculptures in wood, ivory, and other materials) made the pun hilariously visible by creating a compacted mass of interrelated figures: a poor overburdened sway-backed horse bearing a tired mother, a bawling infant in each side box, and at least two other children clinging to neck and cruppers, and, leading the whole assemblage, a bent and broken father.

Squirrel *as art motif*

The squirrel is an infrequent subject in Japanese art. The animal has been shown eating fruits. In China, a popular decorative design puts squirrels among grape leaves. At least one Japanese carver used this motif to make a beautiful *ramma,* or panel frieze above a *fusuma* (sliding door), for Hideyoshi's palace at Momoyama. The *ramma* with squirrels (and the room around it) is preserved at Nishi-Hongan Temple in Kyoto.

Stars and Constellations

In Western art, stars are usually depicted as irregular devices having three, five, or more points. In Eastern art, on the other hand, complete circles or disks represent stars. All circles in the figure of a constellation are drawn the same size; and often,

especially in *mon* (family crests), each circle is joined by a straight line. According to Weber, Edmunds, and other writers, the constellation most often shown in art is Ursus Major, the Great Bear—primarily because Japanese regard it as the symbol of the Weaver Maid and the Heavenly Herdsman, whose reunion is celebrated each year in the Tanabata Festival.

Stone Lanterns *warders against evil*

According to myth, the god Iruhiko invented the stone lantern, and placed a number of these conveniences along the lonely paths of Mount Sato, in Kawachi Province, because he wanted to protect travelers from brigands who frequented its slopes. Probably in the beginning, *ishidoro* were placed before graves, tombs, or shrines. The faint flickering light they gave off did not deter robbers, but comforted the spirits of the dead.

Stork *symbol of longevity*

Like most people even today, many of Japan's artists (and art historians) were not quite sure how to tell a stork from a crane or a heron. Accordingly, each of those big, long-legged birds may be misidentified in titles of pictures, or descriptions in tales. Fortunately such mislabelings are not important, inasmuch as all of these birds are emblems of longevity in Oriental symbolism. As such they are shown in association with other symbols of long life, like turtles, pines, bamboos, or aged people. A stork and a turtle accompany Jo and Uba, the happily married old couple. Sentaro, the man who did not want to die, was carried to and from Mount Horai, the land of eternal life, on the back of a paper stork. Wasobioe, the Japanese Gulliver, traveled on the back of a real stork. According to legend, when Minamoto no Tametomo escaped from Taira persecution to the Ryukyu Islands, a wolf and a stork went with him.

Sugawara no Kanshusai *endangered child*

When the inimical Fujiwara succeeded in banishing Sugawara no Michizane from Kyoto, they wanted to increase his unhappiness by killing his young son, Kanshusai. The boy had been left in the care of Takebe Genzo, a friend of Michizane, who kept a school in Kyoto. Shihei, the leader of the Fujiwara, sent two of his retainers, Gemba and Matsue, to claim Kanshusai's head from the schoolmaster. Genzo managed to trick the Fujiwara, and saved Kanshusai's life by beheading instead a new pupil who somewhat resembled the intended victim. The Fujiwara never learned what Genzo himself soon discovered. The boy he had killed was Matsue's own son. Matsue, still the loyal retainer to Michizane, his former lord, had deliberately enrolled his son in the school, anticipating that Genzo would act precisely as he did.

This imaginary tale forms the plot of a Kabuki melodrama entitled *Sugawara*

denju tenarai kagami (freely translated as *Sugawara's Secrets of Calligraphy*). Crafted by three ingenious playwrights in 1746, it has been unfailingly popular ever since.

Sugawara no Michizane *scholar, poet, calligrapher, statesman, divinity*

The leading authority of his time on Confucian teachings and Chinese literary classics, Michizane (845-903) supported Emperor Uda (r. 888-897) in a controversy over status, thereby drawing on himself the enmity of the politically powerful Fujiwara family. The emperor, and his successor, Go-Daigo (r. 897-930), rewarded him by appointing him to ever higher-ranking positions in the court.

Fujiwara no Tokihira, as chancellor to the court, was his country's highest appointed official. In 901, he presented charges of treachery against Michizane to the emperor. The accused minister was judged culpable, and was, in effect, banished from the court by being appointed governor of Kyushu, a post of symbolic importance only, reserved for those who had fallen from favor. Michizane did not bother to function as governor of Kyushu. Instead, he wrote poetry—in Chinese. Daily he would climb Tempaizan, a hill nearby his house, and sit facing toward Kyoto for several hours. He died in Daizafu, the governor's seat, in 903.

Many strange events are part of Michizane's history. His favorite plum tree is said to have uprooted itself from its place in his Kyoto estate and flown to the decrepit governor's mansion to keep him company. An image that Michizane carved of himself floated down a river from Kyoto to Sakai, a city in Osaka Prefecture. The image was enshrined in Sakai until one day it burst forth from the protective building, and perched on a branch in a nearby plum tree. During Michizane's funeral, the ox pulling the cart where his body lay was so overcome with grief for the dead man that it lay down in the road, and refused to go any farther. Taking the event as a sign from on high, the attendants buried Michizane's body on the spot.

The early deaths of Tokihira, Minamoto no Hikaru (another of the dead minister's declared enemies), and the crown princes Yasuahira and Yoshiyori (both grandsons of Tokihira) were attributed to Michizane's dissatisfied spirit. Court officials became so worried that in 923 Emperor Go-Daigo ordered the documents relating to the alleged plot of 901 be burned, thereby exonerating the dead man of any guilt. He also reappointed Michizane to his former position as minister of the right and enrolled him in the senior second rank of the nobility.

In 930 the long-dead courtier, riding on a black cloud, in the guise of Raijin, the thunder god, descended on the imperial palace. A lightning bolt killed one of the emperor's attendants. Go-Daigo became ill and abdicated three months afterwards. A series of earthquakes and other natural disasters forced the counselors to conclude

that Michizane's spirit would only be mollified if a shrine was erected in his honor. The buildings for this memorial were completed at Kitano in northern Kyoto in 947, and the spirit of Michizane was enshrined. (The shrine today is composed of buildings erected in 1607 by Toyotomi no Hideyori.) Around 987 the dead man was accorded the highest of honors: He was declared a god, with the title of Tenjin, or "heavenly deity." Each year a festival is held in his honor at Kitano; and more Shinto shrines are dedicated to him than to any other deity in Japan except Hachiman, the god of war. He is revered as the patron-god of learning, literature, and calligraphy.

Sugi *cedar tree*

This species of cedar, known to botanists as *Cryptomeria japonica*, rises tall and straight, when given adequate space, often reaching heights of 30 meters or more, and can live for a thousand years. Its crown is an elongated cone, and its narrow, feathery "leaves" are light green in summer months, dark green in winter.

According to the *Nihongi*, the first *sugi* trees grew from hairs of the beard of Susano-o no Mikoto. According to fable, *sugi* are favored dwelling places for *tengu*, those long-nosed creatures. They hide in the luxuriant foliage and build nests in hollowed trunks. The practical Japanese make use of every part of the god-given tree. The great trunks serve as pillars for temples, posts for bridges, and masts for ships; lumber of smaller dimensions for parts of houses; lesser pieces for making furniture, utensils, boxes, containers, lacquerware; the bark for roofing; and the leaves for compounding an incense. Sake, they say, is especially well flavored if it is aged in tubs fashioned of *sugi* wood.

Sugimoto *impostor-priest*

Kusunoki no Masashige used many tricks to baffle his enemies, who always outnumbered him but never outwitted him. On one occasion, he sent a retainer named Sugimoto, disguised as a priest, to inform Ashikaga no Takauji that both Masashige and Nitta no Yoshisada had been killed in battle. While Sugimoto squeezed out a few tears of sorrow for those victims of war (thereby giving story-tellers cause to remember him as "the weeping priest"), the Ashikaga, rejoicing over these good tidings, relaxed their guard, and Masashige and Yoshisada defeated Takauji's army and saved Kyoto, for a time.

Suijin (also known as *Mizuhanome no Mikoan*) *Shinto deity*

Some people believe that Suijin is another of the innumerable children born to Izanagi and Izanami, while others maintain that he existed during the eons before that ancestral pair created so many divine offspring. Regardless of his age, however, he is recognized as the protector of wells and similar sources of sweet water. He

decreed the laws of cleanliness, not with respect to one's person, but out of respect for water, the supreme blessing. He is stern in his inspections, and severe in punishing lawbreakers. Any owner of a well, spring, cistern, or streamlet who does not maintain it in perfect condition is struck at once by disease or death.

Suijin is difficult to represent, being as formless as the element he protects. Therefore, some artists depict him as a snake, of the kind that lives behind the casing of a well or spring. Grateful people who want to ease Suijin's labors of surveillance release many *funa,* or tiny silvery carp, in cisterns and wells.

Suikoden *translation of Chinese novel*

This huge and bombastic novel, written during the thirteenth century, relates the fortunes and adventures of a gang of outlaws who afflicted two whole provinces during the twelfth century. Scholars believe that chapters one through seventy were written by Shi Naian, the remaining ones by Luo Guanzhong.

The novel tells the personal story of every one of "the Hundred and Eight Heroes of China," as the Japanese refer to them, as well as the complications developing out of their association and activities. The complete work, a favorite among Chinese readers, gained immediate popularity among Japanese in 1806 when two of their novelists, Kyokutai Bakin and Takai Razin, produced a translation in 90 volumes of text. They entitled their translation *Suikoden,* or *Water Chronicles.* Artists hastened to illustrate such a fascinating chronicle, and soon the 108 heroes of China became as familiar to the Japanese as their own heroes and villains.

Hokusai provided vigorous illustrations not only for the 90-volume first edition, but also for a separate book devoted exclusively to drawings that was entitled *Chugi Suikoden ehon,* a *Picture Book of the Persons in the Suikoden.* Utagawa Toyokuni, Yanagawa Shigenobu, and many other print makers selected certain heroes to portray. Yashima Gakutei designed a set of five surimono entitled *Suikoden goko shogun, Five Leading Generals of the Suikoden,* in which the generals appeared about as warlike as lady poets at a moon-viewing party. Then Utagawa Kuniyoshi filled his prints with all the brutal violence and fierce energy that the stories called for in the volume entitled *Tsugoku Suikoden goketsu hyakuhachinin,* or the *One Hundred and Eight Heroes of the Popular Suikoden.*

Suiten *deity from the sea*

Apparently a divinity derived from Hindu and Buddhist precursors, Suiten became a favorite protector of Japanese sailors, and of people forced to travel by sea. They carried talismans inscribed with his name as protection against shipwreck and other perils of the deep. He took the shape of the usual muscular and ferocious demon of

Indochinese provenance, except that he had three eyes, a tangled mass of writhing snakes instead of hair, a nimbus of bright flames, and stood on the back of a tortoise swimming through the waves. In his right hand he held either a chalice or a sword with a thunderbolt for its hilt; and in his left hand a pair of entwined snakes, one blue, the other green. In all these attributes, except for the supporting tortoise, Suiten is identical with one of The Twelve Heavenly Kings. Both seem to be descended from the ancient Brahmanic deity Varuna, regent of the sea and guardian of the western quarter, who in Indian iconography rode on the back of Makara, a sea monster resembling a crocodile.

Japanese found room for Suiten in their own pantheon, and gave him duties previously attributed to their Shinto divinities. Esoteric Buddhists gentled him almost unrecognizably: a colored painting dated 1127 depicts him as almost a feminine deity, with none of the characteristics described above. After 1185, when the boy Emperor Antoku drowned in the battle of Dannoura, he too was worshipped as Suiten.

Sukiya *tearoom or teahouse*

This term referred not to the public teahouse, where any one could go for refreshment or assignation, but rather to the intensely private little hut in a garden, or to the small room in a residence, where one might repair, alone or with one or two chosen friends, in order to "perfect one's spirit" with the regimen of the tea ceremony. The fashion among connoisseurs of the tea ceremony, established by teamasters of the sixteenth century, called for such a secluded *sukiya*. It must be extremely simple in design and furnishings, they decreed, and inexpensive to construct. Indeed, the very word *sukiya* meant "house of the imperfect." Bark was allowed to remain on rafters and on the posts supporting them. Walls were plastered with hardened mud. Ceilings, if they existed, were fashioned of reeds or thin bamboo, and rice straw provided the thatch for the roof. Even the entrance was so humble that guests had to crouch as they passed through it. All this simplicity in style and means seems to have been the refined man's response to the opulence and color being lavished on the palaces of *daimyo,* and in the temples of the Momoyama Period (1573-1615). Sen no Rikyu (1521-91), the celebrated teamaster of Kyoto, is supposed to have been the man of simple tastes who introduced this style of construction not only in his teahouse, but also in his own residence.

Today, the term *sukiya* no longer refers to a tearoom, which is now called a *chashitsu.* Instead, the word *sukiya* has been given a new meaning—it refers to the elegant style of architecture used in building family residences in the manner of Sen no Rikyu's house, constructed in 1587.

Sukumamo *Buddhist novice or priest, possibly legendary*

This story, first put into writing by Kenko-hoshi in his *Tsurezuregusa,* or *Gleanings of Leisure Moments,* survives in at least two versions. One makes Sukunamo an innocent novice, the other a worldly priest from Ninna Temple in Kyoto. The priest's tale is the happier one. He frequented geisha houses more than was seemly, perhaps, and drank more sake than was wise. One night, wanting to enliven a geisha party, he placed a heavy three-legged iron pot (fortunately empty) on the crown of his sweating shaven head, while he danced about the room. The pot slipped down over his face, much to the merriment of everyone else. Only after the use of much lamp oil did they finally lift the encumbrance from his scoured head.

The sadder version makes Sukumamo a guest at a graduation feast for his class of novices about to become priests. Drunk for the first time in his young life, he foolishly put the pot on his head—to very sad effect. Alarmed companions, in rushing to lift it off, wrenched from his head both his nose and the ears, leaving him a deformed and suffering man.

Sukuna-biko-na no Kami *Shinto deity*

Sukuna, a son of Kamimusubi no Kami, one of the creators of the world, helped Okuninushi no Mikoto to create and solidify the land. When Okuninushi retired to Izumo, Sukuna taught his fellow deity subjects the secrets of sorcery and the uses of medicines. The few representations of Sukuna depict him as a dwarf dressed in birdskins.

Sumeru (also known as *Meru* and *Shumisen*)

In Hindu and Buddhist cosmology, Sumeru was the beautiful sacred mountain that stood at the center of the universe. The sun, moon, planets, and stars, in their grand orbits, revolved around it. Like a pyramid—or the seedpod of a lotus—Sumeru had four faces, and each was made of a different substance. The light given off by each surface illuminated the quarter of the earth over which it towered. The northern face, being made of gold, was yellow; the southern face, of sapphire, was blue; the eastern, of silver (or crystal), was white; and the western, composed of rubies, was red. Although its own heavenly kings, or *shitenno,* guarded each quarter of the sacred mountain, one of those, known as Jikoku-ten, was the supreme protector.

Sumi *charcoal and ink*

As far as art is concerned, two different ideographs, both pronounced *sumi,* are involved here. One means charcoal, which is burned as a fuel and often included in New Year decorations, inasmuch as it is durable (therefore an emblem of longevity), and because still another meaning of *sumi* suggests life. The second ideograph means

ink to the Japanese, specifically Chinese ink, which is prepared from soot or finely ground charcoal. This jet-black ink is used by artists in executing anything from enormous murals on temple walls to the inscriptions they use to sign their works. Needless to say, people wrote with brushes dipped in this kind of ink. Even now specimens of beautiful calligraphy are written with *sumi*. The utensils that writers employ—such as the cake of compressed carbon black, the inkstone, the special little water jug, assorted brushes, and paper—as well as the users themselves are frequent subjects in art.

Zen artists were particularly attracted to ink paintings. The medium allowed them to express as much—or as little—as they liked with an economy of brushwork. "Less is more" might have been their guiding principle. Delay (p. 86) writes about a Sesson landscape: ". . . the different intensities of black are used as colour values and the non-coloured background represents the infinity of space. It symbolizes the whole cosmos in which there is no void. Our minds have to restore the link between every part of the world existing beyond what is visible." The last sentence might also describe the experience of looking at and pondering over the *enso,* the celebrated Zen circle.

Sumiyoshi *Shinto deities*

At least two native divinities, and possibly a whole group of them, have been addressed by this name. The first was a phallic deity, quite likely the one who presided over fertility rites in times of planting and harvest. Petitioners pray to this Sumiyoshi to favor them in their search for love and comfortable marriages. His major shrine is located at Uji, near Kyoto. Hashi-hime, "the goddess of lust," shares the precincts with him. So also does Agata, a minor male god, created in a later era, as the need for him arose, because he had the power to cure venereal diseases.

The second divinity, who is sometimes called Suminoe, was a god of the sea (or possibly a number of lesser marine deities). Because he (or they) helped the bellicose Empress Jingo invade Korea successfully in the year 200, she built a temple for Sumiyoshi near her port of departure in Kyushu. Later, Emperor Nintoku (313-99) moved it to a new location on the coast near the town of Naniwa. The god of this shrine, and the shrine itself, play parts in several tales that artists have illustrated, such as the fables about Minamoto no Yorimitsu and Shutendoji, and Jo and Uba. The experience of Ki noTsurayuki— a poet, author of the *Tosa Diary,* and one of the compilers of the *Kokinshu*— as his ship sailed toward the coast of Naniwa, is another favorite incident. After his period of exile at Suma ended, Prince Genji visited the shrine on his journey back to Kyoto.

Sumo *sport*

Wrestling as a sport is supposed to have begun in 24 BCE, during the reign of Emperor Suinin. That was when Nomi no Sukune disposed of Taema no Kuehaya, the braggart kicking killer, by kicking him in the ribs until he died. In modern Sumo, a wrestler in the ring wears nothing more than a topknot and a narrow loincloth fastened with a few wisps of rice straw for good luck. A top-ranking wrestler may add to this basic costume a sort of belt, consisting of a thick, smooth, rope-like cord that is tied in great loops over the buttocks. On ceremonial occasions, however, he dons an elaborate skirt made of heavy fabric, which is embroidered with his personal crest and other extravagant ornamentation.

Emperor Shomu (r. 749-58) elevated Sumo to the level of a court function by making a wrestling tournament one of the events at the Five Grains harvest festival. The rituals established at that time to govern wrestling matches have been followed faithfully ever since. A compact clay square forms the foundation of the ring. The ring itself, 3.6 meters in diameter, is strewn with sand and edged with small straw bales filled with earth. Originally, at each corner of the platform rose a slanting pillar, which supported a wooden roof from which purple bunting was draped. Each pillar was decorated with cloth or paper ribbons in the color appropriate to the season it represented. In 1952 the pillars were eliminated, for the sake of improving visibility—not only for live spectators, but also for those watching by television. Now, instead of posts, four huge tassels, each about two meters long, hang from the ceiling far above. Each tassel has a different color—red, black, green, or white—and these, together with the purple of the bunting, serve as symbols for the five grains.

Umpires, even today, wear an antique costume adopted during the Tokugawa Era (1615-1868): kimono, skirt-like *hakama,* a wide-shouldered surcoat, and high black courtier's hat. The umpires brandish their insignia of office, a lacquered fan of the sort with which generals used to give signals in battle. With this fan an umpire indicates his decisions to both wrestlers and spectators. In the past, a wrestler was limited to 48 pinfalls or other approved maneuvers, such as throws, twists and tosses over the back; today, he may employ any one of about 200 techniques to defeat his opponent. He wins a match if he forces any part of his opponent's body above the ankles to touch the sand, pushes even one of his adversary's heels beyond the circle of straw bales, or actually tosses him out of the ring.

Susano-o no Mikoto *Shinto deity of the sea, and later of the moon also*

He was created from the nose washings of Izanagi, when the father-god purified himself after returning from his search for Izanami in the land of the dead. Izanagi

(who had just created the sun goddess, Amaterasu O-mi-kami, from the washings of his left eye, and the first deity of the moon, Tsukiyomi no Kami, from the washings of his right eye) decided that Susano-o should be the god of the sea.

A destructive and restless youth, Susano-o went about pulling up trees, setting whole forests afire, irritating everyone in the Plain of Heaven with his rude pranks. Finally his father determined to send him down to earth, where his violence would not offend so many divinities. Before he departed from heaven Susano-o asked to be allowed to visit his August Elder Sister, Amaterasu, whom he scarcely knew. Izanagi consented—to everyone's distress, as matters turned out. For Susano-o, while journeying to Amaterasu's home, scattered the seeds of cockleburs across her fields, kicked down the boundary paths between rice paddies, filled up irrigation ditches, trampled on ripening crops, polluted both water and earth with his excrement. Worst of all he defiled his sister's abode. He flayed a piebald colt backwards, and flung its bleeding body through a hole he had kicked in the roof of her palace. In horror at this desecration, her virgin handmaidens killed themselves by thrusting pointed shuttles into their wombs. Amaterasu, angered and humiliated by his deeds, fled into a mountain cave, closed tight its door of stone, and plunged the universe into darkness.

The Eight Hundred Myriad Gods punished Susano-o severely. First they cut off his mustache and beard, then they pulled out the nails of his fingers and toes, and cast him out of heaven. Susano-o was incorrigible. While on his way to earth, he yearned for something to eat. Toyo-uke-hime, Great Food Princess Deity, offered to feed him. When she drew grains, beans, roots, fruits, and other comestibles from diverse recesses in her fertile body, Susano-o recoiled in disgust. Thinking that she offered him "filthy things," he killed her, thereby causing a whole succession of other troubles.

At last he descended to a place on earth called Izumo. In its dank forests, near the source of the river Hi, lived the Yamato no Orochi, a dragon with eight long necks and as many terrifying heads. This monster had devoured seven daughters of the king of Izumo, one each for seven years, and now it was about to claim Princess Kushiinada, the eighth and last of the sovereign's daughters. Quick-thinking Susano-o got the dragon drunk by setting out eight huge tubs of sake, one for each head. The beast drank and fell into a stupor. Susano-o slew the creature, cutting off one snoring head after another. For good measure, he hacked at the dragon's tail and found in its flesh the sword Cloud Gatherer, Ama no Murakumo no Tsurugi. Later, when communication with heaven had been established, he sent this sword to Amaterasu, who accepted it as a peace offering.

Meanwhile, in Izumo, Susano-o married Princess Kushiinada. They settled down in the neighborhood of Suga. He became a good husband and father, committing no further misdeeds against gods or men (other than the usual storms at sea). His family prospered and multiplied, extending their holdings in all directions. A large number of his great-grandchildren, however, began to exhibit some of his youthful exuberances. They alarmed Amaterasu, who was keeping an eye on them from heaven. To impose order, she sent her grandson, Prince Ninigi, to rule over Japan. Although Amaterasu's descendants, the emperors of Japan, have fully established Ninigi's rights in the land, Shintoists still revere Susano-o no Mikoto. Many shrines have been built in his honor. The Japanese are grateful for the beautiful and valuable trees that Susano-o gave them long ago: the *sugi,* or cedar, that grew from the hairs of his beard; the *hinoki,* or cypress, that sprung from his pubic hair; and the *shonoki,* or camphor, that rose from his eyebrows. The *shimenawa,* the sanctifying rope plaited from rice straw, is another of his gifts.

Japan's artists invariably portray him as a young man, slender and handsome. Prints, paintings, sword guards, and netsuke (miniature sculptures in wood, ivory, and other materials) illustrate many events in his career, especially the slaughter of the Eight-headed Dragon and the discovery of the sacred sword. Less often they present him in his role as god of the sea, standing alone on an ocean cliff, looking down on the waters he commands. His youthful wager with Amaterasu— made when he bragged that he could make more children than she could—is symbolized in a vignette in which he creates a tiny deity with a puff of his breath. His wife, Princess Head Comb, is always shown kneeling beside a stream, presumably the River Hi, holding a *gohei,* a strip of paper or cloth intended to fend off misfortune.

Sutra *holy writings*

In art, the sermons of the Lord Buddha and his disciples, as well as other scriptures, are usually represented as scrolls. The actual sutra scrolls themselves may be illuminated, like the scriptures in Christian countries, or enclosed in beautifully decorated cases. Most sutras were transcribed and illustrated by priests, but learned laymen and artists could also acquire merit or achieve remission of past sins by making copies for deposit in a favored temple. The decorative calligraphy of the text served as an important part of the artist's design.

Swallow *as symbol*

Like the sparrow and the willow, the swallow is a symbol of grace, subtlety, and meekness. A white swallow (which is rarely seen) is one of the best of omens. In the sixth month of the year 667, the people of the district of Kadono in Yamashiro

Province presented such a treasure to Emperor Tenchi (r. 662-71). The emperor and his court made a memorable occasion of the ceremony, and freed the bird, in accordance with the teachings of Buddha.

Swastika *symbol*

Artists around the world have employed this geometric figure as a motif. In Japan, it is an emblem of good fortune and of large numbers. Designers of family crests used it in two forms—one with the arms turning to the right, the other with the arms turning to the left.

The grammadion, a variation on the two swastikas, is a figure resembling an aerial view of two streets intersecting at right angles. It often appears in combination with a swastika. In Indian and Buddhist art, the grammadion is an emblem of wisdom. Some images of the Buddha show it on his abdomen, as a sign of his limitless power. The endpieces of roof tiles for Buddhist temples were impressed also with swastikas, grammadions, or both.

Swords *weapons*

From the mythical age until the Meiji Restoration in 1868, Japanese warriors used swords as weapons in combat and in vendettas, and as an insignia of caste. By the tenth century, swords had become such an important part of the military man's thought and dress that, by imperial decree, all warriors received permission to wear two blades simultaneously, one long, the other short. While prized as weapons, swords were also honored for their spiritual attributes. Luck-giving deities or victory-in-combat spirits might reside in swords, like the magical sword, Cloud Gatherer, found by Susano-o in the tail of the eight-headed dragon he slew.

The long sword is called *katana* or *daito;* the short, *wakizashi* or *shoto;* and the pair is known as *daisho*. Both were worn at the waist on the left side of the body. A warrior simply thrust them between kimono and obi, or slipped them through an arrangement of looped cords, worn under the obi. In either case, protocol required that the hafts be tilted upward, ready to be grasped immediately.

This double set of swords became the most distinctive mark of the samurai. The warrior class guarded that distinction fiercely until, by decree of the Meiji emperor's government, both the caste and its members' right to wear swords was abolished in January 1877.

Tachibana-hime *wife of Prince Yamato no Takeru*

Princess Tachibana accompanied her husband during his expedition against barbarians of the eastern provinces. While their ships were sailing across the straits that lead into what nowadays is called Tokyo Bay, Ryujin, the Dragon King, who is also a seagod, sent a great storm to trouble them. Princess Tachibana cast herself into the sea in order to placate the offended god. He immediately quieted those great waves and furious winds.

Taigenjo *sennin*

Gyokushi taught her the secrets of Daoist magic. As a result, she never felt cold, and was not wetted by rain. With finger-signs she could level hills or split boulders, bring dead trees to life, or cause whole groves to wither.

Taiinjo *sennin*

A patient Daoist, she sold wine in a roadside booth for many years, hoping to meet a wise man who would be her teacher. One day Taiyoshi, a great magician, who also happened to love wine, appeared. He sipped Taiinjo's wares, heard her plea, and taught her his skills. As a result, she lived for 200 years.

Taira no Atsumori *warrior; nephew to Kiyomori*

"The Death of Atsumori" is the melancholy theme of many poems, songs, stories, pictures, and, above all, in Noh and Kabuki dramas. Atsumori's story brings to mind

Taira no Kagekiyo

the evanescence of life and the sadness of things.

Taira no Atsumori (1168-84) fought bravely at Ichinotani. As the Minamoto pressed in, the surviving Taira realized that they must flee or die. Those from the defense force who could be spared retreated to ships waiting offshore. Atsumori was one of the last to leave because he took time to fetch his treasured flute from its hiding place. He was riding his horse into the sea, toward one of the Taira ships, when Kumagai Jiro Naozane, a Minamoto general, challenged him to fight.

Atsumori, no match for the burly Naozane, was soon unhorsed. Naozane leapt from his saddle, eager to cut off his enemy's head. He pulled away the helmet and beheld a handsome youth sixteen or seventeen years of age, who reminded him of his own son. Naozane felt pity, but arriving Minamoto soldiers convinced him that the captive warrior must not be allowed to escape. Atsumori knew this too, and more: that a warrior must know how to die with honor. With Atsumori's urging, Naozane cut off the fallen warrior's head.

Afterwards, Naozane abandoned the world, took the vows of a Buddhist priest, and spent the rest of his life as a recluse, praying for the spirits of Atsumori and of others slain in war. The ashes of both Naozane and Atsumori lie buried in the same cemetery on faroff Mount Koya, in Kii Province.

Taira no Kagekiyo *warrior*

Although Taira no Kagekiyo (?-1185?) was a Fujiwara by birth, one of the Taira lords adopted him. He grew up to be a man of great strength and an ardent supporter of the Taira cause. During the Minamoto rebellion that began in 1180, Kagekiyo was forced to seek refuge in a temple where his uncle was chief priest. When he discovered that his uncle was loyal to the Minamoto instead of the Taira, Kagekiyo killed him. At the battle of Yashima, Kagekiyo ripped the *shikoro,* or neck covering, from the armor of a Minamoto warrior, and hoisted it aloft on the point of his spear. This incident is reproduced often in Japanese art.

He may have survived the Taira disaster at Dannoura (1185), and sworn revenge against Minamoto no Yoritomo, leader of the conquering clan. Some accounts say that, in 1195, Kagekiyo hid in the Hall of the Great Buddha in Todai Temple at Nara, and leaped on Yoritomo when he came to worship before the Daibutsu. Being thwarted in his attempt by Hatakeyama Shigetada, Kagekiyo gouged out his own eyes rather than see the triumph of the enemy. For this reason the blind people of Japan made him their patron saint. Other accounts say that after the Minamoto captured Kagekiyo at Dannoura, they thrust him into a prison cave at Kamakura, and allowed him to die from hunger and thirst.

Taira no Kagesue *warrior*

Kagesue (?-1200), unlike his father Kagetoki, is renowned for valor and fidelity. The most celebrated incident in his life, which is represented often in art, occurred just before the second battle at Uji River in 1184. Kajiwara no Kagesue vied with Sasaki no Shiro Takatsuna to be the first man to cross the swift-flowing Uji. Kagesue took the lead, riding Surusmi (one of his commander Yoshitsune's steeds, said to have been born of a prayer to Kannon). Following close behind, Takatsuna, astride Ikezuki (one of the best horses of Yoritomo, the clan's leader), shouted in alarm, warning Kagesue to tighten his saddle girth. Kagesue pulled up short and Takatsuna dashed past him, winning the honor of being the first warrior to cross the river.

During a battle at Ikuta, Kagesue stuck a branch from a flowering plum tree to his quiver, thereby making himself a conspicuous target for Taira bowmen. Surprisingly, they did not wound him. During that same battle he lost his helmet in an encounter with Taira horsemen, and certainly would have been slain if his father had not rescued him. Since that time, any representation of a helmet or a quiver ornamented with a blossoming plum branch is a reference to Kagesue's bravado. In 1200 Kagesue died while defending his father. His crest was the *takanoha,* the ends of two parallel arrows, each fletched with a hawk's feather.

Taira no Kagetoki *warrior*

Even though he fathered a valorous son in Kagesue, and was himself a brave warrior in battle, Taira no Kagetoki (?-1200) is remembered for his treasons and slanders. He was related to the Taira clan by both blood and fealty, yet he betrayed them more than once. On the first occasion, the most fateful of all, he allowed Minamoto no Yoritomo to escape capture by Taira soldiers hunting him after he had lost the battle of Ishibashiyama in 1181. Legend maintains that Kagetoki found Yoritomo hiding in the hollow trunk of a great tree, but pretended not to see him. He thrust his great bow into the hollow space above Yoritomo and frightened two wood doves from their nest, thereby convincing his companions that no one lurked in the tree.

In any event, Yoritomo lived to fight another day. Later, when he and his clan seemed to be winning their rebellion, Kegetoki joined him openly and, in the last climactic year of the Genpei War, (1180-5) helped the Minamoto to annihilate the Taira. Kagetoki continued to enjoy Yoritomo's favor during the years he ruled as the first Minamoto shogun. When Yoritomo died in 1199, Yoshitsune's friends—many of whom had suffered from Kagetoki's slanderous tongue—hunted him down in Suruga. And there they killed him, together with Kagesue, loyally fighting beside his father.

Usually, Kagetoki is represented standing beside Yoritomo, in the role of a guardian-companion, with a ferocious countenance and an enormous iron cudgel in one hand. He appears, too, in the act of scaring wood doves from the hollow tree in which Yoritomo hid from Taira hunters. In an obvious reference to that incident, Kagetoki took for his crest a design showing three doves hovering above a clump of mistletoe.

Taira no Kiyomori *warrior-tyrant*

Of all the Taira, Kiyomori (1118-81) is the most renowned. Through his abilities he made the Taira, within a single generation, the greatest family in Japan; and by the despotism of his rule, he brought about their swift fall.

Kiyomori was said to be a son of former Emperor Shirakawa (r. 1073-86) by a concubine. As a young man making his way in the world, Kiyomori consistently supported the winning faction in the struggles for power being waged between scheming ministers, ambitious *daimyo,* obstreperous abbots and their mercenaries, and the advisers to adolescent emperors. By 1159, Kiyomori emerged as the supreme military authority in Japan. Within eight years he added the supreme civil authority as well, when he became prime minister.

In 1169 he was afflicted with a burning fever acquired (as the chroniclers wrote) because he tried, by haughty commands with his fan, to delay the sun's setting until workmen finished a temple he had commissioned. The fever that struck him soon afterward turned his thoughts to religion—temporarily. He retired from the world and took a monk's vows to save his life, assuming the religious name of Jokai. As a result his sickness departed, but he continued to live luxuriously.

Nor did he cease to run the country. He elevated members of the Taira clan, heedless of the effects such favoritism would have on other envious families. In 1171 he arranged the marriage of his daughter Tokuko, aged fifteen, to Emperor Takakura (r. 1168-80), the eleven-year-old son of former Emperor Go-Shirakawa (r. 1155-58). In 1179 Kiyomori imprisoned Go-Shirakawa in his own palace for daring to oppose certain actions of the Taira. In 1180, in the eyes of his enemies, he committed the unforgivable act of arrogance: he forced Takakura to abdicate, and raised to the throne his own grandson, the first-born child of Takakura and Tokuko. The boy-emperor, then two years old, is remembered as Antoku (r. 1180-85).

This maneuvering for dominance and prestige enraged Kiyomori's adversaries. The scattered branches of the Minamoto clan, seeing their chance, rebelled. Thus began the Genpei War. This struggle between the Minamoto and the Taira ended only when the Taira had been annihilated.

250

Kiyomori's career affords many themes for artists. And they have shown them all; from the moments of surcease he sought in the iced-water baths prescribed during his last feverish days, to his commanding of the sun from the temple's roof. A favorite theme is a macabre hallucination he had just before he died in his splendid palace of Fukuhara, near Hyogo. He imagined that the ghosts of slaughtered Minamoto warriors haunted its gardens. Innumerable skulls jumped about like grasshoppers. Suddenly, they rolled into a heap more than 50 meters high. At its top, menacing and armored, stood the specter of Minamoto no Yoshitomo, assassinated in 1160. Yoshitomo was the father of Yoritomo and Yoshitsune, the two great challengers who at that moment were leading the revolt against Kiyomori and his clan.

Kiyomori is usually depicted as "the Priest-Chancellor Jokai." Fat, with shaven head and heavy jowls, he wears the robes of a lay priest. His face is shrewd, and the small thin mustache does not diminish its suggestion of cruelty. The portrait is not likely to be correct, inasmuch as most other personages of the time were given identical features. Stylized as it is, however, it conveys the sense of power, the arrogance of attitude, that characterized the ablest and the haughtiest of all the Taira.

Taira no Koremochi *warrior; precursor of Kiyomori*

One day Taira no Koremochi (893-953) went to Mount Takao, in the western part of Kyoto, to see the maple trees in their autumn beauty. He joined a party of young girls, ate and danced with them, drank too freely of their sake, and fell asleep beneath the crimson canopy. A terrible voice broke into his dreams; he awakened just in time to see a huge demon rushing down the mountain path to attack him. Koremochi killed the creature with his sword. The incident is the subject of a famous Noh play called *Momijigari*, or *Maple-viewing*, and of the Kabuki play adapted from it.

Taira no Masakado *warrior-rebel*

An aristocrat of extraordinary pretensions, even in a country so full of ambitious men, Taira no Masakado (901-40) failed in everything he attempted. After being denied appointment to chief of the imperial police, and losing his claim to recognition as head of the Taira clan, he rode off in anger from Kyoto. At Ishii in Shimosa Province he committed the most unforgivable of all rebellious deeds— he proclaimed himself *Heishin-o*, "the new Taira emperor," and established a rival government resembling that in Kyoto, complete with ministers, functionaries, and regal protocol. Kyoto's reprisals started the very short Tenkei War (940). Taira no Sadamori, a cousin, shot Masakado down from his saddle; and Fujiwara no Hidesato cut off his head.

Legends have preserved the memory of Masakado. People said that he had

been helped by ghosts who resembled him. In reality, however, he had dressed several of his warriors in armor like his own, so that enemy bowmen never knew which one was him. While Masakado plotted his revolt, a plague of butterflies afflicted Kyoto. According to beliefs at that time, those feeble fluttering creatures were believed to be the spirits of all the soldiers killed in battles that Masakado's vanity would cause. Artists have depicted Masakado in yet another act of arrogance—the moment he orders servants to drive his brother Kinsura from his presence because the younger man urged him to remain loyal to the emperor.

Taira no Noritsune *warrior; nephew to Kiyomori*

Noritsune (1160-85), one of the Taira clan's strongest men and most expert archers managed to escape from the fortress of Ichinotani, fallen to Minamoto forces (1184), because a faithful retainer had donned Noritsune's armor and died in his stead. Noritsune rode westward to rally more support for the Taira cause. The cause of the Taira perished with them at the naval battle of Dannoura (1185). Recognizing that the end of the struggle had come, Noritsune resolved to die and take with him the brilliant young leader of the Minamoto, Yoshitsune. Noritsune tore off and flung away his horned helmet and the sleeves and skirts of his armored coat. Halberd in hand, he cut his way from ship to ship, until he came to the deck of Yoshitsune's vessel. The nimble Yoshitsune then made his famous leap—celebrated in song, story, and art as the *hassotobi,* or eight-boat jump—and alighted seven meters away, in the ninth ship, safe from Noritsune's grasp. As Minamoto warriors closed in on Noritsune, he kicked the first man overboard and seized the next two, one under each strong arm. He dropped with them into the sea.

Taira no Shigemori *statesman; oldest son of Kiyomori*

A man both kind and just, Taira no Shigemori (1138-79) was universally respected. Much of his adult life was spent tempering the excesses of his father. He could be firm, or merciful when he suppressed the revolt of temple mercenaries from Mount Hiei, or opposed Kiyomori's attempt to imprison former emperor Go-Shirakawa in 1177. For that service he has been honored ever since as a model of fidelity to the sovereign. Unfortunately for both the Taira and the country, Shigemori died before his father, and therefore, could not prevent the series of mistakes that caused the fall of their house.

Shigemori expected their ruin. After Kiyomori's daughter, Empress Tokuko, bore her first son (the future Emperor Antoku), Kiyomori became increasingly unmanageable. Sick at heart and in body, Shigemori withdrew from the court and from the world, becoming a monk. He refused the ministrations of physicians, saying

that he preferred to die rather than witness the destruction of his family. He put his trust in Buddha, filling his rooms with holy images before which lamps and incense burned both day and night. Even then he was not spared. In dreams he saw the heads of innumerable Taira, impaled on bloody swords and spears, being carried through Kyoto's streets. Just before he died, he gave a favorite sword, a copy of Minamoto no Mitsunaka's famous "Beard-cutter," to his first-born son, Koremori, who most resembled him in character.

Taira no Tadamori *warrior; father of Kiyomori*

Taira no Tadamori (1096-1153), known to his contemporaries as "Squint Eye," was a minor officer in the guard serving former Emperor Shirakawa (r. 1073-86). On a cold and rainy evening, Shirakawa set out to visit one of his concubines, who lived in the Gion district of Kyoto. As he and his escort passed Yasuka, the great shrine dedicated to Susano-o no Mikoto, Shirakawa saw a fox-spirit flitting about. Its body gave off a flickering light, its hair stood out in all directions, like spikes of iron wire. In great trepidation, Shirakawa sent Tadamori to drive away the evil thing. Not a bit daunted, Tadamori chased after it, and found that the glowing monster was nothing more than an old lamplighter making his rounds. Covered against the weather by a coat and hat made of rice straw, he carried a torch in one hand, and a jug of oil in the other. In another account, a priest stealing oil replaces the lamplighter. How either one was mistaken for an evil creature is not explained.

Tadamori's fearlessness that evening won the former Emperor's favor. Inasmuch as Shirakawa still ruled the country, his son being emperor in little more than name, his patronage assured Tadamori's success. He even gave one of his concubines in marriage to Tadamori—a signal honor for so unambitious a soldier. (Some accounts say that she was the Lady of Gion, to whose establishment they were going on that fateful night.) Five sons were born to Tadamori and his wife. The first of those sons was Kiyomori. As he arrived rather soon after his mother's marriage, many people have believed that he was Shirakawa's son.

Tadamori received the favor of heaven on another and earlier occasion. As he rested from the hunt one day, a great serpent slithered toward him. Without his having to lift a hand, Tadamori's famous sword Nukemaru leaped from its sheath and cut the monster to pieces.

Taira no Tomomori *warrior; fourth son of Kiyomori*

At the battle of Dannoura (1185), Taira no Tomomori (1152-85) and his foster-brother donned suits of armor and, clasped in each other's arms, leaped into the sea. About twenty warriors followed them in death. This brave finish to Tomomori's life

is not as popular a theme for artists as is an imagined consequence of the catastrophe at Dannoura. A melodramatic episode presented in Kabuki as *Funa Benkei,* or *Benkei in a Boat,* tells of the time when Minamoto no Yoshitsune, Benkei Musashibo, and their small party are fleeing across the Inland Sea near Dannoura. A great storm comes up, and the spirits of Tomomori and all the other drowned Taira rise from the foaming waters to threaten the latest fugitives from Minamoto no Yoritomo's hate. Only the prayers of Benkei, the warrior-priest, quiet the storm and repel the ghosts of the Taira.

Taira no Tsunemasa *warrior; nephew to Kiyomori*

Taira no Tsunemasa (?-1184) was praised for his skill in playing the Chinese lute (*biwa*). The prince-abbot of Ninna Temple in Kyoto gave Tsunemasa the famous four-stringed *biwa* named Seizan, or Green Mountain. This ancient lute, made of rare woods, had its face decorated with a painting of the moon at dawn sinking beyond mountains bedecked with trees in summer leaf.

In 1182, just before Tsunemasa accompanied the young Emperor Antoku on his flight from Kyoto, he had a presentiment that he would die in battle, and so he returned Seizan to the prince-abbot of Ninna Temple. Tsunemasa was killed in the battle of Ichinotani (1184). The aristocrats of the imperial court could not regard him as an enemy. They mourned his loss for seven days, with memorial masses, funeral plays, and melancholy music. At Ninna, the prince-abbot who had been his teacher dedicated the biwa Seizan to his memory.

Seami wrote a Noh play about him, called *Tsunemasa.* Artists have portrayed him enchanting a snake with his music.

Taishin O Fujin (also known as *Saishin O Fujin*) *sennin*

She was the youngest daughter (or a sister) of Seiobo, Queen of the West. Taishin's beautiful music, plucked from a harp with a single string, enchanted all the birds (who gathered near to listen), and even tamed the fierce white dragon that became her steed. Some artists depict her alone, standing on the white dragon. Others show her in the company of Jogen Fujin, who is mounted on a *kirin.*

Taiyoshi *sennin*

A disciple of Gyokushi, and a great lover of wine, Taiyoshi lived for 500 years without ever looking his age. Despite Gyokushi's scoldings, Taiyoshi refused to stop drinking until he was 300 years old. Then he drank a magical potion that gave him wisdom, ended his alcoholic bouts, and added 200 more years to his life. Even so, artists usually depict him, fat, slovenly, and drunk, sitting on a rock. He was the teacher of Taiinjo, wineseller turned *sennin.*

254

Taizan Rofu *sennin*

His name means "Old Man of the Great Mountain," and he lived during the time of the Han emperor Wudi (r. 141-87 BCE). One day the emperor passed Taizan Rofu working in his field. To the sovereign's amazement, the peasant had an old man's wrinkled body and a young man's handsome head. Daozan Rofu explained that, when he was 85 years old and near death, a fairy gave him a magical brew to drink. It restored youth only to his head—fitted now with smooth cheeks, bright new teeth, and jet-black hair—but, for some unknown reason, had not been as kind to the rest of his body.

Tajima Mori *example of fidelity to emperor*

In the year 61 Emperor Suinin sent Mori into the world to seek a fruit said never to lose its scent. Tajima wandered and searched for ten long years before he found the fruit. When he returned to Japan, he learned that the emperor he served had died.

Tajima Mori went to Suinin's tomb, and placed on it some of the golden fruits he had brought home. Then he killed himself, so that his spirit might report the story of his successful search to the emperor in the world beyond. Someone in Emperor Keiko's court (r. 71-130?) gave the name *tachibana* to this new kind of fruit, the orange.

Tajima Shume and the Phantom Priest *moral tale*

Tajima Shume, a poor and desperate *ronin,* met a friendly priest on the way to Kyoto, along the Tokaido, or East Coast Road. When he learned that the holy man was carrying in his pack about 200 ounces of silver, donated to his temple for making a bronze statue of the Buddha, Shume resolved to murder the priest for the sake of that money. As they were being ferried across a wide bay, Shume pushed the priest overboard when the other passengers were not looking. The ship sailed on, the priest was left to drown, and Shume claimed his pack.

Several years later, as Shume sat in his garden one day, enjoying the benefits of the murder—a thriving business as a merchant in Kyoto, a good wife and fine children in a comfortable home, and a new name, Tokubei—remorse welled up in his heart. At that very instant he saw, standing beneath a pine tree in his own garden, the gaunt and scowling ghost of the friendly priest he had killed.

The phantom priest gave Tokubei no respite; the guilty man saw him every day and night. Knowing no rest, he fell ill and took to bed. At last, persuaded by his wife, he agreed to send for a wandering priest whom the neighbors said possessed great powers of healing. When the priest stepped into his bedchamber, Tokubei recognized him as the pursuing ghost, come now to claim him. He hid under the

covers. The priest bent over the weeping man, assuring him with touch and voice that he was no phantom. He explained that, being a good swimmer, he had not drowned that fateful day. He urged Tokubei to abandon his evil ways and to repent. Comforted by the priest's words and manner, Tokubei soon recovered his health. He quieted his remorse by presenting to the good priest twice as much silver as he had stolen. After that, Tokubei was at peace with himself.

Takayama Masayuki *model of fidelity to emperor*

As a youth studying Japan's history, Masayuki (1747-93) was astonished to learn how, ever since Minamoto no Yoritomo triumphed over the Taira in 1185, the successive shoguns had usurped the political powers of the emperors. Masayuki traveled throughout the country, telling people about the true state of affairs and trying to revive their devotion to the hereditary sovereigns. In Kyoto, at Third Avenue Bridge, he prostrated himself and venerated the emperor from afar. By the time he reached northern Kyushu, the poverty of the country and the apathy of the people had reduced him to despair. Offering himself as a sacrifice to the imperial cause, he committed seppuku.

Takeda no Yoshinobu *warrior*

Yoshinobu, a captain in the Minamoto army that was advancing towards Kyoto in 1181, used his hunter's lore to good effect. When the Minamoto, marching from the east, came to Fuji River in Suruga Province, they found the Taira army encamped along the western bank. Yoshinobu led some of his soldiers into the neighboring swamps, startling thousands of wild fowl into flight. The Taira believed that a large number of Minamoto soldiers must be moving to the attack. They fled, along with the geese and the ducks. By losing their last chance to stop the Minamoto, they lost the Genpei War (1180-1185).

Takeda Shingen (also known as *Takeda no Harunobu*) *warrior*

Although he was renowned in youth for being a notable poet, artist, drinker, and womanizer, Harunobu, a *daimyo* of Kai Province, spent most of his adult life waging war on neighboring lords, especially against the Uesugi clan of Echigo. Despite almost constant warfare and much devastation, neither Takeda nor his adversaries ever won a decisive victory.

In 1551 Harunobu became a lay priest, taking the name Shingen. Unfortunately, this religiosity did not make him more peace loving. He was killed during the siege of Noda castle in Mikawa Province as he inspected its defenses. He relaxed his vigilance while listening to a soldier playing a flute, and was shot either by an arrow or by a ball from one of the European muskets recently introduced to Japan. In order to conceal

his death for as long as possible, from both allies and enemies, his body, enclosed in a stone coffin, was preserved in the cold waters of Lake Suwa for three years before it was given proper burial. Akira Kurosawa, the Orson Welles of Japanese moviemaking, used Shingen's death and the events following his demise, as the basis for his movie *Kagemusha* (1980), or "Shadow Warrior."

Takeuchi no Sukune *imperial minister*

Judging by his impossible life span, Takeuchi (83-390) is probably the personification of several generations in a family of ministers who served successive sovereigns. The first event mentioned in the *Kojiki* refers to Takeuchi's appointment as prime minister to Emperor Seimu (r. 131-190). One of Takeuchi's chief duties, apparently, made him the shaman who received messages from the gods that affected the policies of the emperor.

While Emperor Chuai ruled, between 192 and 200, Takeuchi tried to persuade him to make war on the kingdom of Shilla in Korea. But Chuai bluntly maintained that his prime minister uttered lies, not counsels from heaven. Takeuchi, perforce, waited until Chuai died, then advised his widow, Dowager Empress Jingo, to lead the expedition against Shilla. She undertook the attack for the sake of her unborn son, the future Emperor Ojin (r. 201-310).

Artists usually portray Takeuchi as an old man with a long white beard, clad in the robes and headdress of a court noble, and wearing shoes made of tiger skin. Sometimes he shares the picture with Empress-Regent Jingo, holding her infant son. At other times he is alone. He may be standing in a boat, receiving for Ojin, from a partially submerged messenger of the dragon king, the *tama,* or sacred jewels, that govern the ebb and flow of tides, or he may be casting the *tama* into the sea, thereby gaining safe passage for Empress Jingo's fleet across the straits to Korea.

Tale of Joruri (*Joruri monogatari*) *a romance*

This story from the fifteenth century relates the sad tale of Joruri, or "Pure Emerald Maid," and her lover, Ushiwakamaru.

Joruri lives in the town of Yahagi, in Mikawa Province. When Joruri is fifteen years old, Minamoto no Ushiwakamaru (who will later become the famous Yoshitsune) arrives in Yahagi, having just escaped from the monastery on Mount Kurama where Taira no Kiyomori had sent him when he was only a child. Ushiwakamaru, himself little more than fifteen years old, finds lodging in Joruri's household. He does not see her, of course, she being properly sequestered, but music brings them together. As she plays on the *koto,* he hears the beautiful melody and promptly accompanies her on his flute. Through the devices of her maid, Reizei, a meeting is achieved.

Tale of the Room Below

The two fall in love and spend ten blissful nights together, before he must resume his journey.

Soon after leaving Yahagi, Ushiwakamru becomes ill. He sends word of his plight to Joruri. She rushes to his side, and tenderly nurses him back to health. When, perforce, he continues his flight to northern Honshu, she returns to Yahagi to await his return. For seven months she waits in vain. He cannot return, yet he does not send her a word about his intentions. Pregnant and fearing she has been abandoned, Yahagi drowns herself in the river. Reizei, the maid, enters a nunnery.

This story (which is not related to the purportedly known facts in the life of Yoshitsune) was adapted for presentation in theatres. Following an established fashion, the narrator of the tale recites his affecting lines to the accompaniment of a *biwa*. Joruri's name is attached to this style of performance, in which lines are delivered with musical accompaniment from *biwa* or *samisen* (a three-stringed, banjolike instrument). (It is also called "the Gidayu style," after Gidayu Takemoto (1651-1714), the first celebrated performer in this mode.)

Musico-dramatic recitals of this nature seem to have originated early in the thirteenth century. According to tradition, the lay-priest Yukinaga—who wrote *Heike monogatari* (*Tales of the Taira*) and several other important works—taught Jobutsu, a blind priest, to recite the lines of that epic drama, the Genpei War (1180-85), while accompanying himself on the *biwa*. Ever since that time, we are told, men who recount the stories of certain Noh, Kabuki, and Bunraku dramas in the *joruri* manner sing in the style begun by the blind priest Jobutsu.

Tale of the Room Below (*Ochikubo monogatari*) *novel*

This is the oldest surviving "*mamako-monogatari*," or stepmother tale, recounting the trials and tribulations of a beautiful girl who is abused by a cruel stepmother. It was written around 980, by an unknown author. The stepmother, in favoring her own children, devises many ways to mistreat the patient stepdaughter, and ultimately thrusts her into a tiny, comfortless room below the stairs. Even in that dungeon a handsome courtier of high rank and great wealth discovers our heroine. He marries her (in the usual Heian way of sleeping with her for three nights), and then whisks her away to his palace, where they live happily ever after.

Tales from Ise (*Ise monogatari*) *anthology*

This collection of about 125 short stories, the oldest anthology in Japan's literature, may have been written early in the tenth century, probably between 901 and 923. The author is unknown. Some authorities believe that they were written by Lady Ise no Osuke, a celebrated poet of Heian Kyoto, who lived early in the eleventh century. *Ise*

monogatari profoundly influenced the development of Japan's classical literature, even more so than *Genji monogatari* (*The Tale of Genji*).

The hero, who serves as the link connecting most of these Ise stories, is Ariwara no Narihira (825-80), "the famous ninth-century poet, Adonis, and lover," as Ivan Morris describes him in *The World of the Shining Prince* (p. 285). The themes of the stories range widely—love, death, filial love, hunting. They combine to form a literary collage portraying the many aspects of the writer's society.

Tales from Uji (*Uji monogatari*) *collection of classical writings*

These 194 tales, apparently assembled in Kyoto early in the thirteenth century, were intended to instruct readers in some of the precepts and values of Buddhist doctrine. The collection ranges from Buddhist moral tales to humorous anecdotes and traditional fairy stories. It abounds in themes for artists. For example, the incidents related in "The Holy Man of Shinano Province" are depicted in the noted *e-maki*, or picture scroll, known as Shigisan Engi, or *Illustrated History of Mount Shigi Temple*, painted in the twelfth century, even before the *Uji monogatari* were gathered.

Tales of the Heiji Period (*Heiji monogatari*)

Heiji is the name given to a reign-period that began in 1159. During that same year Minamoto no Yoshitomo and several other nobles, discontented with the domination of the Taira clan, started a rebellion known as the Heiji War (1156-9). The Taira easily suppressed the revolt and executed its leaders. *Heiji monogatari*, written by an anonymous writer, became one of the classic works in Japan's literature. It describes the heroes and the events in that fateful uprising.

Tama *sacred jewel*

The *tama* is identical with the *mani* in Buddhist art, the symbol of Buddha and his teachings. Since its introduction into that role, it has become a symbol of purity in thought and behavior. Probably because of its shape, and certainly because of its presence among the "precious things" being brought by The Seven Gods of Good Fortune in their treasure ship, in modern Japan it is also a symbol for property in general and, accordingly, for wealth. Usually the *tama* is represented as a tear-shaped pearl, the tapering end bearing several concentric grooves. The "flaming jewel" is surmounted by a lambent halo. In pictures swiftly drawn or poorly reproduced it may resemble the flame motif more than the sacred jewel.

In India, originally, the *tama* was given as an attribute to the bodhisattva Jizo and to several *arhat*, especially to the one known in Japanese as Handaka Sonja. Japanese artists, however, borrowed it freely for other holy purposes. Soon Shinto deities—such as Hikohohodemi no Mikoto, Emperor Ojin, and Raijin, the thunder

god——also gained the *tama* as an attribute. At some Shinto shrines, moreover, the elegant finial ornament atop a *mikoshi*, or portable shrine, has been given the shape of either a simple *tama* or a flaming jewel. At the national shrines at Ise, ornate and flaming *tama* in yellow, blue, red, white, and black (the five sacred colors) decorate the tops of balustrade supports.

Two of the wholly syncretic Seven Gods of Good Fortune—Daikoku and Hotei—are associated with the jewel in its profane sense, as a symbol of mineral wealth. Later artists, who simply wanted to suggest the power possessed by other supernatural beings, put the *tama* into the hands of Buddhist angels (*tennin*) and human fish (*ningyo*); added two of them to the accouterments of Ryujin, the Dragon King and a sea god (for whom they are tide-controlling devices); or adorned it with fantastic animals like the *karyohinga*. An aged tortoise carrying three *tama* on its back symbolized Mount Horai, on one of the isles of the blest imagined by Daoists.

Images of foxes holding *tama* are supposed to be representations of the messengers of Inari, the rice god. According to some authorities, the ball under the paw of the male *shishi*, or Buddhist lion, may be a *tama*. Some artists, no longer associating spiritual power with the *tama*, arranged them in heaps, like apples piled on a plate, or depicted them materializing out of the breath of a clam—like Ryujin's palace under the sea.

Tamagushi *Shinto talisman*

A leafy branch of the sacred *sakaki* tree, *Cleyera japonica,* attached with strips of stiff white paper, is called a *tamagushi*. It is usually placed before or on the altar of a shrine, but in certain ceremonies a priest may wave it about as a means of exorcising malevolent influences from the area around the shrine. It may also serve as the *shintai,* or physical manifestation, of the shrine's special deity, or as a symbol of the divine power the deity commands.

Representations of the Shinto goddess of flowers often show her holding a *tamagushi* in her left hand. In more extravagant times, such as the Genroku Period (1688-1704), artisans fashioned *tamagushi* from gold, silver, jewels, and other precious materials, for *daimyo* to present to shrines or to powerful overlords.

Tamamo no Mae *legendary fox-woman*

Many versions of her life, full of imaginings rather than facts, are told about "Flawless Jewel," the favorite concubine of an emperor who reigned early in the twelfth century. When the emperor fell dangerously ill, his court diviner discovered that Tamamo no Mae was the cause of his sickness. The diviner, Abe no Seimei, identified her as a fox-woman because an eerie glow appeared around her head in the dark of night.

With magical spells and incantations uttered at an altar erected in the palace courtyard (which Lady Tamamo approached with the greatest reluctance), Abe no Seimei forced her to assume her real nature—that of a white fox with nine tails. Having been revealed as the dangerous thing she was, Tamamo no Mae fled over the roofs of the imperial buildings to her refuge in the foothills around Mount Nasu, a volcano in central Honshu. As soon as she departed, the emperor began to recover.

Two warriors, Miura no Kuranosuke and Kazuka no Suke, tracked her to those smoking, vile-smelling wastes, and eventually succeeded in killing her, with helpful suggestions from the gods. As she died her evil spirit took a new form, that of the *sessho seki,* or death stone. To touch it, even to look on it at close range, meant death for any living creature, as the skeletons of birds and animals lying all about it proved. The Noh play *Sessho seki* informs us that the death stone lay there for over 200 years until, sometime during the Oie Period, between 1394 and 1427, the virtuous priest Genno Osho struck it with his wand and invoked the Lord Buddha's help. Immediately the spirit of Tamamo no Mae emerged from the stone and knelt to thank him for setting her free. Other accounts claim that the stone burst into many pieces, which were scattered over a wide area, when it released her spirit.

Tamamushi *fictitious heroine*

One evening, the young priest Shinbutsu rescued the maiden Tamamushi from being raped by a band of farm boys. As it was late, he offered her shelter in the temple where he lived. During the night, however, she willingly slept with him. The next morning, as a parting gift, she put in his hand a golden ornament she had been wearing in her hair.

Unknown to them, he had also presented her with a gift. When her pregnancy became evident, her parents (a rich farmer and his wife) took Tamamushi to the temple to confer with Kaison, its head priest, and Shinbutsu, his assistant. Kaison, who had a good memory, guessed at once what had happened, and made insulting remarks about Shinbutsu, who stood up in anger. The golden ornament fell to the floor from the sleeve of his robe. Kaison accused him of being a thief as well as a seducer. Shinbutsu lost his temper and threw evil-tongued Kaison against the wall.

Tamamushi, consumed with shame, seized the golden ornament and, using it as a dagger, slit open the vein at her throat. Even as she lay dying in Shinbutsu's arms she warned him of danger from Kaison, rushing to attack him with a halberd. Enraged now, by danger, grief, and remorse, Shinbutsu hurled the malicious priest into the courtyard, stunning him. Saddened Shinbutsu, followed by Tamamushi's weeping parents, carried her cold body to the temple graveyard. Then he went away

from the place, to do penance for the spirit of Tamamushi. Later, he changed his name to Benkei Musashibo.

Tama Rivers (*Tamagawa*) *places*

Since their waters were as clear as the *tama,* the jewel of purity, no less than six different "jewel rivers" in Japan bore that name at one time. They flowed through the provinces of Kii, Musashi, Mutsu, Omi, Settsu, and Yamashiro. Poets have praised them, and many artists have depicted scenes along their banks, or illustrated famous poems referring to one or another of these Tamagawa. A group of plovers bathing in the shallow water along a river's shore alludes to the Tama in Mutsu. A lone horseman gazing down at a bush in golden flower is the renowned poet Arihira no Narihira, smitten by beauty beside the Tama in Yamashiro. Two young women washing clothes amid the rocks of a river are being helped by the waters of the Tamagawa in Settsu. An old woodcutter sitting on a bundle of firewood looks out across Musashi's Tama toward distant Mount Fuji. A nobleman standing beside a bush clover, while regarding the reflection of the moon in the surface of a meandering river, recalls the Tama in Omi. Some designers of *ukiyo-e* (woodblock prints), however, being more concerned with showing beautiful women and handsome men in the latest fashions of dress and coiffure, simply ignored the rivers, and implied, through titles or verses, that they were there somewhere in the background.

Tamayori-hime no Mikoto *mythical princess*

According to Shinto myths, Princess Tamayori was the mother of Jimmu, the first emperor of Japan. She also figures, however, in a legendary tale that does not account for her role as Jimmu's mother. In this account, a god in the form of a red arrow winged with duck's feathers made Tamayori pregnant when she picked it out of a stream. Although her parents did not quite believe this story, they accepted the fine young son she bore in due time. Meanwhile, the red arrow, thrust into the roof thatch, was forgotten. When Tamayori's son was about six years old, Kamo no Taketsumi thought to test his grandson about his parentage. In the presence of all the men at the court, he handed the boy a saucer of sake, and told him to present it to his father. The boy, ignoring all the men present, ran to place the drink beneath the red arrow. At that same moment, he was transformed into a thunderbolt and rose to heaven, accompanied by his mother. A shrine at Kamo, near Kyoto, honors Tamayori-hime to this day. A handsome image of her, made of painted wood in the year 1251, is preserved at Yoshino Mikumari Shrine, in Nara Prefecture.

Tamichi *legendary warrior*

In the year 367, while fighting the barbarian Ebisu on Hokkaido Island, a poisoned

arrow killed Tamichi. Some artists have represented him as a gigantic warrior rising out of the earth in a cemetery, still defending the empire. Others portray his invincible spirit in the form of Tani, a great serpent several hundred meters long, devouring enemy Ebisu.

Tanabata *festival*

A Chinese legend gives the Japanese the reason to hold one of their most popular annual festivals. It celebrates the brief reunion of Shokujo, the Weaving Girl, and her faithful lover, Kengyu, the Heavenly Herdsman. According to the lunar calendar, this event happens on the seventh night of the seventh month—the one time in the year when Vega, the star in the constellation of Lyra that Chinese called the Weaver Maiden, and Altair, the star in the constellation of Aquila they named for the herdsman, are as close as they can ever be. Nowadays, however, because of Japan's adoption of the Gregorian calendar, the festival is held on July 7, even though on that date the two stars are still far apart.

The legend tells how Shokujo, beautiful elder daughter of Tentai, lord of heaven, fell in love with Kengyu, the handsome herdsman. She lived on the eastern side of the River of Heaven (the Milky Way), endlessly weaving and sewing in order to clothe her father's numerous offspring. Kengyu (whom Japanese also call Hikoboshi) tended cattle on the western side of the River. Even so, the first time they saw each other they fell in love, but as love between an immortal and a mortal was forbidden, they had to be separated. The lord of heaven transformed them into two stars that could meet only once a year, on the seventh night of the seventh month.

Tanshotan *sennin*

He was a sage famed for his ability to write Chinese ideograms in several styles. Having rested one day at a teahouse known as Kotoken, Tanshotan thanked its hospitable proprietor by writing on a piece of heavy paper the characters for tortoise and dragon. The proud owner displayed this fine calligraphy on the front wall of his establishment. Some time later a fire broke out in the neighborhood. The flames destroyed all the structures on the street except for the teahouse Kotoken, protected by the power of Tanshotan's writing.

Tea

According to tradition, the celebrated priest Dengyo-daishi, founder of the Tendai sect of Buddhism in Japan, returned from a visit to China in 805 and introduced both the custom of drinking tea and the seeds for growing tea plants. In 815 Emperor Saga (r. 810-23) became the first Japanese sovereign to taste the new drink. Despite such royal approval, interest in tea declined, and for about 300 years few laymen

knew of it except as a medicinal agent. Eisai (1141-1215), a Zen priest, is given credit for having revived both the drinking and the cultivation of tea.

Buddhist priests in Japan, as in China, used tea both as a medicine and as a stimulant that kept them awake during their long rituals. Commoners would not accept the new drink, thinking it poisonous. Not until the second decade of the thirteenth century was tea deemed safe to drink. Eisai convinced doubters of its harmlessness when he used tea to cure the young shogun, Minamoto no Sanetomo, of his addiction to sake.

Artists have given full attention to all the motifs found in the production and uses of tea. The modest species of the camellia plant from which the leaves are plucked in their seasons, the occasional flowers, and even the rare seeds, appear as decorative designs. The several processes involved, and the people who perform them—from planting the seedlings, through gathering, sorting, curing, and packaging the leaves, to the brewing, serving, and drinking of the warm infusion—have been depicted in many illustrations. And of course, teahouses and their habitués are popular themes for *ukiyo-e* prints.

Tea Ceremony *ritual*

The Japanese word for the tea ceremony, *chanoyu*— meaning "hot water for tea"— reveals the intention of the men who established it hundreds of years ago. They thought of it as a way to soothe body and spirit while performing a simple routine. Since their time, however, the practice has been taken up by *chajin,* or teamasters, who have prescribed each moment and motion to the point where, indeed, a routine kitchen task has been converted into a trying ritual rather than a relaxation.

According to tradition, a "secularized" former Zen priest, Murata Juko (1422-1502), set forth suggestions for preparing the beverage when a man is entertaining friends, or merely wants to make a cup of tea for himself. Sen no Rikyu (1521-91), the most renowned of Japan's *chajin,* adopted and extended Juko's suggestions, with such an attention to detail that the preparation became a complicated ritual. Rikyu decreed that the utensils should have no "intrinsic value," and that the tearoom or teahouse (called *sukiya* in his day) must be small, simple, inexpensive to build, and finished plainly. Since Rikyu's time several other tea masters have risen to found new schools, each promoting a special style for preparing and serving tea. Their schools still flourish, as does Sen no Rikyu's.

The Tea Kettle of Good Fortune (*Bunbuku chagama*) *folktale*

A priest of Morin Temple had a tea kettle that from time to time turned into a badger. He sold it to a tinker, who began to exhibit the kettle-badger publicly. After

having made a fortune from this activity, he donated the object to Morin Temple.

Tegaie *Shinto festival*

During the eighth century, when Hachiman's image was moved from the town of Usa, on Kyushu Island, to a new shrine in Nara, the god of war promised that all the people of Nara, and of the six neighboring provinces, would be spared plagues and other evils for as long as they were charitable and compassionate. Ever since that time a great festival has been held each year, on October 5th at Hachiman's Shrine in Nara, to remind people of his promise.

Teiisai *sennin*

The wife of a man named Teii, she was well trained in the arts of magic. One day her husband and several of his friends came home unexpectedly and surprised her while she communed with supernatural beings. They began to torture her, wanting to learn her secrets. She easily escaped them. Completely naked, her body smeared with slippery mud, she pretended to be mad and ran about shrieking that she would never tell.

Teireii *sennin*

Having mastered the secret doctrines of Daoism after years of study in mountain retreats, Teireii transformed himself into a crane. A thousand years later, he returned to visit his native land. His ancestral village seemed to be much the same as when he had left it, but its people and their customs were completely different. While he stood on the roof of a rich family's tomb, surveying this alien world, a youth armed with a bow and arrow tried to shoot him down. Artists depict him as a crane perched on a pillar, or as a sage in human form with a symbolic crane at his side.

Teishi-en *sennin*

He lived happily among tigers, and is usually shown riding on the back of a full grown tiger, followed by a pack of cubs carrying his books.

Tekiryu *sennin*

He was a painter of dragons who lived so long ago that his true name has been forgotten. Because of his great artistry, he was esteemed as one of the Daoist worthies who became immortal.

Ten Great Disciples of Buddha (*udaideshi*) *Buddhist saints*

All of them are holy men, and they are portrayed in a multitude of ways, usually clad in the simple robes of Buddhist priests. Each has a shaven head, a pious countenance, and a halo. Sharihotsu and Mokuren are known as "the model pair," and often are shown with Shaka, one on each side. Either one may hold a fan, a vase with three lotus blossoms, an alarm staff, a flywhisk, a censer, or a scroll. They exhibit various *mudra*s.

Tengu

In a set of clay figures displayed in the pagoda at Horyu Temple—which may be the oldest version of the ten disciples in Japan—they are portrayed as half-naked monks kneeling around Shaka's deathbed, amid a host of other people, all expressing in various ways their responses to the Buddha's dying.

Tengu *legendary creatures.*

Tengu may be malicious and harmful, or kind and helpful. They are sly and elusive at all times, and live apart from places inhabited by people. Two kinds of *tengu* have been described. *Hananaga-tengu* (long-nosed *tengu,* also known as *konoha-tengu*) are human in form and size, except that they have a set of wings, like birds, and noses of extraordinary proportions, ranging in length from a mere ten centimeters to over a meter. They dress like *yamabushi,* or mountain warriors, when they venture among humans; but at home, in their colonies amid forests of cedars, they clothe themselves in leaves. *Karasu-tengu* (crow *tengu*), on the other hand, resemble crows in form and feature, having very strong beaks and claws. Both in appearance and in the magical powers they command, they are like a Garuda, the bird-deity of India.

All male *tengu* are experts in the martial arts. Like soldiers, they live in camps or colonies, each governed by a head *tengu*. The paramount chief of all colonies is Sojobo, whose title is *dai-tengu* (great *tengu*) or *tengu-sama* (master *tengu*). *Tengu* can be very malicious indeed. They will interrupt priests at their prayers, or torment them with numerous afflictions. They will even carry some unfortunate holy man to the top of a tall tree or to the summit of a high mountain, and abandon him there to perish of hunger or cold. They kidnap infants and torture them to death. They set men to fighting among themselves and to destroying valuable property. Hating Buddha's faith as they do, they enjoy setting fire to temples and pagodas. They disguise themselves as priests in order to lead the faithful into heresy and sin; or, assuming the form of good-looking youths and beautiful girls, will seduce maidens, wives, and men in order to enter their bodies through the mouth. People who are possessed by such evil *tengu* usually become fox-spirits.

Long-nosed *tengu* are inevitable subjects for comic or erotic fantasies. Many artists, put *tengu* into situations either ludicrous or lubricious. They have the *tengu* using its extensive nose as a prop while it juggles hoops, balls, plates, baskets; lifts copper coins with its nose; hauls bundles suspended from that carrying-pole; breaks through the shell of the egg from which it is born; or rolls eggs not yet hatched. Some creators of erotic art have depicted *tengu* consorting with Uzume, the comic and phallic goddess, thinking perhaps to vary the theme by giving her a *konoha-tengu* for a partner, instead of her usual companion, the long-nosed monkey god, Saruta-hiko.

Tenjiku Tokubei (also known as *Tenjiku Hachibei*) *adventurer*

According to his story, he was born at Sendo in Harima Province in 1618 and died in 1686. At the age of fifteen he left Nagasaki aboard a Japanese trading vessel commissioned by the entrepreneur Yamada Nagamasa. The ship was destined for India, the land the Japanese called Tenjiku. Tokubei lived in that strange and fascinating country for three years and returned to Nagasaki in 1636. In 1637 he went to Macao, the Portuguese colony in China, and spent two years in that busy port. In 1641 he may have returned to India for two more years.

Difficulties with the Portuguese in Macao sent him to sea again, probably as a pirate. According to his fanciful tale, he visited Siam, married a princess, and, through the exercise of his great talents, became the virtual ruler of that country. The enmity of natives for foreigners drove him out, so he returned to Japan and settled down. Somewhere along the way he wrote (or dictated) an account of his adventures that he entitled *Tenjiku Tokubei monogatari*, or *The Tale of Tenjiku Tokubei*. Later, feeling penitent about misdeeds he committed as a sailor, Tokubei entered a monastery and spent the rest of his life in seclusion.

Artists have been drawn to one of the adventures he related in his novel. They portray him in a swamp, surrounded by frogs. He claimed that by simply making a magical sign with his fingers, he could change himself into a frog whenever he wanted to escape from enemies. A Noh play, given his name, features this incident.

Tenkai (also known as *Jigen-daishi*) *Buddhist prelate*

During his distinguished life, Tenkai (?-1643) directed some of the Tendai sect's large temples at Kyoto, Nikko, and Edo. Some historians believe that he was the imaginative one who took an odd assortment of older Buddhist and Shinto deities, gave them more pleasing personalities and duties, and—putting them all in one boat—launched them on a new career as The Seven Gods of Good Fortune.

Tennin *Buddhist angels*

Called *apsareses* in Sanskrit, these beautiful young creatures dwell in the Buddhist paradise, making celestial music with their sweet voices and lulling instruments for the enjoyment of resident spirits. They are more chaste Buddhist versions of the females whom Indra, Allah, and Wotan awarded to heroes when they reached their more sensual paradises.

Tennin are slim, delicate, almost attenuated feminine presences, hovering about, sometimes with the aid of wings, but usually unburdened by such appendages. They float amid diaphanous draperies and swirling ribbons, which display (according to Hindu prescription) the five sacred colors. A light, translucent scarf may provide

decorous covering for shoulders and arms. They may hold a lotus blossom, an emblem of paradise, or a musical instrument, such as a lute or a flute, from which they draw their ineffable melodies.

Thirty-six Poets (*sanjurokukasen*) *literary grouping*

These are the 36 most admired poets who lived before the eleventh century. Several connoisseurs of poetry prepared lists of their favorite writers, but the selection known as *chuko no sanjurokukasen* gained the widest acceptance. Among the poets so immortalized, those best known to Western readers will be the two greatest writers of Heian-kyo: Lady Murasaki Shikibu, novelist, who wrote *Genji monogatari* (*The Tale of Genji*), and Lady Sei Shonagon, diarist, who wrote *Makura no soshi* (*Pillow Book*).

Thirty-two Signs of Wisdom *holy marks*

According to Buddhist beliefs, when these marks appear on the body of a man they are proof that he possesses great spiritual power and will command great temporal power. All these signs appeared at one time or another on the person of Prince Siddhartha Gautama, the Buddha whom the Japanese call Shaka. These signs remained on him as evidence for all to see that he was an incarnation of the savior who has been promised by the prophets. These proofs of Buddha-hood should therefore be shown, whenever feasible, on all representations of Shaka. Of the thirty-two signs, these seven are most often seen in works of art:

Usnisa—a protuberance at the very top of the head, representing knowledge. Often the *usnisa* is shaped as a knot of hair, or a precious jewel, or even as a tiny image of a Buddha.

Enlarged ear—frequently pierced in the lobes, indicating that he hears all.

Hair—so black it gives off blue glints, it is coiled in tight ringlets, close to the skull; the swirl of each coil turns clockwise.

Urna—a third eye, symbol of "the eye divine," set in the space between the brows. (Some people have described it as a curl of white hair.) Often a gem, such as a pearl or a button of crystal or alabaster, represents it. Images of important bodhisattva also may display the *urna*.

Web—the fingers of his hands are joined at their bases by a membrane, and so are the toes of his feet, symbolizing the oneness of all things in the universe.

Shakra—the Wheel of the Law, the paramount symbol of Buddhist doctrine, is imprinted on the soles of his feet. In some images, the *shakra* is replaced by Shaka's hands making the *mudra* of turning the Wheel of the Law.

Swastika—this ancient diagram, swirling in a counterclockwise direction, is a symbol of good fortune, or represents the Wheel of Life. It appears on Shaka's abdomen.

Sometimes the grammadion is shown there instead, as evidence of his limitless power.

Thousand Buddhas (*senbutsu*) *Buddhist motif*

As Japanese artists became more concerned with presenting the spiritual values and doctrines of Buddhism, they stopped using the more naive and worldly story-telling approach that depicts people, plants, animals, mountains, and other mundane things, and replaced them with numerous small images of Buddhas. Eventually, these many Buddhas, arranged in an uninterrupted pattern, dominated the whole background of a composition, whether in painting or in sculpture. The actual number rarely amounted to a thousand, if only because a few hundred repetitions sufficed to achieve the desired effect. Some historians believe that out of these arrangements and replications developed the concept of the mandala.

Three Cringing Creatures (*sansukumi*)

This triad, frequently depicted in Japan, consists of a frog, a snake, and a snail. The frog may eat the snail; the snake may ingest the frog; but the snail, devoured or not, is poisonous to the serpent. Thus, if a natural sequence of events occurs, the three will die; hence, the cringing attitudes.

Three Fat-bellied Deceivers *cynical grouping*

With a certain amount of grim humor, Japanese cynics put together an unholy triad of creatures that ostensibly are attractive, but in fact all too often are cheats: Tanuki, the badger; Hotei, the god of luck; and the *fugu,* or globefish. All they share in common is an inflated paunch and a reputation for being untrustworthy. Despite his jolly mien, Hotei can ignore you during the New Year festival when he hands out portions of good luck and treasures from his bag. The badger can be mean, even murderous. And if you should eat the flesh of a *fugu* that has been the least bit tainted with the very poisonous secretion from its viscera, a swift and painful death will follow.

Three Gods of Poetry (*wakasanjin*) *deities*

These are the legendary Princess Sotori, who is supposed to have lived in the fifth century, and Yamabe no Akahito and Kakinomoto no Hitomaru, two male aristocrats who wrote in the eighth century.

Three Gods of War (*sansenjin*) *deities*

Imported from India with Buddhism, these alien gods of war—Marishi-ten, Daikoku-ten, and Bishamon-ten—have never supplanted the Shinto deity Hachiman in the hearts of the Japanese people. Even though Marishi-ten was not really a god of war (and, moreover, was a feminine deity), the trinity is represented in the form of an armored male with three heads and six arms, riding on a charging boar.

Three Great Models of Fidelity to the Emperor

Three Great Models of Fidelity to the Emperor (*sanchu*) *moral examples*

These are Taira no Shigemori (1138-79), first son of Kiyomori, who tried to soften the actions of his arrogant father, and supported Emperor Go-Shirakawa against the extravagant dictator; Fujiwara no Fujifusa (ca. 1331), a court noble devoted to Emperor Go-Daigo, who accompanied the sovereign into exile when the Ashikaga shogun banished him from Kyoto; and Kusunoki no Masashige (1294-1336), who fought for Emperor Go-Daigo against the rebelling Ashikaga, and died when his small army was overwhelmed by Ashikaga supporters at the battle of Minatogawa no Talakai (1336).

Three Heroes of the Later Han Dynasty *warriors*

The three heroes, Choki, Gentoku, and Kanyu, were military commanders during the declining years of the Han dynasty (206 BCE-220). They swore a mutually binding oath (in a peach orchard owned by Choki) to defend the interests of the Han even to the death. In effect, this meant that Choki and Kanyu agreed to support Gentoku, who was related by blood to the imperial family, in his attempts to gain supreme power over a united China.

Choki took part in various campaigns, proving to be not only a brave but also a wily commander. In one battle he gave Koso time to escape by single-handedly preventing enemy troops from crossing a strategic bridge. On another occasion he found himself in charge of an undergarrisoned city, his reinforcements being delayed. He sent his troops out of the city, but he, playing a flute in the main gatehouse, and a few soldiers, pretending to be civilians, remained. Finding no opposition, the enemy forces occupied the city, and gave themselves over to drinking and carousing. Choki's troops, having joined forces with their tardy allies, returned to the city, fell on their opponents, and won the day.

After the oath-taking in the peach orchard, Kanyu was also involved in many battles against Koso's enemies. During one engagement, he was taken prisoner with two of Koso's wives. Instead of sleeping, he stood guard all night outside the room in which the two women had been confined. In 219 he was taken prisoner again and was executed. Towards the end of the sixteenth century he was named god of war by an imperial edict. In Japanese art he is most often portrayed as a tall man with a long, black beard, who holds a halberd.

Koso established a court in the Chinese province of Szechwan, after a series of indecisive battles against two other military commanders had made it clear that none of the three could defeat the other two. In 221 he declared himself emperor by virtue of his imperial ancestry. With one of his rivals already claiming to be the

emperor and with the other soon to follow, Koso's vision of a unified China became unrealizable, and the country entered into a period of divided rule known as the Three Kingdoms (220-280).

Three Most Beautiful Landscapes (*Nihon sankei*)

Once these superlative views, considered ideal arrangements of earth, sea, and sky, could be seen at Matsushima (in present Miyagi Prefecture), Ama no Hashidate (in Kyoto Prefecture), and Itsukushima (in Hiroshima Prefecture).

In the great bay of Matsushima, about 30 kilometers north of Sendai, more than 800 islets seem to be strewn about the blue waters of the sea. They range from mere rocks protruding out of the ocean to expanses large enough to support a few hills and farms. Many of these islets have been given fanciful names, such as "Peony Trunk," "Blue Eels," and "Twelve Imperial Consorts." In the shoals between them, large numbers of stakes driven into the sea floor sustain the nets on which edible kinds of seaweeds grow. "The Four Grand Sights" of Matsushima were viewed from as many vantage points along the curve of the bay.

Ama no Hashidate, "the Bridge of Heaven," is a long, narrow sandspit almost closing the mouth of Miyazu Bay, on the northern coast of Honshu. On the other three sides high mountains wall the bay. Ama no Hashidate, named for "the Floating Bridge of Heaven" where Izanagi and Izanami stood before they created the islands of Japan, is 3.6 kilometers long and between 37 to 100 meters wide. Clusters of wind-bent pine trees grow along the narrow sandbar, and a small Shinto shrine stands at its very tip.

Itsukushima, also known as Miyajima, is a small island in the Inland Sea, lying a few kilometers west of the city of Hiroshima. Its several shrines are dedicated to three of the daughters of Susano-o no Mikoto: Itsukushima-hime, Takitsu-hime, and Tagori-hime. The most splendid of these shrines is built far out into the U-shaped bay on the northwestern shore, and seems to float above the waters of the sea. At the entrance to this bay, standing above the ebb and flow of the tides, rises the most famous *torii* (free-standing arch) in Japan. Made of camphor wood, the present one was set in place in 1875. The first of its precursors was raised in 1674.

Three Sacred Monkeys (*sambiki saru*) *art motif*

These are the most famous monkeys in art, recognized throughout the world: Mizaru, who, closing his eyes with his hands, sees no evil; Kikizaru, who, putting a hand over each ear, hears no evil; and Iwazaru, who, by covering his mouth, speaks no evil.

Three Sacred Treasures *imperial regalia*

These are the regalia of Japan's imperial family. Amaterasu, the sun goddess, gave

them to her grandson Ninigi, when he went down from heaven to rule over the islands of Japan. The three are:

Sacred Sword—the blade drawn from the tail of the eight-headed dragon slain by Susano-o and given by him as a peace offering to his sister, Amaterasu.

Sacred Mirror—about 25 centimeters in diameter, it was cast in the shape of a flower having eight pointed petals. It is a symbol of wisdom, justice, and purity.

Eight-foot String of Beads—made by the deity Tama no Oya, it was hung in the *sakaki* tree that stood outside the cave in which Amaterasu was sulking after being grievously offended by the destructive actions of her brother, Susano-o.

Three Sake Tasters (*sake-sui sankyo*) *moral*

This representation conveys a subtle moral. It brings together Asia's greatest teachers, Laozi, Buddha, and Confucius, all drinking sake poured from the same jug, and each showing, by the expression on his face, a different reaction to the brew. Out of this common situation emerges a message: just as each teacher responds in his own way to liquor drawn from the same vessel, so do listeners respond in different ways to the truth. Thus, the truth, one and unchanging, coming from the same source, may be expressed in different ways by different teachers.

Another trio known as the three drunkards (or *sannin jogo*) is a variation on this theme, but assembling a less august cast. The face of each reveals the state of his soul, while it also demonstrates one of the effects of drinking too much alcohol. Jizo-bosatsu, the true accepting Buddhist, sits in tranquil apathy; Emma-o, King of Hell, glares about in choleric rage; and an ogre slumps in self-pitying dejection.

Tiger

In both Chinese and Japanese art, the tiger and the dragon are often shown together. The tiger is an emblem of wind and autumn, and—because that was the season for marriage—is a symbol for yang, the masculine principle in nature. The dragon is an emblem for water and spring, and—because that was the season for betrothal—is a symbol for yin, the feminine principle. It is also one of the signs of the Japanese zodiac and one of the symbols for the hours of the night from 4 until 6 a.m. For astronomers and astrologers, the tiger ruled the western quadrant of the sky.

In Japan the image of a tiger was introduced as a symbol for the power of Buddhism. Later, as people emphasized the strength of the animal rather than of the faith, the tiger became a symbol for physical prowess and courage among men. As a talisman, the tiger promises good fortune in traveling.

Japanese artists usually depict tigers as big striped cats rather than fierce jungle beasts, because they only had paintings from China as models. Many famous

personages in Japanese and Chinese lore—*sennin*, holy men, demons, heroes, warriors, aristocrats—are shown in the company of tigers. Busho, one of the 108 heroes of China celebrated in the novel entitled *Suikoden* (*Water Chronicles*), is portrayed killing a tiger with his mighty fist. A tiger accompanied the *rakan* whom Japanese call Hattara-sonja. Of the *shisui* mistakenly called "the four sleepers," three are men and one is a tiger. The quartet represents the serenity to be found in Zen Buddhism, gained through meditation, and the spiritual rewards of religious life. Here, the tiger retains its earlier symbolism.

Tobacco Pipe (*kiseru*) *implement*

Throughout Asia, the tobacco pipe is simply a slender wooden tube, usually made of bamboo, twenty to thirty centimeters in length, with a brass mouthpiece at one end and a shallow thimble of a bowl at the other. The bowl holds enough tobacco for three or four puffs. More ostentatious *kiseru,* in the same shape, are made of costlier materials, ranging from tin to gold.

Tobacco Pouch *container*

The Japanese became acquainted with tobacco only towards the end of the sixteenth century. Traders from Europe introduced them to "the American weed." Despite governmental attempts to discourage the vice, people of all classes quickly acquired the habit of "sucking smoke." (Unlike the Chinese, however, they did not develop a passion for snuff.) The usual smoker's accessories, such as the long slender pipe and the tobacco pouch, soon entered into the designs of artists.

Toba Sojo *priest-artist*

Although he was a Minamoto by birth, and took a religious name when he became a priest, this artist (1053-1140) is best known as Toba Sojo, or the Abbot of Toba, a small monastery south of Kyoto. He made satirical drawings that he claimed were to instruct. Much more incisive than mere caricatures, they are really transformations of familiar people and animals into imaginary creatures who still retain the foibles and peculiarities of the originals. They illustrate the homily that Tobo Sojo is delivering, whether it is directed at the avarice of merchants or the noisiness of crowds. Sketching only the quickest of lines for long, stick-like limbs projecting at odd angles from misshapen bodies, with only the merest suggestions of features, he created a gallery of types. Almost any viewer who sees them recognizes that any artist other than Abbot Toba could not have done them. Ever since his time, illustrations in his style, even those done by numerous imitators, are known as *toba-e,* "Toba's pictures."

Tobosaku *sennin*

One of the most famous of Daoist immortals, Tobosaku was reborn at least six

times. In his seventh reincarnation, he appeared in 138 BCE at the court of the Han emperor Wudi (r. 141-87 BCE). In his last incarnation, the legend goes, his widowed mother conceived him in a miraculous manner. Because of his wisdom and command of Daoist magic, Tobosaku became one of Wudi's most important advisers. Not at all impressed by the trappings of imperial protocol, he often astonished the monarch with audacious speech as well as feats of magic. Many stories describe Tobosaku's ability to change his shape, to appear and disappear at will, and to foretell future events. Thus, when Wudi saw a green sparrow, Tobosaku explained that it was a portent of a visit from Seiobo, Queen of the West and protector of the Peach Tree of Immortality. Before long Seiobo did arrive, bringing a gift of ten peaches which she herself had plucked from the magical tree that grew in her Gardens of the West. A man who ate one of those peaches, she said, would live for 3,000 years. Tobosaku ate three, becoming a man who would live to be 9,000 years old. Even so, during this last incarnation death came for Tobosaku when he seemed to be about 40 years old. After he died, the court astronomer reported that a new star had appeared in the heavens, which he had named Sui. Emperor Wudi declared that, without a doubt, Tobosaku's spirit had become this new star. Artists represent Tobosaku in many different ways, but always show him with emblems of longevity, such as a peach, stag, or bat. Sometimes they depict him in the company of Seiobo, or attending Emperor Wudi. They also show him borne aloft on clouds, carrying over his shoulder a branch laden with peaches.

Toenmei *sage*

A poet who liked his comforts (with rice wine and solitude heading the list), Toenmei (365-427)—before he attained wisdom—foolishly agreed to serve as a magistrate in his hometown. On the eighteenth day after he took up that burden, he returned the seals of office. He had realized the extent of his foolishness when etiquette required him to kowtow before a visiting mandarin who did not deserve a nod from an imbecile. He went back to solitude and poetry, cultivating flowers in his garden, and living in a modest house with five willow trees planted out front. Because of them he is known as "the Sage of the Five Willows."

Pictures usually show Toenmei as an old man seated among asters and chrysanthemums under a willow tree, lifting high a cupful of rice wine. Sometimes artists provide the sage with a servant, admiring the flowers beside him, or holding a piece of cloth over the mouth of a jar, to filter cloudy rice wine and make it sparkling clear.

Tokaido *national highway*

The road known as the Tokaido extended 514 kilometers, from Nihonbashi, the bridge of Japan in Edo, along the Pacific coast of Honshu as far as Nagoya, and then wound inland until it passed Lake Biwa to reach Kyoto. Although it existed long before 1603, when Ieyasu, the first Tokugawa shogun, established his seat of government in Edo rather than in Kyoto, the fact that he moved to the eastern city immediately made the Tokaido the most important thoroughfare in the country.

A traveler's progress along the Tokaido was measured not so much by distances covered as by the "stages" or "stations" he passed along the way. Apparently those grew up rather haphazardly, at varying distances from each other, usually at places where towns or villages already existed, or where some topographical feature, such as a river or a mountain pass, might restrict the flow of traffic during times of bad weather. The Tokaido had 53 of those convenient stations, each within easy walking distance of the next, provided the traveler enjoyed good health and the weather was considerate. At two places along the route, where intrusive bays and swampy estuaries would have forced the highway to make long detours inland, the road simply stopped and travelers crossed the intervening waters aboard ferry boats.

Each of the 53 stations was at least as big as a hamlet, and some were large towns. There, the weary traveler could find inns, tearooms, restaurants, shops, and other kinds of comforts he might want, such as public baths, brothels, shrines, and temples. There were also porters, runners, guides, palanquin bearers, and horse renters for people who could afford to hire them.

With favorable weather, and no unexpected interruptions, a person could walk from Edo to Kyoto in twelve days. Relays of runners, keeping to their schedule both day and night, could carry messages between the two cities in four days. Couriers on horseback, riding both day and night, with frequent changes of mounts, covered the distance in about 72 exhausting hours.

The great Hokusai, in 1804, published the first of a series of books devoted to the 53 stations of the Tokaido, and followed that with three other volumes before he died. Hiroshige's first set, by far the most beautiful *ukiyo-e* about the Tokaido created by any artist, appeared between 1833-4. Altogether, he designed more than 900 prints concerned with the great highway, in 36 different formats, in addition to a vast number of prints about other subjects.

Tokiwa Gozen *heroic mother*

Out of a thousand aspirants for positions as ladies-in-waiting to Empress Masako, consort of Emperor Konoe (r. 1142-55), only a hundred were chosen to serve.

Tokokei

Of those hundred, Tokiwa Gozen (1135-?) was deemed the most beautiful. Soon after her entry into the imperial court she became the concubine of Minamoto no Yoshitomo, the head of that clan. Tokiwa bore him three sons, the youngest of whom grew up to be the valiant Yoshitsune.

Yoshitomo was assassinated early in 1160, after his futile rebellion against the Taira. Lady Tokiwa, with her three small sons, fled from Kyoto, to escape the wrath of Taira no Kiyomori. He was determined to destroy the power of the Minamoto by killing all of Yoshitomo's ten sons. He tortured Tokiwa's mother in order to learn her daughter's hiding place. Hearing of this cruelty, Tokiwa alone returned to Kyoto, and begged the tyrant to spare her mother's life and her sons. Kiyomori yielded, making only two conditions: the three boys must be sent to a distant temple to become monks; and Tokiwa Gozen must become his mistress.

Kiyomori's interest in Tokiwa did not last long. She seems to have borne him a daughter before he ended the liaison. Then he gave Tokiwa in marriage to a relative of hers, Fujiwara no Naganari, at that time the minister of finance. Artists invariably portray Tokiwa as the intrepid mother, toiling through deep snow along a narrow path in a desolate countryside, carrying one tiny son at her bosom, while two others struggle along, clinging to her kimono. Unaccustomed to such attrition, her tender feet leave a trail of blood in the snow.

Tokokei *sage*

Before she bore him, his mother dreamed that a green dragon emerged from her bosom, while two angels stood before her, holding a bronze censer. After he appeared in this world, Tokokei fulfilled the promise in those portents. When he was four years old he could write complex characters, using a bed of wet ashes for paper and a stick for a brush. He loved to read about sages and *sennin* and, as he grew older, he devoted himself to studies in alchemy and a search for the secret of immortality. He became a most handsome man, slender and extraordinarily tall. He had certain distinctive marks: very long ear lobes, each ear sprouting exactly 77 long hairs; and a right knee adorned with moles of all dimensions, from one the size of a pigeon's egg to one the size of a pinhead. Loving music, he played the lute and the *sho,* a mouth organ of many reeds. When he was occupied with other tasks, a servant soothed him with music. Even his garden was planned to comfort him. He ordered pine trees planted there, so that he could hear the melodies made by the winds as they passed through the grove. Tokokei died in 536, at the age of 85. Painters usually depict him sitting at an open window, deep in meditation, or walking under pine trees, beside a stream or a pond, near his mountain hermitage.

Tokudo-shonin *Buddhist priest*

The pious Tokudo, according to tradition, instituted in Japan the devotional pilgrimage to the 33 famous temples dedicated to Kannon, a bodhisattva of compassion. Emma-o, the King of Hell, gave Tokudo the idea when the priest's spirit appeared before him for judgment. The lord of the underworld complained that his realm was much too crowded with sinners because people "up there" simply did not observe the Buddha's Law. Hoping to reduce the congestion somewhat, he prepared a list of the 33 temples of Kannon and gave it to Reverend Tokudo, assuring him that any person who made a pilgrimage to all those sacred shrines would never suffer in hell. As a pledge of his sincerity, he gave the rejoicing priest his own personal seal, beautifully set with precious gems.

The spirit of Tokudo-shonin returned to his body on the third day after he had died. Fellow priests, praying at his wake, saw him rise up, holding in one hand the seal of Emma-o, and in the other, the list of Kannon's temples. Tokudo told them of Emma-o's pledge and then led them on the first pilgrimage ever made to the 33 sacred shrines. When the journey ended, his spirit left his body to go straight up to paradise. The seal of Emma-o is still preserved in a temple at Nakayama.

Tokugawa Family

Like the Minamoto and the Ashikaga, whose shoguns dominated Japan before them, the Tokugawa also claimed Emperor Seiwa (r. 859-76) as an ancestor. At the beginning of the thirteenth century, one of Seiwa's descendants, Nitta no Yoshisue, settled in Tokugawa, a village in Kozuke Province. He is the founder of that branch of the Seiwa-Genji family known thereafter as the Tokugawa.

For nearly 400 years those "country Genji" lived inconspicuously, and indeed almost uncertainly, while almost incessant civil war raged about them. Then, on 21 October 1600, Ieyasu, the ablest and wiliest Tokugawa of all, won at Sekigahara the most decisive battle in the history of feudal Japan. It established him as the country's military ruler. Before he died in 1616 he had arranged civil and military matters so advantageously that his sons and their descendants, the fourteen Tokugawa shoguns who followed him, governed Japan until the Meiji Restoration in 1868.

Although the Tokugawa were the most important individuals in the country, and their persons, families, interests, experiences, and deeds afforded many motifs that artists might use, no one dared to represent them in any way other than the occasional approved "official portrait." To be sure, a few allusions to Ieyasu were made in art during the first years of his regime, before the Bakufu, "the government of the tent," lowered its screens around him and his family. The people who were

shut out quickly realized that, in this Tokugawa, they were being given a new kind of ruler, who wished to dwell "above the clouds," almost as invisible and sacrosanct as an emperor. A cartoon-like print, made soon after Ieyasu seized power, showed him eating rice cakes that his immediate predecessors—Oda Nobunaga and Toyotomi Hideyoshi—had prepared with much labor. The new shogun was not amused—and the making of such commentaries ceased. Commoners who, at first, had called him "Old Badger," in tribute to his cunning, soon learned to say nothing at all about him. Official pictures (which never did give authentic likenesses of anyone) seated him amid his seventeen loyal supporters, the *daimyo* who rallied to his support before the battle of Sekigahara, or with his four principal retainers, Sakai no Ietsugu, Sakakibara no Yasumasa, Ii no Naomasa, and Honda no Tadakatsu.

For the family crest Ieyasu's father chose the *mitsu aoi,* three hollyhock leaves arranged in a circle, with their tips at a common center. The Tokugawas' famous battle standard was the red sun disk on a white field, known as *hinomaru,* the round of the sun. As Japan had no national flag in 1860, the shogun's *hinomaru* flew above the first embassy to represent the country abroad. In 1870 the Meiji emperor's government adopted it as the emblem for the new Japan it was building on the foundations laid by the Tokugawa.

Tokutaro and the Foxes *fable*

Tokutaro, a farmer of Iwahara, did not believe in fox-spirits. One evening, annoyed by his neighbors' talk (and fortified with sake), he made a bet with them: he would spend the next night in the swamps of Maki (a place where real foxes lived) and thereby prove to everyone in Iwahara that fox-spirits did not exist.

He went as promised into the swamps of Maki, and there he had a terrible experience—but at the end of the night, he could not be sure if it was a dream or reality. Had he actually met a neighbor woman, the wife of an official in a nearby town? Had he really killed the poor woman, by roasting her over a kitchen fire, because he was absolutely convinced that she could be nothing else but a fox-spirit in a woman's body? Had a jovial priest really come along, just in time, to accept him as a disciple, and thereby save him from arrest and execution for murder? Or had he just dreamed all this?

When he awoke at dawn, propped against a tree in the swamp, he remembered with sickening clarity every detail of that ghastly night—and of how at last it ended, with the kind priest shaving his head to prepare him for the penitent's path. When he lifted a hand to rub his itching scalp, he found that it had been shaved as smooth as the skin on an apple. Tokutaro ran home as fast as his legs could carry him, paid the

bet with his neighbors, and, without pausing to say goodbye, hastened to the nearest temple to become a priest—for real.

Tombs (*misasagi*) *funerary practice*

Sovereigns, imperial princes, and perhaps a few high officials of the court who lived and died during the Tumulus Period (250-552) were buried in *misasagi*. The body of such a personage was laid in a stonelined trough or, later, in a stone coffin placed at the top of a natural hill, or of an elevation made for the purpose. In still later times, a second mound—long, narrow, and triangular in outline—was built up, merging with the cone of the hill in such a way as to form an arrangement resembling a keyhole. The double mounds of very great sovereigns, such as Emperor Nintoku (r. 313-99), were surrounded by moats. The triangular mound served as a place where rites were held in honor of the departed one.

Excavations in some of these mound-tombs have unearthed many objects of ancient art. Among these the most interesting are the clay figurines called *haniwa* and the stone jewels known as *magatama* and *kudatama*. Mirrors made of metal and several kinds of weapons have been found as well.

Tomoe Gozen *female warrior*

When her husband, Minamoto no Yoshinaka, entered the war against the Taira, Tomoe Gozen accompanied him on his campaigns and led a troop of warriors into each battle. Their fighting ended in 1184, with the second battle of Uji River, when Yoshinaka met death at the hands of his own kinsmen, and Tomoe Gozen was taken captive by an enemy stronger than herself.

During that famous engagement, Hatakeyama Shigetada laid his hands on her, but she tore herself from his grasp, leaving him holding only a sleeve. Morishige of Musashi attacked her, and she cut off his head. The strong man Wada Yoshimori swung at her with the trunk of a pine tree, but she shattered that into splinters. Not discouraged, he returned again and again until he subdued her.

Legend has it that she became his concubine, and that they produced one child, Asahina Saburo Yoshihide, a prodigy of strength and valor—despite the fact that history records him as already born before Yoshimori and Lady Tomoe met. The real Wada Yoshimori died in 1213, but legend prefers to kill him off before Tomoe bore him that strong son. Legend also commits Tomoe to the life of a nun in her twenty-eighth year.

This militant female is always shown astride a horse and fully armed, except for the warrior's helmet. She would have worn the helmet in combat, but artistic license, in order to distinguish her from male warriors, puts a chaste white fillet around

her head. Some prints show her leaving that ripped-off sleeve in Shigetada's hands. Others show her beheading hapless Morishige, or splintering Wada Yoshimori's pine tree club.

To no Ryoko (also known as *Miyako no Yoshika*) *poet*

A notable poet in his own right, Ryoko is also remembered as a teacher of Sugawara no Michizane, scholar, poet, statesman, and god of literature. Artists have portrayed Ryoko creating a poem written in the Chinese manner, while standing under a willow tree. From the leafy crown of the willow (or sometimes from a mere cloud) an amiable demon, all fangs and hair, grins down at the poet. Such pictures refer to the time when Ryoko, standing on the shore of Chikubu, the beautiful island in the northern end of Lake Biwa, was moved to compose a poem. He wrote the first line, but could not think of a second. A helpful demon up in the tree completed the verse for him.

Tora Gozen *mistress of Soga no Juro Sukenari*

A beautiful prostitute who lived in the village of Oiso, one of the smaller stations on the Tokaido, Tora was the mistress of Soga no Juro. He was visiting with her on that day in May 1193 when his younger brother Goro galloped in to tell him that the time had come for them to take their revenge on the man who had murdered their father.

Tora Gozen wept to see her lover ride off to die. On 28 May 1193, the day when the Soga brothers appeased their father's spirit and joined him in death, Tora Gozen's tears were changed to saddening rain. Ever since then rain always falls on Oiso on the twenty-eighth day of the fifth month.

Tori-akuma *fantastic creature*

The "flying demon" has a huge head, enormous eyes bright as flames, and holds a long sword as it cruises about, looking for victims. In a household it visits, at least one of its members will be struck mad.

Torii *Shinto arch*

This simple device, so "typically Japanese," stands before all Shinto shrines and other sanctified places. It is made with the minimum number of structural components needed to form an arch that will stand by itself: two upright columns and two crossbeams. By making minor modifications in the relationships between the crossbeams and uprights, Japanese craftsmen have produced at least fifteen different kinds of *torii,* each bearing its own distinctive name. In all *torii,* however, the dimensions of length and width, of material solids to immaterial spaces, are proportioned with exquisite care.

The word *torii* means "bird rest." The usual explanation for both name and object given by historians is that, in ancient times, a pole laid between two supports served as a perch for the sacred roosters kept at a shrine, because their crowing announced the rising of the sun. Shinto mythology explains that the *torii* is a replica of the perch in heaven used by the sacred cock, when it helped The Eight Hundred Myriad Gods to lure Amaterasu out of her cave. As a matter of fact, however, the *torii* is not a Japanese invention. It seems to have evolved from the *torana* of India, the arch with sinuous crosspieces that marks an opening in a fence enclosing a *stupa* or some other holy place. Nonetheless, the idea of a freestanding arch must have entered Japan long before teachers of Buddhism arrived from India. To believers in Shinto, the *torii*—like the cleansing water applied to hands and lips—are agents of purification, whereby both the defiled body and the impure spirit are prepared to stand before the god. The structures are also gateways to the world of the supernatural.

Tori-oi *wandering minstrels*

During the New Year festival, poor women of the "untouchable" *eta* class strolled through the streets in wealthier neighborhoods, begging as they sang to the accompaniment of *samisen* (a three-stringed, banjolike instrument) or *ko-kyu* (a sort of three-stringed viol). Flat, wide-brimmed hats of straw, drab kimono, and battered instruments identify them in prints and carvings. People fortunate enough not to be classed as *eta* (untouchables) dubbed them *tori-oi*, bird-scarers, as much out of contempt for their caste as in recognition of the strident music they made.

Tortoise/Turtle

The Buddhist parable of the *moki*, or one-eyed tortoise, teaches that enlightenment and salvation are almost impossible to attain. The *moki* lives in the ocean's murky depths; and on only one day in every 3,000 years is he given a chance to see the sun. That opportunity is hard to come by. His single eye is not in his head, but in his belly, where his navel should be. In order to look up to the sun, he must find a floating board that has a hole through it. He must lie on this plank in such a way that his ventral eye is positioned over the hole. Then he must wait for a big wave to come along, powerful enough to overturn both the board and its hopeful rider. If he can cling to that slippery board with his flippers, keep that staring eye aligned with the hole; and if clouds do not obscure the sun, then, and only then, may the yearning *moki* have the chance to look at the effulgent sun.

The tortoise, a symbol of longevity like the crane, stork, pine tree, and other such creatures, is depicted quite often with aged people, such as Jo and Uba, or with gods of longevity, like Furojin and Fukurokuju. Sometimes it is shown swimming

beside the treasure ship bringing The Seven Gods of Good Fortune into port, at other times it rides aboard the vessel, among the New Year's gifts with which the boat is laden. The story of Urashima Taro, whose destiny was affected so notably by a tortoise, cannot be illustrated without it.

In representations of real animals, the *minogami,* or "raincoat tortoise," is a favorite. Long filaments of green algae, mosses, and other water-loving plants that grow on the carapace of an ancient turtle and stream behind as it swims, suggest a *mino* or peasant's raincoat made of rice straw. The hexagonal markings in the shells of many kinds of turtles suggest to Buddhists the idea of the six realms of rebirth or the six cardinal virtues.

A depiction of a snake coiled around a turtle recalls older religious lore about the deity Bishamon, either as guardian god of the north or as another avatar of Vishnu. A snake lying at ease on a tortoise's back, so that their heads are in loving contact, tells a story of another sort. This is a reference to bastardy, perhaps even a boast about a man's success despite his lack of a legal father. The Chinese and Japanese believed that all turtles and tortoises were females, and that they mated with snakes in order to bear fertile eggs. The harsh Chinese judgment called a bastard a "tortoise's egg." The softer Japanese term was "turtle's child."

Tosabo Shoshun *villainous priest*

Having decided to remove his half-brother Yoshitsune from this world, Minamoto no Yoritomo sent his retainer Tosabo Shoshun from Kamakura to kill him. When Benkei Musashibo saw this strange priest in Yoshitsune's palace in Kyoto, he questioned him and learned his purpose. Yoshitsune, on being informed of the plot, set Shoshun free, scornfully telling him to go back to the master who had hired him. Shoshun would not take that advice. Shame, loyalty, and fear of Yoritomo made him try again. Benkei's guards caught him, and this time Yoshitsune ordered him beheaded.

Legend and melodramatic playwrights have added to this bare plot incidents gaudy enough to make a scenario for an epic drama. Tosabo Shobun is given 90 samurai to help him gain his nefarious end. When they attack Yoshitsune's palace he is asleep; and only the heroic exertions of his retainers and the aid of Shizuka, his concubine, who helps him to gird on his armor, save him from the murderous band. Realizing that he has failed, Shoshun mounts his horse. Benkei grabs it by the tail and, holding it with one hand, hurls Shoshun to the ground with the other, breaking his neck. When quiet has been restored, Shoshun's head, and those of nineteen henchmen captured in the affray, are displayed on Kyoto's execution ground near the Sixth Avenue Bridge.

Toshikage *fictional hero*

Early in the tenth century an anonymous author wrote a collection of stories called *Utsubo monogatari,* or *Quiver of Tales.* They are both naive and dull, compared with the *Genji monogatari* (*The Tale of Genji*) written later that century. Toshikage is the peerless hero of the first tale of *Utsubo monogatari.* The author made him a member of the great Fujiwara clan, at that time dominating every aspect of life in Heian Kyoto. He was handsome, brilliant, and favored above all others, by both gods and mortals. The emperor sent him as an ambassador to China.

On the way his vessel was wrecked on an unknown coast and only he survived. When he gained the shore he found a horse already saddled. It bore him inland to one strange adventure after another. He came upon a group of men sitting in a shady grove while they played musical instruments. At sight of him all the musicians vanished. He encountered some fearsome demons cutting down a great paulownia tree. A celestial boy riding on a dragon appeared out of a thunderstorm to protect him. From the felled tree he obtained enough wood to make 30 lutes. A typhoon swept him and those 30 lutes home to Japan.

The gods bestowed on Toshikage's grandson the same benisons they had showered on him. Even at the age of five the boy supported his mother when, by mischance, they were separated from father and husband. They lived in a hollow tree, loaned to them by a family of bears. Monkeys brought them fruits and other foods the boy himself could not gather. Then one day the boy's father, while hunting in that same forest, found them. He took them home to their splendid new mansion in Kyoto, and there they lived happily ever after.

Toshiotoko *man of the year*

This timely title is given to the male member of a family who routs demons from the household on New Year's Eve, in the rite of exorcism known as *oni yarai.* He is frequently represented in art, either scattering parched beans throughout the house (while *oni* flee), or else carrying a clutch of captured demons in a bulging sack thrown over his shoulder.

Toshitokujin *Daoist deity*

A minor deity borrowed from Daoism, Toshitokujin originally presided over the Year of the Hare, but the Japanese, once they adopted him, invoked this god at every New Year festival. His name means "Year Virtue God," and people asked him for help in achieving "moral excellence" during the time ahead. According to some accounts, he resembles Jurojin and Fukurokuju among The Seven Gods of Good Fortune. He also has a high forehead, a long beard, and the flowing robes of a Chinese official.

Totoribe no Yorozu *warrior; "the emperor's shield"*

According to the *Nihongi*, Yorozu is the first of Japan's warriors to kill himself on the field of battle rather than submit to being captured and executed by his enemies. Moreover, even though Yorozu served a lord who fought against the reigning sovereign, he is considered to be a model of fidelity to the emperor because of the sentiments he expressed just before he died.

Yorozu was captain of the hundred warriors who guarded Lord Mononobe's fortress-mansion in Naniwa. In the year 587, with a single battle, the Soga clan's faction, staunch supporters of Buddhism, defeated the Mononobe faction, faithful adherents of Shinto. When he learned of his lord's defeat and death, Yorozu sought refuge in the mountains, as did other Mononobe warriors who survived the brief war. The victorious Soga ordered the execution of all members of his family unless he surrendered.

Having heard of this judgment, Yorozu came down from the hills, hoping to ransom his family with his body. Without listening to his plea, hundreds of Soga soldiers rushed to attack the lone outlaw. He held them off for a while, until a guardsman brought him down with an arrow to the knee.

Even then the guardsmen would not desist. Yorozu killed more than 30 men before he decided to fight no more. He cut his bow into three pieces, flung his great sword into the waters of the river. With his dagger he stabbed himself in the throat and died. As was the custom, the victors hacked off his head.

The Soga officials had commanded that Yorozu's body be cut into pieces, to be exhibited in each of the eight adjoining provinces, as a warning to other rebels. Just as the executioners were about to do their duty, a violent storm began. Yorozu's white dog, which had been guarding its master's corpse, took up his severed head, and carried it to a nearby sacred mound. After that, the dog lay down, would not eat, and died.

When this was reported to the imperial court, Lord Soga relented—perhaps interpreting the event as a message from the gods—he ordered Yorozu's kindred to construct a tomb for his remains. They buried Yorozu and his dog in the village of Arimaka, in the very hills from which he had descended to death and honor.

Toyotama-hime *Shinto deity*

Watasumi, a sea god, is Toyotama-hime's father. In her human form, "Princess Rich Jewel" married Hiko-hohodemi no Mikoto, the third son of Prince Ninigi no Mikoto, himself a grandson of Amaterasu, the sun goddess. As the young couple prepared to leave Toyotama-hime's home beneath the sea to live in Hiko-hohodemi's country,

she made him promise that when the time came for her to bear their child, he would build her a parturition hut by the shore.

He kept his word about building the birthing-hut, but not the promise that he would not enter it. Just as his firstborn son was arriving, Hiko-hohodemi peeked between the cormorant feathers he had used to cover the parturition hut, and saw his wife in her true dragon form, sixteen meters long. Unable to forgive him for having shamed her, Toyotama-hime returned to her home at the bottom of the sea. She left her son behind. When he was grown he married his mother's younger sister, Tamayori-hime, who had been sent to raise him to manhood. She bore him four sons, the youngest of whom was Jimmu, who became the first emperor of Japan.

Artists liked to give Toyotama-hime the body of a mermaid, human to the waist and fish-like below. They show her borne on waves, in the act of leaving Hiko-hohodemi, while he, standing on the shore, gazes sadly after her. Some artists have depicted her as a dragon, or as a mostly woman creature but having some features of a dragon.

Toyotomi Hideyoshi (also known as *Taiko*) *warlord*

The son of a peasant from Owari Province, Toyotomi Hideyoshi (1536-98) spent his youth as apprentice to a series of masters in lowly professions, all of whom found this "monkey-faced servant" bright but troublesome. In his early twenties, he attached himself to Oda Nobunaga, the rising general who was "pacifying" the country for Emperor Ogimachi (r. 1558-86). The farmer's son, who began his service with Nobunaga as a personal attendant, soon won the leader's trust and a promotion to the rank of a samurai. He proved to be a masterful strategist and helped Nobunaga to subdue many rebellious *daimyo*. In 1562, having outgrown a whole series of commoners' names, the former peasant took one worthy of a general. He called himself Hideyoshi. In 1586 the emperor granted him the patricians' right to assume a family name, whereupon he chose Toyotomi.

In 1582 Oda Nobunaga was assassinated. Within thirteen days Hideyoshi avenged his murder and took his place as the emperor's champion. Three years later Ogimachi appointed him *kampaku*, or regent, equivalent in everything but name to shogun (that being a title reserved for members of the great Minamoto clan). By 1590 Hideyoshi had restored peace to Japan.

Hideyoshi demonstrated his abilities in other fields as well. He revived and administered an efficient centralized bureaucracy to manage the country. He required all *daimyo*, and their hostages, to live in the capital city, thereby reducing both their incomes and their opportunities to rebel in the provinces. A most crafty

statesman, he played religious factions against each other, whether Shinto, Buddhist, or newly-introduced Christian, always to the advantage of his government.

As the most powerful lord in Japan, and the richest (with an annual income estimated at three million bales of rice), he became a princely patron of the arts. In 1584, at Osaka, he began the largest castle-fortress ever constructed in Japan. In decorations and furnishings it surpassed anything ever seen before. In 1594 he commissioned the finest artisans and artists to raise a palace-castle near Fushimi, south of Kyoto. The castle of Momoyama was filled with such beautiful things that historians have borrowed its name to describe a whole new style and era in Japanese art.

He learned the art of the tea ceremony, and acted in Noh plays. (In 1594 he commissioned the writing of five plays in which he was the undoubted hero.) He encouraged agriculture, industry, domestic commerce, and foreign trade. Since he was peasant-born, near the bottom of the social structure, he favored the peaceful pursuits of farmers, merchants, and artisans, rather than the destructive excesses of samurai.

In 1590 Hideyoshi, unquestioned master of all things in Japan, pretended to withdraw from the duties of high office. After that he was known as *taiko,* or retired regent. Needless to say, he did not retire, but still managed the country. In 1592, to give restless samurai a safe outlet for their energies, and for the Japanese in general a larger realm to exploit, he undertook to conquer first Korea and then China. Contrary to his expectations, he did not capture Korea easily. The war dragged on for six years, at great cost in money and lives to both sides. In 1598, just as both adversaries were ready to sue for peace, Hideyoshi died. His generals called Japan's troops home to employ them in the inevitable war of succession.

Artists did not often portray Hideyoshi, possibly because his lean peasant's body and unhandsome face did not appeal to them. One very revealing incident in his career, however, appears in at least one print. In it, he is shown in full battle array from helm to heel, during his memorable visit to the shrine of Minamoto no Yoritomo in Kamakura. Yoritomo, the first *daimyo* to make himself shogun of all Japan, 300 years before Hideyoshi's time, had set him a worthy example.

A few other prints (not to be construed as portraits) show Hideyoshi with his seven principal retainers. He is depicted, more or less authentically, in two sets of six-fold screens painted while he was at the height of his power. One of these, "Cherry Blossom Viewing at Yoshino," shows him, borne in a palanquin and attended by a large retinue, while visiting the shrine of Zao Gongen in the Yoshino

mountains. The other set, "Cherry Blossom Viewing at Daigo," shows him, old and frail, but sumptuously dressed, followed by wives and concubines, guarded by samurai carrying European firearms and Japanese bows. The visit to Go-Daigo took place in March 1598, only a few months before Hideyoshi died.

The object associated with him that is most often depicted in art is his unusual battle standard, a cluster of gourds. Early in his service with Oda Nogunaga, just as he and his small army were about to attack an enemy fortress, Hideyoshi realized that he lacked an insignia for his warriors to follow. He snatched a gourd from a vine and impaled it on a spear. After that, with each successive victory, he added one more gourd to the cluster. Decorated with ribbons in good luck colors, they served as the peasant-general's battle flag throughout his campaigns. His crest, however, was not a common gourd. In granting Hideyoshi the privilege of taking a family name, the emperor also conferred on him the honor of using in his crest the leaves and flowers of the paulownia tree, an insignia of the royal family itself.

Toyo-uke-hime *Shinto goddess of foods and of the earth*
"Luxuriant Food Princess Deity" is one of the many children born to Izanagi and Izanami, the ancestor-couple. She gives humankind the fine foods that grow from her fertile body, the earth. Her younger brother, Susano-o, did not know Toyo-Uke-hime well enough to understand this fundamental fact when he met her and, being hungry, asked for something to eat. She brought forth rice and fish and game foods, all of which she offered to the youth. He, however, drew back in revulsion because he thought she gave him "filthy things." Exceedingly angry, he cut off her head, and stormed away. From Toyo-uke-hime's fallen body sprouted many other good things—such as beans, millet, fruits, herbs, and seeds bursting with oils—that Amaterasu, the sun goddess, presented to the human race for its sustenance. As she is such an important deity, Toyo-uke-hime is honored in many shrines. The principal one is in the Geku, or outer shrine, at Ise, not far from the Naiku, or inner shrine, which is Amaterasu's sanctum.

Toys *playthings*
Compared to the diversity of playthings they are given today, Japanese children of a hundred or more years ago had relatively few kinds of toys. In general, toys were enjoyed only by the offspring of wealthy families. Children of the poor went without toys, or played with things made by parents or siblings from pieces of wood, scraps of cloth or paper, and snippets of string.

Infants were given images of birds or animals, carved in wood, prettily painted, mounted on wheels; rattles, drums, and tinkling bells; and round-bottomed

Daruma dolls, or other kinds of dolls made of wood, clay, or papier-mâché. Boys received figures of legendary heroes, martial paragons, historical personages, and noted wrestlers (not to play with, but to display at the annual Boy's Day Festival on the fifth day of the fifth month); miniature weapons and pieces of armor (provided the boy belonged to the samurai class); kites in beautiful colors, fanciful shapes, in a whole range of sizes; pinwheels; miniature carts, wagons, or sleds; spinning tops of assorted sizes, shapes, and colors; stilts and hobby horses; balls made of hide, cloth, or paper; musical instruments; masks; playing cards; and games of skill, such as *go,* a Japanese board game.

Girls received dolls to play with, as well as more costly figurines to exhibit during the Girl's Day Festival on the third day of the third month; fans; trinkets for hair ornaments; sets for battledore and shuttlecock (or materials for making them); "flower cards" and "poem cards"; musical instruments; and games of skill their elders thought seemly for girls to know.

Everybody, from infants to elders, seems to have enjoyed masks of all sizes, materials, and features, representing phantoms, ghosts, demons, notable characters in Kabuki and Noh dramas or in morality plays and fairy tales, and even some of the Shinto deities of fertility. Articulated puppets made mostly of cardboard, with rolling eyes, long tongues, and movable limbs, also were popular.

Traveling by Shank's Mare (*Hizakurige dochu suzume*) *comic novel*

A literal translation of the Japanese title is "A Sparrow Traveling on a Chestnut-colored Knee." That "chestnut-colored knee" is the Japanese equivalent for the English expression "shank's mare." Jippensha Ikku (1765-1831), an Edo novelist, made fame and fortune with this picaresque novel. Humorous, vulgar, even coarse, but above all realistic—because it describes things, places, events, and people in this world, rather than in some impossible realm of fantasy—it presents the adventures of two commoners who fancy themselves sophisticated urbanites. Despite their high opinions of themselves, the two heroes—Yajirobei and Kitahachi—are not very bright. They are good-natured, most of the time, even generous some of the time, but also naive, as well as amoral, irresponsible, and calculating. In consequence, they blunder in and out of all sorts of complications, from the merely scatological through the fumbling erotic to the thoroughly terrifying. In doing so, they (and we) learn a great deal about Japan and its common people, who are shown to be natural and human to a degree that no novelist before Ikku ever achieved. His first installment of eight chapters, published in 1802, took Yajirobei and Kitahachi along the Tokaido, from Edo to Kyoto. After its resounding success, Ikku spent the next twenty years

producing sequels that took his irrepressible pair along many other highways into less familiar parts of Japan. The stories, adapted to Kabuki theatre, *ukiyo-e,* and other popular media, gave *Traveling by Shank's Mare* further exposure, until hardly a person in the country was unacquainted with Ikku's inventions.

Treasure Ship *(takarabune) seagoing vessel*

This is the ship that brought The Seven Gods of Good Fortune across the seas to Japan. Nowadays it is the vessel that will sail into your homeport on New Year's Eve, bringing not only the seven gods but also all the precious things that human beings may want. It is one of the favored motifs in popular art.

Many artists show the little vessel jammed to the gunwales with its cargo of beaming deities and all their attributes. Others prefer to ignore the gods and load the craft with the treasures they are supposed to bring. A restrained few, reminding us of the important things, present only the *tama,* the sacred jewel of purity, which recently has become a symbol of wealth rather than of the Buddha's teachings. Some heretical few put seven monkeys in the boat, or the twelve animals of the zodiac, or some other equally frivolous substitutes for the deities who are so important in granting happiness and good fortune.

Tsukiwaka Maru *fictitious hero*

Many prints and paintings have been made to illustrate the *Hori-monogatari* or *Tales of the Hori-e,* a popular novel. Tsukiwaka Maru's life of trial and testing begins while he is still a babe in arms. When his samurai father and mother are killed in a raid on their castle, his nurse flees with him to the mountains. There they meet a powerful *daimyo,* eager for a son and heir. He adopts the boy and raises him as his own son.

Tsukiwaka's old nurse does not fail in her duty to his true parents. As he approaches manhood she often reminds him how they are waiting to be avenged. With the blessing of his adoptive father, he gathers a small troop of warriors, leads them against the castle-fortress of the villain, and destroys him, thereby granting peace to the spirits of his parents.

Tsurezuregusa *collection of essays*

Kenko-hoshi (1283-1350), a Buddhist priest, wrote *Tsurezuregusa (Gleanings of Leisure Moments)* around 1330, during a time when, once again, civil war threatened the country. The collection consists of 244 sections or "chapters," each presenting a short anecdote, aphorism, homily, or reflection, and is regarded as a classic in literature for both the quality of Kenko's writing and for his wisdom. Kenko studied not only Buddhism, but also the principles of Shinto, Daoism, and Confucianism; and his awareness of these philosophies, complemented by an aristocrat's taste

and a familiarity with Japanese and Chinese literature, prepared him to create this esteemed work.

Almost every section of *Tsurezuregusa* presents themes for artists. For example, Chapter 53, "The Priest and the Three-legged Pot," is the original account of Sukamamo, the man who put an iron brazier over his head while he danced, and then could not take it off. Chapter 19, concerned with the changes of the season, paints word pictures of landscapes that many artists have endeavored to reproduce.

Tsuta *"Japanese ivy"*

A clinging vine similar in appearance to ivy, the *tsuta* is a popular motif in art and family crests. Its leaves also resemble those of the grape, certain species of maple, and especially those of the *kiri, Paulownia-imperialis*. The latter can be differentiated by the number of major lobes the leaves display—the *tsuta* has five lobes, the *kiri* has only three. Moreover, the *tsuta* bears no flowers, while the *kiri* is noted for its spectacular blossoms.

The *tsuta*, evergreen and hardy, impressed aristocrats of Heian times. They wrote poems about it, and from it developed designs for decorating clothes and furniture. During the Muromachi Period (1392-1573) Igarashi Shinsai, notable for his creations in lacquerware with inlays in raised gold, made a handsome writing desk and a matching inkstone box using the design called "*tsuta no hosomichi*," or "ivy lane," after a story told in *Ise monogatari* (*Tales from Ise*).

Twelve Celestial Generals (*juni shinsho*) Buddhist guardian deities

Buddhists took these protective divinities from the Hindu pantheon and assigned them to guarding Yakushi-nyorai, the Healing Buddha. Each celestial general faced one of the twelve directions, preserving Yakushi against evils emanating from that region. These twelve godly generals must not be confused with The Twelve Heavenly Kings, the *juni-o*. The godly generals may be identified by two clues: the proper name of each ends in -*ra* and each bears the title *taisho*. Their names, in alphabetical order, are: Annira, Antera, Basara, Bikara, Haira, Indara, Kubira, Makora, Mekira, Santera, Shatora, and Shindara. The correct address of the first, for example, is Annira Taisho.

Heroic painted clay images of all twelve generals, made around 748, still stand in a protective ring around the Healing Buddha in the main hall of the Shin Yakushi Temple at Nara. Many other representations of the twelve have been made, both in sculpture and in pictures. Gradually, during the course of centuries, artists began to decorate the helmet or head of each general with the animal of the zodiac that was associated with the direction he governed. In 748, however, this linking had not

yet been made, and no animal emblems help to identify the twelve celestial generals assigned to duty in Shin Yakushi Temple.

Twelve Heavenly Kings (also known as Twelve *Deva* Kings; *juni-o juni-ten*)

These lesser Buddhist deities are descended from earlier Vedic and Brahmanic divinities who were responsible for guarding Heaven, Earth, Sun, Moon, and the eight directions—or, in other words, the universe. Numerous representations and adaptations of them can be found in Japan. They are usually portrayed as individuals, but groupings of three, six, or all twelve also exist. In pictures each may stand on either a low pedestal or a lotus leaf, and a simple halo may appear behind the head. In sculpture, such as the painted clay images at Todai Temple in Nara, these adjuncts are missing and other symbols, such as swords, tridents, and *stupa* are introduced.

Japanese artists, so far from the Indian source, seem to have altered the physical aspects of these deities to please their imaginations. Several of the *deva* kings are so androgynous that one cannot be sure whether they are meant to be masculine or feminine presences. As is the case with all Buddhist deities, the number of arms an image is given, the positions of its hands, and the articles they hold will help to distinguish one *deva* king from his companions. The descriptions given here, however, are not applicable to all images of these divinities:

Bishamon-ten (also known as Tamon-ten)—He is the guardian of the north, and his Sanskrit name is Vaisravana. To the Japanese he is also a god of prosperity and wealth. As such, he is included among the *shichifukujin* or The Seven Gods of Good Fortune, and also as one of the *shiten-o* or The Four Heavenly Kings. Japanese artists, therefore, depict him in a variety of ways, according to the group with which he is being associated. In his position as a *deva* king he may be presented as a bearded male, holding a warrior's helmet but not wearing armor (or, conversely, wearing armor but not holding the helmet). In this second style, he holds in one hand a scepter (or a lance, sword, or three-pronged halberd), and in the other a small *stupa* or pagoda, the most reliable attribute for identifying him.

Bon-ten—Bon-ten, known in India as Brahma, the creator of the universe, represents the zenith. Here, too, the feminizing tendency may make him a womanish figure standing on a lotus leaf. He has three heads of normal size, each with three eyes; atop this cluster a fourth and smaller head is placed, which has only two eyes. Four arms emerge from the body. His upper right hand holds a trident, his lower right arm hangs toward earth, with hand open and palm forward, in the *varada mudra* of charity. His upper left hand holds a lotus blossom, the lower left a vase.

In other versions, however, Bon-ten is a thoroughly feminine deity, full of

serenity and grace. She has only two arms, and her hands are joined in prayer. Bon-ten is frequently a member of a trinity with Kannon-bosatsu and Taishaku-ten, and can also be found in the sextet known in Japan as the *rokubuten,* or six gods of war.

Emma-ten—Also known as Emma-o, he is the *deva* of hell and of the earth, and the king of the ten judges who determine the fate of each spirit that appears before them in the Buddhist netherworld. In the Brahmanic religion, he is the deity (called Yama) who conducted the spirits of the blessed dead to paradise. As such, he is shown seated on a white ox, holding in his left hand a scepter topped by an image of a human head. Some Japanese pictures depict him in that earlier guise, as a gentle adolescent, almost feminine, with three eyes, the third being the eye of wisdom. His left hand holds a scepter terminating in the image of a bodhisattva, his right hand, palm upward in a shoulder-high gesture, makes an uncommon *mudra.* This early version of a helpful escort for disembodied spirits has been replaced almost completely in Japanese imagination and art by the ferocious and violent tyrant of hell, who wears a crown emblazoned with the ideogram for king and who punishes the spirits of the dead.

Futen (also known as Fujin)—In Brahman lore, Vasu Deva was deity of the winds, guardian of the northwest, and messenger of the gods. He was depicted as a bare-headed old man dressed in flowing robes, holding his bag of winds under his right arm and in his left hand a staff from which a banner flutters. Japanese artists, however, made of their wind god a much fiercer and fearsome thing.

Ga-ten—To Brahmans, Soma Deva was the god of the moon and guardian of the northeast. Japanese artists, predictably, have transformed him into a goddess. In her right hand she holds a silvery disk representing the moon. Her left hand is lifted in the *abhaya mudra* of reassurance. Sometimes a rabbit or a hare (symbol of the immortal hare who lives on the moon) replaces the disk. In other pictures, the hare may be playing at her feet or embracing her knees, or may be reduced to an ornamental design on her robes, along with crescent moons and other symbols of Ga-ten's role.

Ishana-ten—Sometimes male in appearance, at other times a female, Ishana is always furious of face and wild of eye. He is India's Siva, the god of destruction and of regeneration. He has three eyes, the third being the eye of wisdom. He carries a trident in his right hand, a basinful of clotted blood in his left. His skin is green.

Ji-ten—The only truly female *deva* in origin, she is India's Prithivi, the goddess of earth, and represents the nadir, Bon-ten's opposite. In her right hand she carries a bowl filled with heads of grains and clusters of fruits, representing the produce of earth; while

her left hand, held upward before the breast, makes the *abahya mudra*. Sometimes she holds a basketful of peonies, rather than the bowl of fruits and grains.

Ka-ten—The god of fire and of the southeast, Ka-ten is represented as a bearded old man wearing a tiger skin around his hips and, in keeping with his duty, is enveloped in an aureole of flames. In older images he has four arms.

Ni-ten—In Japan, the masculine Brahmanic god of the sun and of the southwest, Suriya Deva, has become Ni-ten, a female deity resembling the native sun goddess, Amaterasu. In her left hand she holds the long stem of a lotus blossom, while with her right hand she supports the heavy corolla, on top of which rests a solar disk (or, on occasion, a transparent ball). Sometimes the disk bears a picture of a three-legged crow, itself an ancient adjunct of the sun.

Raisetsu-ten—A bearded old man with bushy hair, he is the king of the furies, known in India as Nacriti. His right hand holds a long sword pointed upward; his left lies against the shoulder, making a *mudra* with thumb and forefinger.

Sui-ten—The guardian deity of water and the west, Sui-ten probably represents a fusion of a native Shinto deity with Varuna, the Brahmanic water god. Japanese artists have portrayed him as an epicene adolescent, holding in his right hand a sword with a *vajra,* or "thunderbolt," for a hilt, and in his left hand a cobra with an inflated hood. He wears five or more serpents as either hair or a headdress. Like Varuna, he may be standing on the back of a huge tortoise, or seated on either a tortoise or a sea monster resembling a crocodile.

Taishaku-ten—He is Indra, the guardian of the east, and the regent of all the *deva* kings, who lives in a palace atop Mount Sumeru. He stands on a lotus leaf, and has three eyes and two arms. His left hand holds a covered basin, his right a *vajra,* or "thunderbolt," terminating in a single point. Some artists give Taishaku-ten a feminine appearance. A heroic image of him, carved in the year 839 and now at To Temple in Kyoto, shows him sitting on the back of an elephant.

Twenty-eight Servitors of Kannon (*nijuhachi-butsu*) *minor Buddhist deities*

This group of lesser deities is believed to refer to 28 important constellations known to Chinese and Japanese astronomers. The 28 *butsu,* or Buddhas, are represented in Japanese art in different ways: either personified as ordinary mortals, as bodhisattva, or as disembodied symbols connoting force and power. Statues of the whole group of 28, in carved polychromed wood, attend the image of Kannon of the Thousand Hands in the Sanjusangendo at Kyoto.

Twenty-four Paragons of Filial Piety *role models*

The Japanese adopted in its entirety the group of 24 men, women, and children

extolled by the Chinese as models of concern for their parents. The stories about these paragons are intended as devices for implanting in young minds the respect for parents that is the fundamental commandment in Japanese society. Only the Japanese names of the Chinese paragons are given in the following summary accounts. The paragons are:

Binson—(also known as Shiken). His cruel stepmother mistreated Binson so relentlessly that the unfortunate boy scarcely had strength to do the chores assigned to him on the family farm. When Binson's father finally realized his son's plight, he decided to divorce the cruel woman. Binson, knowing that his father loved her, as well as being concerned also for the welfare of her two sons, declared that he preferred to die rather than be the cause of the family's breaking up. Happily for all, Binson's goodness led his stepmother to change her ways.

Choko and Chorei—These two devoted sons took good care of their aged mother. One day, as Choko carried a cabbage to her house, a band of robbers captured him. They were about to kill him, but he begged to be allowed to deliver the cabbage first. At this, Chorei emerged from the wayside bushes, offering his life in exchange for Choko's. The robbers were so impressed by this proof of brotherly love combined with filial piety that they set both men free.

Chuyu—Perhaps because the Thunder God was his real father, Chuyu possessed a strong body and a martial spirit. Even so, he was a respectful son to his mother and earthly father. He carried huge blocks of ice on his back, from the lake to the house, for his parents to use as they needed. Despite such feats of strength, Chuyu was also a scholarly man, and became a disciple of Confucius.

Enshi—His mother suffered from a disease of the eyes, for which doe's milk was the only treatment. One day, in order to obtain some of this medicine, Enshi wrapped himself in the skin of a stag, and tried to approach a doe grazing in a mountain meadow. Some hunters almost shot Enshi, thinking he was a real stag, before he called out to them. Then they wanted to beat him for having fooled them. But when they heard the reason for his disguise, they bowed low in respect for this fine son.

Gomo—When he was only eight years old, Gomo's sole concern was the well-being of his parents. He allowed swarms of mosquitoes to bite him at night, without chasing them off, because then he could be sure that they were not attacking his mother and father. This virtuous lad grew up to be a renowned Daoist wizard. He killed a giant white snake. He could transport himself through the air merely by waving a fan, or by riding in a chariot drawn by two stags.

Kakkyo—Reduced to desperation by poverty, Kakkyo preferred to bury his own little

son alive rather than deprive his aged mother of the few morsels of food the child would have eaten. The gods rewarded him for his filial piety. In the hole he dug to be the boy's grave, Kakkyo found a pot of gold. On the pot was written: "Heaven's gift to Kakkyo. Let no one take it from him."

Kan no Buntei—Even though he was the third son of Emperor Gaozu, founder of China's Han dynasty, and himself became emperor in 179 BCE, Buntei is renowned for his devotion to his mother, a concubine in the imperial palace. For the three years of her last illness, Buntei waited on her constantly, taking little care of himself, not even changing his clothes. Moreover, to prevent enemies from poisoning her, he tasted all medicines the physicians administered to her.

Koko—When he was seven years old, Koko's mother died. The boy resolved to give his surviving parent every fond attention. He cooled his perspiring father by fanning him during hot summer nights; and on cold winter nights he lay first in his father's bed in order to warm it.

Koteiken (also known as Sankoku)—Although Koteiken was a celebrated poet and a government official of high rank, he honored his mother by performing the most menial services, such as emptying and washing her chamber pot.

Kyoshi and Choshi—Both Kyoshi and his wife Choshi delighted in taking good care of his mother, and prayed to the gods to allow them to serve her for many years. Since the old lady liked to drink the sweet water from a certain lake, and to eat raw carp from a distant pond, Kyoshi and Choshi walked for many hours each day to provide her with those delicacies. The approving gods eased their labors by causing a spring to flow from the earth in Kyoshi's own garden. Every day, in the pond made by that spring, two fat carp appeared, eager to be caught.

Moso (also known as Kobu)—In the coldest time of winter, Moso's mother had a craving to eat some fresh bamboo shoots. Despite his misgivings, Moso trudged through deep snow to the bamboo grove to see if he might find a shoot left over from last season's growth. When he cleared away the snow he discovered, to his great joy, many bamboo shoots, finer than any he had ever seen.

Osho (also known as Kyusho)—In the middle of winter, Osho's stepmother yearned to eat raw fish. Dutiful Osho went to the family's frozen pond, lay on the ice until the heat of his body melted it, and caught two nice carp for his stepmother.

Osui (also known as Igen)—Although his mother was dead, Osui continued to comfort her spirit during thunderstorms because in life she had been so afraid of them. While winds raged, lightning flashed, thunder rumbled, he would stand by her grave saying "Fear not, mother. Your son is near."

Rikuzoku (also known as Chisho)—A rich neighbor gave Rikuzoku some fresh oranges to eat. Even though he was only six years old, the boy thought first of his mother. He put those treasures into his gown and carried them home to her.

Roraishi—In order to spare his parents the feeling that they were growing old, Roraishi pretended to be a child even after he had reached his seventieth year. He dressed in bright clothes and played with children's toys. To amuse his mother and father, he did childish things.

Saijun—Early one morning, as Saijun picked mulberries, a band of rebels captured him. When they asked him why he bothered to gather such birds' food, he explained that he picked them for his mother because he could offer her little else to eat. The rebels, praising his virtue, gave him the leg of an ox to take home.

Saishi—(also know as Kaku Sannan). One of the few females to be honored as a paragon of filial piety, Saishi had a great-grandmother so old that, being toothless, she could not eat solid food. For many years Saishi fed the venerable ancestor with milk from her own breasts.

Shujusho—Parted from his mother when he was seven years old, Shujusho longed to be united with her. Even when he became a minister to the emperor, he yearned to see her. At last he abandoned position and honors to go in search of her. After wandering for many years, he found his mother. By that time she was 75 years old.

Sosan—He is doubly distinguished, being both a paragon of filial piety and one of The Four Assessors of Confucius. He is believed to have been coauthor of *Great Learning,* a classic in Confucian literature. As a model son, he was very sensitive to his mother's dependence on him. One day, while gathering firewood in the forest, he felt a sharp pain in a finger, and understood immediately that his mother needed him. On returning home, he learned that she had bitten her finger in vexation because he was not nearby when she called him.

Taishun—The son of a querulous blind man, Taishun was afflicted with a cruel stepmother and a selfish half-brother. Taishun never complained and did his duties with filial respect. When his father ordered him to cultivate the family's lands in a distant mountain country, Taishun went without murmur. The gods took pity on so good a son, and sent an elephant to draw his plow. Emperor Yao heard of Taishun's exemplary piety and gave him one of his imperial daughters as a wife. When Yao died, the esteemed Taishun succeeded him as emperor.

Teiran—Even after his parents died, Teiran continued to honor them. He carved wooden images of them and offered respect to these each day. His wife scoffed at such foolishness. When Teiran left home on an errand, she jabbed a hairpin into

the finger of one of those statues. Blood seeped from the wound and, try as she might, she could not stop the flow. With such proof of her impiety, Teiran divorced the woman and the villagers despised her forever after. On another occasion in Teiran's absence, a neighbor said something insulting to the images. When Teiran came home he saw at once that his parents looked displeased. The servants told him the reason for their change of face. Teiran rushed out and beat the offensive neighbor with a bamboo pole. After that, the images of his parents again wore their benevolent countenances.

Toyei—Although he was a poor man, Toyei wanted to honor his dead father with a fine funeral. In exchange for the money needed to pay for the expensive ceremonies, Toyei sold himself into bondage to a weaver. The terms of the contract required him to weave 300 lengths of silk cloth before his debt was repaid. Ordinarily that task would have cost him several years of labor, but the attentive gods rescued him with remarkable speed. They sent him, in the guise of a helpful wife, none other than the Heavenly Weaver Maid. In the course of a single month she wove the 300 lengths of silk. Happy Toyei delivered them to the weaver who held his bond, but his skillful wife disappeared forever.

Yoko—Fourteen-year-old Yoko and her father were traveling along a mountain trail when suddenly they met a tiger. As the beast leaped, Yoko stepped in front of her father. The tiger killed her, but her father escaped alive.

Yukinro—One day Yukinro, the governor of a province, felt a sudden pain in his heart. Believing that this was a call for help from his father, who lived in another province, Yukinro hurried to his ancestral home. There the attending physician told him that his father was very ill, and that he alone could determine whether heaven intended that his parent would live or die. The test to be performed was simple: he must taste his father's excrement. If it proved to be sweet, his father was doomed; if bitter, he might live. Without hesitation Yukinro did the test—and found the taste sweet. He prayed the whole night through, begging heaven that he might die in his father's place.

Ubaga sake *a comic dance (kyogen)*

In the Noh theatre, a *kyogen* affords comic relief after the solemnity of the usual moralizing play. *Ubaga sake* or *The Wet-nurse's Sake,* is a popular *kyogen,* which tells the story of a young man who visits his old foster mother only when he wants something from her. On this occasion, he arrives craving a taste of the new batch of sake she is brewing. To his surprise (for she has been generous in the past), she refuses to give him so much as a drop. He goes away, only to return in a few minutes disguised as a demon, and threatens to kill the old woman unless she gives him all the sake he wants. She yields to his demands. He drinks too much of the potent stuff, and is soon babbling drunkenly. The nurse recognizes her good-for-nothing foster-child under the mask and beats him with her fists until he staggers off.

Artists have used several incidents from this *kyogen.* Some have summarized it in a single dramatic moment—the false demon, his mask slipping, fallen to the ground, while the old woman, her fists clenched, glares down at him in disgust.

Ubume-dori *bird of fable*

This monster had ten heads on a single body until a dog bit off one of them. Since then, blood has flowed without ceasing from that ugly stump. If so much as a drop of that blood should fall on a house, the people who live in it will be visited by some terrible misfortune, such as fire, sickness, or death. Ubume-dori also devours

children whenever it can get at them. The only possible protection against such a fiend is a barking dog, or a person who can bark like a dog in moments of peril. Some mothers painted the ideogram for dog on a child's forehead to protect him or her against sorcerers and kidnappers as well as Ubume-dori.

Ueno Park

This great public park lies in what used to be the northern part of Edo and is now near the heart of metropolitan Tokyo. In the Tokugawa Period (1615-1868), it was renowned for its avenues of cherry trees, great temples, pagodas, the tombs of several Tokugawa shoguns, and throngs of visitors. Artists made innumerable *ukiyo-e* (woodblock prints) showing scenes at Ueno: people promenading, visiting temples, eating and drinking, and dancing under the cherry blossoms or autumn foliage, or viewing the full moon shining on Shinobazu Pond.

Ujigami *personal guardian deity*

In addition to Shinto and Buddhist gods worshipped by the nation, each Japanese family honors a more private and personal deity, its *ujigami*. He (or sometimes, she) may be the actual founder of the family line, or an ancestor, who has been deified because of exceptional abilities or deeds demonstrated during life in this world. For example, the Minamoto clan considered Hachiman, the god of war, to be their *ujigami*.

Ukiyo-e *popular pictures*

"Ukiyo" means "floating world," "e" means "picture." *Ukiyo-e*, then, are pictures, especially notable in the form of woodblock prints, that show the people, activities, and surroundings of ordinary folk in this material world. They are "vulgar" and "realistic," to be sure, inasmuch as they portray commoners in commonplace situations. For those very reasons they can also be full of life and movement and beauty. They are expressions in art created by commoners that were intended for the enjoyment of other lively commoners, not for cloistered priests or etiolated aristocrats. Yet, often enough, superimposed upon this rather reportorial aspect of illustration is the touch of melancholy that all Japanese learn from the Buddhist philosophy of evanescence and death. By intent, and by definition, *ukiyo-e* are reminders of the sadness of all things in this ephemeral floating world.

Toward the end of the sixteenth century a number of artists turned away from the techniques and motifs endorsed by conservative older schools, and found more exciting ones in "the floating world" about them. Before their time a few painters had dared, on occasion, to introduce incidents from the vulgar life into picture scrolls, screens, and other forms of *yamato-e,* or pictures in the Japanese style. After the early 1600s, as commoners themselves took an increasing interest in the works

of artists; and as designers, engravers, and printers developed improvements in the techniques of making block prints, many artists came down to earth, so to speak, to find endless inspiration and innumerable motifs in ordinary people, places, and things. The works they created—in prints above all, but also in paintings, picture books, sculptures, furniture and furnishings, ornaments, household utensils, netsuke (miniature sculptures in wood, ivory, and other materials), even textiles, games, and toys—literally brought art to the masses, whether or not they understood it, and changed the economics as well as the aesthetics of art in Japan.

Umbrella *protector against sun and rain*

The sovereign of Kudara, a kingdom in Korea, sent a number of gifts to Emperor Kimmei of Japan (r. 539-71), among them several elegant umbrellas. After that introduction, the umbrella of state became an insignia of high rank for use on important occasions. Made of silk, it was borne above the head of an emperor, a great prelate, or a *daimyo*. It escaped from ceremonial use into the hands of practical commoners around the end of the fifteenth century.

Townsfolk made their umbrellas of oiled paper stretched over a framework of bamboo. Within a hundred years these sturdy and inexpensive devices became a common item in the Japanese scene. Merchants wrote on them the names and addresses of their establishments, and on rainy days gave or loaned them to favored customers, thereby gaining pleased patrons and mobile advertising. Prostitutes and geisha did the same, as Hiroshige showed in a triptych devoted to troops of geisha visiting temples on the island of Enoshima. Villains and heroes—such as Sadakuro of the Forty-seven Faithful *Ronin* of Ako—hid their identities just as well under umbrellas as under basketlike hats woven of straw. Temple guards always carried tattered old umbrellas, at least in art. Desperate women, forcing an answer from the gods or a change of heart in lovers, opened their umbrellas and leaped from the balcony of cliff-hung Kiyomizu Temple in Kyoto. If the umbrella acted as a parachute, the omens were favorable. If not, death settled all their problems. Gossips, eager to tell the whole world what lovers were trying to hide, devised a revealing graffito—the bare outline of an opened umbrella and, sheltered under its arc, the names of the lovers. Anyone who could read would know at once that those two were living together as man and wife—or at least sleeping together—without parental knowledge or consent.

Umegae *courtesan*

Kajiwara Genda Kagesue spent so much money on the famous courtesan Umegae of Osaka that he had to pawn his suit of armor. This happened at the time when

Minamoto no Yoshitsune called Kagesue to duty in the last stages of the war against the Taira. Umegae wanted to help her impoverished lover. First she thought to go to the temple on Mount Mugen because she had heard that the god there sent money to honest petitioners who prayed for worthy causes. Then, realizing that Mugen was too far away for a girl like herself ever to reach, she decided to stay at home and say her prayers. She did so, banging on a bronze washbowl for want of a bell, calling on the god of hell for aid.

She made such a racket that everybody in the house could hear what she prayed for. Someone in the room above tossed several gold coins onto the mats where she knelt. Umegae, believing that the god of hell had answered her, promptly ceased to importune him. With this heaven-sent gift, she redeemed Kagesue's armor from the pawnbroker. Touched by her devotion, Kagesue wore a plum blossom painted on his armor, in memory of Umegae, or Plum Scent House.

Umetsu Chubei *fictitious warrior*

While Chubei was guarding the gate of his lord's castle one night, a woman asked him to hold her baby for a few minutes. Chubei agreed to do so. The woman went away. The baby became so heavy that Chubei could scarcely hold it. Thinking that he was being assailed by demons, he said "*Namu Amida Butsu*" three times. The infant vanished. And Chubei sighed with gratitude at being saved by Amida's intervention.

To his great surprise, the woman returned and thanked him for his help. It turned out that she was the deified spirit of a member of the earliest family to settle there. She told Chubei that a kinswoman from the village below the castle had sought her help because "the gates of birth would not open" for her child. Chubei's invocation to the Buddha had brought the savior to her aid, and on the third pronouncement of the holy name the child had slipped through the gates into this world.

Umewaka Maru *kidnapped boy*

Umewaka Maru was the son of Yoshida no Korefusa, a general who served Emperor Murakami (r. 947-67). The boy was five years old when his father died, and seven when his mother sent him to a temple school on Mount Hiei, near Kyoto. At the age of twelve he ran away from the temple because its priests mistreated him. Not knowing the road home to Kyoto, he wandered toward Lake Biwa. In the town of Otsu a slave-merchant seized him, and put him among the children he was taking for sale in the eastern provinces.

By the time they reached the Sumida River, at the northern bound of Edo, Umewaka was near death from sickness and exhaustion. The slave dealer abandoned

him at Azuma. Kind villagers took care of him, but they could not save his life. He told them his name, home, and age before he died. Chuen, a wandering priest, said the funeral prayers for Umewaka Maru, and planted a weeping willow tree on his grave.

Exactly one year later, on the anniversary of his death, Umewaka's mother arrived in Azuma, still looking for her son. She noticed the villagers gathered around a lonely grave, where a priest chanted *sutras* for the repose of a spirit. They told her whose body lay beneath the willow tree. Thus did she learn that her search had come to an end. Marveling at the karma that had brought mother and son together at last, the people of Azuma built a small temple beside the grave, naming it after Umewaka.

Unai *moral tale*

This story about a maiden who could not make up her mind dates from the tenth century. Unai lived near the Ikuta River in Settsu Province. Two eligible young men wanted to marry her, but she could not choose between them. Her father, impatient with such indecision, thought of a way for the gods to settle the matter. The two suitors would shoot at a duck swimming on the river, and the better marksman would win Unai. The men agreed, both shot their arrows at the same moment and both hit the mark, one in the head, the other in the tail. Unai, seeing how even the gods in heaven withheld their assistance, threw herself into the river. The two suitors dove in to rescue her. One took hold of her head, the other her feet. In their struggling, all three were drowned.

Unkei *priest-sculptor*

Of the several generations of fine sculptors produced by his family, Unkei (a son of the first carver in their line) was the greatest. Moreover, many critics have considered him to be the greatest sculptor in Japan's history. He began his career in Nara, where he was born, and soon after Minamoto no Yoritomo established the shogunate at Kamakura, he moved to the new center of activity. Still later, Unkei returned to central Honshu, working in both Nara and Kyoto. He and his school of assistants carved many images of *rakan*, lesser Buddhist deities, bodhisattva, and Shaka. The gigantic statues of the *nio,* or two benevolent kings, that he and Kaikei made in 1203 for the South Gate of Todai Temple in Nara, are the largest *nio* in Japan.

Legend-makers tell of how even Emma-o, King of Hell, so admired Unkei's work that, after he died, he was restored to life, with instructions to carve a true image of the lord of the nether world. Unkei completed the commission with his usual speed and skill; and, before he died again, had time to carve another statue as well, this one of Shozuka-baba. (She is the old hag of hell, who torments the spirits

of the dead, especially of children, before allowing them to cross the River of Sai.) Both those sculptures can be seen at Enno Temple in Kamakura.

A painted wood image of the aged sculptor, sitting cross-legged while telling the beads of his rosary, is supposed to have been carved by Unkei himself only a few years before he died. It is preserved in Rokuhara-mitsu Temple in Kyoto.

Urabe no Suetake (also known as *Yukinojo Suetake*) *warrior*

As one of the four principal retainers of Minamoto no Yorimitsu, Suetake took part in many exciting expeditions. The strangest adventure of all befell him one evening as, all alone, he walked homeward on a shadowed path. The insubstantial spirit of a woman stopped him, put a weightless bundle into his hands, and vanished. In that instant the bundle became so heavy that Suetake almost dropped it. Hurriedly unwrapping it, he found within its folds a fine newborn boy. Suetake took the infant home and raised him as his own son. The *yamauba,* or mountain witch, assured that she had placed the baby in the hands of a good man who would take care of him, was never seen again.

Urashima Taro *hero of a fairy tale*

Urashima Taro, a young fisherman, freed a tortoise he had caught in his net. The tortoise turned out to be Ryujin, the Dragon King, who is also a god of the sea. (Some versions say that the tortoise was Ryujin's beautiful daughter, Princess Oto.) The grateful tortoise took Urashima Taro on its back to the Dragon King's palace at the bottom of the sea. There, he married Princess Oto.

The two lived happily for a time. One day, after perhaps two or three years had passed, Urashima Taro realized that he was homesick. Despite his wife's pleas, he insisted on going home for a visit. She gave him a magical casket, warning him that he must never open it if he wanted to return to her. Promising faithfully to obey her instructions, he went off. Some people say that a tortoise brought him home, others that he rode astride a great fish.

When he reached home he discovered that 300 years had passed since he left it. Bewildered by this terrible truth, he forgot the promise he had made to Princess Oto. He opened the casket. From it rose a little puff of spirit. In that instant his body's immense age caused it to fail him, and he fell dead on the graves of his ancestors.

A later and more sentimental ending to the tale ignores the moral by transforming him into a crane, which flies off to Mount Horai to meet his wife in her guise as a tortoise. Both crane and tortoise are emblems of longevity; and Mount Horai, one of the isles of the blest, is a paradise offering eternal life.

Urashima Taro and other characters in his fable appear frequently in art. He is

shown going to Ryujin's underwater realm sitting on a tortoise, and often holding a rod and line. When he is shown clutching a casket, he is returning to his homeland. For this voyage transportation may be provided by the cooperative tortoise, or by a huge fish, usually a bream of the kind Japanese call *tai*. His reception by the Dragon King, his marriage to Oto-hime, their life in that enchanting undersea abode, are other favorite themes.

The whole fairy palace allows the fullest freedom for artists' imaginations. The messengers and servants of Ryujin are as varied as the creatures of the deep. Dragons, sea horses, octopuses and squids, jellyfish, oysters, clams, crabs, shrimps, lobsters, eels, fishes, corals, and seaweeds are all put into service, colorfully, if not realistically. A marvel of carving has produced at least one netsuke (miniature sculptures in wood, ivory, and other materials) in which the entire palace has been enclosed within a clamshell. In paintings it has been shown materializing from the breath of a clam.

Usui no Sadamitsu *warrior*

Sadamitsu's mother died when he was an infant. His father, a barrelmaker, tied the child to a heavy millstone, in order to keep him from wandering into danger. By the time he was two years old, the boy could drag that stone around as if it was merely an air-filled gourd. Watanabe no Tsuna, the first of Minamoto no Yorimitsu's four principal retainers, reported Sadamitsu's strength to his lord. Yorimitsu brought the boy into his own household for training. Sadamitsu grew up to be a stalwart youth, who became the fourth of Yorimitsu's famous *shiten*. He helped his master destroy the evil Tsuchigumo, the Earth Spider. For this reason, artists usually show him holding a flaring torch as they explore the spider's dark lair.

Uta-e *calligraphic decoration*

Uta-e means poem-picture or, better, a picture to illustrate a poem. With characteristic Japanese restraint, all 31 syllables of the kind of poem called *uta* are not presented along with the picture. Instead, related bits of the poem's text—chosen for their decorative qualities as well as their literal meaning—are "strewn" throughout the background of the picture. From these fragmentary allusions the person studying the illustration is supposed to recognize the poem. Whether he does or not, the graceful calligraphy is an integral part of the picture's design. Apparently priests in Kyoto popularized this use of writing as decoration during the eleventh and twelfth centuries.

The characters that are incorporated in a design may be written in any of the several styles of calligraphy with which literate Japanese are familiar. Some styles require a hand so swift that the characters are so cursive and flowing as to be all but

unreadable, although they may be beautiful components in the whole design. Thus, in the style known as *ashi-de,* or reed hand, the brush strokes that form the ideograms are inscribed in such a manner that they are rounded and slanted. In the *mizu-de* style or water hand, the brush strokes suggest the sinuous lines of swift-flowing water.

Vajra (*kongosho*) *symbolic thunderbolt*

For Buddhists, the *vajra*, or "thunderbolt," is the emblem of the great spiritual power that must be employed by the forces of good against the forces of evil. Accordingly, Buddhist artists put the *vajra* into the hands of many guardian deities. The most notable of the lesser deities is Vajradhara, the Thunder-hurler, whom Japanese call Shikkongoshin. And great prelates, especially those of the Shingon sect of Esoteric Buddhism, carried a *vajra*, as a kind of scepter, in token of their temporal as well as spiritual power.

In its simplest form, the *vajra* is spindle-shaped, more or less tapering to a point at both ends, usually carved and ornamented along its shaft. Later and more elaborate versions come with two to five curved, barbed, and clawlike prongs at one or both ends. Some had a bell at one end and prongs at the other. The renowned priest Kukai (774-835), who introduced Esoteric Buddhism to Japan, employed such a *vajra* during temple rites. He tinkled the bell to remind the people to focus their minds on the Buddha.

Vulture Peak (*Ryozen or Ryoju-sen*) *Buddhist motif*

Atop Mount Ryoju, Shaka preached the sermon that became the foundation of the Lotus Sutra. Shaka on the mount, accompanied by numerous disciples, bodhisattva, and guardian deities, served as an important theme in early Buddhist art in Japan.

The oldest known version is painted on the back panel of the Tamamushi Shrine at Horyu Temple. Representations of the mountain usually give it three pinnacles, each surmounted by a pagoda sheltering a Buddha. These several trinities probably symbolize the three basic approaches to teaching the precepts that Shaka set forth in the Lotus Sutra: theory, parables, and stories about the lives of previous Buddhas.

Wada no Yoshimori *warrior*

A member of a rural branch of the great Taira family, Yoshimori (1147-1213) took the name Wada from the village where he lived. Despite his lineage, he assisted the Minamoto in destroying the Taira in the ferocious Genpei War that ended in 1185. He is especially celebrated for his part in the campaign against Kiso Yoshinaka in 1184. At the second battle of Uji River in that year, where Yoshinaka met defeat and death, Yoshimori captured Yoshinaka's wife, the formidable Tomoe Gozen. On foot, armed only with a stout cudgel of fir wood, he attacked her while she was mounted on horseback. She seized his staff in one hand and snapped it in two. Even so, Yoshimori dragged her to the ground and claimed her as his prize. He kept her as a concubine, and, it is said, she eventually bore him a son, the famed Asahina Saburo (also known as Yoshihide).

Years later, in 1213, two of Yoshimori's sons and a nephew joined in a revolt against the repressive Hojo family (who ruled the whole nation through their nephew, the ineffectual Shogun Minamoto no Sanetomo). Yoshimori hurried to Kamakura to ask Sanetomo to pardon his rebellious kinsmen. Sanetomo granted pardon to Yoshimori's sons, but not to his nephew. Yoshimori, believing that Hojo Yoshitoki was responsible for this decision, gathered an army and attacked the shogun's palace where Yoshitoki had fled for refuge. The shogun's troops repelled the attack, and

Wada no Yoshimori died with his two sons in the fray.

Wagojin *genies of amiability*

These two fat and jolly figures, younger versions of Hotei, a god of happiness, have been borrowed from China, and Japanese artists always depict them as Chinese boys (*karako*). They wear scanty Chinese garments which fail to cover their prosperous bellies; their hair, long and straight, hangs halfway down the back instead of being short and neatly tied, as would be the case with proper Japanese boys. One named Wa holds a lotus blossom in his pudgy hand, the other named Go, a box. One look at these godlets of good luck suffices to explain that they are amiable because they have everything they may want to excess. Hokusai's black-and-white sketch in his *Manga* shows them practically wallowing in "precious things," not trampling on them, as some Western scholars have written.

Wani *K. scholar*

Japanese regard Wani as the first of the great teachers and "civilizing influences" who came to them from the Asian mainland. A son of the king of Kudara, a country in Korea, who had recently represented his father in an embassy to Ojin, fifteenth emperor of Japan (r. 201-310?), Wani became a preceptor to Japan's imperial princes. In teaching the principles of Confucianism, Wani established the Chinese system of writing in Japan and probably the Chinese system of thought and their style of ceremony. Tradition also assigns him credit for suggesting that Emperor Ojin's officials should erect a storehouse, apart from the palace buildings, where precious gifts received from Korea might be preserved without fear of fires that so frequently destroyed the palace structures.

Warabi *fern*

Before they unfold, the young fronds of the *warabi,* a species of fern known as *Pteris aquilina,* are good to eat, either raw or cooked. These shoots, called *warabi-de,* are models for graceful motifs employed as decorations on lacquer objects, metal work, and family crests.

Wasobioe *fictitious hero*

In 1774 Yukokushi, an Edo novelist, published *Shikaiya Wasobioe,* a satirical tale named after his hero. Wasobioe lived in Nagasaki. He left his home one night in the eighth month, in order to escape the crowds of townsfolk out in force to view the full moon. He went far before he returned to Nagasaki. The Sea of Mud; the Land of Eternal Life; the Land of Boundless Plenty; the Lands of Steam, Antiquarians, and of Paradoxes; as well as the Land of Giants, are only some of the places he visited. They were not quite The Three Thousand Worlds mentioned in Buddhist

scriptures, but they were more than enough to give him many memories when, by a set of curious chances, he returned at last to Japan.

Artists have fully illustrated all of Wasobioe's adventures in successive editions of the novel, as well as in prints and picture books that virtually eliminated Yukokushi's text. Wasobioe's mode of transportation—a beautiful white crane that he "steered" by hammering a spike into one side of its back or the other—especially intrigued the illustrators. So did his sojourn in the Land of Giants.

In that country the learned Doctor Kochi, who stood about 23 meters tall, carried Wasobioe about in his kimono sleeve, and held the little visitor in the palm of his hand when displaying him to fellow giants. Using chopsticks whittled from small trees, Doctor Kochi fed his engaging guest with bits torn from a single immense grain of rice. Doctor Kochi, although kind and scholarly, suffered from certain limitations of the intellect. Whenever Wasobioe tried to tell him about the Land of the Rising Sun, or asked questions pertaining to important affairs in the Land of Giants, Doctor Kochi merely laughed. Stroking Wasobioe with a finger as broad as a poor man's house in Edo, he replied that, inasmuch as a person's intelligence is proportional to his size, such a small thing as Wasobioe could not be expected to comprehend the ways and thoughts of big people.

Watanabe no Tsuna *warrior*

Minamoto no Yorimitsu, also known as Raiko, had been charged by Emperor Enyu (r. 970-84) with ridding the countryside of bandits. In 976 Raiko sent one of his four trusted retainers to perform the same service at Rashomon, the southern gate in Kyoto's great wall. Giving fair warning of his mission, Watanabe no Tsuna posted a sign on the notice board beside the gate saying simply "Prohibited." He stood watch for enemies, whether human or demon, during the long cold dark night. Suddenly a mighty force seized his helmet, lifting him from his horse. Tsuna struck out with his sword, felt it cut through the flesh and bone of his assailant. Shrieking hideously, the creature loosed his hold and fled. By the light of torches Tsuna saw that he had cut off a mighty demon's arm. It was huge and black, and every hair on it was as thick as a goose's quill. Tsuna wrapped the gruesome thing in a cloth, took it home, and, telling no one, locked it in a strong box. Then he waited for the demon to make the next move.

Not long afterwards an old woman came to visit him. She said that she had been his nurse when he was a baby. He believed her, having no reason to doubt her story. They talked about his duties, deeds, and adventures; she always full of praise, he being flattered by this old nurse's interest in him. To please her curiosity,

he brought out the strongbox, and unwrapped the monster's arm. In that instant she assumed the form of a demon, seized the loathsome arm, and flew away with it.

Another version of this tale ends in the same way, but starts in a bolder fashion. As Tsuna rode across the First Avenue Bridge one day, a beautiful young woman asked him to take her to the Fifth Avenue Bridge. As they rode along, with her behind him on his steed, she assumed her demon shape and seized him by the hair. He drew his sword and hacked off her arm, while she flew away, screaming with pain and rage.

Waterfall of Yoro (also known as *Cascade of Sake*) *legend*

One terrible winter a poor woodcutter, who took loving care of his aged parents, could gather so little fuel to exchange for food that the three of them were in danger of starving. He could not even dream of buying his mother and father some warming sake. Discouraged, he went one evening to the river near their home, and filled the jug with fresh water from the famous waterfall of Yoro that flows down a cliff on Mount Tado. On his way home the gods—helping this son who was so noble an example of filial piety—changed the water into sake.

Wen Pluckers (*kobutori*) *fairy tale*

One evening, having been delayed in the mountains, a peasant decided to spend the night in the trunk of a hollow tree growing in the midst of a large clearing. Around midnight he was awakened by the sounds of merriment coming from a crowd of *kobito*, or little people, singing, dancing, eating, drinking sake, all having a fine time around a fire in the clearing.

Fear soon gave way to a wish to join them at their party. They welcomed him heartily, and he passed the hours most enjoyably. At dawn, when they had to disappear, their chief urged him to come again. Just to make sure that their guest would keep his promise to do so, the chief took as a forfeit the only thing the farmer could spare—a large wen growing on his forehead.

He went home, and immediately everyone noticed that he had lost his wen. He told them exactly how the *kobito* had plucked it from him. A neighbor, similarly afflicted, thought that he would rid himself of his wen by joining the little people during the following night.

Everything went as he had hoped. He feasted and drank and danced. The little people, delighted with his company, and thinking that he was the first peasant who had come back as he had promised, returned to him at dawn the pledge they had taken the morning before, sticking the wen on his forehead, right beside the other one.

Western Paradise *Buddhist heaven*

The Pure Land of the West, to which perfected spirits ascend after they have attained enlightenment, is a serene and lovely place. Most artists accept the vision of untroubled beauty ordained by scriptures—a broad and placid lake, its unruffled surface almost covered with the round, flat leaves of lotus plants, above which rise the unblemished blossoms, presenting all the hues known to earth and heaven. Each awakened flower serves as the throne for a Buddha, while buds await the arrival of future Buddhas. At the center of this divine host, seated on a throne resting on a lotus blossom, Amida Buddha presides in majesty. All along the shore of the lake stand the pavilions of the blessed, wrought from gold and silver, adorned with precious jewels. These are gathered in paradise not because the Buddhas need or covet them, but only because they too are things of perfect beauty.

Wheel *art motif*

Anything that had wheels found a place in art. Vehicles that were put to practical use in real life included vendors' pushcarts; carriages in which nobles were drawn by slow-paced oxen; flower barrows freighted with peonies, chrysanthemums, roses, irises, and other kinds of blossoms; the top-heavy houses-on-wheels employed as war chariots by Chinese generals and emperors (but not by Japanese); and the *shinansha,* or south-pointing cart, said to have been invented by China's "Yellow Emperor," Huangdi. The limited variety of children's toys provided the dove carriage, a wooden image of the bird poised on two wheels, and the *buriburi,* an octagonal piece of wood similarly mounted. Both of these could be drawn along at the end of a string.

Priestly imaginations invented the frightful *hi no kuruma,* or wheel of fire, that carries the spirits of evil people off to hell. This flaming wheel is whipped on its course by three devils, one red, one black, and one green. Some artists have added a fourth fiend to the device—a ferocious face glaring out from the center of the vortex.

Whisk *utilitarian object*

Brushes made of leaves, twigs, animals' tails, horse hair, strips of cloth, or other things were used in Asia by the pious for sweeping from their paths any small creatures that might be crushed by heavy human feet. All sorts of people, pious or not, needed whisks to beat off flies, mosquitoes, gnats, and other airborne pests. The *hossu* was also used to indicate religious and political figures' functions and positions—the higher the rank, the more elaborate the designs.

The White Fox (*byakko*) *legendary creature*

Also called Amatsu Kitsune, or Heavenly Fox, the *byakko* is able to fly through the

air. Sometimes it carries a *tama,* or sacred jewel, in its forepaws. Usually the White Fox is a mount for a lesser deity.

The Buddhist priest Sanjaku-bo of Echigo Province lived to be more than 500 years old, performed all sorts of miraculous deeds, and finally rode through the air, borne on a white fox, from Echigo to Mount Akiha in Totomi Province. After he died, Sanjaku-bo was made Lord Protector to Akiha-san Gongen (the Shinto deity of that mountain). Similarly, Dakini-ten and Izuna-gongen, other minor deities who are worshipped in rural provinces, are associated in legend and in iconography with white foxes. More than likely the white foxes that serve as emblems and messengers of Inari, the god of rice, have the same origin in the ancient past.

Wild Goose *in art*

The outline of a wild goose (*karigane*), distorted to a degree that few other natural objects were subjected to, was an important motif for family crests, sword guards, and other decorative designs. It is usually shown with wings outspread, in a very stylized silhouette resembling the figure three. Okuni, the dancing priestess who started Kabuki, wore a crest featuring the *karigane.* The *musubi karigane,* or knotted wild goose, is a weird form. Naked and attenuated, twisted into something resembling an earthworm tied into a tight curl, it kept only the open-mouthed head to show that it represented a goose.

Willow Tree *as symbol*

The weeping willow, with its long supple drooping branches, is an expression of yin, the feminine principle in nature (just as the pine tree is an emblem of yang, the masculine principle). The willow is the very epitome of submission and grace. A popular saying is that as a willow bends to the force of the wind, so must a wife bend to the will of her husband.

A willow branch can also be a symbol of care for living things. Kannon, a bodhisattva of compassion, in order to avoid stepping on insects in her path when she walked, would brush them away with a whisk made of willow twigs and leaves. A willow tree is often the abode of a wandering spirit, or reversing the relationship, a woman is the incarnation of the willow tree's spirit. That is why, if one cuts or fells a willow, one can see blood flowing from the wound.

Belief in this close association between women and willows started in China during the Song dynasty (960-1279), when a young woman hanged herself in a weeping willow tree. The Japanese story of the willow wife simply confirms this belief. So also does the willow tree in Hitachi Province, which could transform itself into a woman, whom Japanese call Yanagi-baba. Sometimes she is young and lovely,

sometimes old and ugly, but however she looks, she bewitches travelers on the road. Hiroshige, in his picture book entitled *Kyoto meisho,* or *Kyoto's Famous Places,* made a print showing the famous willow at Shimabara, the city's "pleasure quarter." At night the spirit in this tree became a woman who robbed passers-by. Inasmuch as this tree grew at the very entrance gate to Shimabara, some cynics have declared that the story is only a fanciful way of saying that prostitutes who dwelled in Kyoto's "flower district" were the robbers.

In art the willow tree appears often, either alone, for its own beauty, or in association with deities, or with people. Sometimes the swallow, or *tsubame,* is shown with a willow as an allusion to the graceful motions of both.

Willow Wife *fairy tale*

Heitaro, a young farmer, so loved the beauty and shade of a great willow tree near his home that he saved it from neighbors' axes when they wanted to cut it down for a bridge post. Soon afterwards, under this same tree, he met a beautiful young woman. Her name, she told him, was "Willow Slip." He fell in love with her, and she accepted his offer of marriage, provided he never ask about her family. He agreed to this condition, they were married, and lived happily. After a suitable interval, she bore him a fine son whom they called Chiyodo.

In the year 1132 Emperor Toba (r. 1108-23) commissioned the building of a splendid temple in honor of Kannon, a bodhisattva of compassion. Instructions came from Kyoto to cut down trees needed for its columns, beams, and ridgepoles. Despite Heitaro's pleas and protests, woodsmen hacked down his beautiful willow. With each stroke of their axes his wife shuddered in agony. Just as the tree toppled to the ground, she vanished. Chiyodo wept for the mother he would see no more. Only then did Heitaro understand that his gentle wife had been an incarnation of the spirit of the willow tree.

The woodsmen, heaving, tugging, shouting, strove in vain to move the great trunk. It would not budge. Heitaro could have hardened his heart against them, but he did not, out of love for his lost wife and respect for Kannon. He offered the woodsmen the help of his son. The moment Chiyodo put his tiny hands on the huge log, it slipped easily down the riverbank into the water.

The Witch of Adachi Plain *folk figure*

A woman who murdered and ate the flesh of babies, she reserved their blood for her feudal lord, whose illness could be treated only with the blood of babies born in a certain month.

Wood Sorrel *in art*

The crests of several families employ leaves or flowers of *Oxalis acetosella,* the wood sorrel. The flowers usually have four petals, each ending in two rounded lobes. They should not be confused with cherry or plum blossoms, which have five petals.

Wrestler and the Serpent *story*

While Tsuneyori, a famous wrestler, strolled beside the river one day, the tail of an immense serpent emerged from the water, coiled around his leg, and started to drag him down the bank. Tsuneyori dug his big feet into the sand, scouring a trench half a meter deep, breaking his *geta,* but not yielding another millimeter. Suddenly the serpent's body snapped, and Tsuneyori fell back, saved from a gruesome death. Later his servants recovered the serpent's tail. It was 30 centimeters in diameter. People across the river reported they had found the upper portion, coiled twice around a tree.

Tsuneyori tied a thick rope around his leg, and set a team of men to pulling on it, gradually increasing their number until he thought their combined effort was about equal to that of the living serpent. They were astounded when they realized that Tsuneyori had withstood the strength of 60 men.

Wuling-jin *character in a Ch. poem*

Wuling-jin ("the man from Wuling") is the leading character in a Chinese poem called "Peach Blossom Spring." While fishing one day in the familiar river from which he drew his livelihood, he happened on a tributary stream he had not noticed before. Enchanted by the groves of peach trees along its banks, he stepped from his boat and wandered along the stream. He came to its source, where he found a village set in a broad and fertile plain. The people he met there were friendly, but puzzling as well. They wore clothes of a kind he had never seen before, and knew nothing of the history of the country beyond the mountains, not even the name of their fair land. He did learn, however, that they had taken refuge in this peaceful place 600 years before, during the wars that marked the end of the Qin dynasty (221-207 BCE). Finally bidding them farewell, the fisherman returned to his ancestral village. Yet, once there, he longed unbearably to go back to the Peach Blossom Spring. Search as he might, he could never find it again. The great Chinese poet Dao Yuanming (Toenmei; 365-427) first told this story of a lost paradise; James Hilton gave us Shangri-la in a modern and more elaborate version of the tale in his novel *Lost Horizon.*

Yakushi-nyorai *Buddhist deity*

"The Healing Buddha," Yakushi-nyorai, is one of the five great Buddhas of wisdom. His mercy has healed many ailing petitioners. Images of Yakushi are not easily distinguished from those of the other Buddhas of wisdom, and are easily confused with those of Shaka himself. Either a small herb jar or a short baton, held in his left hand, best identifies Yakushi. Sometimes, as in the famous "Yakushi Trinity" at his temple in Nara, he is attended by two lesser divinities, Nikko-bosatsu and Gakko-bosatsu, the first associated with the sun, the second with the moon. Other artists have depicted him being attended by The Twelve Heavenly Kings. Most often, however, Yakushi stands or sits alone. One of the oldest images in Japan presents him in this solitary fashion. Commissioned by Prince Shotoku as a memorial to his father, Emperor Yomei (r. 586-87), it was made in 607, the year in which Shotoku founded Horyu Temple.

Yamabe no Akahito *poet*

Emperor Shomu (r. 749-58) aided Akahito in his career at court. Several of his poems are included in the *Manyoshu*. For these he is revered as one of the three gods of poetry.

Yamabushi *mountain hermit; soldier-priest*

Ascetic men and woman who retreat to huts in mountains, in order to practice

316

austerities and perfect their spirits, have a long history in Japan. Even so, the term *yamabushi,* meaning "one who hides in the mountains," seems to have been applied to Japan's recluses only after Buddhism was established in the country. Some of the first men to be called *yamabushi* may have been Buddhist converts following the example of En no Shokaku, who lived in solitude on Mount Katsuragi for more than 30 years, devoting both prayers and energies to consecrating nearby peaks in the holy name of Buddha. Other hermits, neither priests nor Buddhists, may have been Shinto ascetics, or outlaws, bandits, charlatans, fortunetellers, and necromancers pretending to be holy men.

By the ninth century the number of genuine Buddhist *yamabushi* had increased to the point where they were burdens on the charity of local populations, and an embarrassment to the religion they professed. Shobo (834-909), a grandson of Emperor Saga and also a priest at Ryuzen Temple in Kyoto, determined to impose some control over the hordes of *yamabushi* who cluttered the forests on Mount Hiei, a few kilometers north of Kyoto. Discipline being one of the first steps toward such ordering, Shobo persuaded several instructors in the martial arts to attempt the task. Those strict disciplinarians were so successful that they created a corps of soldier-priests, ready to fight as well as pray. During the tenth and eleventh centuries, abbots of other wealthy temples in Kyoto and Nara followed Shobo's example and trained some of their monks and *yamabushi* to be armed protectors of temple property and rights. Thereafter, inasmuch as the word *bushi* can take a number of meanings, the term *yamabushi* was interpreted to signify mountain warrior by admirers of the corps, and mountain sleeper (or worse) by detractors.

Upon occasions of great need, such as political unrest, civil wars, and famines, temple administrators also hired authentic warriors to supplement the ranks of their armed monks and priests. Those mercenaries, technically not members of a religious order, were called *sohei,* priest-soldiers. *Yamabushi* were distinguished from *sohei* by differences in dress, dwelling places, and style of living. As time passed, however, and each group imitated the other, such differences tended to disappear.

Troops of *yamabushi* from the temples around Kyoto, especially from those on Mount Hiei, became increasingly belligerent and enjoyed their martial sorties much more than their priestly duties. Before long, ambitious prelates were employing them as threats of force, if not as actual soldiers in battle, in the endless maneuverings for political power that marked the centuries between 1150 and 1590. Whether or not *yamabushi* fought in combat, their very existence was a continuing source of concern to emperors and shoguns alike. At length their numbers, wealth, and arrogance

became insupportable. In 1571 Oda Nobunaga decided to end the problems they caused by exterminating them. At his orders every temple and monastery-barrack on Mount Hiei was burned to the ground. Most *yamabushi* and *sohei* were slaughtered in the process. A few managed to escape the holocaust to carry on the profession until 1868, but never again did *yamabushi* interfere with the policies and deeds of shoguns.

Both as individuals and in groups, *yamabushi* offered many themes for artists. The most famous one of all was Benkei Musashibo; and the costume he and his companions wore toward the end of the twelfth century is by far the most picturesque of the costumes adopted by *yamabushi*.

When girded for battle, a *yamabushi* donned an armored skirt and a cuirass over a white underrobe. Instead of a helmet he wore either a white fillet around his head, tied in a knot at the front, or a shapeless sort of beret with long flaps covering cheeks and neck. Like Benkei, almost all *yamabushi* took for their crest the eight-spoked Wheel of the Law, symbol of the Buddha's teachings.

When dressed for travel (at least in art, if not in real life) each man wore over the priest's underrobes a wide-shouldered surcoat made of brocades in patterns and hues ranging from somber to gorgeous; the *tokin,* a hard, black, polygonal pillbox hat, its white straps tied under the chin; a hamper strapped to the back for carrying extra clothing, food, sacred writings, holy images, toilet articles, and other necessities; a trumpet-conch hung from the sash; a rosary, either in hand or at the waist; the warrior's two swords, thrust under the obi; a walking staff; and, most characteristic of all, a brocade stole affixed with four large white balls made of a fuzzy cloth, two on either side of the chest, the whole thing resembling an enormous rosary.

Yamachichi *legendary creature*

Looking something like a cross between a bat and a monkey, Yamachichi has the pointed muzzle of the former and the long limbs of the latter. Despite the fact that the breath of human beings is its only nourishment, it is more than a thousand years old. It steals that nourishment either by butting a person in the belly, thus knocking the breath out of him, or—as Toka Sanjen has depicted in his illustration to *Hyakku monogatari*—by sucking the breath out of a person while he or she sleeps. In that case, the person dies.

Yamada Nagamasa *adventurer*

Nagamasa (1578-1633) maintained that he was a grandson of the warlord Oda Nobunaga. He was born in Suruga Province, and probably went to sea as a youth. By 1615 he had learned enough about maritime traffic and countries along the coast of Asia to take a trading ship from Osaka to Siam. After establishing himself there, he

helped the king of Siam suppress a rebellion and, as a reward for his service, received the king's trust and a princess in marriage. An able and imaginative organizer, Nagamasa began a program to increase trade between Siam and Japan. As one consequence of these developments, many Japanese merchants and sailors settled in Siam.

As the years passed, Nagamasa's influence at court increased until only the king's powers exceeded his. Envious Siamese aristocrats could not tolerate this alien intruder, and so in 1633 they poisoned him. His daughter tried to avenge his death, but she, too, was murdered.

Yamanaka no Yukimasa (also known as *Yamanska Shika-no-suke*) *warrrior*
Yukimasu (1542-76), noted for his great strength, was a vassal of the Amako family in Izumo Province, and supported them in their efforts to resist repeated attacks by the Mori clan of Aki Province. In 1563 Yukimasu and about 300 warriors withdrew to Kyoto, where they prepared in secret to rally round the Amako cause when next their lord summoned them to battle. Yukimasu is depicted in full armor, with a shining crescent moon ("the third-day moon," a symbol of good luck) at the front of his helmet, while he casts huge rocks at the invaders.

Yamato *name for province, nation, and style*
Honshu, the largest island in the Japanese archipelago, is the heart of the empire conquered by Jimmu, the first emperor (r. 660-585 BCE). The conquerors called the new province Yamato. Jimmu, as he looked over the wide rich plain ringed about by mountains, likened his prize to a dragonfly biting the end of its tail.

For more than a thousand years Jimmu's successors built their dwellings and their successive capitals in Yamato. During the Kofun Period (200-552), the sovereigns were buried in great mound-tombs, so many of which rise above Yamato's plain to this day. Nara, the first "permanent" capital city, was built near the northern edge of this central province (which, since the Meiji Restoration in 1868, has been called Nara Prefecture).

During the Heian Period (794-1185), after the new capital at Kyoto had been occupied for several decades, poets and essayists, looking to the glorious past, gave the name Yamato to the entire country—"this grand and noble land"—and to all aspects of its culture that they regarded as "purely Japanese," as opposed to being borrowed from China and Korea. The native language, untainted by foreign words, they called "the Yamato tongue," although few of those patronizing males, so proud to display their knowledge of things Chinese, condescended to use the language of Japan in their writings. Fortunately, many women of the court, having been less instructed in Chinese ideograms and prosody, did compose lively diaries, letters, and "pillow

books," as well as memorable novels and poems, in their relatively pure "Yamato tongue." In the same period paintings of native subjects, done in a new "Japanese style" rather than in the academic Chinese manner learned from professors of Tang and Song modes, were called *yamato-e*.

Members of the imperial court began to speak of *"Yamato damashii,"* or "the true Japanese spirit," that sense of honor founded on absolute loyalty to family, friends, liege lords, and emperor and, therefore, on the code of behavior that exacted a readiness to sacrifice individual wishes to higher obligations. The oldest known reference to *"Yamato damashii"* occurs in Lady Murasaki's novel *Genji monogatari* (*The Tale of Genji*), written about the end of the tenth century.

Yamato Takeru no Mikoto *warrior-hero*

Yamato Takeru is the archetype of Japan's folk heroes. Emperor Keiko (r. 71-130), the twelfth sovereign, was his father. A wild and unruly child, he grew up to be enormously strong and uncommonly tall. When they were sixteen years old, he "chastized" his twin brother in a palace privy and tore him to pieces. Soon after this incident his father sent him off to subjugate the backward Kumaso tribesmen of Kyushu.

Disguised as a girl, the prince entered the Kumaso chieftain's pit-dwelling and, during the drunken aftermath of a feast, stabbed both the chieftain and his brother to death. As the brother lay dying, he bestowed on his killer the admiring name "Yamato Takeru," Brave of Yamato. During his journey homeward, the prince visited Izumo province, and became a sworn friend of its chieftain. Nevertheless, Yamato Takeru killed his host because he would not agree to become Emperor Keiko's vassal.

Next his father sent Yamato Takeru on an expedition against the barbarians of the east. In preparation for that campaign the prince obtained from his aunt, the chief priestess of the grand shrines at Ise, the sword known as Ame no Murakamo no Hoken. This was the very blade that Susano-o, god of the sea, had drawn from the tail of the eight-headed dragon of Izumo. Yamato Takeru's forethoughtful aunt also gave him a small bag holding some articles he might find useful on his mission.

In Sagami, when barbarian opponents tried to kill him by setting fire to a field of grass, he used the sword to cut a wide swath in the green grass immediately around him (which is why he was known thereafter as Kusanagi, or "Grass-mower"), and set a counterfire with the flint and steel he discovered in the little bag his aunt had given him.

From Sagami he went farther eastward across the straits to Kazusa. When his ship was far from shore, the Dragon King, Ryujin, being exceedingly annoyed by some rude remark Yamato Takeru had made about the stretch of water, unleashed

a terrible storm. Princess Otachibana, the one of Yamato Takeru's consorts who accompanied him, saved his life by casting herself into the raging waves. With this sacrifice the tempest subsided.

After subduing the barbarian Emishi of the east, Yamato Takeru turned homeward once again. In Shinano he went alone to the top of a high mountain. While he rested at the summit, eating lunch, the baleful god of the mountain appeared in the form of a white deer. Yamato Takeru killed it by throwing a clove of garlic into one of its eyes. Other evil spirits caused him to lose his way as he descended to camp at the foot of the mountain, but a white dog appeared to lead him to his destination.

While ascending Mount Ibuki, near Lake Biwa, Yamato Takeru met a white serpent—or a white boar as big as a cow—blocking his path. Not knowing that this was a manifestation of the mountain's powerful god, he spoke insultingly to the animal. The god retaliated by causing a fierce hailstorm, covering the mountain's peak with mist, and filling the valleys with darkness. Even so, the undaunted prince succeeded in returning to camp.

Unknown to Yamato Takeru, the mountain's god had won this contest. Soon after their meeting, the prince fell ill of a malignant fever. He died of it at the age of 31, in the northern part of the land of Ise. His father, the emperor, ordered a tumulus to be raised on the spot where his son had died. The hero's spirit, taking the form of a white bird, probably a crane, emerged from the mound-tomb. It flew westward to his homeland of Yamato, and alighted on the plain of Kotohiki. A second tumulus was built there, and once again the white bird left the burial place. This time it flew to the town of Furuichi in Kochi on the island of Shikoku. Yet another mound-tomb was raised, but the bird departed from that one as well. Soaring upward, it vanished into the high heavens.

Yamauba *legendary creature*

Yamauba, or old women of the mountains, are as variable in appearance and traits as are the human beings who describe them. In general, they are malicious (because they eat little children), but sometimes kind and helpful (as was the old woman who aided Watanabe no Tsuna when he hunted down the Earth Spider, or in another manifestation, assisted in the rearing of the hero Kintaro). Almost everyone imagines that *yamauba* are wild, unkempt, even witchlike old things. In his Manga, however, Hokusai drew his *yamauba* in the shape of a young woman, pensive, somewhat fey perhaps, most certainly un-Japanese in features and dress, and yet thoroughly disheveled as well.

Yangdi

More than likely a *yamauba* changes her appearance to meet the expectations of the person seeing her. Thus, another artist draws her as a veritable monster, old, bent, messy, with a large mouth in the top of her skull, through which she used to devour the flesh and blood of infants, and with long straggly hair that, whenever she wished, she transformed into writhing serpents. Very different is the *yamauba* who adopted Kintaro. She is a kind old woman who sometimes carries a basket of fruits, or sometimes suckles the fat overfed boy while rabbits, monkeys, and other small creatures play at her feet.

Yangdi (*Yotei*) *emperor*

One of the worst of China's emperors, Yangdi was notorious for his vile deeds, utter lack of morality, endless warmaking, and use of forced labor. In 604, as his father, Emperor Wendi, lay ill, Yangdi hastened his death. With guile and false promises, this unfilial son induced one of Wendi's favorite concubines to add a poison to the medicines that court physicians had prescribed for the ailing monarch. When he became emperor, Yangdi indulged in excesses of every kind that shocked the court. He squandered the empire's resources and the lives of thousands of laborers on great undertakings that people of his time considered worthless. Among those was a canal hundreds of kilometers long, connecting the Yellow River with the Yangzi, dug merely to please a concubine who wanted to sail in a decorated barge from one great watercourse to the other. Another work much criticized was the addition of thousands of kilometers to the Great Wall begun by Emperor Shihhuangdi about 850 years before. In 618, after enduring fourteen years of his profligacy, and with the empire disintegrating around them, upright members of the court assassinated Yangdi.

Yang Guifei (*Yokihi*) *famous Ch. concubine*

Yang Guifei was a daughter of a minor government official. Prince Shou, a son of Emperor Minghuang (r. 712-56), chose her to be one of his concubines. When the emperor beheld her beauty and grace, however, he forgot respect for his son and duty to his country. He took Yang Guifei for himself and neglected the duties of state that for 22 years he had performed so faithfully.

His devotion to the woman led him to make other serious mistakes. He showered her with honors and treasures, and he favored members of her family with offices and wealth. Their overweening pride and insatiable greed for more riches offended powerful nobles and scholarly ministers at court. At length those adversaries rebelled against the upstarts. Yang Guifei and her family tried to flee from the imperial capital but were captured and killed.

Japanese artists, also preferring fable to history, have portrayed Minghuang gazing up from earth to Yang Guifei, standing among billowing clouds. Gakutei designed a woodblock print showing her spirit rising from the ink that Minghuang is mixing on his inkstone as he prepares to write another lament for his lost love.

Yin and Yang *Ch. principles of life*

Since ancient times, China's philosophers have taught that all phenomena in heaven and on earth are governed by two forces: the vital spirit (which Chinese call *qi,* and Japanese *ki*); and system, or order (which Chinese call *li,* Japanese, *ri*). Order, *ri,* is the supreme law that tries to direct and regulate all phenomena, great or small, from the grand movements of stars and planets in the heavens to the growing and dying of creatures here on earth. Human beings can acquire virtue only by heeding to the full the exactions of this law that apply to them. On the other hand, life, the vital spirit, or *ki,* is the contrary and disorganizing force that introduces change into the ordered realm of *ri. Ki* is made manifest in two forms, yin and yang, each of which, in its purest state, is the exact opposite of the other. Yin (which the Japanese call *in*) is the passive female principle; yang (which the Japanese call *yo*) is the active male principle. Yin is dark, cold, moist, evil, and negative; yang is light, hot, dry, good, and positive.

All things on earth, whether animal, vegetable, or mineral, whether living or non-living, are created and maintained out of the admixture of diverse proportions of these two forces. Things of earth have a natural tendency to oppose the supreme law of order. Only perfect beings are able to represent true order, and only rarely are such beings formed on earth. Almost all things of earth, being imperfect to greater or lesser degree, introduce disharmony and disorder into their relationships with other things externally, or with themselves internally. In unharmonious or incompatible proportions of yin and yang lie the causes of disease, disruption, discord, and disintegration, not only in human bodies but also in human societies. In harmonious relationships lie the causes and rewards of good fortune.

The very ancient symbol known as *taiji* in Chinese, and *tomo-e* in Japanese, brings together the signs of yin and yang as two comma-shaped monads lying head to tail, within the compass of a single circle, in which each entity occupies exactly half of the enclosed area. All the implications to the concept of yin and yang, of the desirable harmony between order and life, are summed up in this symbol.

Yasutakeru *chieftain*

When Emperor Jimmu (r. 660-585 BCE) invaded Yamato determined to subdue "the barbarians" who rejected his rule, a number of indigenous tribes opposed him.

Yatate

Yasutakeru, "the Brave of Yasu," seems to have been the ablest of the leaders who delayed Jimmu's conquest. Unable to pacify the aborigines by force or promises, Jimmu resorted to guile. He invited Yasutakeru to a parley and a feast. While some of Jimmu's warriors danced in martial attire, others killed Yasutakeru and his retainers.

Yatate *article of apparel*

A literate Japanese who might wish to write a message or a poem to someone else, or a memorandum to himself, while away from home carried the essential materials—tiny brush, stick of carbon black, inkstone, even a few sheets of folded paper—in a small box or pouch known as a *yatate*. This was suspended from his obi by means of a netsuke, a miniature carving, just as an inro, a carrying case, or a tobacco pouch might be.

Yobukodori *birds of a legend*

One day, on the beach of Soto, a robber killed a fisherman and his wife. Their faithful son tracked down the murderer and slew him. At the same moment, the spirits of the dead couple cried out in gratitude. Their cries were taken up by the birds that to this day fly in and out of the sea spray beyond the sands of Soto.

Yoko *sennin*

A famous Daoist sorcerer, Yoko could divide his body into many parts, eliminate his shadow, and even live amid blazing flames. The king of Go, wishing to test Yoko's powers, placed him atop 10,000 bundles of firewood and set fire to the pile. Hours later, when only glowing embers remained, the king returned and found Yoko sitting among them, reading a book. When the king called to him, he looked up nonchalantly, and brushed the ashes from his sleeves.

Yoshiwara *Edo's "pleasure quarter"*

The famed Yoshiwara stood at the northern limit of old Edo, near the Sumida River. In 1617, when the first Yoshiwara opened for business, most of Edo's licensed prostitutes were confined within this "nightless city." Such segregation was the Tokugawa bureaucracy's simple means of controlling, in every sense of the word, the houses of pleasure and their inhabitants, clients, attendants, and all their varied activities. To this "pleasure quarter" went the men of Japan who could afford to pay not only for "a bride of one night," but also for the ministrations offered by tea houses, sake parlors, restaurants, theatres, gift shops, bath houses, barber shops, and other places of comfort. Every aspect of the brothel section was strictly regulated, down to the price charged for the most trivial of services. Because each and every service must be paid for, often enough the bill presented to a guest at the end of his stay was "six feet long."

Yosho *sennin*

According to tradition, Yosho was the first Japanese man to become a *sennin*. Before his mother bore him, in 870, she dreamed that she had swallowed the sun. A soothsayer assured her that this meant that her child would be endowed with miraculous powers. Yosho proved the prophecy correct. He studied intensively, practiced austerities, and trained his body to thrive on only a single grain of millet each day. When he was about to depart for the Realm of the Immortals, he hung his cloak on a tree, with a note indicating that he bequeathed the mantle to his friend and pupil Enmei. The pupil, too, became a celebrated *sennin,* and he followed his master to their Daoist heaven. Even after he left this world Yosho could perform miracles. His father, grieving over the loss of Yosho, begged the gods to restore his son to him. Yosho's voice was heard, saying that if, on the eighteenth day of each month, his father would burn incense on the family altar and decorate it with flowers, his image would appear in the smoke rising from the censer and his spirit would be present in the fragrance of the flowers.

Yoyuki *legendary warrior*

Yoyuki, a commander of "the divine archers," guards to the king of Zhou, was so skilled a bowman that he could hit a marked leaf on a willow tree 300 paces away, or the center of a straw target 99 times out of a hundred. His most famous feat, often depicted in Chinese and Japanese art, happened one misty autumn day when he shot down a wild goose flying overhead, having tracked its course by the cries it uttered. The prince of Chu, who planned to make war on the king of Zhou, knew that he could never win the battle as long as Yoyuki lived. Accordingly, he ordered his soldiers to set up a thousand catapults along both sides of a narrow valley through which Yoyuki must pass on the way to the battleground. There, on a dark night, the soldiers of Chu killed Yoyuki.

Yu *legendary Ch. emperor*

In 2285 BCE, according to ancient chronicles, Emperor Shun gave to Yu the great task of controlling China's rivers, in order to prevent destructive floods. For nine years Yu labored, thinking of nothing else, not even of his wife, concubines, and children, while he supervised the hordes of laborers raising dikes, digging canals, and cutting new courses through which the waters might flow safely. At the end of many generations of benevolent rule Emperor Shun died, after choosing Yu to take his place. Before he would presume to ascend the dragon throne, however, Yu spent three years in mourning for his predecessor. Pictures of Yu show him garbed in imperial robes embroidered with the symbols of his priestly office: dragons,

pheasants, suns, moons, stars, and stones. In a magical gesture, his left hand grasps the right thumb, while the fingers of the right hand hold a scepter. When Yu died, after a virtuous reign of many years, the people venerated him as the god of waters.

Yu Ji *celebrated beauty*

The Chinese king of Chu, Xiang Yu, loved his beautiful consort Yu Ji so much that he could not bear to leave her side when he should have led his army against invaders from a neighboring kingdom. As a result, Yu Ji, out of love for husband and country, slit her throat and died. Crazed with grief, Xiang Yu cut off her head, tied it to his saddle, and rode off to battle. His soldiers were defeated, and he was forced to flee. While crossing a stream his horse saw the reflection of Yu-Ji's face, reared in fright, and threw the king into the shallow water. As the pursuing enemy closed in to capture him, Xiang Yu drew his sword and killed himself.

This story is the subject of a popular Chinese opera and a movie called *Farewell My Concubine*.

Yuima the Layman (*Yuima Koji*)

He was a wealthy merchant who lived in the Indian city of Vaisala. Shaka's preaching converted Yuima to Buddhism, filling him with such eloquence that he went to China as a missionary. In the group of clay statues illustrating "the Colloquy between Monju and Yuima" made in 711, and now preserved in the pagoda at Horyu Temple, the merchant is shown as a gross and ugly person, almost a man diseased, with a neck so swollen and columnar, from jaw to shoulder, as to give him neither chin nor voice box. His forearms rest on a shelf sustained by a single support, touching the ground between his crossed legs. In 1196 the sculptor Jokei I and the painter Koen joined in creating a painted wooden statue of Yuima for Kofuku Temple at Nara. This "portrait sculpture," done in the style of contemporary Song China, makes Yuima look much like a wealthy commoner of Nara, wearing a prosperous man's robes and a merchant's shrewd but affable look about the eyes and mouth.

Yuki-hime *fairy tale*

Because little Yuki would not stay at home, her mother tied the child to a tree in the yard. With her toe Yuki drew a picture of a rat in the dust at her feet. The picture rat came to life and gnawed through the rope to set her free. The plot for this tale was borrowed from an equally contrived story about the boyhood of the great artist Sesshu.

Yu Gong *magistrate*

The neighbors of Yu Gong, a magistrate who lived during the Han dynasty (206 BCE-23), so esteemed him for his fairness and honesty that, while he was still alive,

they erected a small temple in his honor. After a number of years of weathering, the modest gateway to the temple fell down. As neighbors and workmen gathered to repair it, Yu Gong arrived. To everyone's surprise, he made a most immodest statement. He asked that the gateway be made wide enough to accommodate the passage of a four-horse carriage (the kind in which only imperial ministers could ride). Seeing his neighbors' expressions, Yu Gong explained that he suggested this enlargement not for his humble self, but for a descendant who would rise to honors far above those he himself could ever attain. Time proved Yu Gong to be correct in his expectation. His own son, Ting Tang, became prime minister to Emperor Xuandi (r. 73-48).

Yurikawa-daijin *folk-hero*

Each of Yurikawa's feet was about two and a half meters long. When he plucked the string of his huge bow, the vibrations resembled thunder and could be heard several kilometers away. With his bow, he drove one of his enormous arrows deep into Mount Akagi, killing the evil spirit hiding there.

Yuryaku *emperor*

Yuryaku, who ruled Japan from 457-79, began his reign with bloody retributions—he eliminated anyone in the imperial clan who might have claimed sovereignty. Because of this carnage, as well as for many other victims sacrificed to suspicion or savage temper during his long reign, Yuryaku is remembered as a ruler obsessed with killing. Several of Yuryaku's outbursts of violence have served as themes for artists. At a great hunt on Mount Katsuragi in the year 461, a wild boar charged the emperor's party. His attendants fled, failing to protect the sacred person. Yuryaku, as wild as the boar, kicked the beast to a stop and killed it with his fist. Then he turned on his attendants and decreed death for the cowardly ones who had abandoned him. The empress interceded, likening his cruelty to that of a wolf. His anger having subsided in the meantime, he pardoned the offenders. The heroic manner in which he dispatched the boar has been depicted often, especially in calendar art.

A less excusable tantrum seized him at an outdoor feast. A lady-in-waiting, wearing a mask to keep her breath from polluting the imperial drink, did not notice that a leaf from a sheltering tree had fallen into the sake cup she was presenting to him. Aroused to instant rage by the offense, he knocked her to the ground and prepared to behead her, then and there. She stayed his hand with a poem, in which she reminded him that, in a similar situation long before, Emperor Keiko had excused his cupbearer. Once again the empress spoke soothing words, and once again Yuryaku allowed himself to be forgiving.

When one of his several concubines was detected in the arms of her

courtier-lover, Yuryaku imposed a fearful penalty on both offenders—death by crucifixion and burning. On another occasion, while inspecting a troop of warriors, Yuryaku observed one young soldier trembling. Without inquiring why he trembled, the emperor drew his sword and slaughtered the youth where he stood.

Despite Yuryaku's savagery, many good things happened to the country during the years of his reign. He imported builders, weavers, and potters from Korea; and he encouraged development of trade overseas and of agriculture at home, especially in the cultivation of mulberry trees for leaves to feed silkworms. Moreover, some of those builders from Korea added a second story to Yuryaku's own palace, in the year 468, thereby giving Japanese the first two-story structure they had ever seen.

Yuten-shonin (also known as *Doyo*) *Buddhist priest*

Yuten served as a priest in the great temple of Shinsho in Narita, a town in Shinsho Province. Shinsho Temple is dedicated to the god Fudo, defender of the Buddha's faith, who has the power to foil the tricks of demons. One day, while Yuten knelt in prayer, Fudo, holding two swords—surrounded as usual by flames and wearing a terrifying expression on his face—appeared before him. Of the two swords, one had a blade that was bright and sharp, the other one that was dull and blunted. Fudo thrust them at Yuten, commanding him to swallow one as punishment for all the sins he had committed.

Without hesitation Yuten pointed to the bright sharp blade. Fudo pushed that cold steel into his mouth and down his gullet, but the god was merciful in his testing of the holy man. In an instant all the evil blood in Yuten's body poured from the wounds caused by the sword of judgment. In the next instant Fudo withdrew the sword, and Yuten, cleansed of sin, had become both learned and wise. Yuten used the blood lost in this manner to dye his priest's robes. Each year thereafter, to commemorate the god's visit, Yuten fasted for 21 days.

Yuzuri *shrub*

In Japan this species of sweet daphne is regarded as an emblem of longevity because the first leaves it bears do not fall from the stems as later leaves appear. Just so, Japanese hope, will the father in a household live in health and happiness, at least until his first-born son attains an age when he can assume the position as head of the family. For this reason the larger, lance-shaped leaves of this plant, known in Japan as *yuzuri-ha,* are incorporated in New Year decorations.

Zen circle

Cited by some as the most characteristic form in Japanese art, the Zen circle (*enso* in Japanese)—a symbol of everything in the universe and, paradoxically, of the void—is drawn in one continuous brush stroke. It is an elegant and challenging motif for a *sumi-e* artist—in rendering the *enso,* he must have absolute control of his brush, his ink must be of a proper consistency, he must understand the nature of the paper on which he is drawing, and be in harmony with the spiritual associations of the *enso.*

Zao Gongen *minor deity*

Apparently Zao was created during the Heian Period (794-1185) to satisfy the spiritual needs of mountain folk living in northwestern Honshu. He seems to be Shinto in origin, and yet he is given the form of a Buddhist guardian king or one of the five mighty bodhisattva. He survived as a local deity until late in the Kamakura Period (1185-1333), when he was supplanted by images of the mountain ascetic priest, En no Gyoja, and his demon attendants. Several wooden images of Zao Gongen, carved during the late eleventh or early twelfth century, are preserved in temples in Tottori and Saitama Prefectures.

Zenki *demon*

Together with Goki, a fellow demon, Zenki served En no Shokaku, a Buddhist priest

of the Shingon sect, who lived as a hermit on Mount Katsuragi for more than 30 years. Zenki is shown with a woodcutter's ax.

Zennyo Ryu-o *Buddhist goddess*

In the year 824, when a great drought afflicted the land, Emperor Juna (r. 824-33) asked the famous priest Kukai to beseech the gods for relief. Kukai and his fellow priests in Kongobu Temple on Mount Koya prayed ceaselessly for many days and nights, until at last the goddess Zennyo Ryu-o appeared before them, promising to help. Soon afterwards, it poured rain.

Fortunately for posterity, one of Kukai's companions was able to make a painting of the goddess before his memory of her faded. Still another portrait of this divinity is preserved in Kongobu Temple. According to one report, it was painted to conform to a description of the goddess given by a priest to whom she had appeared while he slept. Another account, however, maintains that it was painted from life.

Zenzai-doji *Buddhist parable*

The youth Zenzai prayed to Monju-bosatsu, asking how he might learn the truths of the Buddha's teachings. Monju replied that to find the way, he must seek the advice of many sages, hermits, monks, and priests. So instructed, Zenzai set out in search of counsel. He visited 53 holy places, in many different lands, always asking questions, always weighing answers, from kings and princes, shop-keepers and peasants, even princesses and nuns, as well as from those holy ones that Monju had named. At last, when he was an old man near the end of his life, he realized that he had attained the knowledge of Buddha's truths that he had sought. Zenzai has been depicted as a weary old pilgrim carrying an empty bag.

Zhu Lianxiang *Ch. woman of great beauty*

She was so beautiful that when she went outside her quarters, butterflies and bees, attracted to that "living flower", followed her wherever she went. In classical paintings, beautiful women are often shown surrounded by butterflies.

Zodiac

Derived from Chinese sources, the Japanese *junishi* (twelve zodiac animals) are the rat, ox (or buffalo), tiger, rabbit (or hare), dragon, snake, horse, goat, monkey, cock, dog, and boar. Each one of these animals is thought to influence one of the years in the Japanese duodecimal calendar and one of the double hours of the day. They are venerable markers of supernatural and mundane events.

Zomen *masks*

In olden times a person who was about to place a family's offerings to the household deities on the altar wore a simple strip of cloth over nose and mouth, in order

to avoid breathing directly on the images. Later a mask was worn, consisting of a rectangular piece of white silk cloth, with two eyeholes cut into it. Eventually, in response to changing tastes, rather bizarre *zomen* were made of heavy paper, or of paper covered with white silk, and decorated with elaborate patterns applied in black ink in a peculiarly Chinese style. The markings employed bands, spirals, whorls, squares, triangles, and other such geometric designs, often supplemented with thin sinuous lines representing eyebrows, nostrils, mustaches, lips, ears, and other parts of the face. The fact that performers in some ancient *bugaku* dances wear *zomen* suggests a Chinese origin for these masks.

Zuijin *Shinto attendant gods*

The two martial images that are set at the main entrance to a Shinto shrine, one at either side of the portal, represent minor divinities that have been assigned the duty of guarding the greater deity being venerated in the sanctuary within. The images are Shinto counterparts to the *nio,* or two kings, who guard the inner gates to Buddhist temples. Each *zuijin,* clad in full armor, is equipped with a bow and a quiver full of arrows, and sometimes a sword.

Selected Sources

The works listed below are rich sources of facts and fancies about traditional themes in Japanese art. I have favored paperback editions where available.

Addiss, Stephen (ed.): *Japanese Ghosts and Demons*. George Braziller, New York, 1985.

Aston, W.G.: *Nihongi: Chronicles of Japan*. Tuttle Publishing, Boston, 1972.

Austin, Robert, & Levy, Dana: *Bamboo: Servant of the East*. Weatherhill, Tokyo, 1970.

Baird, Merilee: *Symbols of Japan*. Rizzoli International Publications, New York, 2001.

Baker, Joan Stanley: *Japanese Art*. Thames and Hudson, London, 2000.

Biedermann, Hans: *Dictionary of Symbolism*. Penguin Books, New York, 1994.

Buruma, Ian: *Behind the Mask*. Penguin Books, New York, 1984.

Carr-Gomm, Sarah: *The Dictionary of Symbols in Western Art*. Facts on File, New York, 1995.

Cotterell, Arthur: *A Dictionary of World Mythology*. Oxford University Press, Oxford, 1997.

Davis, F. Hadland: *Myths and Legends of Japan*. Dover Publications, New York, 1992.

Delay, Nelly: *The Art and Culture of Japan*. Harry N. Abrams, Inc., New York, 1999.

Dorson, Richard M.: *Folk Legends of Japan*. Tuttle Company, Rutland, Vermont, & Tokyo, 1962.

Dunn, Charles J.: *Everyday Life in Traditional Japan*. Tuttle Publishing, Boston, 2001.

Earle, Joe: *Netsuke: Fantasy and Reality in Japanese Miniature Sculpture*. Museum of Fine Arts, Boston, 2001.

Ernst, Earle: *Kabuki Theatre*. University of Hawaii Press, Honolulu, 1974.

Edmunds, Will H.: *Pointers and Clues to the Subjects of Chinese and Japanese Art*. Art Media Resources, Chicago, Il., 2001.

Frédéric, Louis: *Daily Life in Japan at the Time of the Samurai*. Praeger Publishers, New York, 1972.

_____: *Japan Encyclopedia* (tr. Kathie Roth). Harvard University Press, Cambridge, MA, 2002.

Hibi, Sadao: *The Colors of Japan*. Kodansha International, New York, 2000.

Joly, Henri: *Legend in Japanese Art*. John Lane, New York, 1908.

Joya, Mock: *Things Japanese*. Tokyo News Service, Ltd., Tokyo, 1960.

Mason, R.H.P., & Caiger, J.C.: *A History of Japan*. Tuttle Publishing, Boston, 2001.

Mitford, A.B.: *Tales of Old Japan*. Charles E. Tuttle Company, Inc., Rutland, Vermont, & Tokyo, 1975.

Morris, Ivan: *The Pillow Book of Sei Shonagon*. Penguin Books, Inc., Baltimore, 1974.

_____: *The World of the Shining Prince*. Kodansha International, Tokyo, 1994.

Munsterberg, Hugo: *The Arts of Japan*. Tuttle Publishing, Boston, 1973.

_____: *The Japanese Print*. Weatherhill, Trumbull, CT, 1999.

Murasaki, Shikibu: *The Tale of Genji* (tr. Edward Seidensticker). Knopf, New York, 1977.

*Papinot, Edmund: *Historical and Geographical Dictionary of Japan*. Tuttle Publishing, Boston, 1988.

Philippi, Donald L. (tr.): *Kojiki*. University of Tokyo Press, Tokyo, & Princeton University Press, Princeton, 1968.

Richie, Donald, & Buruma, Ian: *The Japanese Tattoo*. Weatherhill, New York, 1996.

Richie, Donald, & Silva, Arturo (ed.): *The Donald Richie Reader*. Stonebridge Press, Albany, CA, 2001.

Schirokauer, Conrad: *A Brief History of Chinese and Japanese Civilizations*. Harcourt Brace & Co., New York, 1989. (Contains excellent parallel chronologies of China, Japan, and selected other civilizations, as well as a table to convert the traditional Wade-Giles transliteration system to the modern Pinyin.)

Symmes, Edwin C., Jr.: *Netsuke: Japanese Life and Legend in Miniature*. Tuttle Publishing, Boston, 1995.

Tsuda, Noritake: *Handbook of Japanese Art*. Tuttle Publishing, Boston, 1985.

Varley, Paul: *Japanese Culture*. University of Hawaii Press, Honolulu, 2000.

Volker, T: *The Animal in Far Eastern Art*. E.J. Brill, Leiden, 1950.

Weber, V.F.: *Ko-ji Ho-ten*. Hacker Art Books, New York, 1975. (In French.)

Williams, C.A.S.: *Chinese Symbolism and Art Motifs*. Tuttle Publishing, Boston, 1996.

Willis, Roy: *Dictionary of World Myth*. Duncan Baird, London, 1995.

Where to find it...

A selection of themes (some common to the human experience, some specific to Japanese culture), historical and legendary persons, supernatural and monstrous creatures, ceremonial objects and artifacts of every day life that, together, offer a brief introduction to Japanese beliefs and codes of conduct, as well as guiding the reader to pertinent entries in this book. Main entries are marked with an asterisk.

A

Adultery. Pans on the Head

Agriculture. Ninomiya Sontoku; Nintoku; Saicho; Shennong

Ainu. Bear; *Kobito*

Alchemy. Rihappyaku; Tokokei

Ama. Fujiwara no Kamatari; *Ningyo;* Octopus

*Amaterasu. Ame no Uzume; Fujiwara no Kamatari; Futamiga-ura; Gyogi; Izanagi and Izanami; Jimmu; Cock; Crow; Ninigi no Mikoto; *Sakaki;* *Shimenawa;* Shinto; Susano-o no Mikoto; Three Sacred Treasures; *Torii;* Toyotama-hime; Toyo-uke-hime

*Amida Buddha. Descent of Amida; Honen-shonin; Pageant of Amida's Welcome; Seishi; Western Paradise

Angels. Fumon Mukan; Mandorla; Shaka; Tennin; Tokokei

Animals. Bat; Bear; Cat; Chodoryo; Eight Daoist Immortals; Elephant; Kintaro; Orangutan; Squirrel; Zodiac. *See also* Creatures

Archer/archery. Dreams; Fusho Kadobe; Heitaro Sone Masayoshi; Joga; Kikuchi Jaka; Minamoto no Tametomo; Minamoto no Yorimasa; Riko; Saigko-hoshi; Taira no Noritsune; Yokuki; Yurikawa-daijin

Architecture. Sen no Rikyu; *Sukiya,* Tea Ceremony; *Torii*

Arm(s). *Ashinaga and Tenaga;* Chodoryo; Daito Kokushi; Daruma; Gentoku; Minamoto no Tametomo; Watanabe no Tsuna

Armor, warrior's. Jingo; Masuda Munesuke; Umegae

Art motif. Bamboo; Cherry Tree; Chestnut; Chrysanthemum; Comma; Diviner's Sticks; Eight Bridges; Iris; Lotus; Maple; Minamoto no Yoritomo; *Naga;* Nanten; Orange; Paulownia; Peacock; Peony; Phallic Symbols; Pheasant; Plum Tree; *Rinzu;* Sacred Fungus; *Sansho;* Shakra; Shiba Onko; *Shinobugusa;* Sparrow; Squirrel; *Sumi;* Swastika; Thousand Buddhas; *Tsuta;* Ueno Park; *Warabi;* Wheel; Wild Goose; Zen Circle

Art, religious. Christianity; Comma; Confucius; Descent of Amida; Mandala; Mandorla; *Rakan;* Shakra; Swastika; *Tama;* Vulture Peak

Artist. Osugi and Otama; Toba Sojo. *See also* Painter

Artistic technique. Slit Eyes, Hook Nose; *Ukiyo-e; Uta-e;* Zen Circle

Astrology. Abe no Seimei; Butei; *Ho-o;* Mako; Tiger

Astronomy. Kanroku; Kibi Makibi; Tobosaku

B

*Badger. Badger's Hanging; Badger's Revenge; Cat; Enoki; Haunted Temple; Nichiren's Image; Tea Kettle of Good Fortune; Three Fat-bellied Deceivers; Tokugawa Family

*Bamboo. Badger's Revenge; Bamboo Cutter; Chrysanthemum; Daruma; Magic; Orchid; *Shoryobune*

Bandit. Ayashi no Omoro; Choko and Chorei; Ishikawa Goemon; Kidomaru; Minamoto no Yorimitsu; Obuzawa Sensaburo; Ono no Oki; Shutendoji

*Bat. Shoki

Beads. Dog; *Magatama;* Rosary; Three Sacred Treasures

Beans. Exorcising Demons; *Oni;* Toshiotoko

Beggar. Chinnan; Eight Daoist Immortals (*Tekkai);* Oguri-hangan; *Tori-oi*

Beheading. Dog; Endo, Morito; Forty-seven Faithful Ronin of Ako; Kidomaru; Marubashi Chuya; Minamoto no Sanetomo; Minamoto no Yoshitsune; Morihisa; Morinaga; Mound of Ears; Murakami no Yoshiteru; Nitta no Yoshisada; Oguri-hangan; *Okatsu;* Ono no Oki; Raijin; Saito no Sanemori; Sakura Sogoro; Sato no Tatanobu; Seven Worthies of the Bamboo Grove; Shibata no Katsuie; Shutendoji; Sugawara no Kanshusai; Taira no Atsumori; Taira no Masakado; Tomoe Gozen; Tosabo Shoshun; Totoribe no Yorozu; Toyo-uke-hime; Yu Ji

Bell. Bell of Miidera; Eight Beautiful Views of Lake Biwa; Fujiwara no Hidesato; Hannya; Huangdi [legend]; *Kirin;* Kiyo-hime

Benevolence. Kuya-shonin; Nintoku; Otake; Otokodate

*Benkei Musashibo. The Bell of Miidera; Tamamushi; Tosabo Shoshun

Birds. Baifuku; Chodoryo; Crane; Cormorant Fishing; Crow; Cuckoo; Dove and Pigeon; Dreams; Falcon; Heron; *Hiyoku-dori* (mythical); Horse That Could Run a Thousand Leagues; Jimmu (legendary); Kanmei; Minamoto no Yoshiie; Nightingale; Okyo; Owl; Peacock; Pheasant; Quail; Raijin (thunderbird/*raicho*); Rat; Seiobo; Sparrow; Stork; Swallow; Tama Rivers (plover); Ubume-dori; Willow Tree (swallow); Yobukodori

Blind/blindness. Blind Men; Hoichi; Kakure Zato; Miyuki; Taira no Kagekiyo

Blood. Abe no Nakamaro; Chugoro; Karu no Daijin (ink); Mikoshi; *Okatsu*; Seven Worthies of the Bamboo Grove; Shark Man; Tokiwa Gozen; Twelve Heavenly Kings; Twenty-four Paragons of Filial Piety (Teiran); Ubume-dori; Willow Tree; Witch of Adachi Plain; *Yamauba*; Yuten-shonin

Blowfish. *See Fugu*

*Boar. Cardinal Points and Directions; Monkey and the Boar; Nitan no Tadatsune; Sanzo-hoshi; Sojobo; Three Gods of War; Yamato Takeru no Mikoto (white); Zodiac

Boat/ship. Azazuma-hime; Azuma no Kimi; Izumi no Saburo Chikahira; Nitta no Yoshioki; Shinozuka; Soso; Taira no Noritsune; Taira no Tomomori; Takeuchi no Sukune; Tortoise/Turtle; Treasure Ship

*Bodhisattva, attributes. Monju-bosatsu

Bonsai. Saibo; Sano no Tsuneyo and his Bonsai

Books. Ankisei; Murasaki Shikibu; Ninomiya Sontoku; Precious Things; Shodo-shonin; *Suikoden*; Sutra; Tokaido; Huangdi [historical]

Books, list of literary works. Atago; Azuma no Kimi (novel); Dog (novel); Dragon-horse; Eight Trigrams; Fuxi; Geisha; Genpei War; *Heiji Monogatari* (history); History of a Three-meter-square Hut; Huangdi [legend]; Ikutama-yori-hime; Inki; *Juri*; Ki no Tsurayuki; Laozi; Living Ghost (novel); Minamoto no Tametomo (novel); Miyuki (novel); Murasaki Shikibu (novel/diary); *Nihongi* (history); Okuninushi no Mikoto; Ooka no Tadasuke; Orange; Sanzo-hoshi (novel); Sei Shonagon; Shunkan; Sangoku; *Suikoden*; Takeuchi no Sukune; *Tale of Joruri*; Tales from Ise; *Tales from Uji*; Tales of the Heiji Period; Tenjiku Tokubei; Thirty-six Poets; Tiger (novel); Toshikage; Traveling by Shank's Mare; Tsukiwaka Maru; *Tsurezuregusa*; Wasabioe; Yamato

Box/case/casket. Exorcising Demons; Foxes' Revenge; Sparrow (basket); Urashima Taro; *Wagojin*; Watanabe no Tsuna; *Yatate*

*Boy's Day (Children's Day). Carp; Festivals; Minamoto no Yoshitsune; Toys

Breath. Clam; Eight Daoist Immortals (Tekkai); Hoso; Mask; Mount Horai; Shokuin; Yamachichi; Yuryaku; *Zomen*

Bridge. Benkei Musashibo (5th Avenue); Bridge of Japan; Daito Kokushi (5th Avenue); Eight Bridges; Fujiwara no Hidesato (Seta); Hihashi (Indigo); Iga no Tsubone; Indigo Bridge; Kintaro; Minamoto no Yoshitsune; Osono; Pillar of Gensuke; Sanzu River; Shodo-shonin; Takayama Masayuki; Three Most Beautiful Landscapes; Tosabo Shoshun; Watanabe no Tsuna

*Brothel. Yoshiwara

Buddha. Amida Buddha; Shaka; Thirty-two Signs of Wisdom; Yakushi-nyorai. *See also* Shaka

Buddhism. Binzuru; Daruma; Descent of Amida; Dog; Dreams; Festival of the Dead; Five Great Kings of Light; Four Sleepers; Fugen-bosatsu; Hundred Measures; Jataka Tales; Kanroku; Kasho; Kikujido; Lotus; Mandala; Miroku-bosatsu; Okada; Pageant of Amida's Welcome; Pagoda; *Rakan*; Roben; Ryobu-shinto; Saion-zenji; Sanzu River; Shaka; Shinran-shOnin; Shirakawa; *Shishi*; Six Realms of Rebirth; Swallow; *Tales from Uji*; Thirty-two Signs of Wisdom; Tiger; Tortoise/Turtle; *Ukiyo-e*; Vulture Peak

Buddhism and politics. Shotoku Taishi; Sago no Umako

Buddhism, sects. Deities of the Thirty Days (Tendai); Dengyo-daishi (Tendai); Elephant; Enchin; Five Buddhas of the Diamond World; Ippen-shonin; Jizo-bosatsu (Roku-jizo); Mount Hiei (Tendai); Nichiren (Hokke); Six Patriarchs of the Hosso Sect; Tea (Tendai)

Bunraku, theatre. *Tale of Joruri*

Business/commerce/industry. *Ronin*; Seven Gods of Good Fortune (Daikoku); Yuryaku

Burial. *See* Funerary Practice

Butterfly. Chokyuka; Soshi; Taira no Masakado; Zhu Lianxiang

C

Calendar. Abe no Nakamaro; Huangdi [legend]; Kanroku; Kibi Makibi; Ox; Saruta-hiko no Mikoto; Tanabata; Zodiac

Cannibalism/eater of human flesh. Jizo-bosatsu; Kishibojin; Kokuri-baba (necrophagia); Shutendoji; Witch of Adachi Plain; *Yamauba*

*Carp. Asahina Saburo; Benkei Musashibo; Boy's Day; Kinko; Kintaro; Saji; Suijin

Caste. Hatamoto; Okuni; *Ronin*; *Samurai*; Swords; *Tori-oi*; Toyotomi Hideyoshi

*Cat. Nanzen; Ohan and Choemon; Ooka no Tadasuke; Shaka

Cave. Amaterasu; Ame no Uzume; Daruma; Earth Spider; Four *Go* Players; Four Sleepers; Fusho Kadobe; Genkei; Horse; Izanagi and Izanami; Morinaga; Nitan no Tadatsune; *Shimenawa*; Taira no Kagekiyo

Chant, religious. Honen-shonin; Kuya-shonin; Nichiren; Shinran-shonin

Cherry Blossom Viewing. Toyotomi Hideyoshi

*Cherry Tree. Orange

Children. *Karako; Wagojin*

Children, adopted/foundling. Miyamoto Musashi; Night-crying Stone; Roben; Saito no Sanemori; Tsukiwaka Maru; Umetsu Chubei; Urabe no Suetake; *Yamauba*

*Christianity. Festival of the Dead; Hosokawa no Tadaoki; Koxinga; *Shishi*; Sutra; Toyotomi Hideyoshi

*Chrysanthemum. Dragonfly; Festivals; Kikujido; Orchid

*Clam. Inkyo; Ryujin; *Tama*; Mount Horai

Clay Figurines. Tombs; Twelve Celestial Generals; Twelve Heavenly Kings; Yuima the Layman

Cloud. Boei; Frog/Toad; Hokyosha; Ida-ten; Jimmu; Fujin; *Kirin*; Konohuna Sakuya-hime; Moon; Ragyo; Rinreiso; *Sennin*; *Shinansha*; Shodo-shonin; Shotoku Taishi; Sotan; Sugawara no Michizane; Tobosaku; Yang Guifei

*Cock. Cock Markets; Kyoshinkun; *Torii*; Zodiac

Coin. Aoto no Saemon Fujitsuna; Kenenshu; Shark Man; *Shishi*; Shozuka-baba; Shubaishin; Umegae

Color, as attribute/symbol. Cardinal Points and Directions; Demons; Emma-o; Ida-ten; Dragon; Huangdi [legend]

Colors, five sacred. Feather Robe; *Ho-o*; Joka; *Kirin*; Rinreiso; Sotan; *Tama*; Tennin; Toyotomi Hideyoshi

Compass. Cardinal Points and Directions; Huangdi [legend]; *Shinansha*; Six Bodhisattva; Six Gods of War; Sumeru; Twelve Celestial Generals

Concubine. Abe no Seimei; Azazuma-hime; Banki; Hiketa no Akaiko; Hotoke Gozen; Ippen-shonin; Karukaya-doshin; Kuganosuke and Hinadori; Li Bai; Masuda Munesuke; Ryoko; Sato no Tadanobu; Taira no Kiyomori; Taira no Tadamori; Tamamo no Mae; Tokiwa Gozen; Tomoe Gozen; Tosabo Shoshun; Twenty-four Paragons of Filial Piety; Wada no Yoshimori; Yang Guifei; Yangdi; Yu Ji

Confucianism. Confucius; Shotoku Taishi; Sugawara no Michizane; Wani

Costume/apparel. *Karyobinga; Oiran;* Okuni; *Otokomai;* Prostitutes; *Samurai; Sumo; Yatate*

*Crab. Shimamura Danjo Takanori

*Crane. Abe no Seimei; Heron; Hichibo; Hokyosha; Josakei (form of); Okada; Rinnasei; *Sennin*; Sentaro; Teireii; Urashima Taro; Wasobioe (white); Yamato Takeru no Mikoto

Creator. Izanagi and Izanami; Sukuna-biko-na no Kami; Three Most Beautiful Landscapes

Creature(s). Dolphin; Fujiwara no Hidesato; Huangdi [legend]; *Jogen-fujin*

(unicorn); Koshi-doshi; *Manga*; Minamoto no Yorimasa; Raijin (*raiju, raicho*); *Shachihoko*; *Tama*; Toyotama-hime; Ubume-dori; Yamachichi; *See also* Crocodile; Earth Spider; *Kirin*; Little People

Creatures, fabulous. Chosai; *Kirin*; *Kudan*; *Hiyoku-dori*

Creatures, fantastic. *Ashinaga and Tenaga*; Crocodile; Tori-akuma

Creatures, imagined. *Ichimoku*; *Juri*; Sickle Weasel

Creatures, legendary. Dragon-horse; *Hakutaku*; *Kappa*; *Karyobinga*; Mitsume-Kozo; *Mukei*; *Oni*; *Rokurokubi*; Senkyo; *Shojo*; Shutendoji; Snow Woman; Sojobo; *Tengu*; *Yamauba*

Creatures, monster. *Ippi*; Nitan no Tadatsune

Creatures, mythical. Dwarfs; Earthquake Fish; *Kobito*; *Ningyo*; Shozuka-baba

Crest. *See Mon*

*Crocodile. Asahina Saburo; Minamoto no Tametomo

*Crow. Cardinal Points and Directions; Jimmu; Raijin; Soso; Twelve Heavenly Kings

Culture, Chinese. Huangdi [historical]

Culture, India. Mandala

Culture, Japan. Numerical Categories; *Tales from Ise*; Yamato. *See also* Social history

D

*Dance. Amaterasu; Benkei Musashibo; Bugaku; Feathered Robe; Gigaku; Ippen-shonin; Jizo-bosatsu; Kanja; *Karyobinga*; Lion Dance; *Manzai*; Mask; Noh; *Otokomai*; Sambaso; Sarugaku; Shakkryo; Shojo; Sparrow; *Ubaga sake*; Zomen

Dancer. Ame no Uzume; Banki; Okuni; Shizuka Gozen

Daoism. Ankisei; Baifuku; Deer; Four Sleepers; Inki; Laozi; Mount Horai; Ox

*Daruma. Fox; Miyamoto Musashi; Toys

*Deer/stag. Hokyosha; Ikkaku Sennin; Maple; Minamoto no Tsunemoto; Saion-zenji; Seiobo. *See also* White Deer

*Demons. Ame no Uzume; Cardinal Points and Directions; Cat; Chodoryo; Daruma; Dreams; Dwarfs; En no Shokaku; Enoki; Hannya; Hichibo; Ida-ten; Issunboshi; Iwasa Matabei; Kishibojin; Mirume; Momotaro; Mukan; Pine; Rashomon, Rokusuke; Sanzo-hoshi; Shoki; Sparrow; Taira no

Koremochi; To no Ryoko; Tori-akuma; Toshikage; Watanabe no Tsuna; Zenki. See also *Oni*

Demon-queller. Demons; Dreams; Miyamoto Musashi; *Oni*; Shoki

Deity. Agata; Benten; Bimbo; Bishamon; Buddhist Triad; Cardinal Points and Directions; Dakani; Deities of the Thirty Days; Dosojin; Fox; Fuji; Garuda; Ho Bai; Marishi-ten; Sanbokojin; Suiten; Seiobo; Seven Gods of Good Fortune; Three Gods of Poetry; Three Gods of War; *Ujigami*

Deity, accoutrements of. Benten; Saruta-hiko no Mikoto; *Tama*; Twelve Heavenly Kings

Deity, attributes. Bodhisattva

Deity, Buddhist. Aizen Myo-o; Amida Buddha; Dainichi-nyorai; Elephant; Emma-o; Five Buddhas of the Diamond World; Five Great Kings of Light; Fudo Myo-o; *Gushojin*; Ichiji Kinrin; Ida-ten; Jizo-bosatsu; Kannon-bosatsu; Kariba-myojin; Kishibojin; Kokuzo-bosatsu; Long Nu; Miroku-bosatsu; Mori Jizaemon; Nikko-bosatsu and Gakko-bosatsu; Seitaka-doji and Kongara-doji; Shozen-doji and Shoaku-doji; Six Bodhisattva; Six Tutelary Bodhisattva of the Six Districts; Spirit God of the Three Treasures; Twelve Celestial Generals; Twelve Heavenly Kings; Twenty-eight Servitors of Kannon; Yakushi-nyorai

Deity, Dao. Toshitokujin

Deity, Shinto. Ame no Uzume; Atago; Hachiman; Hiko-hohodemi; *Ichimoku*ren; Inari; Izanagi and Izanami; Izuna Gongen; Jingo (Izora); Konohana Sakuya-hime; Mikoshi; Mount Hiei; Okuninushi no Mikoto; Saruta-hiko no Mikoto; Suijin; Sukuna-biko-na no Kami; Sumiyoshi; Susano-o no Mikoto; Three Gods of War; Toyotama-hime; White Fox; Zao Gongen

Disk/circle. Flaming Disk; Fuxi; Stars and Constellations; *Sumi*; Sun; Tokugawa Family; Zen Circle

Divination/sorcery. Diviner's Sticks; Eight Trigrams; Inkyo; Matsuo Kotei; Pillar of Gensuke; Shiba Kishu; Tamamo no Mae

Divinity, Buddhist, accoutrements. Kokuzo-bosatsu; Monju-bosatsu

*Dog. Dreams; Gihakuyo; *Hayato*; Kariba-myojin; Kyoshinkun; *Shishi*; Shujushi; Zodiac. See also White Dog

Doji. Seitaka-doji and Kongara-doji; Shozen-doji and Shoaku-doji

Doll. Daruma; Fukusuke; Girl's Day; Phallic Symbols; Toys

*Dragon. Benten; Cang Jie; Cardinal Points and Directions; Carp; Chinnan; Chodoryo; Choryo; Choshinjin; Flaming Disk; Fuji; Fujiwara no Hidesato; Fujiwara no Kamatari; Fuxi; Hannya; Hichibo; Hojo Tokimasa; Hokyosha; Ho-o; Ikkaku Sennin; Joka; Kikuchi Jaka; Marishi-ten; Matsumura-so; Matsuo Kotei; *Naga*; Rinreiso; Seiobo (white); *Sennin*; Shokuin; Shoshi; Shotoku Taishi; Susano-o no Mikoto; Taishin O Fujin (white); Tiger; Tokokei; Toshikage; Toyotama-hime; Zodiac. See also

Colors, five sacred; Fuxi

Drama/play. Cherry Princess; Tosabo Shoshun. *See also* Kabuki; Kyogen; Noh

*Dreams. Bokushi; Chuai; Eight Daoist Immortals (Kasenko); En no Shokaku; Fuji; Masuda Munesuke; Minamoto no Yorimitsu; Morihisa; Nanten; Rosei's Dream; Taira no Shigemori; Tokokei

Drum. Beggars; Cock; *Ichimoku*; *Manzai*; Million Prayers; Raijin; Sato no Tadanobu

Dutch. Okiku

E

Eagle. Roben

Ear. Hoichi; Kyoyu and Sofu; Mound of Ears; Muko; *Sennin*; Seven Gods of Good Fortune; Sorori Shinzaemon; Tokokei

*Earth Spider. Kintaro; Minamoto no Yorimitsu; Mitsume-kozo; Spider; Usui no Sadamitsu; *Yamauba*

Earthquake. Earthquake Fish; Joka; Kikuchi Jaka; *Sambaso*; Seven Evils

*Elephant. Blind Men; Eguchi no Kimi; Fugen-bosatsu; Kompira Shrine; Radish

Elixir/potion. Baifuku; Bamboo Cutter; Chodoryo; Fukyoku Sensei; Fuji; Genkei; Ghost Story of Yotsuya; Gihakuyo; Hihashi; Jisshudo; Jofuku; Kenenshu; Kikujido; Lizard; Mount Horai; Rhinoceros Horn; Rihappyaku; *Sennin*; Shutendoji; Taiyoshi; Taizan Rofu

*Emma-o. Asahina Saburo; *Gushojin*; Kakure Zato; Kannon-bosatsu; Mirror of Hell; Mirume; Saga Sadayoshi; Shozuka-baba; Six Realms of Rebirth; Three Sake Tasters; Tokudo-shonin; Twelve Heavenly Kings; Unkei

Emperor. Abe no Seimei; Antoku; Chuai; Gotoba; Jingo; Moki; Nii no Ama; Nintoku; Shinto; Shirakawa; Shotoku Taishi; Soga no Iname; Sumo; Taira no Tsunemasa; Tea; Three Great Models of Fidelity to the Emperor; Yangdi; Yuryaku. *See also* Go-Daigo; Jimmu

Emperor, Chinese. Ankisei; Buntoi; Butoi; Gang Jie; Gentoku; Mu Wang; Yu Huangdi [legend]; Jofuku; Kanmei; Koso; Li Bai; Nangyo Koshu; Rinreiso; Ryoko; Shiiki; Tobosaku; Yu

Emperor, list. Horse Races at Kamo; Kanshin; Minamoto no Tameyoshi; Minamoto no Yoriie; Minamoto no Yoritomo; Mukan; Nightingale in the Plum Tree; Oda Nobunaga; Ono no Komachi; Ono no Oki; Ragyo; Ryujin; Saicho; Sao-hime; Sen no Rikyu; Shoki; Sojo Henjo; Sugawara no Michizane; Sumiyoshi; Swallow; Taira no Kiyomori; Taizan Rofu; Tajima

Mori; Takeuchi no Sukune; Tokugawa Family; Tombs; Toyotomi Hideyoshi; Wani; Watanabe no Tsuna

Emperor, loyalty to. Hiketa no Akaiko; Koxinga; Nitta no Yoshioki; Nitta no Yoshisada; Takayama Masayuki; Three Great Models of Fidelity to the Emperor; Totoribe no Yorozu

Engineer/ing. Matsuo Kotei; Yu

Environmentalist. Suijin

Execution, method. Ishikawa Goemon; Marubashi Chuya; Oshichi; Ryoko; Sakura Sogoro; Yuriyaku

Exorcism. Exorcising Demons; Oni; Tamagushi; Toshiotoko

Expedition. Chosai; Jofuku; Saicho; Sanzo-hoshi; Songoku; Tachibana-hime; Tenjiku Tokubei; Toyotomi Hideyoshi (military campaign); Yamada Nagamasa

Eye(s). Daruma; Emma-o; Ghost Story of Yotsuya; Izanagi and Izanami; Kamakura Gongoro Kagemasa; Kannon-bosatsu; Karukaya-doshin; Minamoto no Tametomo; Mirume; Okazane; Seven Worthies of the Bamboo Grove; Shokuin; Shozuka-baba; Taira no Kagekiyo

F

Fabric design/motif. Ikkyu; Pine; Rinzu; Seven Herbs of Autumn; Tsuta

Fairies. Butei; Genkei; Jogen-fujin; Osho; Seiobo; Sotan; Taizan Rofu

Fairy tale/fable. Heitaro Sone Masayoshi; Issunboshi; Monkey and the Boar; Monkey and the Jellyfish; Mount Horai; Rosei's Dream; Seiobo; Sentaro; Sparrow; Willow Wife

*Falcon. Dreams; Hachiman; Heitaro Sone Masayoshi

Fan. Araki no Murashige; Katsugen; Manzai; Miyuki; Rosei's Dream; Sennin; Shotoku Taishi; Sumo; Taira no Kiyomori; Twenty-four Paragons of Filial Piety

Fertility. Ame no Uzume; Inari

*Festivals. Ame no Uzume; Boy's Day; Carp; Chosai; Cock Markets; Exorcising Demons; Festival of the Dead; Girl's Day; Horse Races at Kamo; Jizo-bosatsu (Obon); Lion Dance; Mikoshi; New Year Observances; Opening of the River; Sarugaku; Saruta-hiko no Mikoto; Shoryobune; Spider; Stars and Constellations; Sugawara no Michizane; Sumo; Tanabata; Tegaie; Toys

Filial piety. Bunsho; Buntei; Deer; Waterfall of Yoro; Twenty-four Paragons of Filial Piety; Choko and Chorei; Dove and Pigeon; Gentoku; Soga

Brothers' Revenge

Fire. Atago; Beggars; Chodensu; Chogen; Gyoshin; Izuna Gongen; Joka; *Kirin;* Minamoto no Tametomo; Mount Hiei; Narita no Tomenari; Nawa no Nagatoshi; Okazane; Okuninushi no Mikoto; Ooka no Tadasuke (firemen); Oshichi; Ranha; Ryuko; Sao-hime; Seven Evils; *Shibi;* Shiganosuke; Sparrow; Susano-o no Mikoto; Tanshotan; *Tengu;* Wani; Yamato Takeru no Mikoto

Fire, as weapon. Ayashi no Omoro; Oda Nobunaga

*Fireflies. Iga no Tsubone; Miyuki

Fish. Badger; Benkei Musashibo; Boy's Day; Bonito; Bream; Earthquake Fish; Fishing and Fishes (as symbols); *Fugu;* Hiko-hohodemi; Jingo (legend); Long Nu; *Ningyo;* Ryujin; Salmon; Sardine; *Shachihoko;* Urashima Taro

Fisherman. Badger; Bream; Feathered Robe; Hiko-hohodemi; Inkyo; Jisshudo; Nichiren; Seven Gods of Good Fortune (Ebisu); Shirakawa; Urashima Taro; Wuling-Jin; Yobukodori

Fishing. Cormorant Fishing; Fishing and Fishes (as symbols); Hashi no Nakatomo

Flame. Fudo Myo-o; Yoko

Flowers. Ariwara no Narihira; Banki; Chrysanthemum; Eight Daoist Immortals (Kanshoshi); Gentian; Horse Races at Kamo; Iris; Konohana Sakuya-hime; Lotus; Orchid; Peony; Sojo Henjo; Toenmei

Folktale. Badger's Hanging; Badger's Revenge; Bamboo Cutter; Crab; Haunted Temple; Hihashi; Nichiren's Image

Food. Baku; Bream; Deer; Dosojin; Eight Daoist Immortals (Kasenko); En no Shokaku; *Fugu;* Hoso; Mojo; Monkey and the Boar; *Mukei;* Octopus; Ofushi; Ooiko; Oshitsu; Otake; Radish; Raijin; Saion-Zenji; Saji; Seven Gods of Good Fortune (Ebisu); Shennong; Toyo-uke-hime. *See also* Cannibalism

Foot binding. Banki

Four Divinely-constituted Creatures. Dragon; *Ho-o;* Jogen-fujin; *Kirin. See also* Tortoise/Turtle

Four Kings of Heaven, The. Bishamon; Cardinal Points and Directions; Ida-ten; Seven Gods of Good Fortune; Six Gods of War; Twelve Heavenly Kings

Four Plants Loved by Artists. Bamboo; Chrysanthemum; Plum; Orchid

*Fox. Abe no Seimei; Cat; Enoki; Foxes' Revenge; Grateful Fox; Inari; *Tama. See also* White Fox

Fox-priest. Fox; Taira no Tadamori

Fox-spirit. Fox; Masuda Munesuke; Minamoto no Yorimitsu; Taira no Tadamori; *Tengu;* Tokutaro and the Foxes

Fox-woman/fox-man. Abe no Yasuna; Fox; Sato no Tadanobu; Tamamo no Mae

Fraternities. *Matoi*; Miyoshi Yuki; Otokodate

*Frog/Toad. Chugoro; Eight Daoist Immortals (Tekkai); Gamma Sennin; Jiraiya; Ono no Michikaze; Rocks and Stones; Tenjiku Tokubei

Fruit. Orange; Peach; Persimmon; Pomegranate

Fugu (blowfish). Badger; Three Fat-bellied Deceivers

*Fuji. Ariwara no Narihira; Bamboo Cutter; Dreams; Falcon; Jimmu; Kato no Kiyomasa; Konohana Sakuya-hime; Nitan no Tadatsune; Saigyo-hoshi; Sesshu; Tama Rivers

Funerary practice. Dog; Festival of the Dead; Okada; Phallic Symbols; Tombs; Totoribe no Yorozu; Yamato

G

Games. Four Go Players; Fujin; Ganshinkei; Ippen-shonin; Kanshin; Karukaya-doshin; Kibi Makibi; Oguri-hangan; Orange; Oshitsu; Sato no Tadanobu; *Shogi*; Toys; Horse Races at Kamo

Garden. Rocks and Stones; Seiobo; Tobosaku

Gautama Buddha. *See* Shaka

Geese and Ducks. Eight Beautiful Views of Lake Biwa; En no Shokaku; Okuni; Okyo; Sobu; Takeda no Yoshinobu; Wild Goose; Yokuki

*Geisha. Diviner's Sticks; Umbrella

Genocide/holocaust/purge. Christianity; Four Go Players; Huangdi [historical]; Lady Yodogimi; *Yamabushi*

Ghost/spirit of the dead. Benkei Musashibo; Cherry Princess; Crab; Dreams; Festival of the Dead; Fumon Mukan; Ghost Story of Yotsuya; Haunted Temple; Hoichi; Iga no Tsubone; Kimi and Sawara; Living Ghost; Matsumura-so; Minamoto no Yoshitsune; Mitsukuni; *Okatsu*; Okiku; Pillar of Gensuke; Sainen and His Mistress; Sakura Sogoro; Sanzu River; Shimamura Danjo Takanori; *Shoryobune*; Snow Woman; Sugawara no Michizane; Taira no Kiyomori; Taira no Tomomori; Tajima Shume and the Phantom Priest; Yobukodori; Yosho

Giant. Benkei Musashibo; Chodoryo; Chosanshu; Joka; Komei; Minamoto no Tametomo; Wasobioe

Gingko (*icho*). Cicada; Shinran-shonin

Go-Daigo, emperor. Ashikaga no Takauji; Ben no Naishi; Dreams; Horse That Could Run a Thousand Leagues; Iga no Tsubone; Kobo-daishi;

Morinaga; Murakami no Yoshimitsu; Nawa no Nagatoshi; Nitta no Yoshisada; Ryochu; Semimaru; Sugawara no Michizane; Three Great Models of Fidelity to the Emperor

Goddesses. Amaterasu; Ame no Uzume; Hashi-hime (Shinto); Hojo Tokimasa; Toyo-uke-hime; Zennyo-Ryu-o

Gods. Fujin; Hachiman; Hashi-hime; Kutsugen; Minamoto no Yorinobu; Raijin; Shodo-shonin; Zuijin

Gourd. Eight Daoist Immortals (Chokaro); Henjaku; Horse; Kyoyu and Sofu; *Sennin*; Shoki; Toyotomi Hideyoshi

Government. Aoto no Saemon Fujitsuna; Huangdi [historical]; Neiseki; Tokugawa Family; Toyotomi Hideyoshi; Yoshiwara

Grave markers. Rocks and Stones; *Sotoba*; Stone Lanterns

Great Wall. Huangdi [historical]; Yangdi [historical]

H

*Hannya. Kiyo-hime; Omori no Hikohichi

Harmony. Futamiga-ura; *Shishi;* Yin and Yang

Headdress. Date no Masamune; Emma-o; Horse Races at Kama; Kokuzo-bosatsu; *Komuso;* Konohuna Sakuya-hime; Neiseki; *Otokomai;* Pans on the Head; Praying at the Hour of the Ox; Ryujin; Seishi; *Shutendoji;* Tomoe Gozen

Heaven, Buddhist. Amida Buddha; Buddhism; Dainichi-nyorai; Descent of Amida; Festival of the Dead; Honen-shonin; Lotus; Miroku-bosatsu; Pagoda; *Shoryobune;* Six Realms of Rebirth; Western Paradise

Heaven, Dao. Kyoshinkun; Mount Horai; Realm of the Immortals; Yosho

Heaven, Shinto. Izanagi and Izanami; Susano-o no Mikoto

Hell, Buddhist. Asahina Saburo (descent into); Emma-o; Jizo-bosatsu; Kakure Zato; Kannon-bosatsu (escape from); Saga Sadayoshi; Sanzu River; Shozuka-baba; Six Realms of Rebirth

Hell, Shinto. Izanagi and Izanami

Helmet. Bugaku; Hatakeyama no Shigetada; Kato no Kiyomasa; Nitta no Yoshisada; Taira no Kagesue; Twelve Celestial Generals

Hermit/recluse. Baifuku; Four Go Players; Karukaya-doshin; Komei; Moki; Moon; Mule; Shiba Shotei; Shodo-shonin; Taira no Atsumori; *Yamabushi;* Zenki

Hinduism. Brahman Triad; Daruma; Fudo Myo-o; Marishi-ten; Dakini; Garuda;

Nio; Snakes and Serpents; Suiten; Sumeru; Twelve Celestial Generals

*Ho-o (phoenix). Baifuku; Cardinal Points and Directions; Dragon; Eight Daoist Immortals (Kasenko); Karyobinga; Kyoshinkun; Paulownia; Rogyoku; Sennin; Shoshi

*Horse. Cardinal Points and Directions; Horse That Could Run a Thousand Leagues; Jingo; Gyokushi (of clay); Komei; Kose no Kanaoka; Minamoto no Mitsunaka; Picture Horses; Rohan (donkey); Saio and His Woes; Sasaki no Shiro Takatsuna; Toshikage; Yu-Ji; Zodiac. See also White Horse

Hunter. Badger; Hiko-hohodemi; Nitan no Tadatsune; Shirakawa

I

Icon/iconography. Hashi no Nakatomo; Kuya-shonin; Ono no Komachi; Ragyo; Roben; Saion-zenji; White Fox

Ideogram/ideograph. Cang Jie; Dog; Emma-o; Kibi Makibi; Kobo-daishi; Ogishi; Shinran-shonin; Shogi; Sumi; Tanshotan; Twelve Heavenly Kings; Uta-e

Incantation. Exorcising Demons; Oni; Umetsu Chubei

Incarnation. Eguchi no Kimi; Miroku-bosatsu; Shotoku Taishi; Six Tutelary Bodhisattva of the Six Districts; Snakes and Serpents; Willow Tree; Willow Wife

Incense/censer. Koben; Nitta no Yoshisada; Sano no Tsuneyo and His Bonsai; Shoryobune; Shotoku Taishi; Sugi; Tokokei; Yosho

India/Indian influence. Dakini; Daruma; Dreams; Dwarfs; Garuda; Jiraiya; Jizo-bosatsu; Kannon-bosatsu; Karyobinga; Kasho; Kokuzo-bosatsu; Mandala; Marishi-ten; Miroku-bosatsu; Monju-bosatsu; Moon; Mount Horai; Naga; Pagoda; Nikko-bosatsu and Gakko-bosatsu; Ragyo; Rosary; Sanzo-hoshi; Seven Gods of Good Fortune; Shaka; Shakra; Sharito; Shiiki; Shishi; Shodo-shonin; Six Gods of War; Songoku; Tama; Tengu; Tenjiku Tokubei; Tennin; Three Gods of War; Torii; Twelve Heavenly Kings; Yuima the Layman

Insect. Bee; Boar; Butterfly; Cicada; Dragonfly; Fireflies; Fujiwara no Hidesato; Iga no Tsubone; Jizo-bosatsu; Kobo-daishi; Minamoto no Yorimasa; Mori Jizaemon and his Image of Jiso-bosatsu; Praying Mantis

Insignia. Comma; Crane; Fuxi; Magatama; Matoi; Military Banners; Murakami no Yoshimitsu; Murakami no Yoshiteru; Praying Mantis; Shoryobune; Sojobo; Swords; Toyotomi Hideyoshi

Inventor/invention. Cang Jie; Huangdi [legend]

*Iris. Ariwara no Narihira; Eight Bridges

*Izanagi and Izanami. Amaterasu; Atago; Futamiga-ura; Konohana Sakuya-hime; Moon; Rocks and Stones; Susano-o no Mikoto; Three Most Beautiful Landscapes; Toyo-uke-hime

J

Japan, discovery of. Jofuku

Japan, national flag. Tokugawa Family

Jellyfish. Monkey and the Jellyfish

Jewel, sacred. See *Tama*

Jewels. Dog; Fugiwara no Kamatari; Gyokushi; Hiko-hohodemi; Kyoshinkun; Long Nu; Moki; Mount Horai; *Sakaki;* Sanbokojin; Shark Man; Three Sacred Treasures

Jewels, of stone. Sharito; Tombs

*Jimmu, emperor. Crow; Earth Spider; Hiko-hohodemi; Konohana Sakuya-hime; Ninigi no Mikoto; Toyotama-hime; Yamato; Yasutakeru; Tamayori-hime no Mikoto

Journey/quest/pilgrimage. Chosai; Tenjiku Tokubei; Tokudo-shonin; Wasobioe; Zenzai-doji

K

Kabuki, theatre. Military Banners; Nitta no Yoshioki; Okiku; Okuni; *Ronin; Sambaso; Saragaku;* Taira no Atsumori; Taira no Koremochi; *Tale of Joruri;* Toys

Kabuki, titles. Forty-seven Faithful *Ronin* of Ako; Fujiwara no Tokihira; Nikki Danjo; Revenge in Ueno; Saito no Sanemori; Sugawara no Kanshusai; Traveling by Shank's Mare

Kanji. Cang Jie

*Kannon-bosatsu. Buddhism; Deer; Enchin; Fuji; *Gushojin;* Hashi no Nakatomo; Jizo-bosatsu; Koshibe no Sugaru; Kuya-shonin; Long Nu; Minamoto no Yoriyoshi; Morihisa; Nitan no Tadatsune; Oguri-hangan; Ragyo; Raijin; Saion-zenji; Seishi; Seitaka-doji and Kongara-doji; Shodo-shonin; Shotoku-Taishi; Taira no Kagesue; Tokudo-shonin; Twelve Heavenly Kings; Twenty-eight Servitors of Kannon; Willow Tree

*Kappa. Rokusuke

*Karako. Wagojin

Karma. Eight Trigrams; Pillar of Gensuke; Six Realms of Rebirth; Umewara Maru

*Kirin. Chosai; Dragon; Hakutaku; Ho-o; Jogen-fujin; Rinreiso; Taishin O Fujin

*Kiyo-hime. Hannya; Octopus

Korea. Ariwara no Narihira; Chuai; Dreams; Gigaku; Jingo; Kanroku; Kato no Kiyomasa; Magatama; Matsuura no Sayo-hime; Mongols; Mound of Ears; Ragyo; Shishi; Soga no Iname; Soga no Iruka; Sumiyoshi; Takeuchi no Sukune; Toyotomi Hideyoshi; Umbrella; Wani; Yuryaku

Kyogen, theatre. Kanja; Ubaga sake

L

Lake Biwa. Bell of Miidera; Eight Beautiful Views of Lake Biwa; Fugiwara no Hidesato; Raigo Ajara; Shiganosuke

Lantern. Festival of the Dead; Fugu; Iga no Tsubone; Karu no Daijin; Stone Lanterns

Leg. Ashinaga and Tenaga; Daito Kokushi; Daruma; Demons; Inkyo; Kanshin; Ningyo; Sompin

Library. Emma-o; Fu-daishi; Kanroku; Rinzo; Saicho; Sanzo-hoshi

Lion. Rinreiso; Shakkryo; Shishi

Little people. Dwarfs; Issunboshi; Kobito; Wen Pluckers

Longevity, symbol of. Bamboo; Bream; Cicada; Chrysanthemum; Crane; Deer; Gourd; Heron; Ho-o; Jo and Uba; Lobster; Mannetake; Mount Horai; Nanten; Orange; Pine; Sacred Fungus; Salmon; Shoki; Stork; Tortoise/Turtle; Yuzuri

*Lotus. Amida Buddha; Emma-o; Fugen-bosatsu; Heron; Jizo-bosatsu; Kishibojin; Kokuzo-bosatsu; Miroku-bosatsu; Monju-bosatsu; Shumoshiku; Sumeru

Lovers. Chosai; Endo, Morita; Festivals (Tanabata); Hime-gimi; Jo and Uba; Kamei; Kuganosuke and Hindori; Miyuki; Ohan and Choemon; Oshichi; Pans on the Head; Shizuka Gozen; Shokuro and Chiyo; Stars and Constellations; Tale of Joruri; Tanabata; Yu Ji

M

Madness (insanity). Endo, Morito; Ghost Story of Yotsuya; Kiyo-hime; Praying at the Hour of the Ox; Ryoko; Sakura Sogoro; Teiisai; Tori-akuma

*Magic. Abe no Seimei; Ayashi no Omoro; Butei; Chodoryo; Gourd; *Hayato*; Heron; Hichibo; Hiko-hohodemi; Hozuki; Ikkaku Sennin; Issunboshi; Iwasa Matabei; Jiraiya; Kenenshu; Kiyo-hime; Kobo-daishi; Kokin; Komei; Mandala; Mirrors; Okuninushi no Mikoto; Okyo; Praying at the Hour of the Ox; Rosei's Dream; Ryuko; Seiobo; Shujushi; Taigenjo; Teiisai; Tenjiku Tokubei; Tobosaku; Yu

Magician. Abe no Seimei; Chokyuka; Choryo; Choshinjin; Dog; Gotoba; Henjaku; Hichibo; Jizo-bosatsu; Joka; Kume; Rinreiso; Saji; Shiba Shotei; *Shinansha*; Taiinjo

*Mandala. Shaka; Thousand Buddhas

*Mandorla. Aizen Myo-o; Fudo Myo-o; Miroku-bosatsu; Monju-bosatsu

Marriage customs. *Tale of the Room Below*

Martial arts. Minamoto no Yoshiie; Minamoto no Yoshitsune; Osono; Sasaki no Moritsuna; *Sohei*; Sojobo; *Tengu*; *Yamabushi*

Martyr. Sakura Sogoro

*Masks. Bugaku; Dance; Gigaku; *Hayato*; Horse; Lion Dance; *Manzai*; Pageant of Amida's Welcome; *Sambaso*; Toys; Yuryaku; *Zomen*

Masseur. Blind Men

Mathematics. Eight Trigrams; Kanroku

Medicine/healing. Enoki; Grateful Fox; Henjaku; Huangdi [legend]; Jiraiya; Miyuki; Ofushi; Oguri-hangan; Rhinoceros Horn; Ryokyo; Sakuna-biko-na no Kami; Seiobo; Seven Herbs of Spring; Shennong; Shuyu; Tea; Twenty-four Paragons of Filial Piety (Enshi)

Meiji Restoration. Ryobu-shinto; Sanada Saiemon no Yukimura; Shinran-shonin; Swords; *Ronin*; Tokugawa Family; Yamato

Merchant. Cock Markets; *Ronin*; Umbrella; Yuima the Layman

Mermaid. *Ningyo*; Toyotama-hime

Millet. Daruma; Quail; Rosei's Dream; Yosho

*Minamoto no Yoshitsune. Benkei Musashibo; Kiichi Hogan

Miraculous conception. Dreams; En no Shokaku; Laozi; Shotoku Taishi; Tamayori-hime no Mikoto; Tobosaku

*Mirrors. Amaterasu; Emma-o; Fukyoku Sensei; Ki no Tsurayuki; Koso; Matsumura-so; Mirror of Hell; Rhinoceros Horn; Rocks and Stones; *Sakaki*; Three Sacred Treasures

Mochi. Crab; Moon; Rabbit; Tokugawa Family

*Mon. Chrysanthemum; Comma; Gentian; Hojo Tokimasa; Kato no Kiyomasa; Lotus; Nawa no Nagatoshi; Okuni; Peony; Pine; Plum Tree; Pomegranate; Sasaki no Shiro Takatsuna; Shakra; *Shogi*; Sparrow; Stars and Constellations; Swastika; Taira no Kagesue; Taira no Kagetoki; Tokugawa Family; Toyotomi Hideyoshi; *Tsuta*; Wood Sorrel

*Mongols. Fujin; Nichiren; Raijin; Sobu

*Monkey. Crab; Dance; Monkey and the Boar; Monkey and the Jellyfish; Persimmon; Saito no Sanemori; Sanzo-hoshi; *Sarugaku*; Saruta-hiko-no Mikoto; Songoku; Treasure Ship; Zodiac

Monkey, mystic three. Saruta-hiko no Mikoto; Three Sacred *Monkeys*

Monkey Prince. Dosojin; *Sarugaku*; Saruta-hiko no Mikoto; Snakes and Serpents

Monster. Shutendoji

*Moon. Abe no Nakamaro; Bamboo Cutter; Fox; Frog/Toad; Joga; Izanagi and Izanami; Li Bai; Marishi-ten; Nikko-bosatsu and Gakko-bosatsu; Rabbit; Tama Rivers; Yamanaka no Yukimasa

Moon Viewing. Grateful Fox; Moon; *Suikoden*; Ueno Park; Wasobioe

*Mount Hiei. Ashikaga no Takauji; Bell of Miidera; Dengyo-daishi; Minamoto no Tameyoshi; Narita no Tomenari; Pageant of Amida's Welcome; Raigo Ajari; Saicho; Taira no Shigemori

*Mount Horai (Dao paradise). Clam; Fuji; Muko; Sentaro; Stork; *Tama*; Urashima Taro

Movies. *Chushingura*, (1962, see Forty-seven Faithful Ronin of Ako), *Rashomon* (1950, see Rashomon); *Farewell my Concubine* (1993, see Yu Ji)

Mugwort. Akusen; Eight Daoist Immortals (Ransaika); Mako; *Sennin*

Murder. Antoku; Buddhism; Endo, Morito; Forty-seven Faithful *Ronin* of Ako; Funakoshi Juemon; Ghost Story of Yotsuya; Hojo Tokimasa; Hosokawa no Fujitaka; Jiraiya; Matano no Goro; Minamoto no Sanetomo; Minamoto no Yoriie; Minamoto no Yoshitsune; Miyagino and Shinobu; Night-crying Stone; Oguri-hangan; Okazane; Revenge in Ueno; Ryoko; Sasaki no Shiro Takatsuna; Shizuka Gozen; Soga no Iruka; Tajima Shume and the Phantom Priest; Tokutaro and the Foxes; Toyotomi-Hideyoshi; Yamada Nagamasa; Yamato Takeru no Mikoto; Yobukodori

Mushroom. Sacred Fungus; *Mannentake*; Nyoi

Music. Neiseki; Nitta no Yoshisada; Noh; Shennong; Taishin O Fujin; *Tale of Joruri*; Tennin; Tokokei

Musical Instruments. Akoya; Benten; Bugaku; Choshinjin; Conch Shell; Eight Daoist Immortals (Sokokukyu); Hime-gimi; Hoichi; Huangdi [legend]; *Karyobinga*; Kibi Makibi; *Komuso*; Lion Dance; Minamoto no Yoshimitsu; Osugi and Otama; *Sennin*; Shoshi; Taira no Tsunemasa; *Tale of Joruri*; Tokokei; *Tori-oi*

Musician. Blind Men; Bugaku; Eight Daoist Immortals (Kanshoshi); Minamoto no Yoshimitsu; Neiseki; Osugi and Otama; *Sarugaku;* Semimaru; Shoshi; Taira no Tsunemasa; *Tale of Joruri;* Tokokei; *Tori-oi;* Toshikage

N

Netsuke. *Fugu;* Lizard; Minamoto no Yoritomo; Shiba Onko; *Shogi;* Snail; Spirit God of the Three Treasures; Susano-o no Mikoto; Urashima Taro; *Yatate*

*New Year Observances. Festivals; Fuji; Lion Dance; Lobster; Magic; Mansai; Nanten; Osugi and Otama; Persimmon; Pine; Precious Things; Radish; Saibo; Salmon; Sardine; Toshiotoko; Toshitokujin; Treasure Ship; *Yuzuri*

*Nio. Marubashi Chuya; *Shishi;* Unkei; Zuijin

*Noh, theater. Feathered Robe; Hannya; Jo and Uba; Okuni; Ono no Komachi; Pine; Rocks and Stones; *Ronin; Sambaso; Sarugaku;* Shunkan; Masks; Taira no Atsumori; Taira no Koremochi; Taira no Tsunemasa; *Tale of Joruri;* Tamamo no Mae; Tenjiku Tokubei; Toyotomi Hideyoshi; Toys; *Ubaga sake*

Noh, titles. Jo and Uba; Ono no Komachi; Rocks and Stones; Shunkan; Taira no Koremochi; Taira no Tsunemasa; Tenjiku Tokubei

Nue. Minamoto no Yorimasa

Nun. Ben no Naishi; Hojo Masako; Nii no Ama; Nitto no Yoshisada; Sei Shonagon; Shizuka Gozen

*Nyoi. Sacred Fungus

O

*Octopus/Squid. Hiko-hohodemi; Monkey; Monkey and the Jellyfish; Ryujin

Omen. Butterfly; Crow; Horse That Could Run a Thousand Leagues; Minamoto no Yoritomo; Soso; Spider; Swallow; Tobosaku; Tokokei

*Oni. Dwarfs; Issunboshi; *Nio;* Pheasant; Ryujin; Toshiotoko

*Orange. Saji; Sotan; Tajima Mori

Ornament. Foxes' Revenge; *Magatama; Shibi;* Tamamushi

*Otokodate. Miyoshi Yuki

*Ox. Aoto no Saemon Fujitsuna; Cardinal Points and Directions; Kidomara

(hide); Komei; Laozi (emblem of); Neiseki; Ninomiya Sontoku; Shohaku; Sugawara no Michizane; Zodiac

P

*Pagoda. Fujiwara no Jo-e; Seven Gods of Good Fortune; Twelve Heavenly Kings; Vulture Peak

Pail. Anju-hime; Jichu's Dream

Painter. Chodensu; Iwasa Matabei; Kimi and Sawara; Kose no Kanaoka; Kudara no Kawanari; Sesshu; Tekiryu; Toba Sojo

Painting. Enoki; Miyamoto Musashi; Otsu-e; Picture Horses

Paper. Abe no Seimei; Gohei; Ichimokuren; Ki no Tsurayuki; Monkey; Praying at the Hour of the Ox; Saihai; Shimenawa; Sumo; Susano-o no Mikoto; Tamagushi; Sobu

Peach/peach tree. Butei; Kishibojin; Mako; Mojo; Momotaro; Monkey; Seiobo; Sennin; Tobosaku; Wuling-Jin

Pearl. Long Nu

*Peony. Shakkryo; Shohaku; Twelve Heavenly Kings

*Persimmon. Crab; Quail

Phoenix. See Ho-o

Physician/Healer. Binzuru; Fukyoku Sensei; Hanjaku; Kiko-hohodemi; Jofuku; Kobo-daishi; Octopus; Shogyo-bosatsu; Sumiyoshi; Yakushi-nyorai

Pillow book. Sei Shonagon; Seven Poets of the Pear Chamber; Thirty-six Poets; Yamato

*Pine. Akusen; Bamboo; Crane; Huangdi [historical]; Iga no Tsubone; Koben; Kyoshinkun; Magic; Mako; Mojo; Willow Tree

Plants. Hozuki; Moon; Nanten; Sansho; Seven Herbs of Autumn; Seven Herbs of Spring; Shinobugusa; Tea; Tsuta; Warabi; Wood Sorrel; Yuzuri

Plants loved by artists. Bamboo; Chrysanthemum; Orchid; Plum

*Plum Tree. Bamboo; Chrysanthemum; Laozi; Minamoto no Y0shitsune; Nightingale in the Plum Tree; Orchid; Rinnasei; Seven Worthies of the Bamboo Grove (Oju); Sugawara no Michizane; Taira no Kagesue

Poem/poetry. Banki; Eight Bridges; Eight Daoist Immortals; Fuji; Karu no Daijin; Kobo-daishi; Kutsugen; Manyoshu; Minamoto no Sanetomo; Saigyo-hoshi; Shumoshiku; Tsuta; Uta-e; Yuryaku

Poem, titles. Ki no Tsurayuki; Kobo-daishi; Manyoshu; Minamoto no

Sanetomo; Ono no Komachi; Saigyo-hoshi; Wuling-Jin

Poet. Abe no Kakamaro; Abe no Yasuna; Hosokawa no Fujitaka; Ariwara no Narihira; Hosokawa no Tadaoki; Ki no Tsurayuki; Minamoto no Sanetomo; Nightingale in the Plum Tree; Ono no Komachi; Rinnasei; Saigyo-hoshi; Sei Shonagon; Semimaru; Seven Poets of the Pear Chamber; Six Poets; Sojo Henjo; Sotori-hime; *Tales from Ise;* Thirty-six Poets; Three Gods of Poetry; To no Ryoko; Yamabe no Akahito; Toenmei

Poet, Chinese. Li Bai; Shumoshiku

Poison/venom. Frog/Toad; Fujiwara no Hidesato; Jiraiya

Politics. Daruma; Fujiwara no Fuhito; Ryobu-shinto; Shotoku Taishi; Soga no Umako

*Pomegranate. Kishibojin

*Praying Mantis. Boar; Cicada

*Precious Things. Cowrie Shell; Seven Gods of Good Fortune (Hotei); *Tama*

Priest. Benkei Musashibo; Fumon Mukan; Hoichi; Ragyo; Raigo Ajari; Saigyo-hoshi; Saion-Zenji; Tosabo Shoshun

Priest, attire. Ippen-shonin; Jizo-bosatsu;

Priest, accoutrements. Beggars; Koben; *Nyoi; Shakujo;* Shinto; Rosary

Priest, Buddhist. Bonze; Cherry Princess; Chogen; Chodensu; Daito Kokushi; Daruma; Dengyo-daishi; Dosen; Enchin; Fu-daishi; Fujiwara no Jo-e; Gyoshin; History of a Three-meter-square Hut; Honen-shonin; Ikkyu; Ippen-shonin; Jichu's Dream; Jizo-bosatsu; Kanroku; Koben; Kobo-daishi; Kuya-shonin; Mukan; Murata Juko; Nichiren; Roben; Sanzo-hoshi; Shinran-shonin; Shodo-shonin; Shohaku; Shuko; Shunjobo Chogen; Shunkan; Yuten-shonin;

Priest, Shinto. Matsumura-so

Prophecy. Dragon-horse; Yu Gong

*Prostitute/courtesan. Akoya; Brothel; Cherry Princess; Diviner's Sticks; Eguchi no Kimi; Geisha; Ikkyu; Minuni Kojoro; Miyagino and Shinobu; Miyoshi Yuki; *Oiran;* Tora Gozen; Umbrella; Umegae; Willow Tree; Yoshiwara

Purple. Ariwara no Narihira; Cardinal Points and Directions; *Sohei;* Sumo

Q

*Quail. Rat

R

*Rabbit/hare. Moon; Toshitokujin; Zodiac

*Radish. Ooka no Tadasuke

*Raijin (Raiden). Fujin; Koshibe no Sugaru; Mongols; Shokuro and Chiyo; *Tama*

Rain. Dragon; Eight Beautiful Views of Lake Biwa; Ganshinkei; Huangdi [historical]; Ikkaku Sennin; Ono no Michikaze; *Rashomon,* Ryuko; Tora Gozen

*Rakan. Bodhisattva; Bonze; Chodensu; Deer; *Sennin; Shakujo*; Tiger; Unkei

*Rat. Fox; Nikki Danjo; Okuninushi no Mikoto; Quail; Raigo Ajari; Sentaro; Sessho; Yuki-hime; Zodiac

Red/crimson. Aizen Myo-o; Ankisei; Cardinal Points and Directions; Emma-o; Gigaku; *Ho-o*; Ida-ten; Lobster; Nangyo Koshu; Shokuin; Tamayori-hime no Mikoto

Reeds. Anju-hime; Daruma; Joka; *Komuso; Shoryobune*

Reincarnation/transmigration. Emma-o; *Karyobinga; Sennin*; Six Realms of Rebirth; Tobosaku

Religious conflict/debate. Confucius; Four Sleepers; Shotoku Taishi; Totoribe no Yorozu; Toyotomi Hideyoshi

Reliquary. Ida-ten; Sharito

Repository. *Sotoba;* Tombs

Resurrection. Kobo-daishi; *Mukei;* Saga Sadayoshi; Tokudo-shonin; Unkei

Revenge. Miyagino and Shinobu; Miyamoto Musashi; Omori no Hikohichi; Revenge in Ueno; Soga Brothers' Revenge; Tora Gozen

Rice. Amaterasu; Aoto no Saemon Fujitsuna; Bee; Cuckoo; Fox; Fujiwara no Hidesato; Inari; Mako; Moon; Nintoku; Revenge in Ueno; Seven Gods of Good Fortune; Seven Good Fortunes; Toyotomi Hideyoshi (as currency); White Fox

River. Cang Jie; Carp; Chugoro; Iga no Tsubone; Indigo Bridge; Minamoto no Yoshiie; Sanzu River; Shodo-shonin

Robe. Feathered Robe; Fuxi; Ida-ten (symbol); Okada; Shiiki; Seven Good Fortunes

Rock/stone, as weapon. Aku Hachiro; Asahina Saburo; Badger's Revenge; Sanado no Yoichi; Yamanaka no Yukimasa

*Rocks and Stones. Amaterasu; Badger's Revenge; Eight Bridges (stepping); Futamiga-ura; Hachiman (god); Hokyosha; Horse-hoof Stone; Jingo (sacred); Kyoshinkun; Matsuura no Sayo-hime; *Magatama* (gem); Mount Horai; Nangyo Kushu (turned into); Night crying Stone; Ogishi;

Ooiko; Phallic Symbols; Riko; Saruta-hiko no Mikoto; Shiba Onko; Tamamo no Mae. *See also* Water

Ronin. Forty-seven Faithful *Ronin* of Ako; Funakoshi Juemon; Komusa; Okada; Revenge in Ueno; Tajima Shume and the Phantom Priest

Rope. Amaterasu; Badger's Hanging; Earth Spider; Fudo Myo-o; Futamiga-ura; Magic; Million Prayers; New Year Observances; Rocks and Stones; Ryuko; *Shimenawa; Shoryobune;* Shutendoji; Sumo; Susano-o no Mikoto; Wrestler and the Serpent; Yuki-hime

*Rosary. Saruta-hiko no Mikoto; Million Prayers

*Ryujin, Dragon King. Clam; Fujiwara no Hidesato; Genkei; Hiko-hohodemi; Jimmu; Jingo; Long Nu; Minamoto no Mitsunaka; Monkey and the Jellyfish; Nitta no Yoshisada; Octopus; Tachibana-hime; Takeuchi no Sukune; *Tama;* Urashima Taro; Yamato Takeru no Mikoto

S

Sacrifice, human. Ho Bai; Pillar of Gensuke

Sacrifice, of self and martyrdom. Matsuo Kotei; Sato no Tsuginobu; Sugawara no Kanshusai; Taira no Noritsune; Tajima Mori; Takayama Masayuki; Twenty-four Paragons of Filial Piety (esp. Yoko); Yamato Takeru no Mikoto

Scepter (*Nyoi*). Moki; *Nyoi*

Scepter/thunderbolt (*Vajra*). En no Shokaku; Sanbokojin; Seitaka-doji and Kongara-doji; Seven Gods of Good Fortune; Shozen-doji and Shoaku-doji; Spirit God of the Three Treasures; *Vajra*

Scholar(s). Eighteen Learned Men of the Tang Dynasty; Four Go Players; Ganshinkei; Kanroku; Kibi Makibi; Kutsugen; Ogishi; Seven Worthies of the Bamboo Grove; Sugawara no Michizane; Wani

Science/Invention. Fuxi; Gyogi; Henjaku; Huangdi [legend]; Kanroku; Kibi Makibi; Shennong

Sculptor. Unkei

Seasons. Dragonfly; Eight Beautiful Views of Lake Biwa; Fireflies; Maple; Peony; Persimmon; Pheasant; Plum Tree; Seven Herbs of Autumn; Seven Herbs of Spring; Shoquin; Taira no Koremochi; Tiger; *Tsurezuregusa*

*Seiobo, Queen of the West. Butei; Deer; Eight Daoist Immortals (Ransaika); Joga; Jogen-fujin; Mu Wang; Rogyoku; Taishin O Fujin; Tobosaku

Sennin. Akusen; Ankisei; Baifuku; Bee; Boei; Bokushi; Bunsho; Chinnan; Chodoryo; Chosanshu; Eight Daoist Immortals; En no Shokaku; Fishing and Fishes; Four Sleepers; Gama Sennin; Gyokushi; Henjaku (attire);

Heron; Hihashi (transformed into); Hokyosha; *Ho-o*; Horse; Hoso; Ikkaku Sennin; Inki; Jisshudo; Josakei; Katsugen; Kikujido; Kinko; Kokin; Koshi-Doshi; Kume; Mako; Mojo; Moki; Muko; Nangyo Koshu; Ofushi; Oho; Okyo; Oshitsu; Osho; Ranha; Rihappyaku; Rinreiso; Rogyoko; Ryokyo; Ryuko; Saji; Sanzo-hoshi; Shiiki; Shosei; Shoshi; Shujushi; Sosenon; Sotan; Taigenjo; Taiinjo; Taishin O Fujin; Taiyoshi; Taizan Rofu; Tanshotan; Teiisai; Teireii; Teishi-en; Tekiryu; Tobosaku; Yoko; Yosho

*Seven Gods of Good Fortune. Benten; Bishamon; Bream; Fishing and Fishes; Precious Things; *Tama;* Tenkai; Tortoise/Turtle; Toshitokujin; Treasure Ship; Twelve Kings

Sexual symbols. Ame no Uzume; Clam; Cowrie Shell; Elephant; Lizard; Lobster; Monkey; *Nyoi;* Octopus; Phallic Symbols; Radish; Rocks and Stones; Sacred Fungus; *Tengu.* See also *Shunga*

*Shaka. Fugen-bosatsu; Kannon-bosatsu; Kasho; Lotus; Miroku-bosatsu; Monju-bosatsu; Nichiren

Shaman. Amaterasu; Masks; Mirrors; Praying at the Hour of the Ox; Takeuchi no Sukune

Shape-shifter/transformer. Abe no Seimei; Ayashi no Omoro; Badger; Badger's Hanging; Badger's Revenge; Cat; Chugoro; Enoki; Demons; Fox; Fujiwara no Hidesato; Hannya; Jiraiya; Josakei; Kiyo-hime; Kobo-daishi; Mikuni Kojoro; Quail; Rat; Shark Man; Snakes and Serpents; Snow Woman; Sotan; Tamayori-hime no Mikoto; Tea Kettle of Good Fortune; Teireii; Tobosaku; *Yamauba*

Shell. Conch Shell; Cowrie Shell

*Shinto. Girl's Day; Gyogi; Koben; Magic; Mikoshi; Mirrors; Mount Hiei; Roben; Ryobu-shinto; *Sakaki;* Shotoku Taishi Soga no Umako; *Shimenawa*

Shinto and politics. Ryobu-shinto; Shotoku Taishi; Soga no Umako

Shinto sect(s). Gyogi

Shipwreck. Futamiga-ura; Toshikage

*Shishi. Lion Dance; Monju-bosatsu; *Tama*

Shoe(s). Ankisei; Choryo; Daruma; Eight Daoist Immortals (Ransaiku); Fujiwara no Kamatari; Koben; Magic; Nangyo Koshu; Okyo; Praying at the Hour of the Ox; Wrestler and the Serpent

Shogun. Ashikaga no Takauji; Azazuma-hime; Minamoto no Yoritomo

*Shokujo. Chosai

Shutendoji. Kidomaru; Kintaro; Minamoto no Yorimitsu

Siblings. Choko and Chorei; Fuji; Genkei; Gihakuyo; Izanagi and Izanami; Miyagino and Shinobu; Sao-hime; Seiobo; Soga Brothers' Revenge; Tora Gozen; Twenty-four Paragons of Filial Piety

Silk. Huangdi [legend]; Saga Sadayoshi; Sotori-hime

Skulls/skeleton. Karukaya-doshin; Mitsukuni; Shodo-shonin; Taira no Kiyomori; Tamamo no Mae

Slavery. Anju-hime; Yangdi

*Snakes and Serpents. Benten; Cardinal Points and Directions; Frog/Toad; Fuji; Fuxi; Ippen-shonin; Jiraiya; Karukaya-doshin; Koso; Minamoto no Mitsunaka; *Naga*; Shodo-shonin; Snail; Suijin; Taira no Tadamori; Taira no Tsunemasa; Tamichi; Wrestler and the Serpent; Zodiac. *See also* White serpent

Snow. Daruma; Deer; Forty-seven Faithful *Ronin* of Ako; Gentoku; Minamoto no Yoshitsune; Snow Woman; Tokiwa Gozen; Twenty-four Paragons of Filial Piety

Social history. Traveling by Shank's Mare. *See also* Culture

Social reform. Nintoku; Sakura Sogoro

Sorcerer/sorceress. Asahina Saburo; Ayashi no Omoro; Gama Sennin; Jofuku; Kenenshu; Kokuri-baba; Masuda Munesuke; Ofushi; Sakuna-biko-na no Kami; Yoko

*Spider. Cicada; Earth Spider; Kibi Makibi; Sao-hime. *See also* Earth Spider

Spirits. Dreams; Gama Sennin; Heitaro Sone Masayoshi; Jiraiya; Rocks and Stones; Seven Worthies of the Bamboo Grove; Shinto; Shuyu; Urashima Taro

Spit. Ranha; Rinreiso; Ryuko

Stars. Marishi-ten; Stars and Constellations; Tanabata; Tobosaku; Twenty-eight Servitors of Kannon

Stepmother. Hime-gimi; Miyoshi Yuki; Oguri-hangan; *Tale of the Room Below*; Twenty-four Paragons of Filial Piety (Binson, Taishun)

Stork. Rinreiso

Storm(s). Eight Daoist Immortals (Ryotohin); Fujin; Gyokushi; Jingo; Katsugen; Kodama Kura no Jo; Koshibe no Sugaru; Matsumura-so; Minamoto no Yoritomo; Minamoto no Yoshitsune; Mongols; Nichiren (Kamikaze); Nitta no Yoshioki; Ragyo; Sickle Weasel; Sosenon; Tachibana-hime; Taira no Tomomori; Toshikage; Totoribe no Yorozu; Yamato Takeru no Mikoto

Strongman. Aku Hachiro; Asahina Saburo; Benkei Musashibo; Goshisho; Hatakeyama no Shigetada; *Kappa* (Rokusuke of Keyamura); Kintaro; Matano no Goro; Minamoto no Tametomo; *Nio*; Nitta no Yoshisada (Kinryu Saemon); Rohan; Saginoike Heikuro Masatora; Sanada no Yoichi; Shinozuka; Taira no Kagekiyo; Taira no Noritsune; Tiger; Tomoe Gozen; Twenty-four Paragons of Filial Piety (Chuyu); Usui no Sadamitsu; Wrestler and the Serpent; Yamanaka no Yukimasa; Yamato Takeru no Mikoto

Strongwoman. Iga no Tsubone; Kaneko; Ooiko

Suicide. Ando Zaemon Shoshu; Antoku; Badger's Hanging; Indigo Bridge;

Kanmei; Kimi and Sawara; Kokin; Kuganosuke and Hinadori; Kutsugen; Muko; Murikami no Yoshiteru; Nii no Ama; Ohan and Choemon; Okiku; Otoma; Sentaro; Shoki; Shubaishin; Sojo Henjo; Tachibana-hime; *Tale of Joruri*; Tamamushi; Willow Tree; Yu Ji

Suicide, ritual (*seppuku*). Forty-seven Faithful *Ronin* of Ako; Iga no Tsubone; Minamoto no Tametomo; Minamoto no Yorimasa; Narita no Tomenari; Oshichi; Sen no Rikyo; Shibata no Katsuie; Shiganosuke; Takayama Masayuki; Totoribe no Yorozu; Yu Ji

Sumptuary laws. Sen no Rikyu

Sun. Flaming Disk; Taira no Kiyomori

*Susano-o no Mikoto. Amaterasu; Futamiga-ura; Horse; Izanagi and Izanami; Miyajima; Ninigi no Mikoto; Okuninushi no Mikoto; *Sugi;* Swords; Taira no Tadamori; Three Most Beautiful Landscapes; Three Sacred Treasures; Toyo-uke-hime; Yamato Takeru no Mikoto

*Sutra. Dreams; Fumon Mukan; Kannon-bosatsu; Mandala; Nichiren; Nightingale; Pageant of Amida's Welcome; Seven Evils; Seven Good Fortunes; Vulture Peak

Sword, magic. Eight Daoist Immortals (Ryotohin (Katsugen), Shoriken); Jimmu; Kobo-daishi

*Swords. Banki; Benkei Musashibo (*samurai*); Gotoba (manufacture); Hiko-hohodemi (blade); Hokyosha; Miyamoto Musashi; Morinaga; Nichiren; Nitta no Yoshisada; Revenge in Ueno; Susano-o no Mikoto; Taira no Shigemori; Taira no Tadamori; Three Sacred Treasures; Yamato Takeru no Mikoto; Yuten-shonin

T

Taira and Minamoto clans. Antoku; Genpei War; Hoichi; Jomyo; Matano no Goro; Saito no Sanemori; Sasaki no Moritsuna; Shunkan; *Sohei*

*Tama. Flaming Disk; Inkyo; Jingo; Mount Horai; *Ningyo;* Ryujin; Seven Gods of Good Fortune; *Shishi;* Takeuchi no Sukune; *Tama;* Tama Rivers; Treasure Ship; White Fox

*Tea. Daruma; Murata-Juko; Saicho; *Sansho;* Shuko

*Tea Ceremony (*chanoyu*). History of a Three-meter-square Hut; Murata Juko; Sen no Rikyu; Shuko; *Sukiya;* Toyotomi Hideyoshi

Teahouse. Brothel; Geisha; Otoma; *Sukiya;* Tea Ceremony; Yoshiwara

*Tengu. Gigaku; Izuna Gongen; Jiraiya; Kintaro; Minamoto no Yoshitsune; Mount Hiei; Sojobo; *Sugi*

*Tennin. *Tama*

Third eye (*urna*). Kokuzo-bosatsu; Shaka; Thirty-two Signs of Wisdom

Three Cringing Creatures. Frog/Toad; Jiraiya; Snail; Snakes and Serpents

Three Friends, The (three companions of the deep cold). Bamboo; Plum Tree

Three Heroes of the Early Han Dynasty. Choryo; Hankai; Kanshin; Koso

*Three Heroes of the Later Han Dynasty. Gentoku; Kanshin; Kanyu

*Tiger. Bamboo; Bunsho; Cardinal Points and Directions; Chodoryo; Chosai; Four Sleepers; Shiiki; Teishi-en; Zodiac

Time lost. Genkei; Oshitsu; Ryokyo

Tobacco. Tobacco Pipe; Tobacco Pouch

*Torii. Miyajima; Three Most Beautiful Landscapes

*Tortoise/Turtle. Cardinal Points and Directions; Chosanshu; Fuxi; Joka; Mount Horai; Muko; *Tama;* Urashima Taro

Torture. Hasebe no Nobotsura; Karu no Daijin; Ryoko; Sakuro Sogoro; Teiisai; Tokiwa Gozen

Trade. Yamada Nagamasa. *See also* Business

Transformation. Raijin; Saion-zenji; Saji; Willow Tree. *See also* Shape-shifter

Treason. Taira no Kagetoki

Tree(s). Amaterasu (*Sakaki*); Bamboo (plum); Cicada (gingko); Dreams (camphor); *Enoki* (nettle); *Ho-o* (*kiri*); *Ichimoku*ren (*gohei*); Kanmei; Kompira Shrine; Maple; Mount Horai; *Ni*; Night-crying Stone (fir); Orange; Paulownia; Persimmon; *Sakaki;* Saruta-hiko no Mikoto (*enoki*); Shaka (teak); *Sugi* (cedar); Susano-o no Mikoto; *Tamagushi;* Three Sacred Treasures (*Sakaki*)

Tree, as weapon. Aku Hachiro; Asahina Saburo; Iga no Tsubone; Jo no Hangaku; Tomoe Gozen

Trigram(s). Diviner's Sticks; Dragon-horse; Eight Trigrams; Fuxi; Shennong

Tsukiyomi (moon). Izanagi and Izanami; Moon

*Twelve Heavenly Kings. Bishamon; *Nio;* Rabbit; Seven Gods of Good Fortune; Suiten; Twelve Celestial Generals; Yakushi-nyorai

Twins. Yamato Takeru no Mikoto

Tyrant. Taira no Kiyomori; Yuryaku

U

Ukiyo-e. Military Banners; Moon; Prostitutes; Tama Rivers; Tea; Tokaido; Ueno Park

Umbrella. Chinnan; Jingo; *Oiran*; Ono no Michikaze; Osho; Pagoda

Unicorn. Jogen-fujin; *Kirin*

Universe. Amaterasu; Ame no Uzume; Cardinal Points and Directions; Sumeru; Stars and Constellations; Taira no Kiyomori; Tiger; Twelve Heavenly Kings; Twenty-eight Servitors of Kannon; Yin and Yang; Zen Circle

V

Virtues. Dog; *Ho-o*; Spider

Vision. Ryujin

W

War. Cock; Mule; Saito no Sanemori; Shujobo Chogen; Taira no Kiyomori; Taira no Masakado (Tenkei); Toyotomi Hideyoshi

War, Genpei. Genpei War; Hoichi; Matano no Goro; Minamoto no Yoshitsune; Soga Brothers' Revenge; Taira no Kagetoki; Takeda no Yoshinobu; *Tale of Joruri*; Wada no Yoshimori

War, Heiji. Heiji Monogatari; *Tales of the Heiji Period*

War, Hogen. Minamoto no Tameyoshi; Minamoto no Yoshitomo

Warrior. Abe no Sadato; Abe no Muneto; Akechi no Mitsuhide; Aku Hachiro; Araki no Murashige; Asahina Saburo; Benkei Musashibo; Dog; Endo, Morito; Forty-seven Faithful Ronin of Ako; Fujiwara no Hidesato; Goshisho; Hatakeyama no Shigetada; Hojo Tokimasa; Izumi no Saburo Chikahira; Kamakura Gongoro Kagemasa; Kiichi Hogan; Kiyowara no Takenori; Mask; Matano no Goro; Miura no Yoshiaki; Morihisa; Morinaga; Murakami no Yoshimitsu; Narita no Tomenari; Nawa no Nagatoshi; Nitan no Tadatsune; Nitta no Yoshioki; Oda Nobunaga; Oguri-hangan; Omori no Hikohichi; Ono no Oki; Rokusuke; Ryochu; Saito no Sanemori; *Samurai*; Sanada no Yoichi; Sanada Saiemon no Yukimura; Sano no Tsuneyo and His Bonsai; Sasaki no Moritsuna; Sasaki no Shiro Takasuna; Sato no Tadanobu; Sato no Tsuginobu; Shibata no Katsuie;

Shiganosuke; Shimamura Danjo Takanori; Shinozuka; Shuyu; Soso; Takeda no Yoshinobu; Takeda Shingen; Tamichi; Three Heroes of the Later Han Dynasty; Tomoe Gozen (female); Totoribe no Yorozu; Urabe no Suetake; Wada no Yoshimori; Watanabe no Tsuna; Yamanaka no Yukimasa; Yamato Takeru no Mikoto; Yoyuki

Warrior, Chinese. Choryo

Warrior, female. Tomoe Gozen

Warrior, Minamoto clan. Minamoto no Mitsunaka; Minamoto no Tametomo; Minamoto no Tameyoshi; Minamoto no Tusnemoto; Minamoto no Yoriie; Minamoto no Yorimasa; Minamoto no Yorimitsu; Minamoto no Yorinobu; Minamoto no Yoritomo

Warrior, Taira clan. Taira no Atsumori; Taira no Kagekiyo; Taira no Kagesue; Taira no Kagetoki; Taira no Kiyomori; Taira no Koremochi; Taira no Masakado; Taira no Noritsune; Taira no Tadamori; Taira no Tomomori; Taira no Tsunemasa

Water. Frog/Toad; Kikujido; Kyoyu and Sofu; Oguri-hangan; Pillar of Gensuke; Shogyo-bosatsu; Sotan

Water, from rock. Kobo-daishi; Minamoto no Yoriyoshi; Minamoto no Yoshiie

Waterfall. Carp; Endo, Morito; Kintaro; Li Bai; *Okatsu*; Ragyo; Saginoike Heikuro Masatora; Seitaka-doji and Kongara-doji; Waterfall of Yoro

Weaponry. Aku Hachiro; Benkei Musashibo (*samurai*); Okada; Shotoku Taishi; Swords; Takeda Shingen

Weaver/weaving. Amaterasu; Chosai; Horse; Saga Sadayoshi; Shokujo; Spider; Tanabata; Twenty-four Paragons of Filial Piety (Toyei);

*Wheel. *Rinzo*; Mandala; Million Prayers; Sanbo Kojin; Six Realms of Rebirth; Toys

Wheel of the Law. Kasho; Lotus; Shakra; Spirit God of the Three Treasures; Thirty-two Signs of Wisdom; *Yamabushi*

*Whisk/broom. Eight Daoist Immortals (Sokokukyu); Four Sleepers; Willow Tree

White. Benten; Cardinal Points and Directions; Fox; *Ho-o*; Rabbit

White deer. Deer; Yamato Takeru no Mikoto

White dog. Ayashi no Omoro; Dog; Totoribe no Yorozu; Yamato Takeru no Mikoto

White elephant. Fugen-bosatsu

*White Fox. Dakini; Grateful Fox; Izuna Gongen; Masuda Munesuke

White horse/mule. Eight Daoist Immortals (Chokaro); Horse; Kaneko; Ooka no Tadasuke

White serpent. Benten; Yamato Takeru no Mikoto

*Willow Tree. Azazuma-hime; Fireflies; Heitaro Sone Masayoshi; Ohan and Choemon; Ono no Michikaze; Seven Worthies of the Bamboo Grove; Swallow; Toenmei; To no Ryoko; Umewara Maru; Willow Wife

Wine (sake). Confucius; Eight Immortals of the Wine Cup; Gourd; Maple; Minamoto no Yoshitsune; Shojo; Shutendoji; Sugi; Taiinjo; Taiyoshi; Tamayori-hime no Mikoto; Three Sake Tasters; Toenmei; Ubaga sake

Witch. Ippen-shonin; Mikuni Kojoro; Sanzu River; Urabe no Suetake; Witch of Adachi Plain

Woodcutter. Bamboo Cutter; Momotaro; Oshitsu; Snow Woman; Tama Rivers; Waterfall of Yoro; Willow Wife

Wrestler/wrestling. Asahina Saburo; Daidozan Bungoro; En no Shokaku; Fujin; Kappa; Matano no Goro; Nio; Ooiko; Rokusuke; Sanada no Yoichi; Seven Gods of Good Fortune (Hotei); Soga Brothers' Revenge; Sumo; Wrestler and the Serpent

Writer. Murasaki Shikibu; Sei Shonagon; Seven Poets of the Pear Chamber; Thirty-six Poets

Writing. Cang Jie; Kibi Makibi; Kikujido; Kobo-daishi; Ogishi; Ono no Michikaze; Shennong; Tanshotan; Uta-e; Wani

Y

*Yin and Yang. Comma; Dragon; Fuxi; Ho-o; Shimenawa; Tiger; Willow Tree

Z

*Zodiac. Boar; Chosai; Cock; Dog; Dragon; Goat; Horse; Monkey; Ox; Rabbit; Rat; Snakes and Serpents; Tiger; Treasure Ship; Twelve Celestial Generals